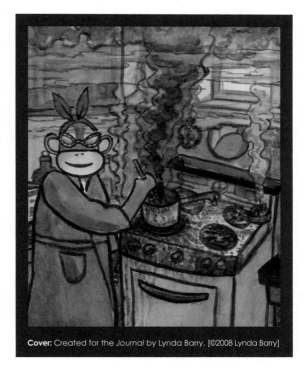

Cover: Created for the *Journal* by Lynda Barry. [©2008 Lynda Barry]

THE COMICS JOURNAL #296 (ISBN: 987-1-56097-986-9) Feb. 2009. Published monthly in Jan., Feb., Apr., May, July, Aug., Oct., Nov. by Fantagraphics Books, Inc., from the editorial and business offices at 7563 Lake City Way N.E., Seattle, WA 98115. *The Comics Journal* is copyright © 2008 by Fantagraphics Books, Inc. All images/photos/text © Their respective copyright holders. Unauthorized reproduction of any of its contents is prohibited by law. Periodicals postage paid at Seattle, WA, and at additional mailing offices. POSTMASTER: Please send address changes to The Comics Journal, 7563 Lake City Way N.E., Seattle, WA 98115. PRINTED IN SINGAPORE.

COMICS COUNTRY

You will find all of your favorite comics, 'zines, books and lots of neat stuff at these well-stocked, highly recommended specialty stores:

Alternate Reality COMICS

4800 South Maryland Pkwy Ste D Las Vegas NV 89119
702-736-3673

www.alternaterealitycomics.net

Atomic Books

3620 Falls Road
Baltimore, MD 21211
410-662-4444

www.atomicbooks.com

The Beguiling

601 Markham St.
Toronto, Ontario,
Canada, M6G 2L7
416-533-9168

www.beguiling.com

Big Brain Comics

1027 Washington Ave South
Minneapolis, MN 55415
612-338-4390

www.bigbraincomics.com

Chicago Comics

3244 N. Clark
Chicago IL 60657
773-528-1983

www.chicagocomics.com

★ Big Planet Comics ★

(4 locations)

4908 Fairmont Ave.
Bethesda, MD 20814
301-654-6856

3145 Dumbarton Ave NW
Washington DC 20007
202-342-1961

426 Maple Ave. E.
Vienna, VA 22180
703-242-9412

7315 Baltimore Ave.
College Park, MD
20740

301-699-0498 www.bigplanetcomics.com

Comic Relief

2026 Shattuck Ave
Berkeley, CA 94704
510-843-5002

PAT MORIARTY

www.comicrelief.net

Comicopia

464 Commonwealth Ave
Boston Ma 62215
617-266-4266

www.comicopia.com

Comix Revolution

606 Davis Street
Evanston, IL 60201
847-866-8659

www.online-revolution.com

Cosmic Monkey Comics
5335 Ne Sandy Blvd
Portland, OR 97213
503-517-9050
www.cosmicmonkeycomics.com

Criminal Records
466 Moreland Ave NE
Atlanta, GA 30307
404-215-9511
www.criminal.com

The Fantagraphics Store
1201 S Vale St, Seattle, WA 98108
800-657-1100
www.fantagraphics.com

Golden Apple
7018 Melrose Ave
Los Angeles, CA 90038
323-658-6047
www.goldenapplecomics.com

Jim Hanley's Universe
(two locations)
4 W. 33rd Street
New York, NY 10001
212-268-7088
325 New Dorp Lane
Staten Island, NY 10306
718-351-6299
www.jhuniverse.com

Hijinx
2050 LINCOLN AVE
San Jose, CA 95125
408-266-1103
www.hijinxcomics.com

Laughing Ogre
4258 N High Street
Columbus, OH 43214
614-A-MR-OGRE
www.thelaughingogre.com

Quimby's
1854 W. North Ave.
Chicago, IL 60622
773-342-0910
www.quimbys.com

TEE HEE!
WWW.PATMORIARITY.COM
WWW.PATMORIARITY.COM
THE STANDARD OF PURITY

PAT MORIARITY

Strange Adventures
5262 Sackville St.
Halifax
Nova Scotia
Canada B3J 1K8
902-425-2140
www.strangeadventures.com

October, 2008 – December, 2008
by Eric Millikin and Staff

British Cartoonist Ken Hunter Dies

Oct. 20: British comic-book artist Ken Hunter died at the age of 91 of undisclosed causes. Hunter drew a variety of strips for such comics magazines as *The Topper*, *The Beano* and *The Beezer*. He created several science-fiction serials, including *Mick on the Moon*, *Back to Zero*, and *Jellymen*. Other long-running strips drawn by Hunter were *Big Chief Running Chump*, *General Jim* and *Danny's Tranny*. Hunter retired from cartooning in 1990.

Smurfs Celebrate 50 Years

Oct. 23: The Smurfs, or Les Schtroumpfs, celebrated their official 50th birthday. Created by Belgian cartoonist Pierre Culliford, also known as Peyo, the Smurfs first appeared on Oct. 23, 1958 in the comic strip *Johan et Pirlouit*, which was printed in the Belgian magazine *Le Journal de Spirou*. To celebrate the day a charity auction of 15 celebrity Smurfs was held at the Brussels town hall. The celebrity Smurfs were designed by celebrities from each country the Smurfs Euro tour had visited. They included

From Peyo's *The Smurfs and the Egg*.
[©1978 Peyo and S.A. Editions Jean Dupuis]

Smurfs by Albert Uderzo, creator of *Asterix the Gaul*, soccer star Phillipp Lahm and Finnish hockey player Tuomo Ruutu. The auction raised 124,700 euros to benefit UNICEF, the United Nations' children's fund.

Congolese Cartoonist Mongo Sisé Dies

Oct. 31: Mongo Sisé passed away Oct. 31 at age 60 following a cardiovascular attack. A graduate of the Academy of Fine Arts in Kinshasa, Sisé was considered one of the Republic of Congo's pre-eminent cartoonists. Exiled from the Congo in 1980, he settled in Brussels and began collaborating with Hergé, later winning a parallel degree in graphic arts and cartoon illustration at the Royal Academy of Fine Arts in Brussels. Sisé became the first African cartoonist to be published by a European comics publisher when his art appeared in *Spirou* in 1980. He wrote several books featuring a young African farmer named Bingo. The titles include *Bingo in Town*, *Bingo Yama Kara*, *Bingo in Belgium* and *Mandio and the Country Bingo*. During his time in Brussels, he also met and worked with Pierre de Witte to create Eur-Af Editions, a publishing house for African comics. In 1985 Sisé returned to the Congo and launched *Bédée Africa*, a Pan-African magazine comic strip, and became the first cartoonist to teach at the Academy of Fine Arts in Kinshasa. Later in his career, Sisé designed and edited magazines for the National Bank of the Congo.

APE 2008

Nov. 1-2: The Alternative Press Expo moved to the fall this year for a post-Halloween event at the San Francisco Concourse. Guests included Jessica Abel and Matt Madden — who gave a presentation on their recent Drawing Words & Writing Pictures instructional book — Megan Kelso, Paige Braddock and Ethan Nicolle. *Kramers Ergot* 7 was unveiled by Sammy Harkham

The Comics Journal

http://www.tcj.com

Publisher: Fantagraphics Books

Editor in Chief: Gary Groth

Managing Editor: Michael Dean

Art Director: Adam Grano

Scanmaster: Paul Baresh

Assistant Editor: Kristy Valenti

Online Editor: Dirk Deppey

Interns: Jenny Ellen Catchings, Alexa Koenings, Gavin Lees and Ben Neusius

Columnists:
Bart Beaty, Tom Crippen, R. Fiore, Steven Grant, R.C. Harvey, Rich Kreiner, John Lent, Tim O'Neil, Donald Phelps, Bill Randall, Kenneth Smith

Contributing Writers:
Simon Abrams, Jack Baney, Noah Berlatsky, Bill Blackbeard, Robert Boyd, Christopher Brayshaw, Ian Brill, Gabriel Carras, Michael Catron, Gregory Cwiklik, Alan David Doane, Austin English, Ron Evry, Craig Fischer, Jared Gardner, Paul Gravett, David Groenewegen, Charles Hatfield, Jeet Heer, John F. Kelly, Megan Kelso, Tim Kreider, Chris Lanier, Bob Levin, Chris Mautner, Ana Merino, Eric Millikin, Ng Suat Tong, Jim Ottaviani, Leonard Rifas, Trina Robbins, Larry Rodman, Robert Sandiford, Seth, Bill Sherman, Whit Spurgeon, Frank Stack, Greg Stump, Matthew Surridge, Rob Vollmar, Dylan Williams, Kristian Williams, Kent Worcester

Proofreader: Rusty McGuffin

Transcriptionists: Carol Gnojewski, Kristy Valenti

Advertising: Matt Silvie

Publicity: Eric Reynolds

Circulation: Jason T. Miles

"Who was I with? What time was it?"
— The Unicorns

For advertising information, e-mail Matt Silvie: silvie @fantagraphics.com.

Contributions: *The Comics Journal* is always interested in receiving contributions — news and feature articles, essays, photos, cartoons and reviews. We're especially interested in taking on news correspondents and photographers in the United States and abroad. While we can't print everything we receive, we give all contributions careful consideration, and we try to reply to submissions within six weeks. Internet inquiries are preferred, but those without online access are asked to send a self-addressed stamped envelope and address all contributions and requests for Writers' and/or Editorial Guidelines to: Managing Editor, The Comics Journal, 7563 Lake City Way N.E., Seattle, WA 98115.

The Comics Journal *welcomes all comments and criticism. Send letters to Blood & Thunder, 7563 Lake City Way N.E., Seattle, WA 98115. E-Mail: dean@tcj.com*

and Alvin Buenaventura, along with contributors Chris Ware (making his first appearance as an APE guest), Dan Clowes, Jaime Hernandez, Kevin Huizenga, Johnny Ryan, Ted May and Eric Haven.

Australian Cartoonist Bill Leak Recovering From Fall

Nov. 4: Cartoonist Bill Leak is recovering from a serious head injury after falling from a balcony. The accident occurred Oct. 21, and Leak was placed in a medically induced coma for three days after receiving two brain surgeries. Leak has no memory of the fall, but he does "remember being on that balcony and I do remember Singo pointed out some birds to me that I was trying to feed, and that's it." In an article from the Australian Associated Press, Leak is quoted as saying his drawing hand felt fine, but he doesn't know when he will create his next cartoon for *The Australian*. "I'll have to feel a lot better than I feel now before I take on the responsibility of doing the cartoon again," Leak stated. He will remain on anti-seizure medication for the next six months. Leak has won eight Walkley Awards and 19 Stanley Awards from the Australian Cartoonists' Association, and has entered the Archibald Prize for portrait painting 13 times.

Dates Set For Siegel's Superman Case

Nov. 5: Judge Steven Larson set two dates for the remaining issues in Joanne and Laura Siegel's case against DC Comics, Warner Bros. and Time Warner. On Jan. 20, the court was scheduled to hear the Siegels' claim that DC Comics, Warner Bros. and Time Warner are alter egos. They contend that the companies are so interconnected that they are effectively one and the same. According to Jeff Trexler at newsarama.com, "the primary reason a plaintiff files an alter-ego claim is to reach the assets of separate identities that would otherwise not be required to pay." The trial to determine if the Siegels are owed compensation for the use of material from *Action Comics* #1 will be held on March 24. Neither trial will be heard by a jury. The judge previously ruled that the Siegels did successfully terminate the grant to the copyright and are now co-owners of the Superman copyright contained in *Action Comics* #1.

Animator Shot In Pasig City, Philippines

Nov. 10: Benjie Guevarra, 39, an employee of Fil-Cartoons Inc. in Mandaluyong City, was shot and killed in Pasig City by an unidentified man riding a motorcycle. Reports say the motorcycle blocked Guevarra's path. The report also states that the suspects sped off after making

The Largest Comic Book & Pop Culture Convention in the Pacific Northwest

EMERALD CITY COMICON

April 4-5, 2009 • Seattle, WA

ALWAYS INDY FRIENDLY!
2009 GUESTS INCLUDE:

**JAIME
HERNANDEZ**

**MIKE
MIGNOLA**

**JAMES
KOCHALKA**

**DAVID
PETERSON**

**VASILIS
LOLOS**

**BECKY
CLOONAN**

**STAN
SAKAI**

**G. WILLOW
WILSON**

**SCOTT
MORSE**

**ALEX
ROBINSON**

**BEN
TEMPLESMITH**

**DAVE
CROSLAND**

FOR THE LATEST NEWS, INFORMATION AND GUEST UPDATES, PLEASE VISIT

WWW.EMERALDCITYCOMICON.COM

sure Guevarra was dead. Fil-Cartoons Inc. is a subsidiary of Hanna-Barbera and has produced such animated television shows and movies as *Dexter's Laboratory*, *The Ren & Stimpy Show* and *The Jetsons Movie*.

Erotic Comics Book Banned By Australian Customs

Nov. 12: Tim Pilcher's *Erotic Comics: A Graphic History*, Vol. 1: *From Birth to the 1970s* has been banned by Australian customs from entering the country unless a large "M" sticker, which indicates the book is for "mature readers," is placed on the cover of the book. Pilcher responded, saying "I find it ludicrous and risible that the Australian authorities need a big sticker to point out the book is for 'adults only.' Surely the word 'erotic' in the title gives it away? Perhaps they got confused with the word 'comics' and couldn't believe adults read sequential literature!" The second volume in the series is due to be published Jan. 8, 2009 in the U.K. and will arrive in the U.S. in March.

Ex-Cartoonist Sues San Diego *Union-Tribune*

Nov. 14: Former San Diego *Union-Tribune* editorial cartoonist Steve Kelley is suing the newspaper, accusing previous employers of pressuring his replacement to not work with him on a joint comic strip. Kelley was fired in 2001 after his editors refused to run a submitted cartoon. He said he reached an agreement with Steve Breen, the *Union-Tribune*'s current editorial cartoonist, to jointly create a newspaper comic strip called *Dustin* that The Universal Press Syndicate agreed to distribute. According to the lawsuit, the deal fell through when Breen pulled out. Kelley's lawsuit alleges that the *Union-Tribune* "applied undue pressure and coercion" on Breen, and "caused him to believe that his job at the *U-T* would be in jeopardy should he continue his involvement with Dustin." Publisher David Copley, Editor Karin Winner, Editorial Page Editor Bob Kittle and Senior Editor/Opinion William Osborne are named in the suit.

Stan Lee Receives National Medal Of The Arts

Nov. 17: Legendary comics creator Stan Lee was one of this year's recipients of the National Medal of the Arts. Established in 1984, the award, which is presented by the president, is considered to be the most prestigious art award given by the government. Award recipients are selected by the National Endowment for the Arts based on their contributions to the arts in the United States. The NEA stated that "Stan Lee is being recognized for his innovations that revolutionized American Comic Books. ... Throughout his career he has devoted himself to the excellence, growth and availability of this unique American artform."

Belgian Artist Guy Peellaert, Dead At 74

Nov. 17: Pop artist Guy Peellaert died after losing his battle with cancer. Peellaert is best known for his album covers for David Bowie and The Rolling Stones, as well as partnering with author Nik Cohn to create the book *Rock Dreams*. The artwork of the Bowie album *Diamond Dogs* was especially controversial as it depicted Bowie as half human-half dog with visible genitalia. Peellaert was born in Brussels in 1934 into an aristocratic family. He studied the fine arts and developed an interest in jazz, pop culture and film. He volunteered to fight in the Korean War as an act of rebellion, later settling in Paris, where he worked as a set designer for several theater companies. He also be-

Image from John Howard's "God Forgives, Weasels Don't" in *Horny Biker Slut Comics*: published in Pilcher and Kannengberg's *Erotic Comics*. [©1991 John Howard]

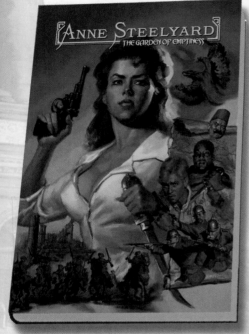

gan creating comic strips at this time. His first two comics were published in 1966 in the French magazine *Hara-Kiri*. *Les Aventures de Jodelle* and *Pravda la Survireuse* had protagonists modeled on the singers Sylvie Vartan and Françoise Hardy, respectively. He also wrote the books *Carashi*, and *Bye Bye, Bye Baby, Bye Bye*. Later in his career, Peellaert created movie posters for the movies *Taxi Driver, Paris, Texas* and *Short Cuts*. He collaborated with Michael Herr to create the book *The Big Room*, a surrealistic homage to Las Vegas. In 1999, Peellaert worked with Cohn again on *20th Century Dreams*. The same year, he was also commissioned to design a New Year's greeting card by French Interior Minister Jean-Pierre Chevènement.

King Features To Launch Online Portal

Nov. 18: Hearst-owned King Features Syndicate, one of the largest syndicators of newspaper comic strips, is launching *Comics Kingdom*, a portal for local newspaper websites. According to *Editor & Publisher*, the service allows sites to link to 60 of the syndicate's daily strips and to split the advertising revenue. The newspapers will have 30-day access to each strip, and the service allows users to comment on and share comics. Users access the strips from the local newspaper's website, and remain on the paper's site as they read the comics. John Soppe, managing director of King Digital, told *Editor & Publisher* "it is very important to them, from a branding standpoint, to keep people on their site. ... As our newspaper partners face new challenges in the ever-changing media landscape, we are continually looking to develop innovative ways to help them reach their business goals — which still remain the same as ever: attracting new readers and driving ad sales."

Court Rules On Suspects Held In Alleged Plot To Murder Danish Cartoonist

Nov. 19: Denmark's supreme court ruled illegal the detention without trial of one of two Tunisians held for allegedly plotting to kill cartoonist Kurt Westergaard, the Agence France Presse reported. Westergaard's drawing of the Prophet Mohammed with a bomb in his turban was one of 12 cartoons of Islam's prophet published in the Danish newspaper *Jyllands-Posten* in September 2005. The cartoons sparked worldwide controversy. The two suspects were arrested Feb. 12. The Supreme Court said in a statement that the Danish intelligence agency P.E.T. did not have sufficient evidence to detain the older of the suspects, a 37-year-old. The judges, however, ruled that there was reason to detain the younger, 26-year-old

suspect, based on evidence presented by P.E.T. to lower courts. That evidence included material gathered during searches of the man's apartment, as well as witnesses placing him near Westergaard's home.

Broccoli International USA To Shut Down

Nov. 25: Broccoli International USA will close operations by the end of the year. Broccoli International USA includes the manga imprints Broccoli Books and Boysenberry. Owned by the Japanese company Broccoli Co. Ltd., Broccoli Books launched in 2004 printing primarily *shoujo* manga. Titles published included *Di Gi Charat, Aquarian Age — Juvenile Orion* and *Galaxy Angel*. According to *Publishers Weekly*, Managing Editor Shizuki Yamashita noted, "We noticed that the sales of our shoujo manga line started declining in 2007." President Kaname Tezuka stated that "the corporate group in Japan evaluated the current U.S. comic book market and the U.S. economy as a whole, and decided that it would be best to concentrate their efforts in the Japanese market for the time being." Fourteen series, which include *Galaxy Angel II, Koi Cupid* and *Kamui*, remain unfinished. Yamashita said the company is "working with our licensors and have offered to assist them and any future U.S. publishers by providing them with all the production materials necessary."

Devil's Due Undergoes Restructuring

Dec. 1: Devil's Due Publishing, publisher of comics including Tim Seeley's *Hack/Slash* and Milo Ventimiglia's *Rest*, has laid off editor Cody DeMatteis and marketing manager Brian Warmoth, according to *Comic Book Resources*. CEO P. J. Bickett has stepped down and left the company. Editor Mike O'Sullivan's status with the company has also changed, but it was unclear at press time what his future position might be. Devil's Due states that the layoffs are a result of the current economic climate. Bickett, who will stay on as an interim consultant, will now be spending most of his time focusing on growing Kunoichi Inc., a creative services outlet he helped found.

British Artist Jim Cawthorn Dies

Dec. 2: Illustrator Jim Cawthorn died shortly before his 79th birthday. Cawthorn created a comics adaptation of science-fiction author Michael Moorcock's *The Jewel in the Skull*. He was the first illustrator employed by Savoy Books in the early 1980s, and was a frequent collaborator with Moorcock. The two worked together on such publishing projects as *Tarzan Adventures*, the *Sexton Blake Library* and the *New Worlds* anthologies. He also illustrated children's science-fiction anthologies, editions of *Lord of the Rings* and the graphic novels *Stormbringer* and

Petey & Pussy
By John Kerschbaum
$19.99

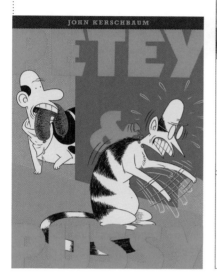

Monologues for Calculating the
Density of Black Holes
By Anders Nilsen
$22.99

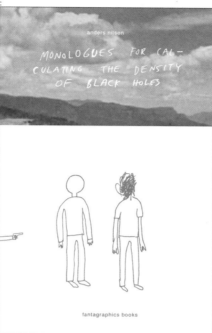

Sublife
By John Pham
$8.99

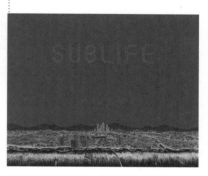

Fuzz & Pluck: Splitsville
By Ted Stearn
$24.99

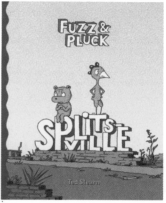

Unlovable
By Esther Pearl Watson
$22.99

The Lagoon
By Lilli Carré
$14.99

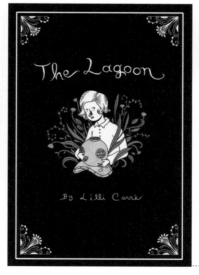

New Book-Form Comics from Fantagraphics

See video previews and page galleries at www.fantagraphics.com

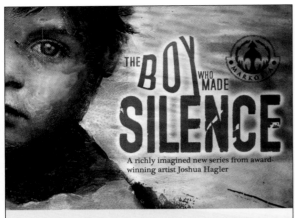

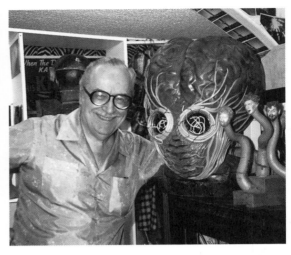

Photograph of Ackerman taken in the late '80s in the Ackermansion.

The Crystal and the Amulet. In 1987, Cawthorn edited *Fantasy: The 100 Best Books* with Moorcock.

Vampirella Creator Forrest J. Ackerman Dies

Dec. 4: Forrest J. Ackerman, creator of Vampirella and editor of *Famous Monsters of Filmland* magazine, died of a heart attack in Los Angeles. He was 92. As a teen, Ackerman started the Los Angeles Science Fiction Society. He edited its fanzine, in which he published the first story by a young Ray Bradbury in 1938. After serving in the Army during World War II, he began a career as a literary agent, representing Bradbury, L. Ron Hubbard and Isaac Asimov. He is often credited with coining the term "sci fi," which he said came to him in 1954 when he heard a radio announcer use the word "hi-fi."

He edited and wrote most of the stories for *Famous Monsters of Filmland* magazine, published by Jim Warren from 1958 until 1983. Ackerman often used photos of his extensive collection of movie memorabilia to illustrate stories; this collection filled his 18-room home, which he christened the "Ackermansion." He gave tours every Saturday, showing off such items as the ring Bela Lugosi wore while playing Dracula in *Abbott and Costello Meet Frankenstein*, and the pterodactyl from *King Kong*. In 1969 Warren launched *Vampirella*, with Ackerman writing the title character's first appearance.

Ackerman had no children. He was preceded in death by his wife, Wendayne, who died in 1990.

S. Clay Wilson Recovering From Head Injury

Dec. 7: Underground cartoonist S. Clay Wilson is recov-

Classic Comics Press

In the 1950s, small-town soap opera dramas - stories meant for a romance-hungry female audience with newfound economic clout - saturated all forms of entertainment ranging from movies to the Sunday funnies. *Classic Comics Press* presents the most romantic and dramatic comic strip from that era, advertising illustrator *Stan Drake's The Heart of Juliet Jones*.

The first volume of a series that will encompass Drake's entire 30-plus years on *The Heart of Juliet Jones*, this edition reprints the complete dailies from March 9, 1953 to August 13, 1955, including a never-before-reprinted eight-month two-story sequence. Also featured is a biographical essay on Stan Drake by Armando Mendez and an Introduction by award-winning cartoonist and lifelong Stan Drake friend, Leonard Starr.

280 8½ X 11 Pages - $24.95 plus $4.95 Shipping and Handling.

From Lauzier's *les sextraordinaires adventures de ZiZi et Peter Panpan*. [©1979 Lauzier and Editions Jacques Glénat]

ering after a serious head injury incurred on Nov. 1 while walking home from a friend's apartment. The 67-year-old required a two-and-a-half week stay in intensive care and is regaining his ability to communicate again with the help of a speech therapist. Lorraine Chamberlain, Wilson's long-time partner, said Wilson is still suffering from aphasia, a loss of the ability to produce or understand some language, and has difficulty with short-term memory. "The part of the brain that was injured," she notes, "makes him weigh a question so long that you don't think he's going to answer it at all." After a month-long stay at San Francisco General, Wilson has been moved to California Pacific Medical Center, and Chamberlain hopes he will be able to return home before Christmas. Wilson is best known for his highly detailed, violent and sexually explicit images in *Zap*. His books include *Bent*, *Barbarian Women* and *Collected Checkered Demon*. A career-spanning interview with Wilson appeared this year in *The Comics Journal* #293.

French Cartoonist Gérard Lauzier Dies

Dec. 8: Comic-book author and satirist Gérard Lauzier has died after a long illness. He was 76 years old. Born in Marseilles, Lauzier was educated at the Ecole des Beaux Arts in Paris. At age 22, he moved to Brazil where he lived for five years while working at an advertising agency, and he later became the political cartoonist of a leftist newspaper. He returned to France to serve in the military during the Algerian War. In 1974, he produced the albums *Lili Fatal* and *Un Certain Malaise*. Between 1975 and 1985 he

published at Dargaud the five volumes of *Tranches de Vie* that was later brought to the screen by François Leterrier. Lauzier also wrote *La Course du Rat, La Tête dans le Sac, Les Cadres* and *Souvenirs d'un Jeune Homme* during this time. He then suspended his comics career to focus on theater and movie scriptwriting, and he later moved on to directing films. He partnered with Gerard Depardieu to make *Mon Père, Ce Héros* which was later remade in Hollywood as *My Father the Hero*. In 1992, Lauzier returned to comics with *Portrait de l'Artiste*. He received the Grand Prix de la Ville d'Angoulême at the Angoulême International Comics Festival in 1993. More recently he was the writer and director for the films *Le Plus Beau Métier du Monde* and *Le Fils du Français* and wrote the dialogue for *Astérix et Obélix contre César*.

Tribune Co. Files For Bankruptcy

Dec. 8: Media conglomerate Tribune Co. has filed for Chapter 11 bankruptcy protection. Among its holdings, the Tribune Co. owns 10 daily newspapers (including the *Chicago Tribune, Los Angeles Times* and *Baltimore Sun*), as well as Tribune Media Services (which syndicates comics such as *Dick Tracy, Gasoline Alley* and *Brenda Starr*, as well as 12 editorial cartoonists, including Pulitzer Prizewinners Dick Locher of the *Chicago Tribune* and David Horsey of the *Seattle Post-Intelligencer*). It has been struggling financially due to declining advertising revenue and almost $13 billion in debt, much of it incurred from Chicago real-estate magnate Sam Zell's takeover of the company in 2007. It also owns several televisions stations and the Chicago Cubs baseball team, and employs about 20,000 people.

Australian Judge Rules Internet Parody Of *Simpsons* Is Child Porn

Dec 9: A supreme court judge in Australia has ruled that an Internet cartoon depicting child characters from *The Simpsons* engaging in sexual acts is child pornography, reports *The Sydney Morning Herald*. The court upheld the conviction of Alan John McEwan for possessing child pornography after the cartoons were found on his computer. The cartoons depicted Bart, Lisa and Maggie Simpson engaging in sex acts. The main issue was whether a fictional cartoon character could depict a "person" under law, according to *The Herald*. "In my view the magistrate was correct in determining that … the word 'person' included fictional or imaginary characters," Justice Michael Adams said in his judgment. McEwan had been convicted of possessing child pornography and of using his computer to access such material. He was fined

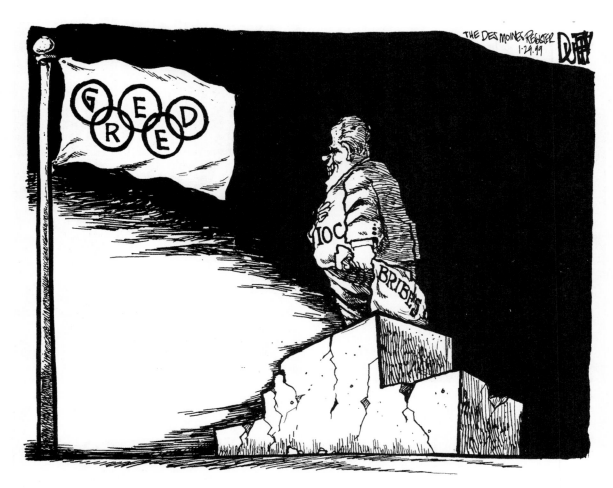

$3,000 and given a two-year good behavior bond for each offense.

More Editorial Cartoonist Positions Eliminated
Nov. 10, 11 and Dec. 3: Since the last edition of *Datebook*, three more staff cartoonists were laid off from newspapers around the country. They are Steve Greenberg of the *Ventura County Star* (Nov. 10), Lee Judge from the *Kansas City Star* (Nov. 11) and Brian Duffy from the *Des Moines Register* (Dec. 3).

Greenberg, who was the only artist on staff at the *Ventura County Star*, was responsible for editorial graphics, as well as editorial cartoons. The paper is part of the E. W. Scripps chain, which announced it was eliminating 400 jobs chain-wide.

Judge was one of 50 employees laid off from the *Kansas City Star*. He had been with the paper for 27 years and had a blog and stand-alone feature on the paper's website.

Duffy's firing from the *Des Moines Register* was part of a mass layoff by Gannett Company Inc., which owns the newspaper. His cartoons were frequently featured on the front page of the *Register*, which has a long-running tradition of placing editorials on its front page. Duffy, who had a cartoon run on the front page on Monday Dec. 1, learned on Wednesday Dec. 3 his position was being eliminated and, according to *The Daily Cartoonist* website, was summarily escorted out of the building and not allowed to return to collect his belongings. According to his profile on the paper's website, Duffy had been the *Register*'s editorial cartoonist since 1983, he has received two Best of Gannett awards, two World Hunger media awards, and was a finalist for the prestigious John Fischetti Award for editorial cartooning. ■

An Interview with The Comic Artist

Johnny Ryan

Drawn by NOAH VAN SCIVER

Does your boss at **NICKELODEON** magazine ever see **ANGRY YOUTH COMIX**?

Well, he will once you post this interview on the **INTERNET!** Thanks for spilling the beans, Blabbermouth!

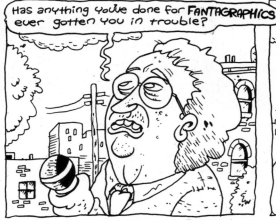

Has anything you've done for **FANTAGRAPHICS** ever gotten you in trouble?

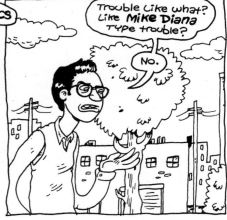

Trouble like what? Like **MIKE DIANA** TYPE trouble?

No.

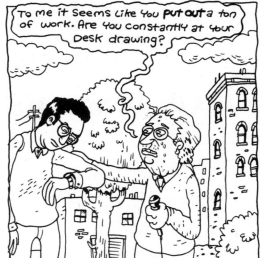

To me it seems like you **PUT OUT** a ton of work. Are you constantly at your Desk drawing?

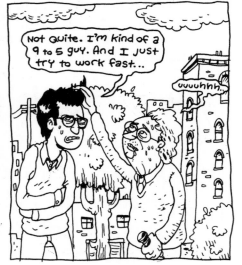

Not quite. I'm kind of a 9 to 5 guy. And I just try to work fast...

uuuuhhh..

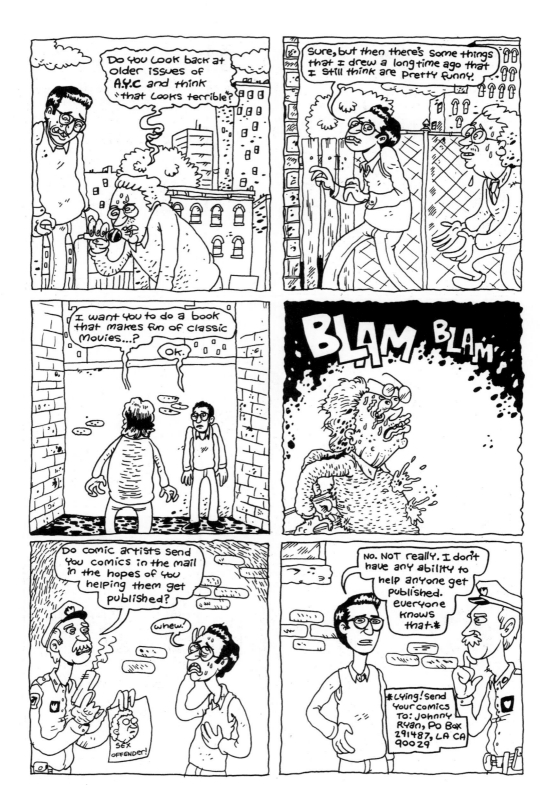

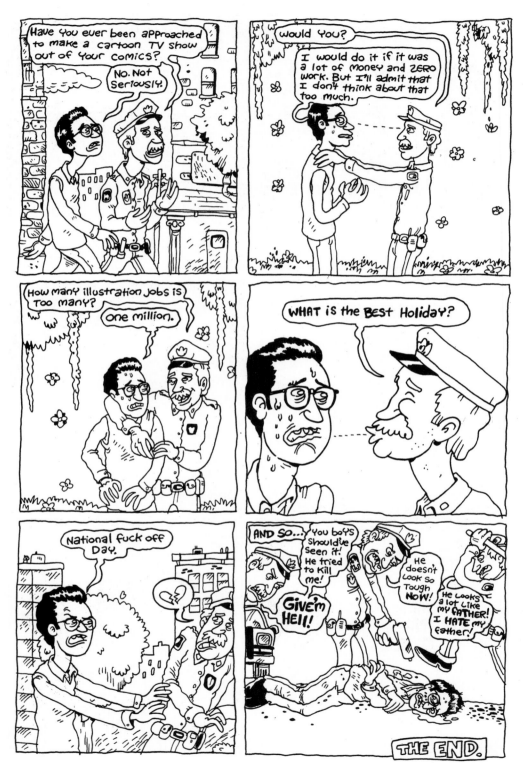

BEST OF
20

The pages that follow are not so much about crowning the Top 10 or Top 50 comics of the year as they are a guide to a bunch of comics and comics-related books that came out in 2008 and are well worth getting a hold of if you haven't already. Cannes Film Festival-style, we asked some of the most-mentioned creators on last year's lists to tell us about the comics that got their attention in a good way this year. Here you will also learn what *Journal* contributors consider the best work of the year, and to keep things from getting too lovey-dovey, some were kind enough to share a little nastiness by nominating their choices for Most Overrated Comics of 2008.

Our instructions were simple to nonexistent: "No particular number. No particular categories. Just whatever you'd like to say about the best comics that came out in 2008." And even that last restriction got bent a little. Because we have to start collecting these lists well before the end of the year, works from the tail end of 2007 were also eligible.

In addition to everybody's picks for 2008, we went straight to those responsible for some of the best of the year and asked them to talk about their work: Lynda Barry (*What It Is*), Frank Quitely (*All Star Superman*), Dash Shaw (*Bottomless Belly Button*), David Hajdu (*The Ten-Cent Plague*), and Mike Luckovich (editorial cartoons of the *Atlanta Journal-Constitution*). In her interview, Barry — who edited Houghton Mifflin's recently published *Best American Comics 2008* — discusses the frustrations of having to make her choices within a limiting set of rules and parameters. No such problem with the *Journal*'s Best of the Year. If you doubt how rule-free our selection process was, just take a look at Kim Deitch's wide-ranging enthusiasms in the opening list.

— MD

Kim Deitch's Best

Comics Discoveries of the Last Year

When I did this in 2007, I hadn't really read too many comics that year. The same is not true now. One reason I haven't been reading them so much has been that for, oh, I guess the last three years and change, I have been involved in trying to read most of the voluminous adventures of Frank and Dick Merriwell, which is rather remarkable early pulp fiction that ran in a magazine with color covers not unlike comic books, called *The Tip Top Weekly*; great stuff, but I'm not here to talk about that.

A particular comic book that I read just slightly over a year ago that got me back to reading comics was **Wimbledon Green** (2005), by Seth, published by Drawn & Quarterly, an absolutely amazing book. A copy of this book had been in our apartment ever since it was new. I had put off reading it because, from things I'd heard about it, it sounded similar in theme to something that I was writing and I didn't want it to influence my story.

Suffice to say: when I finally did read it, I absolutely loved it. What I love about it, besides how extraordinarily entertaining it is, is that it makes such a good case for what it is that is so appealing and utterly fascinating about comics and related forms of gaudy pulp fiction; that wild, in-your-face, circus-come-to-town thing that

HE YEAR 08

is often so hard to describe and explain. And it seems to have reopened the comics floodgate for me.

Here are some subsequent comics of appeal that have crossed my path since then:

The first is a no-brainer and I'll only mention it briefly. The latest number of Chris Ware's **Acme Novelty Library** [**#19**]. He's always good and he's getting better. The warm human-interest level in the newest issue is dramatically up, making it, by my reckoning, the best issue yet of this remarkable series.

Another new book that took me somewhat by surprise is the reissue of Art Spiegelman's **Breakdowns**, published by Pantheon Books, with its new, ambitious, long comics introduction, which is the real attraction of this book. Quite frankly, I didn't quite know what to make of this introduction piece when I was seeing it piecemeal as it was being serialized. You really have to see it complete and in the context of the book it introduces to fully appreciate it. The long memoir introduction effectively amplifies, without ever seeming redundant, Spiegelman's famous story, "Prisoner Of The Hell Planet," that deals with the suicide of his mother, a story that, probably most will agree, was the big upward turning point in his career in comics. The introduction gives a fascinating view of Art's parents as people, particularly his mother that is both interesting and very moving.

It also deals in some detail with Art's fascination with the comics medium; color comic books in particular, that trashy outlaw literature that so many of us were suckled on and were not quite weaned from.

This summer, I was invited to the big San Diego Comic-Con and made a few more interesting comics discoveries. On sale at Bud Plant's booth were some color-scanned booklets called *Mary Marvel Fanzine* [latest issue #7 (2006)], which were essentially, beautifully scanned Golden Age stories featuring Mary Marvel, part of the Marvel family consisting of Captain Marvel, Captain Marvel Junior, Mary and that lovable fraud, Uncle Dudley Marvel. I'm old enough to fondly remember this knock-off of Superman that was better, funnier and more wildly imaginative than Superman. I remember also how it turned up abruptly missing from newsstands in 1954.

Only years later did I find out that this was because of the settlement of an ongoing lawsuit that had been working its way through the courts some years before I was even born. These zines, scanned right from the comics, have a vivid quality one seldom sees in Golden Age comics reprints. The stories? Well, they're written for 10-year-olds, but the splash panels are usually worth the price of admission all by themselves. One, depicting the end of the world, is especially memorable. It turns out to be a hoax in the story; a World War II-era Japanese plot. These are published by a guy in San José and are very well produced.

Another discovery at the Comic-Con were nice facsimile reprints of the old Classics Illustrated comics. This was a series of comic books produced from 1941 and on through the 1950s. What made them so unique over and above the fact that they were adaptations of literary classics was that the titles, more or less stayed in print for

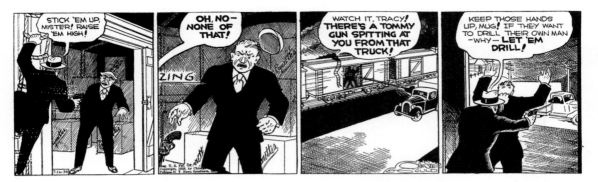

This July 25, 1938 comic strip is collected *The Complete Chester Gould's Dick Tracy: 1938-1939* Vol. 5. [©2008 Tribune Media Services, Inc.]

the two decades and change that they were produced in. Thus you had a series, in microcosm, which showed the stylistic trends of the comic book from the 1940s Golden Age and on forward. They're not all good, but many are gems or near gems.

I had already got onto these again even before my recent San Diego trip because there is a street vendor on 86th and Second Avenue, not far from where I live, who sells, among other things, old back issues of this series for $5 a pop; $10 for some of the rarer ones. A few standouts are W. H. Hudson's *Green Mansions*, drawn by Alex Blum. Another good Blum job is an adaptation of Jack London's *The Sea Wolf*. It leaves out all the socialism in the later part of the story (as does the '40s Warner Brothers movie), but what *is* there makes a surprisingly smart comic book. There are many other good ones, but one more special treasure is R. H. Dana's *Two Years Before The Mast* with its original line-art cover, illustrated by Robert Hayward Webb and David Heames, which by any yardstick is an outstanding Golden Age-style comic book.

One final San Diego discovery, which is not, strictly speaking, comics, but has a similar old-time comics feel, are a series of ongoing pulp magazine CD reissues of stories by L. Ron Hubbard. They come in wonderful lurid color packaging and from an outfit called Galaxy Press which seems to be an arm of the Church of Scientology, a thing that, to me, makes this series all the more fascinating.

Getting away from four-color comic books, I have been keeping up with the excellent-looking **Walt & Skeezix** books [**Book 3** (late 2007)], published by Drawn & Quarterly. In fact I even sprang for the giant *Sundays with Walt & Skeezix* (2007) published by Sunday Press Books: having said that, I freely confess that I haven't yet actually read any of them. (There are only so many hours

in a day and much work to be done.) Still, I want this material to be there for me when I am ready to read it. In the same vein, my wife, Pam, has been devouring the excellent *Dick Tracy* reprints (IDW Publishing) [**Complete Chester Gould's Dick Tracy** Vols. 4-5], *Popeye* reprints, (Fantagraphics) [***Popeye* Vol. 3**], and the extremely handsome-looking *Little Orphan Annie* reprints (again IDW Publishing) [***The Complete Little Orphan Annie* Vol. 1**] currently coming out.

Another interesting new reprint volume is *Little Nemo In Slumberland* (*Hardcover Limited Edition Vols. 1-2*, 2007), published by the Checker Book Publishing Group, which contains all of the Winsor McCay later and seldom-seen *Little Nemo* strips of the 1920s. I have the jumbo *Little Nemo In Slumberland – So Many Splendid Sundays* (2006), Sunday Press Books, and may yet get volume two with its generous selection of '20s Nemo in better reproduction, but the Checker book with all the '20s strips is worth having, I think.

Moving on to more recent material: There has been an amazing series of comics running in the pages of a fanzine called **Mineshaft** [**#20-21**], memoirs written and laid out by Jay Lynch and beautifully drawn and rendered by an exceptionally bright, young rising star in the comics world, Ed Piskor. Ed is a man to watch. His new solo volume, **Wizzywig Vol. 1**, self-published, is worthy of note and two earlier zines, *Isolation Chamber* #1 and 2 are, in my humble opinion, underground classics. Of the Lynch/Piskor collaborations, the one describing an account of Jay Lynch and Robert Crumb visiting veteran cartoonist, Chester Gould, is especially memorable.

Another more recent oldie that has recently re-entered my life is *Collier's* #2 (2003), originally published by Fantagraphics in 1994 by the great, under-appreciated Canadian cartoonist David Collier. Recently, I bought a DVD of an IMAX documentary about beavers. An ex-

tra on the disk was a silent short from 1930, also about beavers, featuring an Indian naturalist named Grey Owl. This totally blew my mind, as Grey Owl was the subject of *Collier's* #2. This book really holds up and deserves to be reprinted. I liked it better this time than the first time I read it, and I loved it then.

It's about an Englishman who is so obsessed with Indians and Indian lore that he adopts the Indian persona Grey Owl and becomes a naturalist, while leading a somewhat dissolute life that brings fame, notoriety and an untimely end to the poor guy. I can't recommend this book too highly.

And finally, this is perhaps the biggest 2008 discovery of all. Getting back to Art Spiegelman, Art has put me onto something quite amazing, which is, *if* you have a DSL line on your computer, it is now possible to download loads of great Golden Age comic books. You can fairly easily take a bloody bath in them. It's the strongest argument to get off dial-up and onto DSL that I have yet encountered.

At last, the wondrous promise of *Wimbledon Green* is available to one and all for mere pennies. This is really the only practical way to experience the wonder that was the Golden Age of comic books. A little dab, here and there, really doesn't do it, whereas the grand panoply of it wafting before you in voluminous free downloads begins to smack of the seventh heaven or a catbird seat in a secret back room of the fabled Akashic records.

One that Art flashed on me was particularly memorable: an issue of something called *Super World* published by science-fiction pioneer Hugo Gernsback. Even the ads seemed to have been produced in-house and were some of its most memorable pages. The stories all seemed to have been produced by fabulous unknowns to me, who seemed to be spiritual kinsmen to Fletcher Hanks. The last pages of this fat book were paste-ups of old Winsor McCay pages, one even predating *Little Nemo*, featuring just the jungle imps that had their own strip a handful of years *before Little Nemo* started.

Anyway these are the highlights of my very interesting year of comics discoveries and rediscoveries. It was a great year in comics. Also noteworthy is **Where Demented Wented** (Fantagraphics), a collection of the legendary work of Rory Hayes and the eagerly awaited, jumbo **Kramers Ergot #7** (Buenaventura Press) to top it all off.

From *Cunt Comics* (1969), collected in *Where Demented Wented: The Art and Comics of Rory Hayes*. [©2008 Rory Hayes Estate]

Lynda Barry's Best

Art Spiegelman's **Breakdowns** really knocked me out. The mixture of past work and new work to make this other thing is mind-bending. The way the story keeps lifting off the page and moving through something akin to the "worm holes" people talk about when they talk about quantum physics. It's a key, too. When I was little I'd heard about the "Key to the City" that mayors gave people, and somehow got it mixed up with skeleton key, and I had the idea that the Key to the City was an actual key that could open any lock in the whole town. *Breakdowns* is that for comics. Something very big is going on in that book.

Jamilti by Rutu Modan is a book I have by my bed. And I find myself looking at often. That book has soul. Real soul. I love *Exit Wounds* too. There is something about what she is doing that is so deep and completely original. The way it swings between the unimaginable and the day-to-day and back to the unimaginable. I like looking at *Jamilti* before I go to sleep. Her drawing is genuine.

A book by Nadeem Aslam called *The Wasted Vigil* isn't a comic book, he's not a cartoonist, but that book gave me the feeling I get when I read the very best kind of comics. He was born in Pakistan and lives in England. His book

takes place in contemporary Afghanistan. It alternates between the most gritty, violent, and hopeless scenes and then something like very strong poetry. It put something on me. That mix is what makes his writing remind me of comics. That thing that drawings and words can do to make a third thing, in the way lyrics and melody make a third thing. If you're going to spend time inside of war, small bits of very strong poetry are necessary.

Steve Brodner's work seems like comics, too. The cover of last month's *Harper's* showing Bush and Cheney and Rumsfeld in orange prison suits in a cell is a very good comic to me. His line and his watercolor work just like dialog. I feel like I'm reading his pictures. Actually, the idea of what is a comic and what is not a comic is something I've been thinking about a lot. I don't know where the edge is on that one, what makes something qualify and what makes it not qualify. I've been thinking about it ever since I found out single-panel cartoons weren't eligible for the *Best American Comics*. Why not? I've had people patiently explain to me why not, but I still find myself wondering?

My favorite cartoonist moment of 2008: meeting Jay

From *Gus* by Chris Blain, translated by Alexis Siegel. [©2008 Chris Blain]

Lynch. I love his mind and the way he talks. He made me laugh so hard I was crying. I just wanted to follow him around and listen to him comment on things. I'd like to do that right this minute. He is a beautiful, beautiful man.

Emmanuel Guibert's Best

My book of the year, *the* book of the year, is Chris Blain's ***Gus***.

Anders Nilsen's Best

Not exhaustive and in no particular order:

Dix Fois/Kymmenen Kertaa (Various)(strips by Amanda Vähämäki, Jenni Rope and Pauliina Makela)
Aitienpaiva by Amanda Vähämäki (Huuda Huuda)
Closed Caption Comics #7 Various
Funny Humor and ***High Five*** by Bendik Kaltenborn and Kristoffer Kjolberg (Dongery)
Kuti Kuti (various) (Huuda Huuda)
Tom Gauld's strip in ***Kramers Ergot #7*** (Buenaventura Press)
An Anthology of Graphic Fiction, Cartoons, and True Stories Vol. 2 (Yale University Press), various; edited by Ivan Brunetti
Hoytiden by Rui Tenreiro (Jippi Forlag)
La Puttana P Getta il Guanto by Anna Feuchtenberger (Logos)
Berlin Book Two: ***City of Smoke*** by Jason Lutes (Drawn & Quarterly)
Il Treno (The Train) by Chihoi-Hung Hung (Canicola)

John Porcellino's Best

Three of my favorite comics of 2008:

Laterborn #6 by Jason Martin. $3 (plus $1 postage) from PO Box 123, Belmont, CA 94002-0123. www.myspace.com/laterbornzine

Jason Martin's true-life and/or quasi-autobiographical (?) comics are simple, heartfelt and affecting.

You Don't Get There from Here (various issues, she's up to #9) by Carrie McNinch. $2 each postpaid from PO Box 49403, Los Angeles, CA 90049. (Google it!)

Carrie's *Snakepit*-inspired diary comics are consistently

From *Berlin* Book Two: *City of Smoke*. [©2008 Jason Lutes]

good, and oftentimes stunning. Plus, she's prolific!

Stew Brew #3 by Kelly Froh and Max Clotfelter. $3 post-paid from 706 Belmont Ave. East #4, Seattle, WA 98102. www.scubotch.com

Max and Kelly's affectionately honest tales of human nature are at their best in this tag-team effort — an in-depth look at the role TV played in their lives growing up.

Plus: Most promising new talent — Denver homie **Noah Van Sciver** (www.noahvansciver.com)

Johnny Ryan's Best

1. **Berserk** by Kentaro Miura. Brutal, over-the-top action.
2. **Cat-Eyed Boy** by Kazuo Umezo. Fun and creepy monster manga.
3. **Speak of the Devil** by Gilbert Hernandez. Beto gets ultra-violent!
4. **Boy's Club** by Matt Furie. Hilarious!
5. **Powr Mastrs** by CF. Psychedelic weirdness. [Late 2007 release]
6. **Tokyo Zombie** by Hanakuma. More fun, gross, retarded manga.
7. **Pit Dwellers** by Mat Brinkman. Not comics, but lots of cool monsters.
8. **Monster Men Bureiko Lullaby** by Takashi Nemoto. The most disgusting comic ever.
9. **1-800-MICE** (2007) by Matthew Thurber. Weird and funny.
10. **Night Business** by Benjamin Marra. This comic reminds me of those bizarre self-published action comics from the '80s.

10.5: And of course all the great reprints including *Herbie* [**Herbie Archives Vol. 1**], *Dick Tracy* [**Complete Chester Gould's Dick Tracy Vols. 4-5**], *Peanuts* [**The Complete Peanuts 1967-1968**, **The Complete Peanuts 1969-1970**], *Popeye* [**Popeye Vol. 3: "Let's You and Him Fight"**], *Baby Huey* [**Harvey Comics Classics Vol. 4: Baby Huey**], etc...

10.75: Oh, and the new **Kramers Ergot #7** is pretty amazing but I feel weird about mentioning it since I'm in it.

Paul Karasik's Best

My top Books of the Year are all by the Old Guard. Does this say something about the present state of the medium or the medium state of the present? Or am I just an old fart, myself?

Top three/four Books of the Year:
The Comics Journal #292 and **Deitch's Pictorama**, Deitch Family (both published by Fantagraphics)

Alone, either of these publications is of interest. Taken together (twice daily with a mug of Ovaltine) they zoom up to the top of my Best of the Year list. I read both si-

From Kim's "The Sunshine Girl" in *Deitch's Pictorama*. [©2008 Kim Deitch]

multaneously, going back and forth between interviews with various Deitch family members (*TCJ #292*) to stories created by the same subjects (*Deitch's Pictorama*). This alternating reading kicked in a turbo-charged *gestalt*. The sum of the family dynasty is far greater than the individual parts alone. While I have been a longtime fanatical fan of Kim's work, the contributions of brothers Seth and Simon become much richer having read their interviews and what the others have to say about them. Toss in the interview with patriarch, Gene, and a unique and, yes, moving, family psychodrama comes into focus.

Breakdowns, Art Spiegelman (Pantheon)
 The *Citizen Kane* of modern comics changed the way cartoonists built comics. Essential.

Gary Panter, Gary Panter (PictureBox)
 Wake up, America.
 A terrific bargain for so much terrific work. This is one art book that I keep pulling off my shelf to bathe in. Do yourself a favor and splurge. Buy this two-volume set now … and a towel.

The rest of the best in alphabetical order:

Skyscrapers of the Midwest, Josh Cotter (AdHouse)
 I'll admit a reluctance to take this work seriously at first. But as a collection of several issues of a comic book done over a period of years, the book demonstrates the extraordinary growth of a young cartoonist. The final "chapter" is really solid and all the better for what comes before it. Keep a watchful eye on Josh Cotter. I'll bet money on this guy.

Daddy's Girl, Debbie Drechsler (Fantagraphics)
 New edition. If you missed it before, get it now. Debbie Drechsler, where art thou now?

Explainers: *The Complete Village Voice Strips (1956-1966)*, Jules Feiffer (Fantagraphics)
 Part of the reason I ever wanted to become a cartoonist. Jules, you bastard!

More Old Jewish Comedians (A Blab! Storybook), Drew Friedman (Fantagraphics)
 More? Oy.

Red Colored Elegy, Seiichi Hayashi (D&Q)
 This portrait of a struggling artist in his 20s created by a struggling artist in his 20s while full of age-typical posturing and self-incrimination is also deft and poignant. Sometimes, when faced with a work so experimental in modalities, one is tempted to read slowly in an effort to mentally translate the jumpy action into traditional sequencing. In this case it is best to let the narrative flow over you.

Where Demented Wented, Rory Hayes (edited by Dan Nadel and Glenn Bray, God bless them.) (Fantagraphics)
 The Fletcher Hanks of his generation.

Ganges Vol. 2, Kevin Huizenga (Fantagraphics)
 Just when you think you have seen everything in

From Seiichi Hayashi's *Red Colored Elegy*, translated by Taro Nettleton. [©2008 Seiichi Hayashi]

Kevin's bag of tricks, he comes up with some new twist.

Moomin Vol. 3 Tove Jansson (D&Q)

With this volume, I finally begin to understand what all the fuss is about.

Berlin Book Two: City of Smoke, Jason Lutes (D&Q)

I am not exactly sure why I found this volume more compelling than the first. In part, it is rare for a historical-based comic to have such nuanced characters, but the storytelling is also more nuanced. If you think you know Lutes' *Berlin* from Volume I, guess again.

Three Shadows, Cyril Pedrosa (First Second)

A sentimental allegory best read if you don't know anything about it before cracking it open. Accomplished drawing that is part Mattotti / part Disney (huh?). A good entry-level book for a Significant Other who does not give a damn about comics.

Bottomless Belly Button, Dash Shaw (Fantagraphics)

Shaw has embarked upon a mission to tell a human story, utilized a formalized approach toward making comics, and ended up with a tome that is what very few comics are: a serious read.

Fuzz and Pluck: Splitsville, Ted Stearn (Fantagraphics)

A true original, and funny, too.

Acme Novelty Library #19, Chris Ware (Acme)

Dear editor,

Excelsior! *Acme* #19 rocks! The rock-'em-sock-'em fracas between Quasar "Rusty" Brown and Turgo "W.K." Brown has got to be a high point in the annals of Acme Battle Royales. My only bugaboo is the persistent ticking of the Karmic alarm clock (set to EST?! Yeesh!). And while I'm throwin' brickbats, my jury's still out on your new artist, Chris Ware "Wolf by Day." What's up with all these panels where nothing appears to occur? Face front, true believers: more explosions and senseless decapitations, if you puh-lease!

Make Mine *Acme*,

Phil, the restless drifter who calls the road his home

Travel, Yuichi Yokoyama (PictureBox)

Disclaimer (shouldn't that be "Claimer"?): I wrote the intro. Jam-packed with details from everyday life funneled through a unique graphic kaleidoscope. Very little actually happens but you cannot take your eyes off the page. An essential new voice.

From Cyril Pedrosa's *Three Shadows*.
[©2007 Cyril Pedrosa, English text ©2008 First Second]

Middle of the Ocean, Lydia Conklin (Self-published: lydiaconklin@gmail.com)

Every time I go to SPX, I seek out something I have not seen before and that I would not see anywhere else. I look for something fresh, not necessarily polished and professional, but that tickles me in a way only comics can do. This year's find is by a young woman who is a student of Lauren Weinstein. It's also weird.

Thoreau at Walden, John Porcellino (Hyperion)

Terrific distilled synthesis of why Thoreau is so important. One of the best adaptations ever 'cause Porcellino gets to the essence of the matter via his poignant breakdowns and style. A perfect match.

Mark Newgarden's Best

Comics I enjoyed most this year:
Acme Comics Library #19 — Chris Ware
Tales Designed to Thrizzle #4 — Michael Kupperman
Travel — Yuichi Yokoyama
King-Cat #69 — John Porcellino
The Arrival — Shaun Tan [2007]
The Goddess of War #1 — Lauren Weinstein
Kramers Ergot #7 — Various, ed. Sammy Harkham

— Best of the Year lists continue on page 47 —

An Interview with Lynda Barry

Conducted by Michael Dean

With the uncanniest knack since *Huckleberry Finn* for unsentimentally capturing the perspectives and voices of kids, Lynda Barry has been reminding us what the world looks like through the eyes of our inner child for nearly 30 years. Her early comics, including *Big Ideas* and *Girls and Boys*, mostly satirized a society of grown-ups, but beginning in 1979, her weekly strip *Ernie Pook's Comeek* demonstrated an amazing facility with the way kids talk and think in the margins of the adult world. The strip was one of the prime critical and popular successes of the alternative-weekly boom of the 1980s.

In addition to her strip work, now coming back into print through Drawn & Quarterly, Barry has produced two novels (*Cruddy*, *The Good Times Are Killing Me*) and a major work of semiautobiographical comics (*One! Hundred! Demons!*) that she would be loath to call a graphic novel. Her newest work, *What It Is*, is another departure, although in some ways a natural extension of *One! Hundred! Demons!*. In place of her usual linear string of heavily narrated comics panels, *What It Is* offers a densely packed gallery of richly suggestive and ominous multimedia word-and-image collages.

Though couched in the structure of a grade-school activity book and partially marketed as a kind of how-to book for writers, its pages form, more than anything else, a meditation into the essence of imagination and creativity. Interspersed among the speculative collages on the nature of thought and imagery are a few autobiographical comics-panel vignettes. These episodes, along with parts of *One! Hundred! Demons!*, allow glimpses into aspects of her own childhood that evidently continue to haunt her adult self. She has reportedly been long estranged from her parents, and two questions about her family connections and the painful elements of childhood were the only questions that she declined to reply to.

Her responses to the interview as a whole, however, were almost superhumanly generous, open and thoughtful. If I were going to take an expedition into some of the darker corners of the human cranium and try to figure out where memories, nightmares, language and drawing intersect, I can't think of a nicer guide than Barry. At first glance, *What It Is* looks a little scary. Strange, malformed creatures peer out of gloomy swaths of black and brown and tumble together with antique diaries, primers, alphabets, photos and drawings — ghostly fragments of an early 20th-century childhood. To read the book, though,

Barry photo taken by Kristy Valenti at the 2008 Comic-Con International: San Diego.

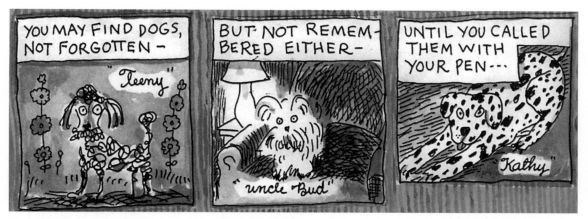

This sequence is from "Where Do They Go?" in *What It Is*. [©2008 Lynda Barry]

is to set sail on an open boat with a friendly, infinitely patient and inquisitive captain at the helm steering you through fundamental, sometimes darkly disturbing mysteries of consciousness.

The interview that follows is sometimes a clash of sensibilities, as I try to fit the ideas suggested by her book into various theoretical models, while Barry remains true to the intuitive energies that course back and forth between her mind and her writing/drawing hand. She made time for our conversation in between "tilting at windmills": She and her husband, praire-restoration-expert Kevin Kawula, are resisting the installation of industrial wind turbines next to their converted-dairy-farm home in Footville, Wis.

What It Is asks question after question that you will have a hard time getting out of your mind, and I enjoyed the opportunity to turn the tables and assign her some of the hardest questions I could think of. Naturally, as it turns out, she eats hard questions for breakfast.

— Michael Dean

MICHAEL DEAN:
From the reviews and promotion I've seen, it appears that *What It Is* has to some degree been marketed and reviewed as a writing how-to book. There's a thin line, though, between A) getting in touch with our memories as a way of writing and B) writing as a way of getting in touch with our memories. The Activity Book pages could be taken literally as a series of semi-automatic writing exercises, but they also function (brilliantly) as another evocation our childhood and our school days. So my question is: What is *What It Is*? Was your goal primarily to help readers to write

or to explore, in words and images, the relationship between language and the unconscious?

LYNDA BARRY:
What is *What It Is*?! I love that question. In terms of where to put it in a bookstore, no one seems to know, including me. Amazon seemed to have the more original solution. I heard they listed it in Science Fiction.

What It Is is based on something I learned from my teacher, Marilyn Frasca, at the Evergreen State College in Olympia, Wash. I studied with her for two years in the late 1970s. Her idea seemed to be that everything we call art, whether it's music or dance or writing or painting, anything we call art is a container for something she called an image. And she believed that once you understood what an image is, then the form you give it us up to you.

This question "What is an Image?" has guided all of my work for over 30 years. Because of what I learned from Marilyn, there isn't much of a difference in the experience of painting a picture, writing a novel, making a comic strip, reading a poem or listening to a song. The containers are different, but the lively thing at the center is what I'm interested in.

It's the living thing we activate when we read a book. Like Scrooge, for example. I know Scrooge came from a book, came from the hand of Dickens, but where is Scrooge really? Where is he right now? He's not inside a book. If I say Scrooge and you know just who I'm talking about, and so do the first 1,000 people we stop on the street to ask if they know who Scrooge is, where is Scrooge located?

Scrooge is an image. Batman is an image. The alphabet is an image. I'd say Abraham Lincoln is an image, too.

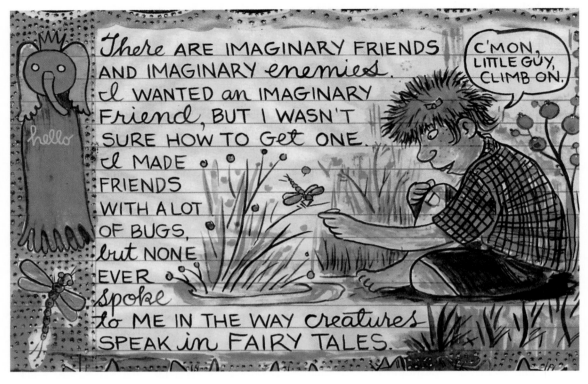

From "Where Do We Keep Bad Memories?" in *What It Is*. [©2008 Lynda Barry]

Although the bones of Lincoln are in a specific location, that's not what we mean when we speak his name. We don't mean his bones. Images are entities with no fixed location, they can occur to us at any place at any time. You and I can talk about them, though you and I have never met.

I can't help but believe that our use of images has an absolute biological function. It's not decoration or an elective or something like what was once so pompously called "junk DNA," though our current culture treats it like junk. The public school system certainly does.

I believe that images are also at the center of what we call deep play for kids. It's something like our immune system and autonomic nervous system. I believe it has a vital role in creating and maintaining our mental health, which first and foremost requires a feeling that life is worth living.

About 10 years ago, I decided to try to teach this thing I learned from Marilyn. I found that writing was the easiest way to do it because it involves practicing a physical activity with a state of mind. Handwriting is a physical activity that works perfectly for this and it doesn't seem to make people as nervous as drawing does. And in the beginning I like to use spontaneous memory because it approaches the state of mind I'm referring to and quickly lets you know what an image feels like.

An image feels much like the sensation of smelling something that makes your Aunt Carol's kitchen come flooding back to you. It may only last a vivid instant, but for that instant the image of the kitchen is entirely there. It's much more than a picture of the kitchen in your mind. It's an entire experience. Much like the one we get when we're reading a good book. We forget we are reading, although that's the physical activity we are doing. The state of mind is the state of experiencing something and that is very different than thinking about something.

Once you know what this feels like, it's not hard to learn to sustain it and to transfer it to fiction, if that's what you want to do. One of the reasons I think people believe all my work is autobiographical is because of working this way, working with something that feels absolutely alive.

I wanted to find a way to make a book about this thing, but I didn't want to make a book that was writing about how to write. I'm lucky that Drawn & Quarterly was so

willing to risk publishing such an odd book that has no obvious spot in any bookstore. I have a hard time explaining what this book is to anyone who asks, but I especially like the way you asked. That sentence "What is *What It Is?*" is one that makes me laugh.

What It Is has possibly more questions than statements in it. How transparent do you want the book to be? Is there an element of mystery to the work's themes that you would like to preserve and protect against too many nosy questions? Or is your main goal to communicate as clearly as possible to readers who are interested in strategies for writing?

The questions in *What It Is* are questions that, for me at least, created that state of mind I keep referring to. For example, is a dream autobiography or fiction? In the first moments of pondering that question, before logic and reason jump in to answer, there is an odd openness of not having considered this question before, and not knowing the answer even though we know what dreams are, what fiction is and what autobiography is. When I was working on the book, these questions would just pop into my head and as I painted the letters that made up the question, I'd find myself in that state of mind, that kind of open wondering. Kind of like the way the underside of the Magic 8-Ball looks just before the answer floats up. When I work, I like to keep my mind as much like a Magic 8-Ball as possible. Including the "ask again later" option.

I'm tempted to describe it as a series of Socratic questions, except that Socrates was leading his disciples down a deliberate path toward anticipated conclusions; What It Is feels like a journey, but with neither a path nor a particular destination. Here's an activity question for you: Can you name three conclusions that you drew or things that you learned in the process of producing this book?

I don't think conclusion is the right word, it's more like realization than conclusion. There were big realizations and small ones. The biggest one was the same one I had when I wrote *Cruddy*. The realization that the back of the mind can be relied on to create natural story order. It's not something I have to try to do, or think too hard about. If I just work every day on a particular project, it seems to begin to form itself if I keep moving my hands while maintaining a certain state of mind. I wish I could do that right now as I answer these questions, because answering questions like this directly this is much harder than making a comic strip. It feels like commentary about

a thing that can't be explained with commentary but here I am trying to do it anyway.

A smaller realization was noticing how free I feel with garbage paper. Once a piece of paper is in the trash, it's something I feel I can finally use. And while I'm working on collages it's a mistake to sweep the floor or clean up my desk, because often it's scraps and garbage that help me finish a page.

The most gratifying realization was that I actually have a publisher who will let me make something as non-commercial and unclassifiable as *What It Is*, and who actually seems to have some attachment to my work. I never felt like Drawn & Quarterly was trying to talk me out of anything, or giving me tips on how to make my book more saleable, or insisting that I explain the book before the book existed. To have a publisher like this is a very nice gift after having had such a sad experience with other publishers, and then going through that very long period of no one wanting to publish any kind of book from me. That was a strange feeling because I'd been putting out books for half of my life and then it just seemed over.

The good thing about it was that it got me to sell my art on eBay, which was one of the best moves I've made. I was lying in bed thinking, "What the hell?" There is a preciousness about original art and how it's sold in galleries that I've never liked. There was something about selling my work for under $100 and then throwing in extra images when I sent the work to the buyer that really made me happy. I felt free of "The Man" when I did it, and free of coolness, and free of success. I felt like I had a reliable decent job. I wish I had artwork up on eBay right now, but the turbine fight has taken all of my time and crushed it. I miss my life very much. I miss open-ended days and following images along. I hope that will be back someday.

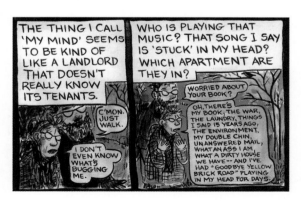

From "The Three [Thousand] of Us" in *What It Is*. [©2008 Lynda Barry]

You're referring to the planned construction of giant wind-powered turbines next door to you, which I understand might force you out of your rural Wisconsin home. Can you talk about how that fight is going and how it has affected your opinion of wind power as an alternative energy source?

The issue of reducing CO2 emissions is so serious that we just don't have the time to fall for a fake solution, and what most people don't know is that industrial-scale wind power is the only renewable energy choice that has little or no effect on reducing current CO2 emissions. Our own National Academy of Sciences came to this conclusion a year ago — not that anyone is listening to them.

The reason is because machines that are 40 stories tall with blade spans wider than a 747 require a lot of electricity to operate. Most people don't know that wind turbines must be powered by a conventional power plant or they can't function. Unless the wind is at least 10 miles [an hour], they can draw more electricity than they produce. Because the wind is unreliable and because conventional power plants are never powered down in response to the wind's fluctuations, the same amount of CO2 is being released. The turbines can generate electricity, that's true. But the more turbines you put up, the more conventional power you need to support them. In Germany, which has a lot of industrial wind turbines, they've built many more coal-fired plants. Not a single thermal-powered plant has gone off-line anywhere in the world because of wind power.

Although smaller, on-site turbines that directly power a home or farm can work, the industrial-scale turbines are notoriously inefficient. When you hear a wind developer say 10 turbines are enough to power 5,000 homes, what he's leaving out is they could do that if they were operating at capacity. Even the wind industry admits that at best, they generate less than 30 percent of capacity. In Wisconsin, where there is low wind resource, they gener-

ate about 17-20% of capacity. And they can only power homes when the wind is blowing.

So why the rush toward wind if it doesn't work? Most people have no idea that it doesn't work. Most people have only seen large turbines on TV or in ads in magazines, always a blue sky in the background, green grass, maybe a cow or a kid with a kite, but no houses anywhere, no wires, no cables, no access roads, no transformers, no power lines, no deforestation or fragmentation of natural habitat, just this "magic" machine spinning.

Well, of course, the power companies like it, because there is no customer loss [as there would be] from smaller on-site generation that actually works. Also the contracts with landowners are good for between 30-60 years and include all sorts of things in them that farmers are not aware of, like the right to run new transmission lines anywhere on the property. There is a huge push for "upgrading the grid" which means more and more power lines. But, at least to me, the grid is the problem. On-site generation of power, or community generation of power, is the direction we should be going. There are so many other great options, but none of them keep money in the pockets of the big power companies like big wind does.

And then there are those incredible production tax credits which every corporation needs, and the tax credits can be sold and transferred. And then there are those carbon credits, which are the most heartbreaking of all — the get-out-of-jail-free cards for polluters, unregulated, traded on Wall Street and invented by Enron.

The worst thing is the impact on wildlife. Right now there is a push to site industrial wind turbines in national parks, national wildlife refuges and other protected wildlife habitat. On the East Coast, ridge tops are being deforested to put up turbines. They are commonly put up in migration corridors because that's where the wind is. The recent findings on how they kill bats — the bats' lungs expand and fill with blood when they encounter the pressure drop in the wake of the turbine blades — that alone is a nightmare.

I've made some little videos about the bats and the turbines along the Horicon Marsh National Wildlife Refuge here in Wisconsin. You can see them here:

http://www.youtube.com/watch?v=jf2bxMje2-A
http://www.youtube.com/watch?v=epdPCN5TEm8

I run a website about it at betterplan.squarespace.com.

That we will lose our home when the turbines are built 1,000 feet from our door is the least of the problems. Kevin and I will lose a lot, but we can move. Birds and

WHERE DO SUDDEN TROUBLESOME THOUGHTS COME FROM?

WHAT ABOUT YOU?

OH, FOR ME IT'S TORNADOES, FAMILY, ALL THE WOOD I STILL NEED TO CUT, AND THEN THERE'S KIND OF A KETEL COLLECTION OF MY 25 GREATEST SCREW-UPS OF ALL TIME, I REPLAY THAT ONE A LOT

MAN, I KNOW! I'M STILL CRINGING ABOUT STUFF I SAID WHEN I WAS NINE.

WHY IS THERE ANXIETY ABOUT A PAST WE CANNOT CHANGE? THE TOP OF MY MIND HAS NO ANSWER FOR THIS.

WALKING DOES MAKE ME FEEL BETTER

MOVEMENT IS KEY

I WONDER WHY?

This page is also from "The Three [Thousand] of Us." [©2008 Lynda Barry]

bats cannot. And the habitat being destroyed to put up turbines can't be replaced. It's going on all over the country. By the time people get the real picture of what this is about, it will be too late. We'll be stuck with the SUV of renewable energy.

I've been called a lot of names because of speaking up about this, I started to keep a list — my two favorites are "wind-jihadist" and "victim of turbine envy."

This is our Best of the Year issue, which, besides having this marvelous interview with Lynda Barry and a jaw-dropping cover by Lynda Barry, will have various lists of the Best of 2008 by comics professionals and *Journal* contributors. You just went through that process of choosing the comics to be represented in the recently published third volume of Houghton Mifflin's *Best American Comics* series. What was that experience like?

Man, every comic I read for the *Best American Comics* stood out to me. It was hard to pick the few I was able to put in the book. And then there was the nightmare of who I forgot to put in the book. My greatest regrets are not including work by Patrick McDonnell (*Mutts*), Keith Knight (*K Chronicles*), Ruben Bolling (*Tom the Dancing Bug*) Heather McAdams, Jules Feiffer, Mark Alan Stamaty, Stan Mack, even just writing these names makes me sick, because I know tonight I'll lay in bed and the list of more people I forgot to mention here will start scrolling down over the inside of my eyelids again and torture me some more. I really, *really* regret not doing a better job. I revolve like a gas-station hot dog on a spit over that regret.

One thing I did not like about the *Best American Comics* guidelines is that no single-panel comics are eligible. That's automatically leaving out a lot of great cartoonists. What's that about? It really made me mad the way snobs in junior high school made me mad with their rules about who can sit at their lunch table and who couldn't. No comics or cartoonists should be ever excluded, for any reason, including Bazooka Joe comics that come with my bubble gum. I regret not fighting for them. I was stupid to go along with a stupid rule. That was a mistake.

I feel bad about my inability to have gotten more superhero and action and fantasy comics and manga and daily and weekly comics in the collection. That was another failure. I don't go along with the idea certain cartoonists have that nothing of value is going on in these type of comics and that's another thing that pisses me off. It's so insane. Especially considering that most of the people who feel this way were themselves shunned throughout

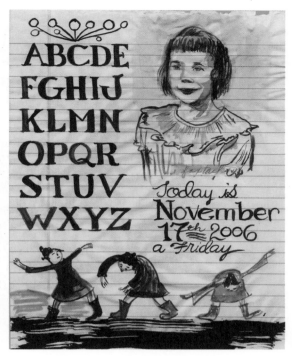

From "The Little Women" in *What It Is*. [©2008 Lynda Barry]

their school years by popular kids who saw no value in them. Cartoonist snobs make me feel violent. When they are so dismissive and disrespectful of other people's work, I always feel like socking them one in the face. That's why I can't drink around certain cartoonists.

Originally I had this vision of really opening up the collection to everybody. In the end I didn't have the time or resources to do a good job. I did a terrible job of it. I live on a farm in rural Wisconsin and my access to comics is so limited I should have done more than rely on people to send me things. So even though I adore every single strip in the collection, I wish I could have do-overs. The last thing I wanted was to restrict the collection to the kind of comics — whatever they are called now — the kind that are always in such collections. I don't even know the name of what they are. The term "graphic novel" is so terrible and doesn't make any sense and is a snobbish term. And "alternative" doesn't do it any more either, because mainstream comics barely exist the way they used to. I guess just "comics." I like the word "comics" and I like the word "cartoonist."

One last failure of mine is this: I believe if I had felt like fighting with the co-editors and publisher I may have been able to make a case for including sections of Ivan

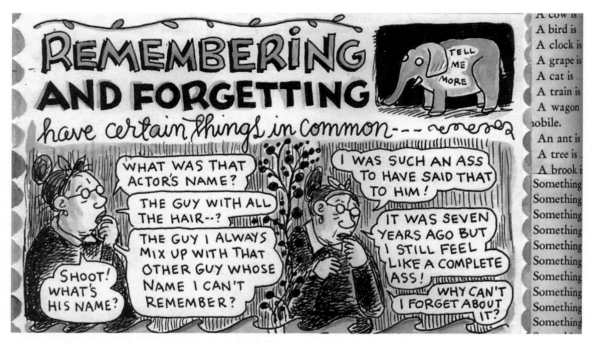

This panel is from one of the *What It Is* book's chapter summaries. [©2008 Lynda Barry]

Brunetti's absolutely brilliant book, *Cartooning: Philosophy and Practice*. To me, it completely qualifies as a comic book and without a doubt it was the best comic book I read all year. That it happens to also instruct one on a very good way to make comics doesn't change that. But I was too tired of fighting about the crazy-ass rules that go with doing a book like that. So I failed there, too.

I hope one day I get to edit a book like that again. I really loved waking up in the morning and realizing my job that day and for the next few months was just to read comics. That part was heaven. That part was the best job I've ever had.

I just wrote an article about the precedents, both good and bad, that the *Best American Comics* series has set for comics in the book market. I interviewed several people and ended up praising the kinds of choices that the series has made but criticizing the compensation that it offered cartoonists. Was the question of compensation of cartoonists ever discussed between you and the editors? When your work was collected in earlier volumes, did you object at all to the amount of compensation that was offered?

This is a really good point because it does seem like a rip-off to get a flat fee and then "So long, Charlie," no profit-sharing. The book sells because of the artists, but the artists don't see any payoff other than that flat fee. I wish I'd thought a little bit harder about this before now, because it strikes me as quite unfair when you lay it out that way. The thing that may have blinded me to the issue is that when I was included in the first two volumes, I had the idea that it's an honor to be selected, and if I got extra money on top of that, yay. But looking at it again, it could also be seen as a contest that you win but actually you end up losing more than you win. That's something that should surely be looked at a little closer.

By the way, I've recused myself from being included in the future *Best American Comics* collection. It feels too weird to me to be in the first two, then editing the third, and then to keep on being included. Something seems off about that. It's not like I was asked to be included this year, I just let them know I wouldn't be contributing if I was asked. Seems like there should be something like term limits with these things. I have a friend who makes violin bows; he's one of the best bow makers in the world. After you win something like three international competitions for bow-making you get a special designation that is an honor but also puts you out of competing. That happened to him. I like that idea.

The approach that you outline in *What It Is* suggests that creativity comes not from thinking about things, but from freeing the unconscious. But isn't art usually the product of the conscious mind thinking about and ordering the raw material of experience and memories (both conscious and unconscious)? For instance, a comic-strip creator has to very deliberately negotiate a number of strictures, introduce an idea, develop it and arrive at an amusing climax in the space of an average of four panels. And although you present your own strips as the products of a naïve and spontaneous kid's perspective, didn't a lot of careful adult thinking go into them?

Not at all. Very little thinking things out goes into my work. And though I'm sure thinking one's way through the making of a comic strip can work, for me it's not very fun or rewarding, and it usually leads to a bad comic strip. Bad in the way a bad joke is bad. You get a bad joke, but instead of it giving you something it seems to take something from you.

It's funny this idea of freeing the unconscious. I don't think I can free it. I think it can free me, but I'm not sure I can do much to it. I think it's plenty free and I'm kind of like its Beanie Baby. I remember when I first heard about the unconscious in high school, and I resented the idea. It sounded like baloney to me. I thought "If I had an unconscious, I'd know about it." And then I came to accept having one, but I imagined it to be a very small thing, like a tiny strange pea-sized thing in my brain that sent out little stupid waves. As time goes on, my image of the unconscious has gotten bigger and bigger. Now I think I'm the tiny pea-sized thing inside of it. Now it seems like an ocean to me. Something huge and moving that I'm inside of. It's a relief, actually, to think there is a part of me that maintains images in the same way there is a part of me that maintains my body temperature, and I can rely on it.

What It Is is not a narrative, as such, but it seems to be very carefully structured. Can you say a little about how you went about organizing the book?

It's not carefully structured at all. The collages came first, with no thought of making a book or anything at all besides some collages because I like cutting things up and gluing them down and painting around them, and after awhile I noticed there was something going on, kind of a theme, something I recognized but didn't have much of a plan for. In fact, that's the most important part of this state of mind I'm talking about. It's not thought up ahead of time. The direction may be, but the act of moving

along happens as the thing is being made. So no pencil roughs, no outlines, no trying to figure it out unless I was actually working on the book physically. After a while, it was just like arranging furniture in a room. I made whatever I felt was missing and I took out whatever seemed to be crowding the book.

I knew I wanted to make a workbook, so that was pretty easy, because of the specific way that I teach, it's really like a recipe and not hard to put onto the page, just like writing down a set of directions that you know by heart.

The last part of the book was the narrative part — the comic strip that is done on legal paper. I wanted so badly to find a way to tell the story without putting myself in it, I didn't want to be a character in the book at all if I could help it. But I just couldn't figure out any other way to do it, to tell this story that happens to all of us. We have this thing, this ability to work with images, then we lose it, and then we spend years and years trying to find it again. If we do, it's important to know we'll lose it again, too. That's probably the most recent thing I've realized. It's as crazy to think your ability to work with images will always be with you as it is to think your inability to work with them is a permanent state. It's a relationship.

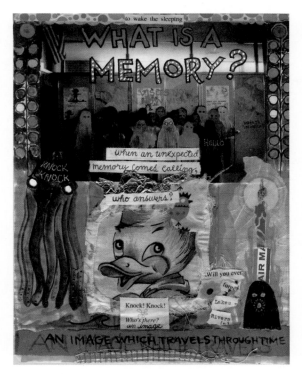

This page is from *What It Is*. [©2008 Lynda Barry]

A relationship to something that I would argue is very much a living thing. It's not alive in the way you and I are alive, but it sure isn't dead. It's alive like Scrooge is alive, or Little Lulu.

As you were working through your approach to this book and the relationship between words and images, did you think at all about William Blake's illuminated texts? Was Blake an influence, or does *What It Is* share a kinship with those illuminated texts?

I love William Blake. And I know his illuminated texts and they were emboldening influences for me starting about 10 years ago. His work does that thing I'm talking about: It can give you that state of mind that is other than thinking. But actually, the biggest influence on me while I was working on *What It Is* was Emily Dickinson. I'd struggled with her poetry for years, it was just absolutely opaque to me, or it seemed simple and kind of cute: "Bee! I was expecting you —" But then I decided to try memorizing some of her poems and also the poems of A.E. Houseman and I noticed that something completely unexpected happened. They seemed to build themselves into something else entirely — something I'd never experienced with poetry before. They certainly then became a container that contained an image. Not the thought of an image, but the living thing that seems to change as I change. Not fixed at all, but fluid. And they qualified as an image too, because they certainly did give me the feeling that life was worth living. It's different than happiness. I'm not sure it has anything to do with happiness, in the same way deep play for kids has nothing to do with fun. It's something else. *What It Is* is an attempt to house that something else.

You emphasize the importance of the physical aspects of writing, and that would seem to be borne out by the change in your own work as a result of the physical transition from pen to brush. When you worked with a pen, your earlier comics involved more direct adult commentary; when you switched to a brush, you began to do strips that expressed your ideas through a child's point of view. Do you think the shift to a brush brought about the change in point of view or did your wish to work with that point of view cause you to look for a different artistic tool? Can you talk about how the brush encourages you to work more through the eyes of a child?

I'd never thought of that, of a brush bringing about different content than a pen might, but I think it's right. Writing with a brush is slower than writing with a pen, at least the way I do it, and in my work, slowing down changes a story in the same way walking through a neighborhood is a different experience than riding through a neighborhood.

But I think it was not the pen so much as it was a period in my life when I thought I had love and relationships figured out — this was when I was all of 23 or 24, and I wrote about things from that perspective. Then something happened and kids became the focus of the strip. Marlys, Arna, Arnold and Freddie all showed up at once in one comic strip one day and I had no idea they would stay with me for the rest of my comic-strip life. I never know how to answer the question of why I write so much about kids and adolescents. It's sort of like asking my niece why when I take her to the store for her birthday she buys yet another My Little Pony. She has so many of them because she likes them so much. But I'm not sure she could tell me why she likes them that much, beyond saying she thinks they are very pretty. However, when I watch her playing with them it's clear that she is able to get into some deep state of mind when she moves them around. So maybe it's the same kind of answer. I don't know why I write from a kid's perspective except that when I do, I find myself in the state of mind I value so much. I feel better afterward.

How does the mixed-media collage approach of *What It Is* affect the voice that you're writing from?

Collage is something I've always done since I was a kid. I've always gotten a reliable satisfaction from cutting things out and gluing them down. Who knows why this is, but to this day whenever I feel lost or rudderless I can sit down with Elmer's school glue and a stack of paper headed for the recycling bin and a nice small sharp pair of scissors and cut and paste my way out of one mood into another. I like to make very disturbing collages. There are a few hints of this in *What It Is*, some sort of scary-looking images, but not as many as there are in the collages that no one sees. Sometimes my husband sees them, but I avoid showing them to people, because they are upsetting. Of course, I love them.

Is there more work in the collage style that you would like to do for publication?

Well, I'm not sure if I'd want people to see all of it, but there are sure a lot of collages that I've been building over the years. I can't think of a venue for them that would make sense, and really, they're just done for no reason at all, except to move me from one mood to another. It always works, though. I always feel better after

2 NOVEMBER 2006

LITTLE WOMEN

Today is Friday

Meg Jo MARCH Beth Amy

Little Women

Here are my rejected little Women I like them so much BUT have been TOLD they are not LYNDABARRY enough — The art director says it DOESN'T look like my WORK enough which makes me laugh a little and also cry a little

This page is from *What It Is.* [©2008 Lynda Barry]

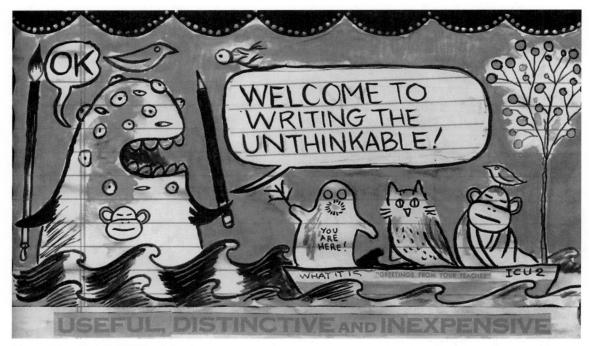

This panel is from *What It Is*. [©2008 Lynda Barry]

I work on a collage.

Assistant Editor Kristy Valenti just reminded me of a quote from Jean Cocteau's introduction to Pablo Picasso's *Drawings* collection (which gives you an idea of the air of elevated sophistication that lingers around the *Journal* offices): "Poets don't draw. They untie handwriting and then knot it up again in a different way." Do you think the shrinking role of handwriting in our everyday lives (as it's displaced by text-messaging, e-mails, computerized lettering fonts, etc.) could have a detrimental effect on our ability to express ourselves creatively in writing?

Writing by hand is something I believe in with all my heart. The physical act of drawing a series of letters on a page involves so much more of the brain than typing. Even just positioning letters spatially involves a part of the brain that using a computer does not. It may not seem like a big deal to people but my feeling is that we are giving up quite a bit when we don't use our hands to shape lines directly on a physical object. Handwriting is drawing. And it contains an image too — the image is the thing we recognize when we recognize someone's handwriting, which in itself is pretty interesting. What is it that we're seeing that lets us know who wrote those lines?

It's as recognizable as a voice or a face. We don't even have to think about it. Why is this?

Handwriting was very hard to come by for all of us, as hard as learning to play an instrument or speak another language. So it's odd to think it is being given up without a thought about what else may be getting tossed out with it. And one of the things I believe is tossed out is the state of mind that the physical activity of handwriting can give you. For one thing, it's slow; handwriting is slower than typing. And it's slower to get rid of than typing on a computer is. I can make all I've just written here vanish in an instant. Images aren't always recognized in an instant. Sometimes it's because they are hard to destroy that you let them hang around long enough to even see what they are. The computer lets you delete whatever you feel unsure about. This is a disaster if you want to work with images. They always appear as something I'm unsure about. That's one of my first clues that something new is here. "What the hell is this?" With a computer I can delete it before I even have a chance to ask myself if perhaps it should stay around a little bit longer.

At one point in *What It Is*, you make the observations that sometimes the best way to remember something you're having trouble remembering is to forget about

it for a while and let it come back to you on its own and that sometimes the best way to forget something that is troubling you is to fully remember it. Although I don't think you directly mention Freud or his theories anywhere in the book, I can picture him nodding approvingly at this, which sounds very like the strategy of traditional psychoanalysis. How do you feel about psychoanalysis and Freud, who is not so much in favor these days?

Actually, when people say this way of working with images is like psychoanalysis, I always say, no, psychoanalysis is like this way of working with images. And this way of working with images is very, very old. It existed long before the word subconscious existed, and even when it was unnamed it was fully functional.

Telling stories and remembering and forgetting and associative aspects of memory are things which have been with humans all along. Playing has always been with us. All of the things that we call art or psychology or even the skeletal system were there before they were named. They come with the package of being human. So Freud noticed something, but he didn't invent it. Noticing and naming it is not what brings mental health in a troubled person. It's like thinking our immune system works only if we know there is an immune system. The human act of using images to work with what is troubling, what is older than that? The Greeks knew about it. They noticed it and named it, calling it 'catharsis'. It seems to me this is something that has been noticed and named in one way throughout history, but noticed or not, it still is there and it still works.

In Freud's *Interpretation of Dreams*, he says that dreams are like a rebus. A rebus, if you remember, is when a visual image represents a word, so that for example, the images of an eye, a flying bee, a leaf from a tree, the letter N and a ewe from a sheep farm can be read as "I believe in you." In Freud's theory, the images we remember from a dream stand in for a disguised latent content that is based on words and literal puns. If true, this would suggest that even at the deepest most repressed level of our unconscious, our grasp of things is shaped by words. Which do you think come first: words or visual images? Does language precede thought? Can you talk a little about how you feel words and images interact in your work?

I've always wondered if dreams were autobiography or fiction. To be sure, a dream is a living experience, and the meaning of an experience is a hard thing to pin down. It's like the meaning of a poem or a song. It's not fixed. There is a haiku I like that is an image of a singing cricket on a log floating down a swift river. Sometimes I find myself thinking of that image in the happiest way, and sometimes I find myself crying when I think of it. Is it a sad image or a happy image? Or is it something like a living experience that changes constantly? I don't know.

When I read the word "rebus" in your question for an instant I had the meaning of rebus mixed up with "möbius strip" and I thought, "That's exactly right!" — and just as quickly the meaning of rebus asserted itself, but I was still left with this comparison of a dream and mobius strip — and that comparison is much more satisfying to me. It's the kind of "mistake" the back of the mind makes that I find so helpful.

How is the comparison of dreams and möbius strips satisfying to you?

It's the surface switching. The upside down becoming the right side up and then back to upside down and right side up again and again. The material the möbius strip is made of seems like the part of us that can be awake and asleep and then awake and asleep again and again. The awakeness in a dream that is very much like the awake-

From the notebook pages in *What It Is*. [©2008 Lynda Barry]

This page is from *What It Is.* [©2008 Lynda Barry]

ness in waking life, but flipped somehow. Flipped inward? I don't know. I do think that just as there is the awakeness that happens in a dream while we are sleeping, there is something like sleeping going on while we're awake. Doesn't that sound like a möbius strip?

The first chapter in *What It Is* is called: "From the Three of Us" (amended to read "From the Three [Thousand] of Us"). You and your husband are characters in this chapter, but the number clearly refers to the multiple perspectives inside each of us. There is a threesome floating by in a boat at the bottom of the first page of this chapter — an owl, a monkey and a ghostlike figure with tree branches for arms — all of which continue to make appearances throughout the book. I'm tempted to ask what the three figures represent, but I have a feeling you prefer to avoid that kind of one-to-one correspondence between symbol and meaning. So instead, let me tell you some of the associations I see in the three figures and then you can tell me what associations you have for them. Any time you have a threesome, there are several tripartite templates that invite comparison, including; the holy trinity of the the Father, the Son and the Holy Ghost; the familial triangle of the father, the mother and the child; Freud's superego (law, language), id (desire, base drives) and ego (self-image, dialectical negotiation of the other two); and so on. My associations with the owl would be things like wisdom, mind, intellect, maybe the "Who-oo?" that asks the self to be defined in language. With the monkey, I think of the base animal aspects of the self, learning through imitation,

and evolution over time. With the third figure, I've already started making associations when I call it a ghost with tree branches for arms; beyond that my only associations would be of something ineffable, perhaps a phantom of memory. It seems to have a kinship with the deep-sea creatures that appear in the book as denizens of the unconscious. Now your turn.

OW! Wow! What a mind you have. What a good example of how flexible images can be. Nothing of what you've said here seems far-fetched to me, but I can tell you I never thought for a moment about what the boat of *What It Is* creatures might symbolize. It never occurred to me. I just loved to draw them whereever they would fit. The creature that is an owl to you is a catbird to me. A literal cross between a cat and a bird. The monkey is the meditating monkey I've been drawing constantly for a few years, like a toy I like to play with most, and the ghost creature is Stick-Arm Stan. Don't know much about him except his name and that I like to draw him. He always looks good to me.

These characters, like all characters, show up when you move something around. Even fingers on a keyboard, I suppose. But for me it's the brush. There is also the magic cephalopod and Sea-Ma the sea demon who is the big multi-eyed blowhard in the book, and brief appearances of Mr. Beak, Mr. Trunk, the ballerina whose dance is always interrupted by something and the Near-Sighted Monkey — these last characters are ones I've been drawing more of since *What It Is* ended. I'm working on a new book and they are in it. It's called *The Near-Sighted Monkey.* I'm still putting it together so I don't know what the book is going to be yet.

These animals and imaginary creatures were certainly not part of my drawing vocabulary before 9/11. Of all things, after 9/11, the only thing I could stand to draw were cute animals. Compulsively. And then when a friend died I found I couldn't draw anything at all except the meditating monkey. Again, compulsively. What any of it means, I don't know. — Well, I could make some guesses, but they would be like the kind of fake guesses I made in college when I was writing a paper about the meaning of a story or a poem. Guesses that might make sense but I don't actually feel. I used to like to think about the meanings of things a lot. But I don't think about meaning so much any more. I do something similar with these things, but it isn't thinking. Maybe it's feeling the meaning. Actually, though, the one thing I do think about a lot is thinking. What the hell is it? And where is it? ∎

— Best of the Year lists continued from page 33 —

Reprint books of old comics I enjoyed even more:
Sundays with Walt & Skeezix — Frank King (2006)
Popeye Vol. 3 — E. C. Segar
Krazy & Ignatz 1943-1944 — George Herriman
Moomin Vol. 3 — Tove Jansson
Where Demented Wented — Rory Hayes

Not exactly comics, but you know what I mean:
Gary Panter (box set) — Gary Panter
More Old Jewish Comedians (A Blab! **Storybook)** —
Drew Friedman
Deitch's Pictorama — Deitch Bros.

Rich Kreiner's Best

At almost every Olympics Closing Ceremony during his tenure, IOC chairman Juan Antonio Samaranch uses a key phrase to distinguish, in his mind and for the world, each individual set of games. I borrow it here, along with the full measure of Samaranch's objectivity and sincerity, to proclaim the year 2008 for comics as the best ever. Casually lay out for display Art Spiegelman's fortified facsimile of **Breakdowns** [Pantheon], Jules Feiffer's formidable **Explainers** [Fantagraphics], Posy Simmonds' masterful **Tamara Drewe** [Mariner/Houghton Mifflin], Ron Regé Jr.'s array **Against Pain** [Drawn & Quarterly], and Lynda Barry's unmodifiable **What It Is** [Drawn & Quarterly] — all released in 2008 — and you should quiet a whole lot of argument right there.

Which means the former champ, 2007, must be properly laid to rest.

As you know, these Best of the Year recaps need to be compiled well before the end of the calendar year (Happy Guy Fawkes Day, everybody!). This makes for a blind spot for compilers late in the year — between our deadline and January 1st —one that needs to be added, in my case, to the blind spot early — whatever was published after January 1st and forgotten by deadline. With my own blinkered "Best of 2007" list, fellow *Journal* first responders covered my forgetful ass save for three items. Issue **#38** of **World War 3 Illustrated** was titled "Facts on the Ground" and covered inundated New Orleans, renovated Brooklyn, the teachers' protests in Oaxaca, Mexico, bicyclists' rights, and, of course, Iraq. The usual contributors did their usual fine work although this wasn't one of *WW3*'s best issues. But — and this is the important bit

— no other cartoonist cabal has been standing so vigilantly on guard for thee for so long.

The other missed items were Sammy Harkham's **Crickets #2** [Drawn & Quarterly] and a collection of pagelong autobiographical strips, **Little Nothings: The Curse of the Umbrella** [NBM/ComicsLit] from Lewis Trondheim, which were really nice supplements to his longer autobiographical material in *Mome*.

Speaking of Trondheim —and we're back to the shiny new best year ever, 2008! — his zany outer space stories with Eric Cartier, **Kaput & Zösky** [First Second] did a great job of combining kid accessibility and

From Posy Simmonds' *Tamara Drewe*. [©2007 Posy Simmonds]

adult sensibilities.

And speaking of *Mome* [Fantagraphics], a thanks to Paul Karasik in *last* year's "best of" roundup for the tip about this title. Fantagraphics anthologies and I go back (Way back. *Centrifugal Bumble-puppy* and *Pictopia* back) and *Mome* is the most consistently vibrant, interesting and engaging of the company's collection of talents and treats, like, ever.

I'm late to *Mome* because I am, as they say, "slow of study" when it comes to popular entertainment. I never saw *The Simpsons* until their fifth season and I never committed to the complicated network of *Dungeon* comics until Trondheim had already left the building. But this year I caught up to the rest of the class as far as Jason and Yoshihiro Tatsumi were concerned. Jason gleefully

From "Click Click Click" in Yoshihiro Tatsumi's *Good-Bye*, translated by Yuji Oniki. [©2008 Yoshihiro Tatsumi]

slathers on genre conventions in the most unconventional ways, much to readers' delight. 2008's *The Last Musketeer* [Fantagraphics], with its title character Athos battling robots and ancient enemies on Mars, is among the very best of a substantial and evolving body of work by Jason. At the other extreme, Tatsumi pointedly avoids manga conventions in *Good-Bye* [Drawn & Quarterly] and there's precious little glee anywhere. Everything is grimly earned from scratch in these direct, powerful adult stories.

Oh, and thanks too to Mr. Karasik for the heads up on Joshua W. Cotter's *Skyscrapers of the Midwest* [AdHouse]. The series defies easy description (horrific specifics of an unpopular child's adolescence; complex and ineffectual defensive fantasies; an all-too-convincing portrayal of stupidity as evil; a subversion of the miraculous and the religious by sci-fi conventions, the role of an inscrutable Almighty taken up by an inscrutable giant robot), but the four-issue hardcover collection is assuredly the best way to gather up the diverse, fraying strands. Luckily it ends with as beatific and revelatory a moment of humane self-awareness as seems possible in so foreboding a world.

Almost every year I could, if I remembered, highlight a select few of the classy superhero reprints in DC's *Archives* and Marvel's *Masterpieces* series. This year's standouts have been *Doom Patrol* **Vol. 5** and *Adam Strange* **Vol. 3** [DC], both of which mark finales of sorts. The former, betraying a bit of narrative fatigue in the sustained, tormenting weirdness directed at "The World's Strangest Superheroes," ended Arnold Drake and Bruno Premiani's run. Indeed, it extinguished the whole team in a most startling and unprecedented fashion, one for which the "14 useless fishermen" of Codsville (renamed Four Heroes), Maine are no doubt grateful. The Adam Strange book takes us through to the end of the exquisite partnership of Gardner Fox, Carmine Infantino and Murphy Anderson on the character in *Mystery In Space*. There's scarcely a loss of inventive steam — "The Cloud-Creature That Menaced Two Worlds!," "The Emotion-Master of Space!," "The Robot-Wraith of Rann!" (no loss of hyphens either) — nor has the sheen of bracing, gorgeous SF optimism lost its luster.

Our "Golden Age" of comic-strip reprints continues, threatening to become an epoch. Charlie, Krazy, Skeezix, Dennis [*Hank Ketcham's Complete Dennis the Menace 1957-1958* **Vol. 5**], Popeye, Moomin, Terry [*The Complete Terry and the Pirates* **Vols. 2-5**], Tracy, and Mooch and Earl [*Call of the Wild: A Mutt's Treasury*] have been joined by Little Orphan Annie, Little Sammy

THE SPIRITS OF THE WINNING BALLOONISTS ARE SUBSEQUENTLY EMPLOYED BY THE FORESTRY DEPARTMENT IN AN IMPORTANT ROLE, WHERE SPEED IS KEY.

From Matthew Thurber's "Island of Silk and Ectoplasm" in
An Anthology of Graphic Fiction, Cartoons and True Stories Vol. 2.
[©2008 Matthew Thurber]

Sneeze (2007), Scorchy Smith [*Scorchy Smith and the Art of Noel Sickles*] and, by the time you read this, Happy Hooligan. The bounty has grown so great that it's now beyond my ability to keep up with the past.

Also outstripping my asset allocation is the wave of luxurious new uber-coffee-table compendiums. *Little Nemo In Slumberland: Many More Splendid Sundays* **Vol. 2** [Sunday Press Books], the double-barreled *Gary Panter* omnibus [PictureBox], and the latest *Kramers Ergot #7* [Buenaventura Press] are surely among the best of 2008, at least *in my mind*.

It's also been a heartening year for comics repackagings and returns to print. So much so that personal faves threaten to be lost in the gold rush, books like Steve Purcell's *Sam & Max: Surfin' the Highway* [Telltale Inc], Scott McCloud's *Zot!: The Complete Black and White Collection: 1987-1991* [Harper Collins], Jim Woodring's black-and-white collection of *The Portable Frank* [Fantagraphics; an appropriately appreciative review soon], the criminally underappreciated classic, *Journey* from William Messner-Loebs [IDW], and Raymond Briggs' *Gentleman Jim* [Drawn & Quarterly] absent lo these 28 years.

Last year under Chris Ware's stewardship of *The Best*

American Comics 2007, I loved the section that swung from Brown to Regé to Porcellino to Bennett to Huizenga to Heatley to Harkham. It really showed to advantage the differences and daring in each of them. With *Best American Comics 2008*, parade marshal Lynda Barry introduces several cartoonists new to me and far from your usual "*Best Of*" participants. And — get this! — she presents them *alphabetically*! Has anybody got a ballsier faith in the form than she?

Of course, Barry had to content herself with a single 12 months' output of one country's funnies. In *An Anthology of Graphic Fiction, Cartoons and True Stories* **Vol. 2**, editor Ivan Brunetti could comb the whole of North American history for untranslated comics as his luminaries. And roam he does, from 1913 to 2008, making for inclusions that represent for their artists (as the arch cover flap by Dan Clowes relates) "great exposure." In the introduction, Brunetti envisions his series thusly: "If the first volume viewed comics as a developing human being, then this volume treats them as an extended family." Accordingly, if Barry's *BAC 2008* is a handsome contemporary portrait, *AAGFCTSV2* is a glimpse down the estate's long picture gallery.

It's taken a while, but the epic sweep of Eric Shanower's *Age of Bronze* [Image] has finally won me over, especially now that I've given up trying to keep all the sons of Priam straight. By the title's third volume, *Betrayal: Part One*, it's dawning on even me just how many things Shanower is doing right to make the sprawling history work as well as it does. To take one small but telling example: A long-suffering victim of a snake bite takes to crying out and cursing loudly in his pain and hallucinogenic delirium. From out of the background, out of sight, he punctuates tense personal dramas, grand speeches and strategy sessions of the major players in the foreground with interruptions both horrible and hilarious. Plus, if you've read the series from the beginning, when Achilles spent his time masquerading as a girl and frolicked hidden among royal children on a distant island, you'll never look at Brad Pitt's portrayal of the character in *Troy* the same way.

As a reader, I'm uncomfortable with that sort of "giving up on Priam's sons" stuff as a tactic, but submission is the only way to really get into Yuichi Yokoyama's *Travel* [PictureBox]. And it's worth the surrender. Talking Heads' second album was called "More Songs About Buildings and Food"; Yokoyama's second book is more unfolding of pattern and faces. It's comics as ineffable cognitive encounter, what we used to call "a trip."

Howard Zinn's *A People's History of American Empire* [Metropolitan Books] makes Larry Gonick's rollick-

ing *The Cartoon History of the United States* look fastidious and conservative in comparison. Its talented compilers fashion a distinctive approach to the standard canon, making knowledge cool (the Jitterbug Riot of 1942!), enriching (11 pages with Eugene V. Debs!) and curdling (during the U.S. invasion of the Philippines, American troops used "the water cure," an early version of waterboarding, to interrogate prisoners, "forcing water down their throats until they nearly drowned. Torturers then pounded the victims' stomachs to make them talk.") Beware or be square.

Also from the nonfiction shelves, high-profile cartoonists have been doing some fine biographies of late, beginning with Spain Rodriguez's *Che* [Verso] and John Porcellino's *Thoreau at Walden* [Hyperion; see *TCJ* #294]. I also enjoyed Rick Geary's *J. Edgar Hoover* [Hill and Wang], which was a lot scarier and only slightly less creepy than his *A Treasury of Victorian Murder* series. At the risk of spooking the cattle, is comic-book biography the new autobiography?

Don't make the same mistake I did: Actus Comics' *How To Love* [Actus Independent Comics] is *not* an Israeli *Kama Sutra*. Still, could the people who vote in any of those "Story of the Year" awards please pay attention to Rutu Modan's "Your Number One Fan"?

My go-to periodicals on comics did not disappoint this year (save for those missing print this year altogether. You listening, *Hogan's Alley*?). *Comics Comics* #4 [Picture-Box] featured, among plenty else, Spiegelman on Topps innovator and ephemeralist Woody Gelman; Sammy Harkham on "The Slow Death of the Comic Book"; Frank Santoro on, and an interview with, Shaky Kane; Brian Chippendale on Brian Michael Bendis ("Mr. Bendis doesn't have a clue. Or more importantly, give a shit"): and a page of comics from Dan Zettwoch on the "Lost Comics of the Ohio River Valley, 862-1988." Then there is spring's hefty 602 pages (but by no means a record) of *International Journal of Comic Art* which includes scholarly papers from the 2007 comics conference in Dundee, Scotland and a piece on "Art Spiegelman and His Circle: New York City and the Downtown Scene," which makes a nice companion for the autobiographical material in *Breakdowns*.

Likewise my go-to cartoonists held up their end of the covenant and then some, beginning with Jason Lutes who released *two* issues of *Berlin* [Drawn & Quarterly] in the calendar year; #16 ends with the surprising triumph of the National Socialist in the 1930 German national elections. The shit is well and truly deep into the fan.

Remember how in *Marathon Man*, Laurence Olivier

From *Thoreau at Walden*: by John Porcellino (and Walden).

[©2008 Center for Cartoon Studies]

passed up working over Dustin Hoffman's dead tooth with its withered nerves in favor of a healthy tooth with its vulnerable, twitchy nerves? With *Acme Novelty Library* #19 [Drawn & Quarterly], Chris Ware does much the same thing, passing over central characters and discrete storylines of previous volumes to zero in on the history of ensemble member W. K. Brown, father of Rusty, who assumes center stage in his own excruciating drama.

Tony Millionaire's *Billy Hazelnuts and the Crazy Bird* will likely tickle many a fancy but, square inch for square inch, nothing matches his strips, the latest of which were collected in *Maakies with the Wrinkled Knees* [Fantagraphics both].

With *Palookaville* #19 [Drawn & Quarterly], the 10th in the "Clyde Fans" cycle and the conclusion of Part 3, Seth rounds his story into epic form even while he sharpens its edges, courtesy of a wrenching parting and a nostalgic, exquisitely modulated cataloguing.

Michael Connor's *Coelacanthus* #15 [self-published] remains as personal and idiosyncratic even as his story becomes more accessible and resonant ("a silly bear/ mammal anthropomorphoid trading away the things he loves to a few charismatic, single-minded weirdos"). The art just keeps getting better and more accomplished.

As for the Hernandez Brothers, Gilbert's *Speak of the Devil* [Dark Horse] ended as satisfyingly as it began and

I'm anxiously anticipating his *Trouble Makers* [Fantagraphics]. But the reformatted **Love and Rockets: New Stories** [Fantagraphics] ... I mean, if Los Brothers' schedule for this new configuration, with its discontinuous one-offs and — worse! — its continuing story, is consistent with their timetable for past releases, the pace will kill me.

Unless Kevin Huizenga's **Or Else** [Drawn & Quarterly] does it first. His fifth issue begins a serialized story that the laughable "Coming Attractions" reveals to be mapped out with Methuselah in mind. Great interlude with spiders, though!

Is my soapbox ready? OK: In valuing things like an ability to hit deadlines above artistic integrity, the proprietary interests of mainstream superheroes undercut the efforts of their day laborers and dilute product by allowing abuses of narrative sense, thereby betraying reader trust whenever commercially advantageous. The dead rise, turning points are forgotten or turned back on as soon as a new creative shift punches in, characterization is plastic to the point of molten fluidity. There's no personal stake that you, as a reader, can invest in them safely (just your money is sufficient, thanks). There's no future in them. And then there's outrider Grant Morrison at DC, who gets you caught up so entirely in the present moment that you really don't care that there's no tomorrow. Currently he's writing a "**Batman R.I.P.**" saga (with artist Tony Daniel in that character's flagship book) that is authoritatively crazed and persuasively unsettling. I'm unclear as to what exactly is going on, but that too we know to be a hallmark of complete, catastrophic downfalls. At another extreme, Morrison and Frank Quitely have recently finished their work on **All Star Superman**, a story that fairly glistens with untarnishable heroic virtue buffed with postmodern humor. Lastly, his **Final Crisis** with J.G. Jones is, if anything, more disturbing and disorienting than the Batman stuff, yet smeared across a far wider palette. Grandiose Kirby myth-forging and the company's history of assorted "Crisis" mega-crossovers are locked in an ugly, intricate free-fall ballet that threatens to forever expunge Silver Age goodness and dauntless innocence. When Morrison does superheroes, they stay done. In my mind.

I know I say something like this every year, but the team-up in **Donald Duck, The Barks/Rosa Collection Vol. 3** [Gemstone] is an especially good pairing of stories in which the ownership of North America is literally up for grabs. It's a telling contrast between the languorous adventure by Unca Carl's from the '50s and the ingenious, frenetic homage by spiritual son Don from the

'90s, one that flatters the distinctive talents and methods of both men.

Between now and year's end, I'm looking forward to a rich mix of the new (*Beanworld Holiday Special* [Dark Horse] from Larry Marder, *Mister X* [Dark Horse] from Dean Motter, *Fight Or Run* [Buenaventura Press] from Huizenga, *Nocturnal Conspiracies* [NBM] from David B.) and the old (a collected *Beanworld* Book 1 [Dark Horse], a collected *Flaming Carrot* Volume 1 [Bob Burden Studios] from, uh, Bob Burden, a hardcover *Saga of the Swamp Thing* [DC] from Alan Moore, Steven Bissette, and John Totleben, and a *Blazing Combat* collection [Fantagraphics, now slated for next year] with Archie Goodwin editing and writing for a pantheon of artists. And come to think of it, haven't we been promised a new edition of Jerry Moriarty's *Jack Survives* by Buenaventura and a *Perry Bible Fellowship Almanac* by Nicholas Gurewitch from Dark Horse?). With any luck these should carry me straight into a year that may one day truly and solemnly be acclaimed in turn as the best ever.

Noah Berlatsky's Best

As I say every year about this time, I don't actually make any effort at all to keep up with new releases, so this is more a list of things I happened to see and love this year than an actual best-of.

Ai Yazawa's **Nana #8** (Viz Media) is my favorite volume of the only ongoing series I follow.

Hitoshi Iwaaka's **Parasyte** was one of the first manga I read, and it's still a marvel — I haven't seen all the volumes of the ongoing Del Rey reissue yet, but the translation is definitely superior to the earlier TokyoPop edition.

Ariel Schrag's **Potential** (Touchstone) is a reissue of one of the best (and most underrated) comics of the last couple of decades.

Lilli Carré's **The Lagoon** (Fantagraphics) is by an extremely talented artist; a lyrical mind-fuck of time, identity and genre.

Lyrical mind-fuck also describes the opera/graphic thing/poem/performance that is Dewayne Slightweight's **The Kinship Structure of Ferns** (Self-published). Seeing Dewayne perform it live is something else, but for the vast majority of folks who missed it, the hand-bound book comes complete with a play-along CD of his original music.

Dame Darcy's **"We Are the Fae and There Is No**

— Best of the Year lists continue on page 58 —

An Interview with Frank Quitely
Conducted by Kristy Valenti

Comics artist Vincent Deighan (Frank Quitely), is mostly associated with writer and fellow Scot Grant Morrison — they've collaborated on critically acclaimed projects such as *All Star Superman* (2005-2008), *We3* (2004-2005) and *The New X-Men* (2001). Quitely has also worked with other mainstream heavyweight writers such as Mark Millar (*The Authority*) and Neil Gaiman (*Sandman: Endless Nights*). His art appears on promotional posters and on covers, as well.

A Quitely portrait of Beast, collected in *The New X-Men* Vol. 1.
[©2002 Marvel Characters, Inc.]

Deighan began his comics career in 1989 in the underground *Electric Soup*. "The Greens," which he wrote and drew, was a satirical take on the Scottish legacy strip *The Broons* (another way of saying "The Browns"). Soon, he had work in *Judge Dredd Megazine*, and his art (though not his writing) made its way across the Atlantic in such publications as *Dark Horse Presents* ("Blackheart," written by Robbie Morrison), the *Big Book* series (*The Big Book of Death*, etc.) and *Flex Mentallo* (a Grant Morrison Vertigo miniseries).

Quitely's art style, with its detailed backgrounds and broad, fleshy, narrow-eyed visages, perhaps by dint of being so distinctive, has had its share of detractors; however, the Glasgow native has become a fan-favorite (and has very nearly solved the mystery of how to style Wolverine's hair). Quitely's fine lines lend themselves especially well to animals: His pets-turned-war-machines in *We3* may possibly have a wider range of expressions than his humans, giving the polemic a special poignancy, not to mention that his redesign of the X-Men's Beast borders on quintessential. It's safe to say that even Grant Morrison's talents would not have been enough to endear *All Star Superman* to some of this magazine's critics (given their general skepticism of the superhero genre) without Quitely's crucial blend of the fantastical and the earthy.

Research assistance by Gavin Lees and Ben Neusius.

KRISTY VALENTI:
Would you tell us about your early life?

FRANK QUITELY:
Born in Glasgow. Youngest of three. Two big sisters. Both parents graduated as maths teachers, but my mum was a full-time mum and housewife, and my dad became a PE

From "Blackheart Part 2," in *Dark Horse Presents* #92 (Dec1994), which was written by Robbie Morrison and drawn by Quitely.

[text ©1994 Robbie Morrison, art [©1994 Vincent Deighan]

(gym) teacher.

The Internet lore regarding your pseudonym is that you adopted it so that your parents wouldn't see your work and find it "unsettling." The cat is out of the bag now — how did/do they respond to it?

That was a big part of it. I also just liked the idea of being able to hide behind a phony name. There was never any big overreaction from them, just a bit of over-caution on my part.

What are your influences? They needn't necessarily be comics.

In comics: Dudley D. Watkins, John Buscema, Mort Drucker, Jack Davis, Moebius, Katsuhiro Otomo, Frank Bellamy, Jack Kirby, Alex Toth, Will Eisner, Robert Crumb, Geof Darrow, Steve Ditko, Winsor McCay ... it's a really long list ...

Outside comics is probably an even longer list — I was equally impressed with the artists responsible for my album covers as I was with the ones that filled my fine-art books, so it's a pretty big and diverse collection of influences.

You formally studied Fine Art at the Glasgow School of Art. It's clear in "Blackheart" that you had previously taken life-drawing classes: What instruction did you find particularly useful there? What areas of art were you interested in pursuing before you started working in comics?

There are a whole host of instructions, rules, techniques and things to think about in general that apply to pretty much all areas of the visual arts, and then there are a lot of considerations that really only apply to comic books. I like a lot of different areas of art, sculpture and printmaking in particular, but when I was in art school I was in the drawing and painting department and would have liked to have pursued a career painting, or in book illustration.

Would you mind explaining how you broke into comics, especially since you don't appear to have come from a mainstream-comics-fan background?

I got involved with a bunch of guys who wanted to put out an underground comic.

Because we were selling it ourselves we started going to marts and cons, and gradually people kept telling me I should send samples of my work to comic companies, so I did, and eventually, after sending samples to maybe 20 publishers I got a couple of offers of work. It was David Bishop, who was the *Judge Dredd Megazine* editor, who gave me my first commissioned work, which was the first *Missionary Man* strip, written by Gordon Rennie.

Much of what I had seen up to this point was a fairly patchy selection of underground comix, European comics and British comics, a very few manga titles, and a handful of American books — some indy and some superhero, so even by the time I started working for American publishers, I really wasn't very familiar with mainstream comics.

Did you both write and draw the "The Greens" in
*Electric Soup***?**

When I stated in *Electric Soup* we were all just expected to write our own stuff — it wasn't that I had a burning desire to be a writer — I just wrote so I had something to draw. As a general rule I like short stories. The kind of stories that I wrote in "The Greens" were a sort of surreal kitchen-sink slapstick. I'd like to do some autobiographical stories at some point, and some stream-of-consciousness stuff too.

In your *Newsarama* **interview, you wrote that Jamie Grant was in the Edinburgh scene and you were in the Glasgow scene. What would you say the differences are/were between the two scenes?**

I'm not really sure — both had a loosely connected group of people independently producing work, and a few names who were already working professionally, but in fairness, I knew much more about the Glasgow scene, because I was part of it. I got the impression that there was a little more going on in Glasgow, and this is probably supported by the fact that Jamie ended up moving through and setting up his home and publishing ventures in Glasgow, and now the studio where we all work.

How does working for Marvel and DC differ? What are the advantages and disadvantages of (formerly) being on exclusive contract with DC?

Swings and roundabouts: I've had a few minor problems working for both, and I've had plenty of good times working for both too. There are more similarities between them than differences.

Would you describe the studio you have?

Whew! It's on the top floor of an old building on Hope Street, next to Glasgow's Central Station. It's old and faded and crumbling, and it's full of found objects and re-appropriated furniture, and there're a number of different rooms with a few artists in each room. In addition to myself and Jamie, there's also Dom Regan (*Omega Men, Infinity Ink, High Pilot*), Rob Miller (*Khaki Shorts*), a few illustrators and animators, and a regular satellite cast involved in *Wasted* (Jamie and Alan Grant's latest venture) which includes Dave Alexander (*The MacBam Brothers*), John Miller (*Secret Agent*), Kurt Sibling (*Total Fear*), Rab Thompson (*Northern Lights*), Jim Devlin (*Testament*), Colin Barr (*The Freedom Collective*), Paul McCann (*Wasted*) Deadboy (*Kreepy Kat*) and a whole raft of artists and writers, old and new, who visit on a weekly basis. It's a friendly, vibrant place.

In your *Newsarama* **interview, you wrote, "For my part, I approach every script in work in exactly the same way." Would you please describe your approach?**

Read the script until you have a really clear picture in your head of how it works, thumbnail drawings in the margin of the script, arrange the thumbnails into little page layouts, then draw the pages. I've never once started a page that wasn't already planned out.

Would you describe your drawing process and techniques: for example, what size and type of paper do

The garden is a maze of paths that divide and branch and recombine.

From chapter seven, "Destiny," in *The Sandman: Endless Nights*: written by Neil Gaiman and drawn by Quitely. [©2003 DC Comics]

you compose on?

I draw on regular DC or Marvel boards with non-photo blue pencil then draw the finished line-work using a 0.7 or 0.5 technical pencil, usually with HB leads. I then scan the page and contrast the image in Photoshop so it's pure black and white, and then make any necessary corrections and spot the blacks — all digitally.

Jamie Grant taught me how. There's a saying: "Give someone a fish and they'll feed themselves for a day, but teach someone to fish and they'll feed themselves for the rest of their life." What they don't tell you is: "... teach someone Photoshop and they'll nick your job!"

What are the aesthetic advantages and disadvantages of working in a pencil with a light lineweight?

The advantage is that it's faster, and the drawing remains slightly fresher (more life and movement) and the disadvantage is that there's little variation in the line weight. I've found that by scanning in rough pencils, I can ink the finished line-work digitally and get a traditional-looking ink finish that can be tricky using a brush and nib pens, but it takes a little longer than the process I described above.

Would you care to comment about "decompressed" comics-storytelling, seeing as it dovetails so nicely with your preference for wide horizontal panels? Could this preference perhaps be partially due to your enthusiasm for comic strips?

Decompressed storytelling sometimes serves a story or part of a story well and sometimes doesn't. My fondness for the wide horizontal panels has nothing to do with this, or with what's often referred to as cinematic storytelling, but is as you suggested, due to my enthusiasm for the comic strip and the way it works. I find, personally, that the wide horizontal panel lends itself best to exploring the way time moves from one side of the panel to the other, and I particularly enjoy the opportunity this affords me to depict the action/reaction, cause/consequence of one or more events through time in a single image that reads from left to right.

Your pages have an airiness about them. Would you discuss some of your thought process regarding page layout?

When you look around you, objects, people, pattern and detail aren't usually uniformly spread out equidistantly around you — maybe some of this 'airiness' that you're referring to is describing areas where space and sparsity are there to balance the areas of denser detail?

From *Flex Mentallo* #2 (July 1996): written by Grant Morrison and drawn by Quitely. [©1996 DC Comics]

The whole comic has to tell the story, each scene has to be play its part, and each page has to work. Considerations as diverse as "At what point would the reader benefit from an establishing shot to set the scene?" — to allowing the dialogue to inform the composition of each panel so it still reads easily; it's always about trying to make it as easy as possible and as interesting as possible, in that order.

I reviewed your earlier work, and I was interested to see you drop out some of the crosshatching ("Blackheart") and work toward balancing a more realistic, portrait style of comics (your work on the Big Books) with cartooniness. Was this a conscious process?

As a general rule, my style has become a little less fussy.

On the subject of crosshatching in particular, the examples you give are works that were originally drawn to be printed in black and white, so some of the hatching and rendering is to suggest a breadth of color, texture and mood that would otherwise be covered by the colorist. There hasn't been a deliberate move towards cartooniness, but in the case of the Big Books stories I was often having to incorporate people and places from photo ref, which is one of the reasons that some of these books ended up with a slightly more realistic, "documentary" look.

I read that you don't do a lot of photo reference, but do you do other kinds of research, visual or textual? For example, for storytelling purposes, in *Flex Mentallo*, you go back and forth from a '60s Silver Age style to more of a '90s Vertigo style. In *Batman: The Scottish Connection*, you had to draw a lot of architecture and

scenery. I assume you were able to reference the locations directly for that?

With *Flex* I was probably as conscious of going from Wally's "real world" to Flex's "comic world" as I was of going from "Silver Age" to "'90's Vertigo" — but however you look at it, it just comes down to trying to find a way of telling the story, sequentially and stylistically, that works with what the writer is trying to say.

I had to use photo ref for some of the architecture and scenery in the *Scottish Connection* because that's what the story demanded, so I tried to draw from the reference in the same style that I was using for the other 90 percent of the book, which is one of the reasons it has a different look from the Big Books.

In your work with Morrison especially, you must do the visual equivalent of deconstructing superheroes and muscular, superheroic bodies. What techniques or thought processes do you use to accomplish that?

That kind of thing can be a lot of fun, but usually it's more about finding a way of doing your own version of an existing character and try to be true to both the character and your own natural style.

Your waves and clouds often have a flat, planed side. Is that just a stylistic quirk?

The only example I can think of is in *All Star Superman* #3 where I drew clouds with a definite line to show where the horizontal underside of the cloud finished and the fluffy side started — and I meant to ask Jamie to drop all the line-work and just have these out-of-focus clouds with shadowed undersides — but I only realized that I'd forgotten to ask him when I saw the printed comic! I think all other clouds and waves are as intended.

What was it like switching on and off a team of artists on Millar's *Authority*?

Mark and I were both big fans of the *Authority* before we knew we were going to be working on it. It was one of our favorite comics and we knew we had a hard act to follow because Warren [Ellis] and Brian [Hitch] had done such good work on it, so we just went in determined from the outset to do the best work we could on it.

I have gathered that professionally, you can afford to be a bit choosey about what writers you work with. What do you look for in a writer to collaborate with?

I usually take the lead from the writer — some like to give you full script and let you get on with it, some will give you more in the way of a very descriptive script or

additional notes, and others like to collaborate more.

It depends on the project too. On *We3*, Grant [Morrison] and I collaborated all the way through, whereas with *New X-Men* and *ASSman* [*All Star Superman*] we collaborated a lot at the planning stages and just now and then once things were up and rolling.

With some of the other writers I've worked with, there's been no collaboration at all.

Your sensibility seems to lend itself to fantastical elements. Is it just that you have more of an affinity for that type of material?

I just draw what's in the script, and anything else that I feel is needed. I'm actually just as happy drawing ordinary, everyday people, places, objects and events as I am drawing the fantastical.

I felt that *New X-Men* was a dramatic shift for your art: that you had struck a good balance. What kind of aesthetic considerations went into the redesign on your part?

The redesign is my attempt at getting as close as pos-

From *The New X-Men* Vol. 1, which was written by Grant Morrison and penciled and inked by Frank Quitely. [©2002 Marvel Characters, Inc.]

sible to what Grant wanted. I put a lot of time and effort and thought into those redesigns, so there is a lot of me in there, but it was all in an effort to get what Grant was envisioning. I don't see the dramatic shift in the art, but it's interesting that you do. I approached it the same way I did on *The Authority*, but then *The Authority* had a stylistic shine because Trevor Scott inked it, and David Baron colored it, and we had the same team for the seven issues I did on that book. Whereas *NXM* started with Tim Townsend inking, which made it as slick-looking as *The Authority* but with a slightly different look, and then there was Dan Green (whose paintings are superb) who gave it a slightly looser, inky feel, and there was Mark Morales and Perrotta and Florea assisting Tim sometimes, and I inked one issue and the last three were digitally inked by Avalon Studios, so that's seven different inking styles and three different colorists (Brian Haberlin, Hi-fi design and Chris Chuckry) over just 10 issues. I was trying to be as consistent as I always try to be on the penciling but I usually think of my run on *NXM* as not really having one specific look.

You tend to draw your characters with long legs, short, bulky torsos and wide faces.

It's a Pictish thing.

Is it true you used to draw pet portraits? Were you able to use this experience for *We3*?

It's true. Amongst many, many other freelance jobs I happily accepted when there was no other work to be had. I honestly didn't make the connection when I was doing *We3*, but it may well have helped a little?

It looks like you were able to incorporate your interest in fashion into your covers for *Bite Club*.

If you could see me sitting here in my "lounge pants" and lady's slippers you'd be wondering what exactly is my interest in fashion? *Bite Club* was a book with a cast made up predominantly of rich, good-looking, Miami vampires — there was the hot priest, his fashionista sister, her teenage emo brother, his high-school heroin-chic girlfriend, a tattooed Asian S&M cop ... I was just trying to echo the glamour that was so much a part of the book.

***All Star Superman* is probably your most acclaimed work to date. What kind of special challenges and rewards did this project present for you?**

Taking on a character as iconic as Superman is a challenge because everybody feels they know Superman — everybody, not just comic readers. A 12-issue commitment was

From *All Star Superman* #8 (August 2007), written by Grant Morrison, penciled by Quitely and digitally inked and colored by Jamie Grant. [©2007 DC Comics]

a challenge for me, too. But I've known from way back that Grant loves Superman, and he really knows what he's doing, and that he'd been planning this for years, and then when I got the scripts — they were just phenomenal — it was a great project to be involved in.

You said that you "would have liked to pursue a career in painting, or in book illustration." Is that something you might some day still pursue? Do you have a desire to branch out from mainstream comics?

I dream about getting back to painting someday. I love making comics, and I imagine I always will, but painting for pleasure is something that's always out there on the horizon.

I've got a couple of illustrated book plans on the back burner with Grant which I hope to get round to in the next year or two as well.

Would you like to talk about your current and upcoming projects?

I can't yet. What I can tell you is that since about issue 10 of *ASSman*, I started getting in touch with other publishers, a few in the U.S., a couple in France, a couple in the U.K., one in Scotland, and after narrowing it down to three ... I've decided to stay at DC for the time being and I've just started a new project with Grant, which will be launching about June. ∎

— Best of the Year lists continued from page 51 —

Death," from *Meatcake* #17, is a horror story masquerading as a fairy tale, and is also about as beautiful an example of either as I ever hope to see in comics form. It made me wish Darcy would adapt some Lovecraft or Poe ... though I'll settle for the illustrated version of *Wuthering Heights* she promised us a few years back.

Spider-Man and the Fantastic Four: Silver Rage (Marvel) actually came out at the end of 2007, but what the hey. Artist Mike Wieringo's art is OK as superhero fare goes, but Jeff Parker's smart, goofy, all-ages writing is

From "Second Chance for a Deadman?" (Nov.-Dec. 1972), written by Bob Haney and drawn by Jim Aparo, in *Showcase Presents: The Brave and the Bold Team-Ups* Vol. 2. [©2007 DC Comics]

the thing. He's more or less single-handedly restoring my faith in the superhero genre.

Also helpful in that regard is ***Showcase Presents: The Brave and the Bold***, reprinting the series' classic 1970s heyday in 500-page plus black-and-white phone books. Volume 2 came out at the tale end of 2007, and while it's a bit uneven, at its best it's stunning. It would be worth getting for Bob Haney's brilliantly nutty scripts alone, much less the eye-popping art by the likes of Nick Cardy and Jim Aparo. Issue #104, **"Second Chance for a Deadman?"** is probably the best Batman story ever written, for my money. Volume 3 of the series, which should be every bit as good, is scheduled for December 2008.

Dan Walsh's inspired alterations of *Garfield* comics at www.garfieldminusgarfield.net made me laugh so hard I got hiccups. Basically, Walsh simply removes the titular cat from the strip, leaving Garfield's owner, Jon, talking to himself in an arid suburban wasteland. Thanks to Davis' good humor — and his eagle-eye for promotional opportunities — the site has spawned a book, ***Garfield Minus Garfield***, from Ballantine which features excerpts from the site, as well as a few détourned strips by Davis himself.

Mr. Door Tree at ***Golden Age Comic Book Stories*** this year published a jaw-dropping portfolio of illustrations by Dugald Stewart Walker for the 1918 book "The Boy Who Knew What the Bird Said." I'd never heard of Walker before, but he is now one of my favorite artists; his fairy-tale illustrations are unbelievable. Unfortunately, that post seems to have been deleted. As of this writing, there is another selection of Walker's art on the site at this address: http://goldenagecomicbookstories.blogspot.com/2008/10/dugald-stewart-walker-1883-1937-dream.html

Finally, and most self-indulgently: my favorite comic of 2008 was Edie Fake's **"Call the Corners,"** which he created as his submission to the online forum *The Gay Utopia*, which I organized and edited. "Call the Corners" is a single, enormous image; onscreen, you scroll down it, following an elliptical message, more poem than narrative. It's influenced by Fort Thunder and by tattoo art, but the synthesis is completely unique. I was deliriously happy to be able to publish it — it sort of made me feel my existence was justified, at least for this year. You can find it here: http://gayutopia.blogspot.com/2007/12/edie-fake-scroll.html

Overrated:

I only read Grant Morrison's *All Star Superman* and his run on *Batman* through March of this year or so, but I

From the April 9, 1964 *Village Voice* strip collected in Jules Feiffer's *Explainers*. [©2007 Jules Feiffer]

was underwhelmed by both. In *All-Star*, Morrison isn't just rewriting the Weisinger-era Superman; he's rewriting Alan Moore rewriting Weisinger — or maybe more accurately, rewriting the-last-15-years-of-fetishization-of-the-goofy-Silver-Age-Supes rewriting Alan Moore rewriting Weisinger. By the same token, Morrison's Batman stories — obsessed as they are with replications of infinite alternate possible Batman — seem to just be reworking, with a good deal less zip, similar concerns in the *Animal Man* series that Morrison put out there 20 years ago.

Maybe I've simply read my quota of Morrison for this lifetime. Or maybe the 50th corporate-approved fan-fic reimagining of the same long-since-used-up characters just doesn't have the charm that the 49th one did. Either way ... can we just stop now? Please?

Shaenon Garrity's Best

1. ***Explainers***, by Jules Feiffer. Of late, it's been hard to keep up on all the fantastic comic-strip reprint projects chugging along. I've fallen behind on *Dennis the Menace, Dick Tracy* and *Gasoline Alley*, and those *Krazy Kat* and *Peanuts* collections pile up on my bedside table faster than I can read them. But I've been waiting forever for a collection of Jules Feiffer's *Village Voice* strips, and now here it is. It went straight to the top of the must-have list with the *Moomin* books. Next: *Barnaby*, dammit!

2. ***Solanin***, by Inio Asano. My manga-industry friends and I sometimes call books like *Solanin* "too good to be manga," and it's true that when you spend your days nose-deep in peppy tween adventure fare and angsty YA soaps (not that there aren't brilliant soapy manga; see Ai Yazawa's *Nana*), it's easy to forget that the Japanese comics industry also produces comics that are smart, personal, honest and written for readers who are mostly past the acne years. If American comics about disaffected post-collegiate slackers and their bands were this much fun, I wouldn't hate comics about disaffected slackers. I bawled like a baby at the end. True, I was drunk, but it counts.

3. ***The Complete K Chronicles***, by Keith Knight. For years, Keith Knight has been plugging away in the free weeklies, drawing autobio and political comics in laundry marker, hustling small-press books and homemade calendars and generally working his ass off to be the coolest cartoonist on the West Coast. Finally, Dark Horse has put out a massive omnibus of Keef's relentlessly funny weekly strip. There is now no excuse not to know about Keith Knight.

4. **Kate Beaton's Webcomics**. As a struggling cartoonist, there are some comics I look upon with blind envy for being so damn good and so damn funny, and then there are comics I can't envy, because they're so utterly the product of a single unique mind that there's no way anyone else could have created them. The thing about Kate Beaton's

comics is that they're *both*. She writes mostly about historical figures, sometimes about herself. A number of her strips have already become meme-tastic Internet classics: "Tesla the Celibate Scientist," "Mister Darcy," "Shetland Pony Adventures," her cruelly perfect sendup of *For Better or for Worse*. But she never draws a so-so comic. No one is funny like Kate Beaton.

5. *What It Is*, by Lynda Barry. If I could have only one comic on a desert island, a possibility I consider on a more or less daily basis, it would be Lynda Barry's *The Greatest of Marlys*. What we have here is a roundabout course in writing and drawing from one of the greatest cartoonists evah, and every page is a collage of amazing. There are several good how-to-draw-comics books out now, but this is the only one that tells you why to draw.

Overrated:

Last year I stopped reading comics blogs, thus making myself a happier and more delightful person, so I have no idea which comics were overrated, underrated or rated in 2008. I'll go ahead and nominate all monthly pamphlet-style comics, because somehow this year I stopped reading comics in this format entirely. (OK, except for *Castle Waiting,* but even with that one I'm looking forward to the trade.) Like any nerd, I have a stubborn nostalgia for the classic 32-page format and love following serial stories, and yet here I am, skipping the comics store on Wednesdays. I know I'm not the only one; I've heard other fans talk about how their monthly purchases are down to nothing. Of course, those fans were mostly ladies, so they probably don't count. But something's going on here.

If we're allowed to talk about media spinoffs that are *definitely not comics*, I nominate *The Dark Knight*. Haven't 22 years of bad Frank Miller pastiches, some by Frank Miller himself, allowed us as a nerd race to get this emo-noir thing out of our systems yet? *Hellboy 2* was a better comic-book movie sequel. It was dumb fun, but at least it was fun. Just like the comic.

Steven Grant's Best

I generally avoid "best of" lists just because I don't feel it's a worthwhile judgment unless I've read everything, and I haven't come anywhere near. That said, this seemed a weirdly vanilla year in most respects, with nothing either memorably good or memorably bad, and even those things that were especially good examples of their niches,

A Steve Ditko drawing for *Tales of Suspense* #26 (February 1962), which doubled for the cover image for Bell's *Strange and Stranger*.

e.g. *Mome* as best anthology, weren't all that notable solely on their own merits rather than comparatively. Which isn't to say they were bad, just that while they rose above the crest of their niche, they still didn't really punch a hole in my consciousness or seem to merit special notice. Except two books:

Blake Bell's ***Strange and Stranger: The World of Steve Ditko*** (Fantagraphics)
Art Spiegelman's expanded new edition of ***Breakdowns*** (Pantheon)

Both are, in their way, excellent memoirs of the creative life in comics, of the comic story as expression of worldview, of the opportunities and limitations of different areas of the field. Bell's book is especially well-researched.

Overrated:

At the arse end of the field, well, why bother? "Main-

stream," indy and alt comics all seemed this year to have reached levels of creatively stable mediocrity (not that I was much help in that regard) where the excessively bad things were achieved by people who probably don't know any better and don't deserve commemoration in any case, and the rest, even by good talent, was at a passable enough level to please their target audiences and little more can be said of them. Most comics, comics companies, talent and readers have pretty much settled to what they consider their safe levels, and as 2008 shuts down that's where things throughout the business stand: safe, unexciting and, for all the "events" in comics now, uneventful. The good news is that the average level of talent throughout the business is now pretty good, the bad that can come of taking significant risks, especially in story material or storytelling styles, appears to be pretty much a thing of the past.

Paul Gravett's Best

My 10 best comics in English of 2008 are:

Skim by Jillian and Mariko Tamaki

Skim, alias Kimberley Keiko Cameron, is a "not-slim" goth loner and wannabe teen-witch at a private girls' school in 1993. *Skim*, the graphic novel by the Canadian Tamaki cousins, is her diary, its hand-drawn spine warning 'Skim's Journal, Private Property!' The intimate truths we glean from her entries and thought-track regularly contrast or counter with her conduct and comments to others, as she copes with her broken arm, her separated parents, her gradual disillusionment with her sassy best

From Phoenix' *Rumble Strip*. [©2008 Woodrow Phoenix]

friend and her awakening sense of self. When her classmates are rocked by the suicide of one girl's boyfriend, a jock rumored to be gay, her teachers overcompensate in their grief-counseling. All except Skim's favorite, drama and English teacher Ms. Archer, a "freak" like her, the first person to whom she opens up over shared illicit cigarettes. This sparks Skim's first love, their secret kiss in the woods set within one silent spread of lush nature. Writer Mariko and artist Jillian stunningly entwine their acute dialogues and visual riches in brush, soft pencil and gray tones, illuminating this adolescent romance in all its conflicted depths.

Rumble Strip by Woodrow Phoenix

"If you want to get away with murder, buy a car." The killing of his young sister aged 11 in a car accident inspired Woodrow Phoenix to reassess the impact automobiles have on our lives. As a driver himself, Phoenix understands the dangers and pleasures of being behind the wheel, building a persuasive argument out of stark highway signage and statistics. Phoenix loves his Audi A3, so he's perfectly placed to deliver this passionate wake-up call about the absurdities of road deaths, over 1.2 million of us worldwide each year. How can killer-drivers so often get away with little more than a fine, reprimand and perhaps a temporary ban? His unique approach drops all dialogue and balloons and uses only captions for his acerbic, discomforting commentary, accompanied by subjective views of roads and their painted markings of directions and abstract figures, eerily devoid of any cars or real people. Without showing a single human being, this is an extraordinarily human book, whose ideas and questions about how the car affects your life will echo in your mind long after you've finished reading it, whether you're a driver, or a pedestrian, or both.

Alan's War by Emmanuel Guibert

Guibert illuminates in tender outlines and lustrous washes the World War II reminiscences of an American G.I., Alan Cope, whom he first met in 1994 when Alan was 69 and living with his wife on a small island off the French Atlantic Coast. Though nearly 40 years his junior, Guibert struck up an intense friendship and spontaneous collaboration with this vivid raconteur, recording hours of his candid stories in his distinct foreign French. Over the next five years, Cope quickly grew to trust Guibert's visualizations, leaving him free to picture his life as he imagined it from the veteran's tapes, letters, phone calls

— Best of the Year lists continue on page 83 —

An Interview with Dash Shaw

Conducted by Rob Clough

Dash Shaw made a huge splash with *Bottomless Belly Button*, an ambling 720-page epic depicting a weekend in the life of a family after the parents just announced a divorce. While this was the first book of Shaw's to gain widespread attention, the 25-year-old artist is really a comics lifer, having started to publish comics as a teenager. While still at the School of Visual Arts, he published

Dash Shaw at the 2008 Comic-Con International: photograph taken by Kristy Valenti.

Gardenhead through his friends at the MeatHaus collective. Shaw's work has also appeared in numerous anthologies and magazines, including *MeatHaus, Blurred Vision, Garish Zow, The Drama, Other, Stuck In The Middle, Big Dumb Fun* and more.

After seeing Shaw's work to date on *Bottomless Belly Button*, Gary Groth quickly agreed to publish it. Shaw's comics can currently be seen in the pages of Fantagraphics' flagship anthology *Mome*, as well as on his own website (www.dashshaw.com), where *BodyWorld* updates every Tuesday. The latter will eventually be published by Pantheon.

Shaw's work is notable for his interest in the way opposites interact and blur: gender, mind and body, beauty and ugliness, abstract and concrete. The progression of his career has seen him burn through and absorb a dizzying number of influences from comics of all kinds, the art world, film and philosophical writings. His artistic vision is so distinct that those influences are always filtered through his own point of view. That vision focuses on spaces in between, the "gray areas" as Shaw describes them. Shaw has been able to achieve so much in such a short span of time thanks to his dogged work ethic and willingness to evolve as an artist. Considering his astounding learning curve in the past five years, I am eager to see where he will be as an artist when he turns 30.

— Rob Clough

You've noted that your father is a big comics fan. What do your parents do for a living? Did you ever see art made by your parents?

My mom is a child psychologist and my dad is a direct-mail copywriter. My mom's office has a large sandbox and the wall is lined with toys. The children, her clients, play in the sandbox and she analyzes their play. It's called "play

This sequence is from *Bottomless Belly Button*. [©2008 Dash Shaw]

therapy." And my dad writes mail packages that you'd get in the mail asking you for money for a (usually non-profit) organization. He has a blog about effective writing for getting donations.

My dad has a sketchbook from his college years. I only saw it once, briefly. Also he took a watercolor class a few years ago.

How much did your mom's background come into play in creating *The Mother's Mouth*?

Obviously, she doesn't tell me anything about her clients. That would break her clients' privacy. I just remember being at her office and looking at her books. It left a lasting impression on me.

Do you have any siblings? If so, did they draw with you? Did you have any drawing/artistic partners growing up?

I have a younger brother, Nick. He's eight years younger than me, and we never drew together. The age difference was too far apart.

The first drawing partner I can remember is Will Jones. We met in high school and we'd do comics together. We'd trade copies of *Sandman* and Humberto Ramos's *Crimson* and talk about comics a lot. He still draws, and he did a short story in the back of the OddGod Press *Love Eats Brains* book. He's really fantastic. He's one of those people who has a complete visual catalog in his mind, like an encyclopedia. He can draw any animal or object on the spot and it works. If I have to draw a hedgehog or something I usually need reference, but if Will's around, I'll just ask him.

What was the first comic you remember reading? How

did it affect you?

I don't have a distinct first comic memory. My Dad had copies of *The Spirit* lying around. The large Kitchen Sink Press magazines. And he had a stack of underground comics in a box in a storage space that I'd sneak in and look at. I was also really into the Teenage Mutant Ninja Turtles and I did a comic called *Teenage Mutant Ninja Skeletons* that ran for a few issues.

Your tastes, then and now, seem to be pretty broad. Did you read a lot of superhero comics? What about stuff like *Mad*?

My Dad had those small-format *Mad* collections. The one with Alfred E. Neuman as Tarzan on the cover. I remember taking them to school and reading them under the desk. I read the Image-wave people at Marvel and then followed them to Image.

What did you think when you first read those underground comics?

I saw those underground comics too early. I don't remember the exact age, but definitely in elementary school. I didn't get it. They grossed me out. But I kept looking at them. "Is this porn?" I thought. But it wasn't sexually exciting. It was just weird. I liked the fantasy-style books a lot, like *Fever Dreams*.

Why were you in Japan for six months during high school? What impact did that experience have on your development as an artist?

I was there for my junior year. I was in a small town south of Nagoya called Tatsumigaoka helping students and my host-brother learn English. I didn't make any Japanese friends. It was an extremely traditional Japanese

family that I stayed with. Of course, I gorged myself on manga and anime, but I was already totally obsessed with that stuff. But Japanese culture/art is very different than Japan itself, at least the limited experience I had. It's a very different culture that's very group-focused, and, obviously, I being American meant that I could never be a part of that group. It's different in the larger cities. I was probably the only foreigner in Tatsumigaoka. I'd get on the train and everyone would stare at me.

What kind of comics did you do in high school?

In early high school, my comics were extremely manga-influenced. I'd go to Otakon and the few early, start-up anime conventions all of the time. That's where I first met Becky Cloonan, I think. This was just as anime/manga was starting to blow up. I did a comic called *Demon Carnival* and would submit short stories to *Heavy Metal* (a form rejection letter) and *Radio Comix* (a nice, personally written rejection letter).

What sort of things did you draw for the local papers? How encouraging was it to see some early success at a young age?

I got the gig for the *Richmond Times Dispatch* somewhere around the end of sophomore year, I think. I'm not sure [of] the exact time. It was for a teenage supplement called *In Sync* (this was before the band). I got to go [to] the offices and meet Kerry Talbott, one of their staff illustrators who was into comics, work with a couple of editors and writers, learn Photoshop, see the work published and get paid! It was a crash course in illustration and by the end of it I had a professional, big portfolio for SVA, but it also made me realize I wanted to do my own comics instead of illustrating other people's articles. I'm glad I had that experience early on, rather than getting it after college and wasting my post-graduation years in the illustration world.

Near the end of high school, around the same time I was doing the *In Sync* illustrations, I'd started doing mini-comics. They were each drawn a different way, something I'd also try to do for the *In Sync* articles. I'd do one mini from a girl character's perspective drawn one way and another one of the same story from the boy character's perspective drawn a different way. I also did a short horror comic and a bunch of random minis. My senior year was spent working on a 32-page comic called *Shippori* that was more of an experimental thing. It had a lot of different drawings and weird diagrams and was pretty text-heavy. I submitted it for a Xeric Grant and it was rejected. Thank God.

I've read *Shippori*, plus those perspective minis. You're obviously ambivalent at best about your earlier work; what is it about it that makes you cringe? Is it perceived mistakes in writing or art, or was the entire conceptual approach something that turns you off now?

Everyone doesn't like their early work. It's just a gut reaction, feeling sick. I can't look at them or think about them.

You've noted in interviews that one reason why you've been so prolific is that you've arranged your life around drawing (which is why you finished *Bottomless Belly Button* so quickly). Do you still draw at the same pace? Do you ever feel burned out on drawing?

I always admired prolific artists. I'd pick up *THB* when I was 11 years old and read about his work ethic. Paul Pope wasn't shy about it. And I'd think, "I want to be like that." And so I started doing it early on and I'd try to keep upping the ante. This month, August 2008, I did 49 *BodyWorld* pages, start-to-finish full color, plus illustrations for IFC Films, Health Central Network and *The Fader Magazine* and a bunch of animation frames. When I'm not drawing I don't know what to do with myself. I just stare at the ceiling. I don't have any other hobbies and I'm enjoying everything that I'm doing immensely. The IFC and *Fader* illustrations were both "do whatever you want" assignments, and I write *BodyWorld* myself, so I control what I draw and I don't draw anything I don't want to draw. That's important. It's understandable why illustrators get burned out or unhappy, because they're not in control of what they're drawing. People, like me, who do everything don't have any excuse.

What is it about being prolific that's so appealing to you? Having a body of work to show the world? Constantly being in motion and advancing as an artist?

I was in a *Stuck in the Middle* anthology and there was a signing for it at the New York Comic-Con. Since it was published by Viking, they promoted it by just giving away a ton of copies to kids. When I sign/doodle books, I don't like to draw the same head over and over. Some people do that, and it feels cheap to me. I like to do something different in each one, even if it's crappy. So I had to do like a hundred or so little drawings. It blows you out. You have to just go deeper and deeper and follow every thought or direction you have. I like doing that. I want to see all the different directions I can go and where they take me.

It seems like, through your own ambition, luck and trial-and-error, you've put yourself in a position where you've had complete control over your time and projects. Do you feel like your life was leading up to this moment through the choices you've made, or do you feel like you've had some luck to be in your position?

It's a combination of luck and working my ass off. I just did a lot of work at exactly the right time. Ten years ago the climate was different. Now Fantagraphics is taking submissions and the mainstream/non-comic industry press is interested in doing comic-related articles.

Despite that fervent work ethic, you've also dabbled in music and film. How does working in these other arts inform and influence your viewpoint as a cartoonist?

The music thing was just something social I'd do with my friend James. I was looking for a reason to get away from the drawing board, but I ended up not liking it. I'm definitely not going to do that again. I'm a terrible musician and performing live in front of people is a nightmare. Also the short film I acted in, *At The River*, was something where my friend Todd Raviotta needed someone to act. Someone who had free time and would show up and do whatever he said. Again, that was something I did for a

friend. I didn't have any creative input in the short, and I'm definitely not an actor. I just have creative friends who I like to help with their random projects.

Does the physical act of drawing still give you pleasure or satisfaction, or does that only come when you see a finished project?

Drawing has always been enjoyable for me. The only thing that's become less enjoyable is computer work. I have to do a lot of computer work on *BodyWorld* — compiling the different layers, huge scanning, etc. When I started, it was a blast. I felt like George Lucas. Everything was like a special effect. I'd think, "Oh, I'll draw the shower curtains for this scene on separate sheets and then I can change the opacity and it'll be like a semi-transparent curtain! It'll be fucking amazing!" But 200 pages later I'm thinking, "Why did I decide to do the curtain that way? Shit!" I hate spending all day sitting in front of the computer compiling things. It feels like work. But after I finish *BodyWorld* I'm going to take a year break from computer work.

Does reading other people's comics still give you pleasure?

It's been hard since *Bottomless* came out, because I've been working on my own stuff so much. But I have a "to read" stack of comics piling up.

Regarding side projects: If *Bottomless Belly Button* or *BodyWorld* get optioned for Hollywood (as the rumors have been saying), how much of a hand would you want on such a project? Would you want to write a screenplay, direct, etc?

What I've been telling people is this: I don't want to do anything myself involving *Bottomless* unless it's animated. I don't understand how it could make a good movie. Everything that's unique about the book is because of the comic/cartooning properties. It's not a unique story. It'd just be like every other indy family movie. But if it's animated, it's possible that it could be good. *BodyWorld*, I would be open to co-writing or writing, because it has unique story elements. Things like *Dieball* and the telepathy would be entertaining on screen. I wouldn't want to direct either of them. If I was to direct a movie, it'd be animated and I'd want to hand-draw each frame. It'd have to be a different story, something developed that would take advantage of the animation medium. I've been doing more animation recently. Animation makes sense to me. It's a series of drawings, like comics. I don't have any training in animation and so it's an exciting

From *Gardenhead*. [©2002 Dash Shaw]

discovery process.

I've had random meetings about it, and I think that there are some offers on the table. I have an agent now who deals with that. I don't actively try to make a movie happen. I just have an agent who takes the calls and stuff like that. Go get a free lunch with someone in the city.

The influences you've listed on your comics is staggeringly varied, with film being as important as any cartoonist. How does the work of non-cartoonists influence you, especially filmmakers?

Freshman year at SVA, I made a filmmaker friend named Andrew Lucido and he introduced me to a lot of great filmmakers. Tarkovsky, Kiarostami, Bruce Conner, Michael Snow, Bella Tarr, etc. and I worked at the SVA film library for three of my four school years, so I got a strong education there too, and started going to the Anthology Film Archives and stuff like that. I'm interested in beautiful sequences, different people's ideas of what a beautiful sequence is.

Andrei Tarkovsky: Hate the dialogue. Best to just not read the subtitles, or turn them off, if you ask me. But I love the elemental things in his movies. Water! Smoke! Fire! Just these flowing, beautiful things of nature. *BodyWorld* and *Bottomless* and all of my comics have these things. They're already abstract, right? Water is just wavy lines. Sand is just dots. It can be drawn a million different ways. Also the "flowing" style of the sequences, like water. Someone asked Tarkovsky why there's so much water in his movies and he said, "Because water is the most beautiful thing in the world." I like that answer. *The Mirror* is his best. And I like that he did science-fiction genre stories.

Abbas Kiarostami: Tied with Chris Ware as greatest living artist. Kiaostami's camera is like a sketchbook. He captures sequences of reality that are so beautiful, and it appears so effortless. It's as if his camera "just happened" to be there, and it "just happened" to be this beautiful unfolding of a sequence. Like Henri Cartier Bresson, only instead of catching a moment of dynamic symmetry, Kiarostami catches moments of sequential beauty. Like Chris Ware, he's obsessed with the beauty of the world. A real humanist too.

What aspects of Chris Ware's work have been the biggest influence for you? Do you have a particular comic of his that's your favorite?

His latest, *Acme* #18, is his best. He's getting better and

better. Like I said before, his work is about the beauty of the natural world. When I read his comics, I feel like I'm traveling to another place, especially in his post-*Corrigan* work. His post-*Corrigan* works have more characters and more humor. They're small, beautiful universes of characters.

Who is the most significant current influence on you as a cartoonist? What were some of the biggest comics influences on you at other stages of your career?

After doing the *Cold Heat Special* with Frank Santoro and talking to him, I've been interested more in painters or other single-image makers. Also I just moved up to New York City, right after doing that *Cold Heat Special*, and there are so many more opportunities to go to galleries here, obviously. I like the mystery of a single image. I wanted a recent *Mome* story of mine, "Train," to be like that — to try to do a multi-image story that has a single-image feeling. I did that in February, the first thing I did in New York. The electricity wasn't on yet in the apartment so I could only work on it during the day.

Middle school and early high school was hardcore Masamune Shirow. Also Miyazaki. I found out about Moebius from an interview with Miyazaki about *Nausicäa* when it was called *Wind Warriors* or something.

Late high school and early college was mostly the brushy, more artsy cartoonists. Like Bill Sienkiewicz, Paul Pope and a couple of the MeatHaus guys (like Farel [Dalrymple] and Tomer [Hanuka], who I was just meeting). That's during the *Love Eats Brains* series and the *Gardenhead* comic.

And then sophomore year I swung the other way to a more clear line. People like (*MeatHaus* cartoonist) Tom Herpich, Chester Brown, Hergé. Also Keith Mayerson's book *Horror Hospital Unplugged* and Gary Panter hit me hard. Mayerson and Panter are all over the *Love Eats Brains!* OddGod Press book and some of the short stories reprinted in *Goddess Head*. And then it started to get more jumbled together. I run through influences pretty fast. Soak them up.

Could you expand on that *Mome* story a bit? It seemed like in that story you had discrete sequences and several oppositional concepts, but it all boiled down to a series of powerful moments, with the destruction of the train being deliberately misleading in its nature but no less powerful an initial image.

In the "facing pages" style of comics I did ("Goddess Head" and *The Mother's Mouth*), it was about putting two different drawings next to each other and that would

Opposite: From "Train" in *Mome* Fall 2008 Vol. 12. [©2008 Dash Shaw]

This spread: This sequence appears in "Goddess Head," the short comic. [©2005 Dash Shaw]

create a new, exciting third space. In *Train*, I did the same thing, only with whole scenes instead of two drawings. The opening and the closing create a third space, a mysterious zone. And the running sequence bridges the two together.

There are, to me, two things going on in *Train*: The first thing is this feeling that's captured by the sequences. I can't tell you why I like it, but I do. It's a pleasing, emotional sequence of events. And the second thing about that story is the main character, the woman. I tried to draw her in a conventionally attractive way. And she's a therapist, so (I imagine) she's smart and caring. I think that everyone wants something from her. The man tries to get her to stay at the house. She's jogging and everyone's looking at her. When the train crashes, I imagine that she thinks all of these people are going to claw at her, and try to get her to help them. But in the last panel they move on.

You've listed Jules Feiffer as an influence. In what ways?

I'm influenced by his drawings and his relationship-focused stories. I'm not interested in his political work. He does stories about relationships that don't take a "side" of a character. They're more about the humor or absurdity of the situation. They're sort of like comic versions of Laing's *Knots*. That's influenced my stories a lot. Also, many

of them have an extremely mean-spirited, dark sense of humor (like *Carnal Knowledge* and *Sick, Sick, Sick*). His drawings are beautiful. Expression and movement. In Gary Panter's class at SVA, Gary pointed to a frame of *The Mother's Mouth* where older Dick is kneeling next to Virginia in the woods, and Gary said, "That looks like a Jules Feiffer drawing." I also like the pace and story of *Tantrum*. Very quick reading and conceptually tight. That book's underrated.

What was SVA like as a learning environment? Do you feel like it made you a better cartoonist? Did you feel a sense of community there?

Mostly, I was there for the figure drawing. I was a hard-core James McMullan student. He's a famous illustrator who sort of developed a cult at the school. A couple of the MeatHaus guys told me to take his class, so I read his book *High Focus Drawing* before sophomore year and took both of the classes he taught from sophomore to senior year. And then I took other figure-drawing classes — one by a former student of McMullan's — every year and went to all of the "open" figure-drawing sessions at the George Washington dorms, where I lived. When I got out of school I worked as a figure-drawing model at VCU (in Richmond) for a year and a half while working on *Bottomless*. All because of McMullan and his teachings. He's had a similar effect on other students.

Can you briefly describe exactly what his teachings were, and why they drew such a following?

You should just read *High Focus Drawing* by James Mc-Mullan. It's sort of a spiritual approach to figure drawing. It's about capturing the life of a person, rather than just copying what you see. It turns figure drawing into a full-sensory, heightened experience.

As for a community, it's hard for me to say. I made a couple of close friends there, like Andrew. But I never became very close to the other cartooning students in my class. I'm not sure why. I was distracted and alternating between illustration and cartooning classes all of the time.

Why did you wind up transferring from cartooning to illustration?

That's a good question. It seemed like a good decision at the time. I wanted to take more painting and drawing classes, and I had a strong illustration portfolio from *In Sync*, so I thought it would be good for me. It was a mistake. I should have just been in cartooning the whole time. I also took some fine-art-history classes and a bunch of psychology classes, thinking I could go back and get an MFA in Art Therapy. You need a certain amount of psychology credits to apply for that.

Was this inspired by the career of your mother? Have you done any kind of work with kids like this?

I've always been interested in therapy, probably because of my mom. The only kids-related work I did was I taught a summer course to middle-school-aged kids. I taught cartooning, drawing and animation. It was at an all-girls middle school. Boys were allowed to take summer classes there, but it was mostly girls. Middle-school girls are a nightmare. I'm glad I was never a middle-school-aged girl. They're so mean to each other and some of them look like they're 10 and others look like they're 20, but they're emotionally in the same place. It was a weird environment to be a part of briefly. And some of the people who work at all-girl schools are weird too.

What was Gary Panter like as a mentor?

Gary's a very casual, open speaker. He tells stories about his career and love life, brings in weird manga and art books to show students. I don't recall him being very critical. I learned more from him by looking at his work and reading interviews with him.

What other professors were especially inspiring?

I took David Mazzucchelli sophomore year, auditing his junior-year class. Sophomore year, I was an asshole. I was frustrated with my output and general situation and consequently was acting inappropriately all of the time. I apologized to Mazzucchelli later, but he said I wasn't a prick. But I remember asking him once why he didn't point out crappy lettering on one of my comics, and he said, "Because you wouldn't have listened." So Mazzucchelli was just being nice when he said I wasn't a prick, or didn't remember.

In what ways were you acting inappropriately? Were you unresponsive or hostile during class?

I wasn't really mean or anything. I was just thick-headed. It was around that time that I was arrested in New Jersey for "criminal mischief." I was driving around smashing things. But that was happening outside of class. I wasn't violent in his class.

Some of your earlier works seemed to be heavily influenced by philosophy and linguistics. What influence did Kierkegaard and Wittgenstein in particular have on your aesthetic?

I think I was just reading a lot, and putting whatever I was reading into my comics. It felt like a natural thing to do, because I was extremely interested in philosophy and linguistics, and taking a lot of different classes. The influence was pretty blunt. Unfortunately, those comics were printed, albeit on a small scale. Fortunately, the period worked itself over quickly enough.

What influence does/did the MeatHaus group have on you, both aesthetically and as a group of like-minded artists to have as a community?

I get put in with the MeatHaus group because I was in a few of the later books, plus *Gardenhead*, and I am friends with some of them, but they were all graduating as I was entering SVA. They then soon spread out, many leaving New York. I really only hung out with the majority of them my freshman year. They were like-minded artists, to each other, and I was apart, learning from them and trying to make friends, because I'd just graduated high school in Virginia and moved to New York, where I didn't know anyone. I'd walk around the city with Brandon Graham. This was when he was doing the porno comics for NBM. That guy's a living comics education and the most underrated cartoonist today. He really rubs off on people. He's had a similar effect on a few other cartoonists I know. I idolize him. Same with Tom Herpich, who I've seen more often since then and still hang out with now sometimes.

How much do you enjoy collaborating with others in your various artistic pursuits? What do you think is your most successful/satisfying collaboration to date?

I normally don't like collaborating. I do it rarely. I've just got a lot I want to do on my own.

It worked out for the *Cold Heat Special* with Frank Santoro. I'm a huge fan of his work and he asked me to do #3, so I had to do it. He did the layouts for the first half, and I matched his layouts in the second half and did all of the finishes. All of his layouts were drawn over some weird grid pattern thing. What is this? He started telling me

From *Gardenhead*. [©2002 Dash Shaw]

about dynamic symmetry and recommended all of these books. I quickly got the books and read them and now I'm like a weird convert. I draw different design shapes in my sketchbook and e-mail my filmmaker friends links to dynamic-symmetry-related articles or images.

He's a real genius and inspiration. I hope we can do another comic together. That *Cold Heat Special* #3 is hard to find. I don't think there were many copies made. I don't even have a copy of it. But it's my best mini, mostly because of Frank.

What would you say are the themes that you are currently most interested in exploring?

Bottomless and *BodyWorld* are both very character-driven. About relationships between characters. As I'm nearing completion on *BodyWorld* and doing some other things, I'm starting to move into less character-driven territory again.

The formal qualities of language seem important to you — both in the physical qualities of the letters and sounds themselves, as well as the way it fails as a means of understanding. What inspired you to pursue formal and linguistic experiments with comics? How satisfied are you with these experiments? Do you feel the language of comics is any more successful as a means of understanding than standard language?

I'm not a good writer of words. I would never write an all-text book. I don't have a large vocabulary. I find talking to people and the brief writing I do, like in e-mails or this interview, frustrating. Comics are about graphic sequences, presenting information in a graphic way. If

words are used, it's about how the words relate to the drawings or the sequence. If characters are talking in *Bottomless*, the scenes are never about just what they're saying. It's often the opposite of what they're saying.

I understand why "experimental" is a word used a lot with my comics. I'm shooting for a gray area, a mysterious zone. I'm not interested in direct communication, saying something to someone. I like emotional areas, which are harder to talk about. I couldn't tell you why I think something is beautiful or works in a comic. It wouldn't lend itself to words, at least spoken by me. Other people, authors, could probably do it. So I'm not saying that the language of comics is more successful, just that it's more successful and natural for me personally.

Your comics are almost always concerned with physical, visceral experiences: breathing, sweating, scars, deformities, etc. Is this concern for material/phenomenological experience a direct balancing response to the more abstract concerns of your art?

I wouldn't say that. I often have physical responses to abstract things. Maybe I'm more sensitive to formal properties of things than other people. I don't think of abstractions as more brainy or non-physical. Partly because of my many years of figure drawing, I think that the body is beautiful and important. When I'm reading a book or looking at a painting or watching a movie, I want to feel something in my body. Obviously, the body is beautiful (everyone can tell you that), but it also has an ugliness. Shits and farts. It's a package deal. That dichotomy is important to me. I think ugliness is necessary for a comic to be beautiful. Maybe the character designs are ugly, or the drawings have ugliness, or the story has people doing ugly things. There should be a war between ugliness and beauty on the page.

Many standard comics narratives have an immersive quality to them, allowing the reader to be swept along with the story. Your comics seem to be deliberately anti-immersive, reminding the reader that they're reading a comic, jarring the reader with different perspectives/points of view, and employing unusual symbology. Is this a deliberate strategy on your part?

I understand what you're saying. The way most narrative things work is that there's a main character, usually a man, who the reader is supposed to like or relate to. Then the main character goes through experiences that the reader, in turn, experiences. Like a vessel. None of my comics follow this. It's more like you're standing away, looking down on a diagram of relationships or things

interacting with each other. So the only thing you're reacting to is the comic itself, not what a character is reacting to. But I hope that they are immersive. Just in a different way.

Is there a reason why you've chosen this tactic (deliberately not wanting the reader to experience things as the character), or has it just naturally flowed out of how you see the comics page?

Wholly sympathetic characters aren't interesting to me. They're boring. When I'm drawing, I want to be surrounded by different people, characters and spend time with them, like a friend. I have a friend who's had an off-and-on again relationship with a girl over years and years and all he does is complain about her to me. I wish I could just force him to break up with her. What is he doing? It's frustrating. But I can't force him to. He's a different person than me. That's what my characters [are] like. I have to let them make their own mistakes. I'm sure other people let me make my own mistakes, too. *Bottomless* has a lot of scenes where characters try to give advice to other characters, but their advice doesn't make any sense, or it doesn't apply to the situation. You try to

From *Love Eats Brains*. [©2004 Dash Shaw]

move inside other people, but you can't. Unless you have telepathic abilities, which is why I did *BodyWorld*.

Identity seems to be another big theme of yours. From the very beginning, sexual and cultural identities in particular have seemed to have been particular interests. Why is gender identity such an interest of yours?

It's difficult for me to say. I don't have any concrete thoughts on gender identity. I think those come from my experiences in life and they seep into the comics. I've had readers meet me and say that they thought I was a woman from reading my comics. I guess I don't think that there's a strict separation between man and woman or gay and straight. The line is fuzzy to me. I've had strong relationships with both men and women. People use society's thoughts on gender identity for personal reasons. It's on a person-by-person or character-by-character basis.

What exactly do you mean by that last statement?

What I mean is that people are different from each other. I'm not comfortable making a blanket statement about any group of people. And these individual people

will use other people's blanket statements/thoughts for their individual reasons.

Why are you fascinated by the concept of celebrity and celebrities in your comics?

Movies are impossible to ignore. It's the most popular art form, and the vast majority of them are so absurd or awful.

One other big theme in your comics is the relationship of the individual to society. Do you think the individual and society are both mutually sustaining illusions? How important do you think it is for a person to seek out relationships?

I read something in a self-help book that stuck with me: "Interdependency is a choice that only independent people can make." I think that's true. There are very few truly independent people, so most of the time people are just trying to use other people for selfish reasons. I picture people crawling all over each other, scrambling around.

What is it about reading self-help book that appeals

From "Look Forward, First Son of Terra Two" in *Mome Winter/Spring 2008* Vol. 10. [©2008 Dash Shaw]

to you?

There are a lot of different kinds of self-help books. In a way, it's like the comics community. All of the gurus go to each other's talks and reference each other in their books. It's a small world.

I like the time-management books. I've probably read a dozen of them. I try to read them all, but if one looks like it's just rehashing another one I've read, I put it down. As I said earlier, I like to work a lot on comics and my projects, so time management is important to me. Most people's time-management skills are mind-boggling. I don't talk about it to them, because I'd come off as preachy and irritating. After you get into time management seriously, it's incredible what a difference it makes. Everyone else looks like they're lazing around, blowing through their day without doing anything at all.

I also like the general self-improvement or effectiveness books and audiocassettes. I took Tony Robbin's *Personal Power* course first, sophomore year of college. It sounds silly, but they actually are motivational. These books get a bad rep, mostly because people think of them as money-grubbing. But, as Tony Robbins' says early in the course, he uses money as an example, because you can tell someone, "I was depressed a month ago and now I'm happy," and they don't care, but if you say, "I was broke a month ago and now I'm a millionaire," you have their attention. Obviously, I'm not a millionaire. I'm more interested in the motivational speaking, talking about personal happiness and goals. And many of these self-help courses and books have helped me a lot. Laugh all you want.

What in particular about their message spoke to you, in other words, how did they help you reach your personal happiness and goals (other than the time-management courses)? Was it a set of useful tools that you took to heart, a way of changing one's attitude, etc? I'm genuinely curious, especially because it's obviously worked well for you.

If you're curious, you should just start reading them. It's a lot of different information. One example would be Tony Robbins talking about how emotions are physical. It's difficult to be sad if you're standing straight, smiling. It's easy to be sad if you're curled up, frowning. He said emotions are "70 percent physical." Things like that have influenced my behavior and how I think about the body, and I put this body-mind approach into *Bottomless* and *BodyWorld*. But that's just one, small example. You should really start reading them, if you're interested.

Your work transcends and embraces a number of dif-

This sequence is from *Bottomless Belly Button*. [©2008 Dash Shaw]

ferent genres, though it's impossible to pigeonhole your comics in any particular way. Is this a deliberate strategy on your part?

Either everything is a genre or nothing is a genre. A lot of so-called serious literature and stories follow predictable patterns and storytelling tropes. I don't think about a separation between high art and pop art. High art sometimes is as predictable as pop art. It's just different rules for different things. It's best to just clear your mind and do whatever you feel like doing. *BodyWorld* has some science-fiction elements. It felt necessary for what I wanted to do. But it's hardly a classic science-fiction story. I wanted *Bottomless* to follow a family story, like family fiction or television shows, as genre rules.

What did you perceive as the "rules" for family fiction, and how did you either follow them or subvert them in *BBB*?

Family stories are about spending time with a group of characters and observing their relationships. It's an ideal structure for character-driven stories, because there's immediately an excuse, or reason, for all of these different people to be forced to deal with each other. And then there are family-story tropes: the middle child, the outsider, the oldest son, the distant/dumb father, the smart mother, etc.. But *BBB* is as much about autobio as a genre.

I wanted it to be as if all of these characters are starring in their own autobio comic and the autobio comics are overlapping to create a larger tapestry. In part one,

Vehicle Diagram

This diagram is also from *Bottomless Belly Button*. [©2008 Dash Shaw]

there's a scene where Peter masturbates and grabs a random cloth, what his mom is knitting, to clean his cum. I see that as shock-confessional autobio. That's my reaction to a scene like that. But then, something like 100 pages later, his Mom talks about seeing her sweater thrown outside and taking that as a clue that she shouldn't work on the sweater to distract her thoughts. She uses that to give advice to Peter about the girl he just met. Obviously, Peter can't tell her the real reason the sweater was outside. So I took an autobio trope and extended it into a larger universe of characters. The book is filled with things like that, about perception. Claire wakes up from a dream about a dripping coat to see the floor wet from Jill who just took a shower. She doesn't realize that's where the water is actually from and freaks out. Characters go to see a movie and instead undergo a series of events that, we later find out, are the same series of events that were in the movie they were going to see.

What fascinates you most about "pop," be it pop music, pop comics, pop culture in general?

There's something to be said for a well-executed pop piece. Something that's smooth and goes down easy. It's hard to do. *Titanic* did it. *Titanic* is one of the greatest movies ever made. The rare time a billion people were right. Like Gary Panter says, the hippies took over. A lot of "mainstream" media is actually "alternative." I had a meeting with Kevin McCormick, the producer at Warner Brothers who does *The Dark Knight*, *Watchmen* and all these huge movies. His first gig was producing Jodorowsky's *El Topo*. He thinks of the Warner Brothers movies

as big-budget alternative cinema. George Lucas did *THX*. He's still an independent filmmaker. Pop music is different, too. Christina Aguilera and Beyoncé do weird songs. My upcoming Duke gallery show is curated by Diego Cortez, who "discovered" Basquiat and Keith Haring. He said that it used to be that graffiti art wasn't fine art. It was some strange, new thing. Now it's totally accepted, and you go into a modern-day gallery and it's all over the place.

Your earliest comics are talkier than much of your subsequent work, and more densely philosophical. Did you abandon this style deliberately?

I talked about this a little before. I'm interested in philosophy, but I think it should inform your decision-making, rather than sitting on the surface. I soaked that stuff in, and it's over. I don't even read "smart" books any more, really.

***Gardenhead* was extremely ambitious, folding in a number of different themes: symbology, the conflict between mind and body, the conflict between emotion and rationality, the struggle of children versus society and authority, the possibility of connection, and artistic self-expression versus orthodoxy. What lessons did you learn from attempting such an ambitious comic? What would you have done differently?**

I would have done everything differently. It was necessary for me to do *Gardenhead*. I had ideas about how I'd like to do comics, comics with ideas and sequences and different things going on.

What inspired you to use so much collage and mixed media?

I still think of my comics as having these things. Even in *Bottomless*, which has visual restraint, or rules, there's actually a lot of range inside of those rules. There are a lot of different kinds of drawings interacting. Comics are about juxtapositions, drawings and words next to other drawings and words. The comics I've always liked have used this, artists like Keith Mayerson and Gary Panter. Even when I was in middle school, I liked how manga would alternate between different representations of a character, the "super deformed" style, or have a dense, realistic panel among cartoony panels. And then in high school, I liked how Sam Kieth would interject paintings and different drawings, and David Mack and Bill Sienkiewicz. It's just something I've always been interested in.

When you say *Gardenhead* was "necessary," do you mean that, in retrospect, this was the kind of project

you had to do to develop as an artist?

Yes. Every book is a stepping stone to another book.

Schematic drawings and diagrams have constantly popped up through your work. Do you employ them as a way of grounding your characters in a sense of physical time and place?

Throughout middle school and early high school, I was a Dungeon Master, the person who would write quests for *Dungeons and Dragons* games. I spent the majority of my time working on these quests, which involved a lot of schematic drawings and diagrams of different places. Shortly after I got a girlfriend and quit D&D, a friend's older sister lent me a copy of a Chris Ware book, and it made total sense to me. Something just clicked. I don't recall Ware ever using maps as much as I do now. I use it mostly to create an environment, a world, where the characters, like PCs, wander around in. But his drawings had a schematic quality interested in clear, effective communication. Like Edward Tufte's books (*The Visual Display of Quantitative Information*, *Visual Explanations*) illustrate, truthful communication of data is beautiful.

You often write about the struggles of children and teens, attempting to find their place in the world. Why has this struggle become a running theme for you?

Children and teens are important to art. A good piece of art should have this perspective. When you're a child everything is new. I remember just staring at glue in a jar, or dust illuminated from a window. It's a constant struggle to keep your mind in that place. It's the goal of my comics, I think, to feel as though I am in the sandbox playing. Lots of creative people have felt similarly.

You've had librarians as characters in several stories. What about this profession has made this a running device? Do they represent something particular to you or act as a sort of shorthand to a certain kind of point of view?

That comes from me being a book lover. Most cartoonists I've met are. I love sitting in libraries, looking at covers or reading parts of books. I guess librarians are romantic figures to me. I've never met a mean one.

Your earliest comics were very character-oriented, especially the *Love Eats Brains* series. You seemed to

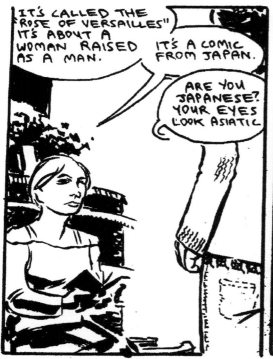

From *Gardenhead*. [©2002 Dash Shaw]

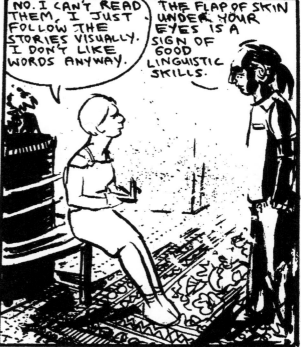

drift away from this in your early long-form works, but have returned to it in earnest with your last two books. What's your current take on how you balance plot, character and symbology?

I don't think of them as separate elements that need to be balanced. It's just that recently I've been interested in more character-driven stories. But I think doing completely not character-driven work is fine, too. I don't think that you have to do everything to "serve a story." That's something people say a lot, like "well, he did this weird thing to serve the story." Or: "It's got this weird stuff, but — don't worry — it's all in support of strong characters!" But I don't think everything has to serve a story. I do comics because I like sequences. Sometimes those sequences are character-driven and sometimes they aren't. Balance (of plot, character, symbology) isn't important to me.

This was your first fully realized long-form work. How frustrating was it to have to scrap your original ideas

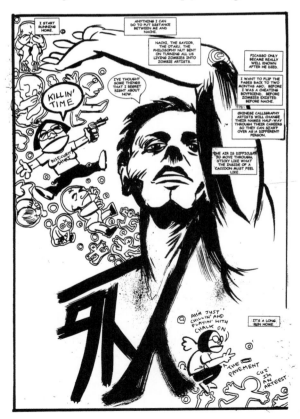

From *Love Eats Brains* Chapters 2 & 3. [©2002 Dash Shaw]

after the original art was stolen? Do you ever wish you could have revisited those characters and ideas?

It's best that I was forced to abandon it. It's just as much my fault. The reason I lent someone the drawings was because I was having trouble with finishing it. His not returning it was probably a blessing in disguise.

The *LEB* long-form comic is much more abstract than the short-form series and seems entirely consumed by the tension of opposites. Looking back, how successful do you think you were in getting these ideas across?

I don't think I was trying to get across any ideas. I was interested in juxtapositions, like I am now. But those comics are terrible, man. I haven't looked at it in years.

You've mentioned that you were unhappy with the ending. What about it was dissatisfying?

I'm unhappy with the whole thing. But I had to do those comics. I like some of the drawings, some of the sequences and ideas. And it's clear how they developed over the course of different comics, but it's a record of a period of growth. "Goddess Head" is like that, too. "Echo and Narcissus" I'm still happy with, and the shorter version of *The Mother's Mouth* for the Spanish edition. But a lot of those things are false starts, ideas of different directions or sequences, etc.

Some of these stories were the densest of your career in terms of their symbology. Do you consider this to be the culmination of a certain period of your career? What led you to later make your narratives more straightforward and less abstract?

That collection covers a few years, and only the square-sized stories during that time. I had other stories, some more narrative, that I didn't put in because everything had to be square format. The square format started with the *MeatHaus 7* issue, that I did a three-page story for. And then I'd do short stories for the SVA magazine *Visual Opinion*, which happened to be square-sized, as well.

The short story "Goddess Head" was a real milestone for me in my thinking. It was the first time I realized I could do comics for myself, like play therapy. That it could feel like free expression. Maybe the story isn't good, but it doesn't matter. It was a significant step forward. I remember working on it vividly. It was sophomore year at SVA, and I was frustrated with things, the comics I was making. I had these ideas of how I wanted my comics to be, but nothing was working. I just decided to abandon everything I was doing (the *Love Eats Brain* pamphlet series and these more illustrative drawings) and just start

over. I wanted to remove myself from the "professional illustration" type field of working, the idea that comics were stories that were then "illustrated." I wanted to do comics where the comic was the comic, rather than an illustrated story, for everything to be presented in graphic sequences. It's hard to explain the difference.

Who did you perceive as your audience before you felt like you had the freedom to make comics for yourself? Do you find creating comics now to be a form of work or a form of play?

Comics have always been a form of play, but "Goddess Head" allowed it to be a form of play therapy. Before "Goddess Head," I was more interested in producing something that I wanted to read. But now I'm interested in producing something I want to produce. The process, the struggle, is what I want to be focused on.

Even though the comics I did before the "Goddess Head" short story were all drawn by me solo, it was as if I had divided my mind into a writer-penciler-inker team. I would write a story and then pass the story over to my "penciler" self, rather than the story, sequences, everything, coming from a single "cartoonist" self. That's a huge step. Most comics I see, you can tell that the cartoonist was divided. Even if the "Goddess Head" short story sucks, it was eye-opening and life-changing. That sounds cheesy, but it's true.

In *Always Seek The Truth*, how did the game Clue inspire you to think about the relationships between the characters in the game, as well as the relationship between the characters and "you," the players/detective?

I like board games a lot. I like board-game art. There's a website called *Board Game Geek* that I go onto all of the time, just to look at pieces and drawings. I used to play and design board games fervently when I was little, and still do now. Comics are similar to board games in that they're a world of characters and they're very hand-done, humble-feeling, unpretentious. There's a dorky, hand-crafted element to them.

***Heart-Shaped Holding Cell* is as much about a sense of place as it is about character. How important is creating a sense of place to you now as a storyteller?**

When I'm reading a book or watching a play or looking at a painting, I'm transported to a place. Comics are worlds when you read them and even more so when you're drawing them. When I'm at a drawing table, it's like a vacation into my imagination. That's why all of my longer comics begin with someone traveling; the plane

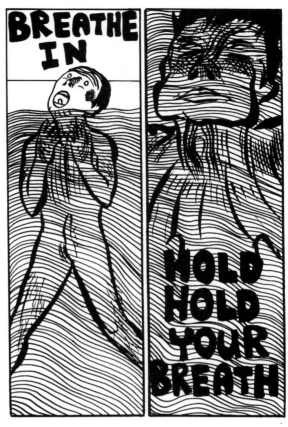

This sequence also appears in "Goddess Head," the short comic.

in *Bottomless*, the truck in *Mouth*, the monorail in *Body-World*. The place is the story itself.

"Operation: Smile" is about family dynamics as much as anything, with the father being portrayed as a sort of distant, imperious king. This is a motif repeated in *Love Eats Brains* and *Bottomless Belly Button*, to a certain degree. What is it about this image of fatherhood that compels you to depict it in your stories?

"Operation: Smile" is the name of an expedition my dad went on in South America. He wrote packages for the Operation: Smile Foundation, which would go to poor areas and perform operations healing children with cleft lip. My dad's job was to sit and cheer up the children who were waiting for their operations. When he came back, he showed me all of these before-and-after photos of the kids and the waiting room and everything there. Those photos had a strong impression on me for some reason. Most of the kids in the photos were around my

From "Always Seek the Truth, Devote Your Life to the Truth," collected in *Goddess Head.* [©2005 Dash Shaw]

age. It's an early memory cemented into my brain.

Also, the process of making comics has a connection to my dad, because he used to work on them with me. Before I could read and write, he'd tell me the story and write in the words, while I did the illustrations.

Perhaps your best-realized story in the collection was "Echo and Narcissus." Did you see it as sort of a capper to your stories about the difficulty of true communication and the way that narcissism leads to solipsism?

I'm proud of that story. That's actually a very faithful adaptation of the Ovid version. I just tried to "illustrate" the story in a comic form, using graphic sequences rather than narration. So I tried drawing whatever the story dictated in a lot of different ways. I'd choose whatever I felt made the best sequence. It's also the best story that used my facing-pages style, a period that started with the "Goddess Head" short story, into *The Mother's Mouth* and culminated in "Echo and Narcissus." Rather than have a sequence that would be "read" across, like a Chris Ware comic or rhythmical sequences of action, *Mouth* and "Echo" used flat deliberately non-rhythmical, juxtaposed drawings, usually across page spreads. So the opening of "Echo" is a title page: Echo on the left-hand page and Narcissus on the right, with Echo being a dense, rough charcoal image of a cavern (vertical lines) and Narcissus being a light, smooth pencil image of water (horizontal lines). And so on. I'd work on everything in page spreads, something that I continued to do into *Bottomless* and chose to abandon in *BodyWorld.*

This was your senior thesis project. How did your preparation for it differ from past work?

The preparation for that book was strange. I did it from the middle, working out, in chapters. All of the chapters were self-contained. Many of them, I self-published as stand-alone minicomics. Like the last section with the children's drawings to the end, was a minicomic that was in a large 8.5-by-11-inch folder. And then I connected the chapters with drawings or connector scenes throughout. It was very intuitive. I drew a lot of sections that I had to cut out, and then after Alternative published it in America, Apa Apa comics asked for a Spanish edition and I cut even more out of it for that. So now it's whittled down to something like 80 pages. It feels like a long short story, a weird length. Most of the pages are empty and don't have words, so it takes just a few minutes to read the whole thing, and nothing happens in the story.

What sort of stuff did you cut out?

Just a lot of different directions or sequences. More collage-like pages. More humorous scenes. I put some of the humorous scenes into the inside-back-cover strips.

When did it become obvious that your original concept — matching a comic with a soundtrack — wouldn't work? Is this something you want to try again in the future?

I don't remember the exact time. Somewhere in the middle of it. I'm not going to try it again in the future. I like it that comics don't have sounds. It's one of comics' greatest strengths.

How so?

Comics can have a pleasing stillness and quietness. It irritates me when comics try to attach themselves to a music scene, like "punk" or "noise" or "rock 'n' roll" comics. Those things are about sounds, and comics are about still, silent sequences of images.

That was your longest-sustained narrative to date. How did you balance the needs of characterization, plot and symbology?

That book was a turning point because it started off completely not character-driven. I drew the characters because I liked the way they looked next to each other.

The woman was round, all circles, and the man was angular like a triangle. I thought it was moving, like Laurel and Hardy. As I worked on it more and more, I wanted to do character-centric scenes and have comedy and things like that. I put those scenes in the beginning, right before the story starts, and into short strips that I grouped together on the inside back cover. But after working on *The Mother's Mouth* I knew I wanted to do a character-driven story. The *Mouth* characters I liked, but I didn't do them justice. I didn't give them anything. I wanted to draw them more and spend time with them, but I blew it. That experience with *Mouth* and a short story I did for *The Drama* magazine, about a world where everyone draws their own overlapping autobio comics, led to me doing *Bottomless Belly Button*.

Do you feel like the themes of this book were well understood?

Once I'm finished drawing a comic, it's done for me. It's over. Everything that happens outside of that, with it being published and people reading it or writing about it is out of my control. That's just the way it is. I've read things that people have said about it and it seems like they didn't even read it. I've actually done interviews with people to find out half-way through that they didn't read the book. Or that they've read it and whatever they got out of it is completely foreign from me, like they read a completely different book. Like the characters in the

From "Echo and Narcissus," collected in *Goddess Head*.
[©2005 Dash Shaw]

book, everyone is coming from different places and projects their experiences. I showed it to my friend, who is somewhat similar to the Peter character in the book, and he thought Peter was a sympathetic character. He was rooting for Peter to get together with Kat, like a romantic movie or something. Obviously, this wasn't my intention at all. It's almost the opposite of my intentions, or where I was coming from. Many more people have read *Bottomless* than any of my other comics, and so most people approach it differently than the few people who've read *BodyWorld* or other things I've done. It's all out of my hands. And that's how it should be, I guess. I think that the book, and where I was coming from, becomes clearer if you read it more than once. But who's going to read a 700+ page book more than once?

Most of these critics come from a literary fiction background. They're used to reading all-word books. The way education works, you start off reading children's books and then you "graduate" to all-text books. The only people who "graduate" to visual thinking are people who take the art elective courses in high school or go to art school in college. The people who write literary reviews for magazines probably didn't go to art school. They majored in English. They're on a literary, all-text mode.

This seems to be the direction for comics as they move into the book market. They're being modeled after literary fiction, which is unfortunate. If I had to choose another medium that I would like comics to use as a mold, I would choose children's books. You wouldn't review a children's book without discussing the images, or thinking about them in a visual way. When you go into a bookstore, the children's-book section is the most exciting place. All of the books have different, unusual formats. There's a wide range of different aesthetics. All of the literary-fiction books look the same, the same size and format, boring.

Do you feel this is your most successful work to date? If so, why do you think it was so well realized?

No, I prefer *BodyWorld*.

Why?

It could be just that I always prefer whatever it is I'm working on at the moment, but I genuinely believe that *BodyWorld* is better. It's a more unique aesthetic. It's funnier. It's more beautiful to me.

Was it a conscious decision to make your longest-form work your most accessible as well?

I wanted to do a character-focused story. It just hap-

pened that the difference between a character-driven story and a non-character-driven story is also the difference between people liking a comic and people not liking one.

The length of the comic came about because of the style of the sequences, which is a combination of my prior "facing pages" style and manga. I didn't want to think about single pages. I wanted it to be like a long, flowing sequence. That's why I didn't put page numbers in it. It's just this flowing thing in three sections. *BodyWorld* is a long flowing thing too, only instead of it being spread-spread-spread, it's a vertical scroll.

How has working in certain genre structures, especially science-fiction, given you a greater freedom as a storyteller?

I wandered into science-fiction because of the stories I wanted to do. Specifically, telepathy in *BodyWorld*. I also like science fiction imagery. It allows for abstractions and unusual sequences. It's like what I said before about water and smoke already being abstract. Science-fiction is the genre of imagination. But I don't think of *BodyWorld* as a science-fiction story, I think of it as a telepathy story. It's about being inside another person. There just haven't been enough telepathy stories for it to qualify as a genre. I wish there were.

You've started to work in color. How has this changed your storytelling approach, but in terms of crafting the narrative and providing decorative qualities?

I've been working in color all throughout this — it's just that they were published in grays. The OddGod Press *Love Eats Brains* was half in color, the printed grayscale half. And *The Mother's Mouth* had color chapters. "Echo and Narcissus" was full color, and was published in color in a magazine in Richmond called *RVA Magazine*, so that was leading up to a full-color book.

Color is extremely freeing for me. It's been the second big step for me, since the "Goddess Head" story. With raw drawing, I carry a lot of baggage: all of these years of figure drawing and looking at other people's drawings. I feel like whenever I draw, it's some weird combination of Mazzucchelli and Gould and Panter and the other billion drawers that I like. There are so many. But with color, I don't have any hardcore heroes and I didn't obsess over it for so many years. I feel like a child. All of the decision-making in the colors is intuitive. There are a handful of colorists I like, but it didn't have such a strong impact on me as drawings.

BodyWorld is by far your funniest work to date. What is it about this story that led you to put your characters in humorous situations?

It's that the characters are humorous, so the situations are humorous. Paulie Panther comes from my sense of humor. He's enjoyable for me to draw. He makes me laugh.

BodyWorld has an unusual, downward-scrolling presentation on the Web. How will you change its design when it's published as a book for Pantheon?

I'm co-designing it with Chip Kidd. It will be a vertical format book, so every spread has a "top" and "bottom" page, rather than a "left" and "right" page. The maps will open on French flaps from the inside covers, so that they sit to the right of the top-bottom pages. It's hard to explain.

You went from OddGod to Teenaged Dinosaur to Alternative and now to Fantagraphics. How did you deal with the frustration of never knowing who your next publisher was going to be? How does it feel to suddenly be a big star in Fantagraphics' stable?

I didn't have to deal with any huge frustration. It's OK if my books don't get published.

Being a big star in the comics world is nothing. It doesn't affect anything in the real world. I'm happy that, for the time being, I don't need a regular job. But I had sections of time when I was working on *Bottomless* where I managed to avoid getting a regular job. It's come about in different ways. It seems like cartoonists and any freelance craftsperson or artist has to constantly be skirting around the outside of society, trying to find random ways of making money without getting a job. You never know how long the money you have is going to have to last.

How much editing have you received in your career? We've talked about your story in Stuck In The Middle getting sent back for story revisions several times. Have you had this experience anywhere else?

Generally, I've received very little editing. Obviously, illustration work comes with some editorial feedback. But my most regular illustration work is from the Health Central Network and they hardly ever give me criticism. I've been doing it for a long time and I know what they want.

Has all of the attention and requests for interviews been strange for you? What did you think of your profile in New York Magazine?

Like I said before, I don't have any control over these outside things. I just control the book. Eric Reynolds ar-

From "The Galactic Funnels," in *Mome Summer 2008* Vol. 11. [©2008 Dash Shaw]

ranges the press, and I'm happy to do them to help Fanta sell some books. Publicity is a huge part of the process. I've told Eric that I'm usually frustrated with how they turn out, and he said every cartoonist feels that way. That's why people like Mazzucchelli or Crumb stop doing them. Crumb and Mazzucchelli sell books without publicity. I don't.

The *New York Magazine* was the first interview I did for *Bottomless*. I'd never read the magazine, so I wasn't sure if they did a lot of cartoonist interviews. What's strange is that you never know where the interviewer is coming from. I've had interviews start with "Would Art Spiegelman be mad if you called *Maus* a comic book?" or "Where were you born?" or something in-depth relating to the book. Also, I don't read any of these publications. I don't know if I'm supposed to be talking to a specific group. Right now after doing a bunch of them I've just settled in and speak as if I was speaking normally. But I blew the first few. Also, I prefer articles that are straight question-and-answer pieces. Of course, they are boring and nobody wants to write or read them, but they're closer to having an actual dialogue. Whenever someone writes about the interviewee's personality it's completely bogus. You're meeting them for an hour in a noisy restaurant and you read the article and they made it sound like they lived with you for a month. They don't know you at all. Why would they write this about you? Ultimately, it doesn't matter. It's just press to help the book. Nobody

remembers these things anyway.

Why do you feel like you blew your first interviews?

I wasn't used to talking about my comics. When I was in Richmond, I didn't talk about them to anyone, really. And now I have to talk about them all the time. It's hard to put into words what you're doing.

How did you get the gig to do breast-cancer comics?

I got the breast-cancer comics gig from Sarah Park at Health Central Network. She'd seen some of my comics and is a friend of Yoni Brook, a photographer friend of mine. She called me up and offered it to me. At first, I thought she was calling to ask if I knew a cartoonist who had breast cancer or how to find someone good for the job. I couldn't believe that she wanted me to do them. But I've been doing them for over a year now and I've done all kinds: lung cancer, asthma, skin care, etc. for the Health Central sites.

Do you enjoy this sort of work, or is it just a paycheck?

It's incredible. I've learned so much doing them. I illustrate all of these different people's blog posts they write for the site. They send me photos of themselves and their family and I translate it into comics. I do them weekly, or sometimes twice a week, so the turnover is very fast. It allows me to constantly be trying different color com-

> This reminds me of that scene in that movie, you know?

From *Bottomless Belly Button*. [©2008 Dash Shaw]

binations. I've then used a lot of the different coloring techniques/styles in *BodyWorld* and my personal work. I get them regularly enough that I never had to advertise myself as an illustrator. Now, I could afford to stop doing them but I still do because I enjoy it so much.

What other illustration jobs have you taken?

Other illustration jobs are pretty random. Usually, it's someone who's into comics who happens to work at a place where they can hire me for a quick drawing. The time spent on *Bottomless* was largely funded by doing a series of huge advertisements for a new apartment complex near Central Park. They said my old people looked too old and they'd send me photos of what all of the characters should be wearing. Ultimately, they paid me a lot of money and hired someone else to redraw parts of my concepts. That's better as far as I'm concerned.

Is that Doctor Strange story you did for Marvel ever

going to see the light of day?

What happened was the original editor of the book, Aubrey Sitterson, left Marvel and so the project was handed to someone else. I got to flip through a rough section of the book. A nice long Paul Pope story was done for it. But I don't know what's happening with it now.

Has anyone at Marvel approached you to do any work for them?

Nobody else at Marvel has approached me for anything. I was working on a pitch for a Ghost Rider story with a writer but that faded out. I just started working on *BodyWorld* and other things. I'd love to have a 12-issue run on *Swamp Thing* for DC, just on the art side, penciling or inking. But I don't have the time to go to the office and pitch myself with a new inker or penciler portfolio and they probably wouldn't say "yes."

Is Swamp Thing a favorite character of yours? Are you a fan of the Alan Moore/Rick Veitch runs on the book?

Yes. I was already a fan before I read the Alan Moore run, though, because I'd watch the cartoons as a kid. There was a short-lived *Swamp Thing* cartoon that I had a VHS of that I'd watch over and over. I had all of the toys. I like the imagery of the swamp and the design of the character. Of the Marvel/DC characters, I prefer the more off-beat monster-ish characters, as opposed to the people in tights.

Do you see comics as a life-long avocation?

Yes.

When did you realize that this would be possible for you?

Do you mean financially possible? Only recently, like in the last couple of weeks.

You have an art show coming up at Duke University. What sort of work will be on display there?

Random drawings from different comics, including some color separations, and the *Bottomless Belly Button* animated video and some of the frames from it. It's all culled from things I had since I moved to New York. Everything I didn't bring with me is sitting in a box in my parent's attic in Richmond, Virginia. I haven't had a chance to go back and get any of that stuff, which includes all of the *Bottomless* originals and a bunch of acetate paintings. ∎

— Best of the Year lists continued from page 61 —

and sketches. Across 40 chapters, they offer no gung-ho glories of combat, but pinpoint incidents of banality, incompetence, humor and horror, and above all Cope's humanity and quest for meaning. After seriously contemplating the priesthood, his growing disenchantment with religion and shallow consumerism led to him quitting America in 1948, never to return. Late in life, he realized, "I hadn't lived the life of *myself*. I had lived the life of the person others had wanted me to be... And that person had never existed." After his death in 1999, Guibert found a way to reconnect to Cope by visiting friends and locations in America and Germany and through a photo album he left to him, reproduced at the back of the book. The reader cannot fail to respond to their friendship as it endures through this remarkable graphic biography.

Britten & Brülightly by Hannah Berry

Nothing is black and white in Hannah Berry's watercolored noir, her murky, moody washes echoing the moral shades of gray of her cast. This includes her downtrodden detective from Ecuador (British Berry has connections to this country on her mother's side), Fernández Britten. He is hired by a publisher's daughter to uncover the truth about her fiancé's supposed suicide. A 'heartbreaker' for

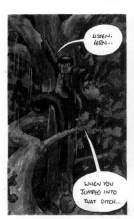
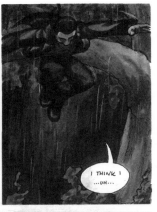

This sequence is from Berry's *Britten & Brülightly*. [©2008 Hannah Berry]

16 years, for once Britten would like the painful truths he has to deliver to a client to have a positive effect. Across 100 pages, Berry has a wry, witty way with words, from Britten's remorseful handwritten voiceover to his dialogues with his surreal partner, a cynical teabag! Where else will you read lines like, "Look, I'm sorry: I infused in your waistcoat"? Another remarkable debut straight out of the gate from a young woman graphic novelist.

Aldebaran: The Catastrophe and *The Group*, first two volumes by Leo

This ecological science-fiction epic came as a revelation. It's all too easy to poo-poo the mainstream, standardized francophone *bande dessinée* mass market, when so much is mired in formula and when amazing work is flourishing elsewhere in French, from L'Association, Fremok, L'An 2, Cornelius, Actes Sud and all the rest of the "independent" houses. But there is real quality within the "B.D." mass production like this series, if you know where to look. Dylan Horrocks first alerted me to this some years ago and now British-based Cinebook are releasing the whole series and rapidly, closer to the pace of manga. Whereas the French had to wait 15 years, from 1990 to 2005, for Brazilian-born Leo to write and draw all of the 10 hardback albums, we can now pick up the two complete cycles so far, Aldebaran and Betelgeuse, in five double volumes issued every six months or so. Quite apart from the enjoyable thriller, mystery and romance aspects of this tale, what captivates me are the brilliantly imagined fauna and flora on this isolated and very watery colonized planet, totally convincing like some alien wildlife documentary, and the feeling of experiencing a foreign culture with its peculiar customs, architecture and machinery and people's daily struggle against a repressive, religion-fueled regime. Leo conjures a real sense of wonder.

Travel by Yuichi Yokoyama

This speechless, soundless 195-page art-manga is the perfect accompaniment to any train journey. It transported me while on the London tube and British rail en route to my mother's. As fellow strangers on a train we seem to enter a special limbo, being between one place and the next, in a transitory state. Yokoyama evokes that detached, slightly wary observation between passengers as they try to avoid physical and eye contact and preserve their personal space. His protagonists, all of them male, mostly maintain what he describes in the footnotes as "severe and urban expressions on their faces," cool, indifferent, almost blank, like fashion models, looking without seeing, with

a hint of homoeroticism in these male gazes. He revels in the textures, organic and man-made, the plays of light, shadow, smokes, the everchanging landscapes and cityscapes rushing by, the varied designs of seating, clothes, advertisements. Crisply, fastidiously drawn, many pages play with trompe l'oeil effects and puzzle-like viewpoints forcing the reader-viewer to re-orientate and observe attentively. Whose viewpoint are we seeing? And from what angle? Whose eyes are we looking through? Are they human eyes at all? He shows us a marvel of a smooth-running integrated transport system, where congestion never causes delays and huge numbers are in constant process and progress. Yokoyama's heightened sense of presence while in motion invites us to re-evaluate how strange our own traveling experiences can be.

Freedom Comics, edited and published by Coco Wang

This is a chunky, limited edition tome translating underground comix from mainland China, drawn from emerging artists based principally in Beijing and Shanghai and featured in the two principal showcases, Cult Youth and Special Comics. A bright cartoonist herself, Coco Wang helped me discover these amazing young talents, while I was curating "Manhua! China Comics Now" in March-April 2008, the first exhibition in Britain of contemporary Chinese comics. Their styles owe more to Western avant-garde styles than either the painterly classically illustrative approach of "lianhuanhua" of the past, or the familiar big-eyed manga tropes dominant today. Their themes are topical, satirical, often cynical, but mostly avoid direct confrontation or specific caricature, preferring to couch their ideas in more surreal or fantasy scenarios. Their distrust of capitalism as much as communism is balanced by their energy and commitment to the comics medium, despite the obstacles they face as non-state-sanctioned cartoonists, such as not being permitted to print, sell or distribute their titles officially or openly. Now that's comix that are truly underground.

The DFC by Various artists

What does this "DFC" stand for? Well it is "Delivered Fridays Consistently" and it's "Definitely First Class." The DFC actually stands for The David Fickling Comic, and he is the determined publiser, backed by powerful Random House, who has made the most significant injection of new ideas and creative talent into British all-ages comics in a decade. You can't buy it in any shops, you have to subscribe online and every Friday it arrives in your morning mail. There's lots of quality here, even a seafaring serial, *John Blake*, written by Philip Pullman of *Golden*

Compass fame, but if I had to pick just two stand-out series they would be Sarah McIntyre's charming sheep-and-rabbit duo Vern and Lettuce, and *Mezolith*, a cave-boy drama written by Ben Hegarty and drawn by Adam Brockbank, concept designer and storyboarder for the Harry Potter movies. Are you ready for their monstrous giant blue baby or their naked, overweight she-creature? This is easily the most vivid, arresting children's adventure I've come across anywhere all year, a masterpiece in the making.

Rick Random: Space Detective, edited by Steve Holland

The main artist here, Ron Turner, was Britain's answer to Jack Kirby, and recalls Mac Raboy too on *Flash Gordon*, when it came to visualizing futuristic spacecraft, technology, aliens and spacesuits. Like Kirby and Wood's *Sky Masters* from a similar period, this is yesterday's tomorrow made manifest, all '50s retro tailfins, grilles, rocket engines, control panels and gleaming metallics. This glorious guilty pleasure offers a bumper 656 pages of comics which benefit from being enlarged 25 percent from the original pocket-sized Super Detective Library booklets. Noted author Harry Harrison even penned some of the scripts here.

The Complete Little Orphan Annie Vol. 1 by Harold Gray

Would you believe that Harold Gray kept the original artwork, or where missing, quality proofs, for all of his daily episodes? Shooting from these amazing sources, here's the opportunity to luxuriate in every succinctly caught expression, gesture and locale. One favorite early strip shows his curly red-haired tyke as the newly arrived toast of a lavish dinner party, when Annie gives back to the waiter all of the extra, excessive cutlery around her plate, insisting she can manage perfectly well with just the one set. Clear those bookshelves now, this is an essential addition to your library.

Bill Randall's Best

2008 sped past. For my Best Of, five new standouts from the world of comics in English. But first a grab bag of lesser lights and milestone reprints:

In translated manga, *Red Colored Elegy* topped 1973, while *Travel* stands with the best of 2006. In minis and comics, Lara Park's *Do Not Disturb My Waking Dream* showcases her glorious drawings of melancholy cute. Kevin Huizenga, in his "open source comics game" *Fight or Run*, plays with cartoon iconography for pure feel. It re-

From the Aug. 16, 1924 Harold Gray comic strip collected in *The Complete Little Orphan Annie* Vol. 1. [©2008 Tribune Media Services, Inc.]

calls Trondheim's theme-and-variation comics like *Mister O*, and I should note that *Little Nothings* is an event. For another import, I suspect I'll love *Tamara Drewe* when I read it based on my esteem for *Gemma Bovery*. Finally, I read dozens of Web-comics. Since my enjoyment of *Achewood* didn't last, my habit shifted to *Scary-Go-Round* and Kate Beaton's plump Napoleon. As part of the ever-ephemeral Web, I wonder if they'll be remembered by me tomorrow. For now, at least, I'm happily traveling with a celibate Tesla in my head.

Now, for my definitive works of 2008:

Kramers Ergot #7, edited by Sammy Harkham

The problem: print's slow, and my deadline predates the Dec. 8 release date. So I'll praise not the comic but the act. The idea of this tome, and its price, inspired more online invective among fans and retailers than most crimes. All because it costs a fraction of some DVD box sets. I guess comics should be cheap. God forbid they be art (or that the price of the *Cremaster* DVD set enter the discussion). I'll close by adding that Sammy Harkham curates his anthology like he does his store, Family in LA: with exquisite taste. Next, I hope *Kramers* #8 fills the thrift store on North Fairfax, entire walls covered by Brinkman, Moriarty and Castrée.

What It Is by Lynda Barry

I find it her best, most complete book. Revisiting it after reading Matthias Wivel's drive-by on his *Metabunker* blog — which amounted to a decree of "it sucks," full stop — only confirmed its welcoming complexity.

The Spirit World by Conor Stechschulte
http://closedcaptioncomics.blogspot.com

Can I disagree with pictures of trees? This odd comic at first appears to be nothing more than ink drawings of a forest. But, following its order to read slow, reveals it to be comic. Each full-page panel moves — the point-of-view at about a human's eye level — among the trees. Slowly. Between some uncut pages, geometry.

If it's arguing for Pythagorean order beneath the organic surface, I'll disagree. But it's open to many readings, and as a play of forms, it works well. Most of all, it's a 32-page transcendental meditation. The title hints at unseen realities, like those floating in the head of a generous reader.

(A second work, *The Spirit World* II, imitates a movie sequel. Instead of drawings of the woods, it uses silk-screened stillframes from horror films. It riffs on the fact that '70s American horror movies usually slaughter the white middle class in the woods beyond the suburbs. But after you get the joke, there's not much here for a non-fan. I much prefer *The Spirit World*'s openness.)

Acme Novelty Library #18 by Chris Ware

I wrote about this for an earlier issue of the *Journal*, certainly one of the most difficult pieces I've written. This *Acme*'s depth of characterization invited psychoanalytic training I don't have, and the craftsmanship is higher than ever. Reading this book alongside Douglas Wolk's essay on Ware in *Reading Comics* made me wonder if he meant some other artist. I admit *Building Stories* is no *Tomb of Dracula*. But I suspect I'll value the completed *Building Stories* more than the rest of Ware's work. Until then, I'm in awe of this installment's compassion.

Cryptic Wit #2 by Gerald Jablonski

This fluently bizarre comic book embodies much of the good the American comic-book market has fostered. For a while, a new independent comic seemed like it could

— Best of the Year lists continue on page 93 —

An Interview with Mike Luckovich

Conducted by R.C. Harvey

In its annual "Cartoon Issue" last fall, *The New Yorker* published two pages of cartoons entitled "What I'll Miss about George W." The cartoons were by Mike Luckovich, editorial cartoonist at the *Atlanta Journal-Constitution*. In the 12 years that *The New Yorker* has published a "Cartoon Issue," no other editoonist has appeared in the magazine's annual celebration of the art form.

"It was fun doing *The New Yorker* thing," Mike said when I asked him about it. "They contacted me and asked if I wanted to do something election-related." And so he did.

A month later, *The New Yorker* published another of his cartoons — not so much an editorial cartoon as a gag-cartoon half-page, with political overtones (about the bailouts). Some magazine gag cartoonists submit thousands of cartoons before getting published in *The New Yorker*.

Another pinnacle in a career that looks like a mountain range: Luckovich has occupied the "Perspectives" page of *Newsweek* magazine with such regularity that his colleagues in the inky-fingered fraternity suspect he's paying the magazine for the exposure. First *Newsweek*, now *The New Yorker*. Are there any heights left to scale?

Luckovich has won two Pulitzers; only 13 editorial cartoonists have won two or more. Luckovich has also won the National Cartoonists Society's Reuben as cartoonist of the year, the same year that he won his second Pulitzer as it happens; only six editorial cartoonists have won the Reuben. Only three editorial cartoonists have won both the Pulitzer and the Reuben — Bill Mauldin, Jim Borgman and Luckovich. There are surely other distinctions to aspire to, but Luckovich has accumulated enough to justify our attention here as we ponder the Best of the Year.

Luckovich wasn't always a cartoonist. He graduated from the University of Washington in Seattle in 1982, sent out resumés all over the country, but didn't get a single positive response. It was a recession year, he explained when I first interviewed him in July 1994 in his office at the *AJ-C*. So he took a job selling life insurance, which he did for two years before being hired by *The Grenville News* in Greenville, South Carolina.

Luckovich heard of the opening in Greenville through an ad in *Editor & Publisher*, to which, in desperation, he had subscribed.

"I kept a copy of *Editor & Publisher* open beside me on the seat of my Pinto as I drove around selling people life insurance," Luckovich said. "It gave me hope. I hated selling life insurance."

When he saw the ad, he sent in a batch of cartoons, and the *News* phoned and flew him back East for an interview. He stayed for nine months. He liked the paper: "It's a good paper, and the people there understood the role of a cartoonist. But I'm from a bigger town, and I wanted a bigger area, something more diverse."

So when he heard of the opening at the *Times-Picayune* in New Orleans, he submitted samples of his work.

"Editors get stacks of stuff," he recalled, "so I wanted to be a little bit different. I sent them a cartoon every day.

First, I sent in a portfolio of what I thought was my best stuff and cover letter; then I sent them a cartoon daily, the ones I was doing in Greenville, so they could see the quality and consistency of my work on a daily basis. They told me it helped. They were able to see what I could do."

While Luckovich never expected to stay in New Orleans forever, he wasn't particularly eager to leave four years later when, in 1989, the job at the *Atlanta Journal-Constitution* opened up. He didn't even apply for it. But the Atlantans invited him up for an interview. He went. He wasn't persuaded. They invited him back for a second look three weeks later.

"Then I kind of got a feel for the city and looked at some of the neighborhoods, which are beautiful," Luckovich said, "and decided to do it. And we're all very happy we came here."

He, his wife and four children.

Luckovich thinks he's neither liberal nor conservative. I'd say he's issue-oriented.

"I'm probably more liberal than conservative," he said, "but I like to keep an open mind. I like to think of myself as independent. I don't want to fudge on this, but I hate labeling myself. I don't want to give people a preconception of where I'm coming from. I like to form my own opinions. If you had to pin me down, I'd be left of center."

Luckovich sees an editorial cartoonist as part crusader, part humorist.

"With the type of editorial cartoon I do," he said, "people have to have a reference for it. They have to know the issues; they have to have an idea about them. And then I reflect on the issues. So I don't consider myself a reporter. I feel I definitely have something to say. And that's what is so great for me: To get my point across and to show the flaws in the other side's arguments or to show this individual to be wrong somehow, through ridicule in my cartoons. I feel that my best cartoons are cartoons that get a point across—and are also funny. Those are the kind of cartoons that I like to read. I don't really particularly care for gag cartoons—editorial cartoons that don't make a point. I think that good editorial cartoons get the point across and are still funny."

And he has his target firmly in mind — as a target.

"That's part of the fun of the job," he said, "—knowing that I'm going to make somebody squirm. I think I want to get across a point and maybe make people out there see an issue the way I see it, but I think probably my main motivation is to get at somebody. For instance, the tobacco industry. These are easy targets. And the NRA. These guys are easy to hit. But I still derive a lot of pleasure from hitting at them."

"Give us a bailout and you get your ship back!"

[©2008 Atlanta Journal-Constitution]

Luckovich frequently attacks the tobacco industry and NRA, but he's glad they're out there. "These guys are like walking cartoons," he said. "When you're having a tough day and you want to come up with a cartoon that writes itself, these guys are always available. So I guess I shouldn't be too mad at them."

When editorial cartoonists want to jab politicians, he observed in a speech several years ago, they sharpen their pens and take their best poke—and then the wily politicians phone up and ask for the original cartoon. It can be the hardest-hitting cartoon, but the politicians say they

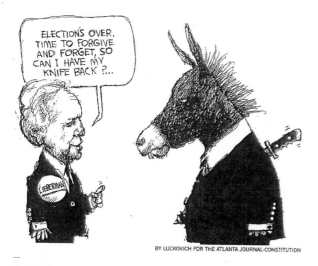

Within the image:
ELECTION'S OVER, TIME TO FORGIVE AND FORGET, SO CAN I HAVE MY KNIFE BACK?...

LIEBERMAN

BY LUCKOVICH FOR THE ATLANTA JOURNAL-CONSTITUTION

love it and want the original. Sort of takes the fun out of editorial cartooning.

So Luckovich was overjoyed at Newt Gingrich's reaction to his election-eve cartoons in 1994. In a hospital-room setting that evoked Gingrich's notorious visit to his wife recovering from cancer treatment to ask for a divorce, Luckovich's cartoon showed Newt asking his Georgian constituency for a divorce in order to spend more time with Washington highrollers, depicted at Newt's side as a couple of bimbos.

Newt was so offended that he raved on about the cartoon at his victory celebration and banned the *Atlanta Journal-Constitution* from covering him for four months. The offending cartoon was one of 20 that won Luckovich the Pulitzer for 1995.

For this article, I interviewed Mike again via e-mail in early December. I asked him about Barack Obama's elusiveness as a cartoon target, but because he types with one finger, Mike's answer was fairly short. When Diane Tucker talked to him about Obama at the *Huffington Post*, their exchange was oral and Mike's response was more detailed. Tucker began by asking him whether it was easy or difficult to draw a caricature of "No Drama Obama."

"At this point, it's hard because for eight years we've had George W. Bush, a president who doesn't like dissension, who's sort of arrogant, and who feels God is talking through him," Luckovich said. "Obama seems like a completely different personality. That's good news for the country, but for cartoonists it's going to be tough not having Bush around."

When she wondered about the size of Bush's ears in Luckovich's cartoons, Mike said:

I don't draw Bush as a human being any more. He's become a cartoon character who also has a beak-like nose and circles for feet — just two simple black circles. I draw Bush smaller and smaller as his incompetence grows larger and larger. And as long as Obama does well, he'll maintain his current height in cartoons. But this brings up another problem. Obama moves in such a smooth way — he's so physically comfortable with himself — that it's difficult to lampoon the guy. Bush always looked awkward and phony to me. I often drew Bush with his arms out, like he's going for his guns at high noon. Whether you agree with a president or not, the longer they're out there, the more likely it is you'll have a cynical view of them. I'm worried about Obama, though, because the more I see him, the more I like him. For me, that's scary. I watched the Barbara Walters special last week and the Obamas seemed so real. They were joking around, and they appeared to really like each other. This is miserable news if you're an editorial cartoonist.

If Obama becomes unpopular, Luckovich said he'd make his ears bigger and more rounded, "like the ears on a Mickey Mouse hat. I'd make his neck really skinny, so he has a lot of shirt collar left over to fill, and I'd furrow his eyebrows to make him look bewildered. Finally, I'd deepen the nasolabial folds on his face, so it looks like he's aging rapidly."

But if Obama "comes up with a great economic stimulus package and everyone gets back to work, I promise to draw him with black hair even though his real hair is turning gray."

Luckovich works fast because he doesn't do preliminary sketches in pencil. "I just ink right on the paper," he said. He does a preliminary sketch to get reaction from those he consults, editors Cynthia Tucker and Jay Bookman, but once he's settled on an idea, he goes directly to the illustration board with pen and ink, using a mechanical pen similar to a drafting pen.

Said he: "And so it's great: it saves me a lot of time, and I think that my line-work — at least in my opinion — has more of a flow to it. I started this, not using a pencil, in 1988. Up to that point, I would pencil everything in; erase, then pencil more, erase and pencil, until I had something down, and then I would ink over that. And now I've just eliminated that."

Following our exchange of e-mailed questions and an-

swers, we talked on the phone a little about the current crisis in the editorial-cartooning profession — the steady decline of staff positions — and I asked Luckovich if he has started learning animation as job insurance. Many of his brethren now do animated political cartoons for their newspaper's website, which makes them more valuable as newspapers move from print to electronic ether.

But Luckovich said he doesn't feel the need yet. He realizes that animated cartooning is an entirely different medium than static cartooning; it would require a different set of comedic as well as technical skills. If his editors say he should take it up, he says he'll look into it. But for now, his traditional panel cartoon gets a lot of hits on the paper's website, and he gets lots of visibility around the country in *Newsweek* and elsewhere. That's good for the paper. And for him.

As for the state of the art of editorial cartooning, he's glad there is no longer a dominant style as there was in Herblock's heyday. And while he appreciates the hard-hitting cartoons he sees and the work it takes to produce them, he also thinks many editoonists are "phoning it in" and calling it a day. That, as he points out in our e-mailed exchange, makes the profession vulnerable.

Like many of his colleagues, Luckovich believes that one of the issues in the editorial cartooning profession is a tendency to tell jokes that don't have a point of view. "I think that there's a lot of very good editorial cartoonists out there who are doing a very good job," he said. "But I think on some level cartoons have begun to rely more on straight gags rather than getting a point across. I'm not big on gag cartoons unless they're on some kind of goofy issue in the first place. But I think overall, what's important is that people concentrate on having an opinion and also getting it across in a way that is different from everybody else. And I think that this is an ongoing struggle that everybody deals with in their own way."

But it's more than just trying to come up with a picture that's different. "Editors a lot of times get worried about what their readers are saying, and it's easier to run a gag cartoon that says nothing than it is to run a cartoon that's hard-hitting. And I hate to see that, because there's a comics page if people want to be entertained in a harmless sort of way. I don't think that's the role of an editorial cartoon. And so when you have gag cartoons that are funny just for the sake of being funny, I think it waters it down a little bit."

At the same time, Luckovich sees a place for the occasional strictly humorous cartoon: "It's kind of like a pitcher with a number of pitches. I'd rather mix 'em up a little bit. Do the stark image occasionally, but also do a hard-hitting cartoon occasionally — and every once in a while, depending upon the issue, do just a funny cartoon. If you can stay fresh that way, I think people like reading you."

In venues other than the columns of the *Atlanta Journal-Constitution*, Luckovich betrays a determinedly humorous approach to life in the form of practical jokes. Take, for example, the time he and fellow editoonist Mike Peters attended the White House Correspondents' Association Dinner in 2006:

"Stephen Colbert's barbed harpoons got all the attention at the dinner," Luckovich wrote in the 2006 collection of his cartoons, *Four More Wars*. "But that was inside the banquet hall. Outside, in the corridors of the Washington Hilton, two men named Mike watched Kissinger's back and, well, if there was excessive alcohol consumption, it came much later." Peters, whose reputation as a prankster exceeds Luckovich's, was a willing co-conspirator in the ruse the two perpetrated during the cocktail hour that preceded the dinner. They came prepared: tucked into their pockets, they each had the spiral cord they'd detached from their hotel room phones and dark glasses. Once onto the premises, they put their dark glasses on, stuck the phone cords into their ears and snaked them around behind and into their jacket pockets, and stood outside the cocktail room, pretending to be security guards.

"We were on each side of the door, and we kept having to remind each other not to smile," Luckovich remembered.

Then Henry Kissinger came up and said to the Mikes: "Can you take me to the security area?"

"So we became Henry Kissinger's security. It was just the two of us, right behind Kissinger, right at his back. He's walking down this hallway to get to the metal detector to go into the banquet hall, and a crowd surrounded him and began taking his picture. So after a few seconds, I yelled out, 'No more pictures!' in a very authoritative voice, and everyone stopped taking photos."

After Kissinger passed through the metal detector, the Mikes stood by the device, "telling people they had to take their shoes off and stuff like that. Nobody did, believe it or not."

During Bill Clinton's 1996 campaign for re-election, Luckovich secured a seat for himself in the press-corps section of Air Force One and persuaded Clinton to draw a self-caricature. He did the same with Paul Wolfowitz during a visit to Donald Rumsfeld's domain early in the Iraq war.

Wolfowitz gave the cartoonist a souvenir of the occasion, a little blue hardcover book called *Rumsfeld's Rules.* When Luckovich got back to Atlanta, he opened up the book and saw that it was inscribed: "To Paul, for all you do and do so well — Donald Rumsfeld." Mused Luckovich: "Maybe he gave me the wrong one."

Luckovich, a couple of whose cartoons about Rumsfeld graced the Secretary's bathroom walls, had been invited to visit the Defense Department by the DOD PR honcho, Victoria "Torie" Clarke. "I guess she thought that having a cartoonist hanging around the Pentagon might lighten the mood a bit," Luckovich wrote in describing his visit in *Four More Wars.* "She also mentioned something about a one-armed push-up contest with a marine in her office."

From my own experience in the Navy in the last century, I know that Marines are likely to drop down and do push-ups at the slightest provocation. And when Luckovich arrived in Clarke's office, sure enough — "a massively muscular marine asked if I was ready for 'the contest.' ... So in the middle of Clarke's office, the one-armed competition began. I did six more than the marine. Short cartoonists are so often underestimated."

And then there was the time that Luckovich was presiding at some sort of gathering, a dinner, at a UN function, probably for cartoonists. (I've forgotten what it was exactly, but that doesn't matter.) A friend of Luckovich's came in late, and Luckovich seized the microphone and introduced him as some sort of foreign dignitary. The guy then gave a short speech. Some days later, Luckovich got a letter from the UN factotum in charge of the dinner inquiring whether Luckovich knew that his friend was not, as introduced, an ambassador but was, in fact, an imposter. Luckovich protested, saying as far as he knew, the guy was authentic.

This precipitated an exchange of several letters, back and forth, in which the UN official kept reporting on his ongoing investigation of the alleged imposter. Luckovich initially defended his friend and objected to the investigation. Eventually, however, he was confronted by evidence he

couldn't deny, at which point, he professed astonishment that any such fraud could have been perpetrated on the UN premises. Finally, despite Luckovich's most vehement efforts, the UN official concluded that Luckovich's friend was an imposter and that Luckovich was in on the deception. Luckovich has capitalized upon this adventure at various public places by reading aloud, in order, the series of letters he and the UN offiical exchanged. Hilarious.

Luckovich provokes other letters, too, telling me about some of them when we talked in 1994. "Among the most interesting letters I've received was just after I'd done an anti-NRA cartoon, and someone used the cartoon as toilet paper and sent it back to us. I'm still trying to decide whether they liked the cartoon or not.

"You sometimes get profanity-laden letters," he continued, "— especially if you deal with a subject that engages the sympathies of a lot of kooks. NRA supporters, for instance, send a lot of weird letters. When I do a cartoon criticizing Rush Limbaugh, for whatever reason, I get a lot of nasty letters. I got a letter from one fellow — full of swear words — and he says I criticize Rush Limbaugh too much, and at the end of it, he says, 'And if you want to make something out of it — and he puts his name and address and phone number. As if I'm going to phone him and say — what? — 'Oh yeah?'"

Luckovich is clearly enjoying himself: "I continue to love my job, and the greatest thing for me is still coming in every day and drawing a cartoon. I love doing this. And I'm having a lot of fun at it."

Last fall, in preparation for this article, I interviewed Luckovich again, this time via e-mail. Here's the exchange.

RC HARVEY:
Is the floor of your office still strewn, perhaps ankle-

deep, in discarded paper?

MIKE LUCKOVICH:
Yes, my office is a mess. I learned recently that my publisher has to pay a yearly $1,000 fine because it's a fire hazard.

What is the function, do you think, of the political cartoon?
It's to get across an opinion in a humorous, hard-hitting way that, hopefully, makes an impression.

Do political cartoons have any impact on public affairs?
Locally, I think they occasionally do. Editorial cartoons can sometimes shame local politicians into behaving correctly or honestly.

Why did you decide to become a political cartoonist rather than a strip cartoonist or a comic-book c artoonist?
I was never interested in strip or comic-book cartooning. I liked politics, so it was always editorial cartooning.

What and/or who were your chief influences as you contemplated getting into political cartooning?
My first influence was Mort Drucker, the *Mad* magazine cartoonist. He's a beautiful artist. I love his work. I think he's a beautiful artist, beautiful caricaturist. And so when I was a kid, I wanted to draw for *Mad* magazine, and I didn't follow the comic strips as a kid. I just drew funny pictures of the teachers and looked at *Mad* magazine; that's the kind of comics that interested me. That is kind of weird. For most people in this field, comic strips or comic books were a good part of their childhood. But not for me. And I still have *Mad* magazine around here. And Mort Drucker is still at it and still looks great, and he's drawing better than ever. You can tell he has a real love for what he does. I just think he's great. As my interest in politics grew, I began to pay a lot of attention to Jeff MacNelly. He combined great artwork with a great ability for getting to the heart of an issue in a witty way.

Since May, when Cullum Rogers of the AAEC (American Association of Editorial Cartoonists) counted 101 full-time staff editorial cartoonists, we've lost 12 of that roster, so now, as of early December, we're down to 89. Do you see an end to this downward spiral? What sort of hope do you hold out, if any?
It's not just cartoonists. Newspapers are becoming leaner. As cartoonists we just have to work extra hard to become such an integral part to our newspapers that they want to hold onto us. If it seems we're just phoning it in, that makes us vulnerable.

The almost universal syndication of editorial cartoonists has probably contributed to the crisis: Newspapers know they can obtain political cartoons on national topics at a pittance compared to what they must pay a staff cartoonist. Maybe to fight fire with another sort of blaze, everyone who's syndicated should cease syndication. Any wisdom in that? Any practicality in it?
No wisdom. No practicality.

You launched a comic strip into syndication several years ago and had to give it up. Given the present state of the profession, are you tempted to revisit that project — if for no other reason than possible job security?
No. A strip became a huge burden for me. I do freelance work at this point.

Bill Mauldin used to say, "If it's big, hit it." Comment?
I'll hit an institution that's big, like the Catholic church (I'm Catholic) when it deserves to be hit.

Herblock once said a political cartoon is "a means for poking fun — for puncturing pomposity, for offering criticism." Comment?
That's a good summary.

What is your working routine? What office hours do you keep? When's your deadline every day?
I get in around noon. Come up with a couple ideas

around 3 o'clock. Almost always they're rejected as not very good. The rejection energizes me and makes me come up with better ideas. My deadline's 6ish. I work right up to that trying to come up with the best idea I can and then quickly draw it. I don't pencil in anything first, I go right to inking, so it goes fast.

How do you generate ideas? Read newspapers? Listen to NPR? Do you have any rituals that usually work?

I read the *AJ-C, New York Times* and various websites. The only ritual that works is when panic sets in if my deadline is close and I don't have an idea.

Have you ever felt, with hindsight, that you were wrong about a particular issue or with the view expressed in one of your cartoons?

No. I spend a lot of time formulating my opinions. I've always supported fuel-efficient vehicles, I was against the Bush tax cuts and the Iraq war. There have been times when I've regretted the way I've expressed an opinion, meaning it could have been clearer, or done in a more clever way.

How important is caricature to a political cartoonist? Do you have any favorite caricaturists among your colleagues? Who's your favorite politician to caricature?

I love caricature. The way I do it is to find a photo of a politician through Google and draw again without penciling first. I don't have a favorite politician to caricature.

You once went on an Air Force One ride with Bill Clinton. Have you continued to pal around with presidents? Is there a danger in getting too chummy with politicians? Or does access trump the pitfalls?

If I have the opportunity to meet a politician, I will. I'm cynical enough not to be swayed even if a politician has a nice personality.

Some editorial cartoonists have been critical in past years of the comedic content of editorial cartoons. Too much Jay Leno and not enough Mike Wallace. I think you hit a pretty good balance between laugh provocation and thought provocation, but how do you view these two aspects of the craft?

Humor is very important to me. Editorial cartoonists who claim you shouldn't use humor are the ones who aren't humorous. If you can make a point using humor, you do, because it's so much more compelling and interesting. Jon Stewart is good precisely because he uses humor to flay his subjects. No one would watch him if he

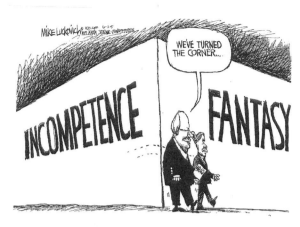

wasn't humorous.

Does a cartoonist with strong political opinions run the risk of becoming an apologist for the candidate who espouses those views?

No, unless you remain silent when that candidate undermines those views.

During the recent presidential campaign, several comedians and comedy writers voiced regret or chagrin about not having made more jokes about Obama. There are various reasons for this, of course — the awkwardness in a white man making fun of a black man, for instance. There may be numerous other reasons. Several comedy writers said simply that Obama provided them with no comedic "hooks" — he didn't stumble like Ford, he didn't have a five o'clock shadow like Nixon, and so on. Do you see the Obama situation changing once he's sworn in? Will he be more of a target as president than as candidate? I noticed, by the way, that most of your cartoons in October slammed McCain but not Obama. Did Obama commit no political sins at all?

As an editorial cartoonist, my problem with Obama hasn't been about race. He's just so smart and comfortable with himself. Unlike McCain, he didn't resort to Joe-the-Plumber-type silliness, so he's been difficult.

You're virtually a regular in every weekly *Newsweek* issue. How do you manage that? Who do you pay and how much?

[Not taking the bait.] They apparently like my cartoons and I'm glad they do. ∎

— Best of the Year lists continued from page 85 —

contain just about anything. Honestly, I don't even know if any DM shops carry *Cryptic Wit*. Yet I can imagine my 12-year-old self finding it on the shelves of a comic-book store, reading it after a Marvel crossover and thoroughly having his mind ended. It is so defiantly personal, so unique, so weird, that all I can say for sure is that it's a comic book.

Cryptic Wit does, after all, have word balloons, panels and jokes. Never mind that the word balloons crowd the panels with tails that swirl and zigzag, or that the jokes work like Vaudeville haiku. Each tiny panel contains a complete routine. The whole issue contains several hundred. What they add up to, I'm not sure. The nonsensical gags, like the Theater of the Absurd, seem to deny language's meaning. Likewise, the characters — a '50s father figure and a punky son, a barnyard versus a farmer — seem to undermine classic American archetypes. Forty years ago, this would have looked like an acid comic. Now it seems like a work of an isolated American savant. I'll get back to you on its themes. I am positive, however, that it could have happened in no other context — not aesthetic, not economic — than comics.

Chris Lanier's Best

My Top Three:

Red Colored Elegy by Seiichi Hayashi

The self-sufficiency of landscape in relation to the human figure in Japanese art has been long remarked upon, being in stark contrast to traditional Western landscape modes, where the human figure is often foregrounded, the unscrolling terrain a marvelous rug for him to wipe his shoes on. In Japanese comics the tendency toward "environment-for-environment's sake" takes the form of panels that establish a scene as if investigating the details of a stage set before the actors have come to occupy it. In *Red-Colored Elegy*, this approach begins to feel downright oppressive: Instead of weightless cloudscapes and close-ups of flower blossoms, we're given ramshackle door-frames and bug-eyed streetlamps.

These are places that would be hard to linger in, much less thrive. The two main characters in *Elegy* are young lovers who are trying to figure the world out, while hanging onto it by their chipped fingernails. They go to the beach, and it resembles more a lunar landscape than a paradise (other beach-goers occupy the margins of their activity like scarecrows, the rim of their beach umbrella fluttering like a flag of bad omen).

The story of their romantic travails is broken up with disjunctive formal effects, translated from the shock-cuts and soundtrack high jinks of French New Wave cinema. It's hard to tell at times whether the word balloons emanate from the characters or from the flotsam and jetsam of the fallen world itself. Car wrecks and Godzilla posters start speaking with the voices of heartbroken and raving 20-year-olds.

Cat-Eyed Boy Volumes 1 and 2, by Kazuo Umezu

It's hard to say whether the horror stories collected in *Cat-Eyed Boy* would be better if they made any sense. You could make the argument that they follow the whiplash logic of nightmares, but I doubt there's that much method to the madness. I get the impression Umezu simply forgets what happened 20 pages ago, or at least hopes the reader does — he doesn't want anything to get in the way of his next grotesque image.

And he has some real doozies: a cross between an old hag and a giant spider, spitting globs of web as if disgorging decades-old sputum; a head-wound emitting blood like a jet of tobacco juice, right into another character's bloodshot third eye; a hysterical man suffocated by humanoid figures that seem to be composed of burnt hamburger and turd, trying to force their way down his throat. These last creatures are called "Meatball," and their victims go running around, screaming, pointing, clawing their eyes out, all while yelling "*Meatball!*" Someone really needs to mix the panels up with R. Crumb's '60s Meatball fantasia.

Umezu's shorter stories, collected toward the end of Volume 2, are a bit more concentrated, more demented parable than demented soap opera. They read like Jack Chick tracts, if Jack Chick were rooting for the devil. Which Chick, in a way, probably is — but at least Umezu's up front about it.

Acme Novelty Library #18 by Chris Ware

If the unnamed protagonist of *Acme* #18 is more assertive and fully human than the pathetic characters Ware usually builds his stories around, she still feels a little too rigged as a receptacle for pity. Her prosthetic leg has to bear too heavy a weight of symbolic import. Still, she really *breathes*, and her voice — smart, perceptive, self-undercutting — rings true enough I thought I could hear her inflections and cadences.

As for the story: Ware finally adapts Richard McGuire's "Here" head-on. Expanded to graphic-novella length, it

From *Acme Novelty Library* #18. [©2007 Chris Ware]

pieces just make no sense whatsoever, like the depiction of LBJ as King Lear and RFK, Hubert Humphrey and Wilbur Mills as his daughters. Can someone please enlighten me as to who of the latter three is supposed to be Cordelia, and which two Goneril and Regan? In this context, Levine's most famous images, such as LBJ with the Vietnam-shaped appendectomy scar, seem increasingly like examples of a broken clock being right twice a day.

American Presidents is a poorly edited book as well. Some images are accompanied by prose commentary while others are not, and some of the most bewildering images — like Carter as Emperor Nero — are the ones that go without. The prose commentaries in other instances inadvertently make the case for excluding pieces: They reveal just how badly some of the images have dated. In retrospect, likening Nixon to Herbert Hoover for downplaying the 1969-1970 recession just seems obtuse, particularly in light of the more severe economic downturns since, including the one we're presently in. The book is also very poorly copy-edited. And really, shouldn't someone have prevailed upon Levine to not call Condoleezza Rice "Congaleeza"? The book implies that this was one of George W. Bush's notorious nicknames for people, but that isn't the case. Everyone would have been better off had Levine kept his racist epithets to himself.

becomes about more than the way time fractures space. It's about how it's possible for people to inhabit that fractured space. There's a vividness of trespass to the whole thing: from the pitch-perfect beginning, where the woman takes to a house-sitting gig with the avidness of a cat-burglar, to even more intimate infractions — showing how easy it is to feel like an intruder in one's own childhood bedroom. *Acme* #18 demonstrates what it's like to feel like a mere tenant in one's own job, one's own home, one's own life.

Robert Martin's Most Overrated

I had to pass on submitting a "Best of the Year" list. (I don't follow the field closely enough, and anyway, I'm behind on my reading.) However, I'm more than happy to submit my candidate for the year's most overrated book: *American Presidents*, by David Levine. This collection of his political caricatures goes a long way toward establishing Levine as perhaps the most overrated U.S. cartoonist of the last century.

There's no denying that Levine is an impeccable draftsman, or that his sculptural pen-and-ink rendering style is gorgeous. But he's a terrible political cartoonist. The book shows him to be neither a thoughtful nor knowledgeable commentator about politics, and he does not, to put it mildly, have a very sophisticated sense of satire. Most of the more pointed images are just cheap insults, like showing Bill Clinton with an elephant trunk instead of a nose, or depicting Jimmy Carter as Alfred E. Neuman. Other

Robert Clough's Five Underappreciated Comics From 2008:

1. ***Wormdye***, by Eamon Espey (Secret Acres). A disturbing, hallucinatory tour-de-force that demands complete engagement from its readers. Espey's humor is pitch black and pervades every aspect of his work. Espey creates his own cosmology from the ground up, one where grisly acts of violence quickly turn into bizarre punch lines and then fuel whole pages worth of cryptic symbology.

2. ***Inkweed*** by Chris Wright (Sparkplug Comic Books). This was the best of Sparkplug's many great comics this year. The short stories here are connected only in terms of theme: lust, loss, madness and creation. "The Urn" was the single most shattering short story of the year, layering unthinkable betrayal on top of unthinkable betrayal.

3. ***Petey and Pussy*** by John Kerschbaum (Fantagraphics). In a year where great humorists such as Michael Kupperman and Sam Henderson had new releases, Kerschbaum's work stands out for its sheer, visceral relentless-

ness. The longer narrative in this book is a nested series of gags both gross-out and conceptual with an understated final payoff.

4. **Against Pain** by Ron Regé Jr. (Drawn & Quarterly). There were a number of impressive archival collections released in 2008, but this career-spanning collection of the former Highwater Books stalwart was absolutely revelatory. Regé's line has a deceptively simple quality that is every bit as immersive as the other artists on this list.

5. **Injury Comics**, by Ted May, Jason Robards and Jeff Wilson (Buenaventura Press). This is the sort of series that would have been a big seller in the golden age of alternative-comic-book series, given its genre-bending nature, sly sense of humor and sharp cartooning. May and his cohorts employ deadpan humor, a genuine enthusiasm for things like autobiographical reveries about '80s heavy-metal romances and cyborgs fighting in diners.

Kent Worcester's Best

A New Yorker's Guide to the Top Comics of 2008:

Woke up in Woodside, caught a cab on Queens Boulevard, headed for the Deegan. Flew by Yankee Stadium (both of them). Picked up a bagel at a Greek diner. Yesterday I saw Newt Gingrich talking to Al Sharpton on Lexington and Forty-Fifth. Wanna make something of it?

Lynda Barry, **What It Is** (Drawn & Quarterly)
Fuggedaboutit.

Alison Bechdel, **The Essential Dykes to Watch Out For** (Houghton Mifflin)
Gimme an egg cream.

Blake Bell, **Strange and Stranger: The World of Steve Ditko** (Fantagraphics)
Gimme a subway series.

Jules Feiffer, **Explainers: The Complete Village Voice Strips (1956-1966)** (Fantagraphics)
The whole schmeer.

David Hajdu, **The Ten-Cent Plague: The Great Comic Book Scare and How it Changed America** (Farrar, Straus & Giroux)
Absoid.

Jaime Hernandez, **The Education of Hopey Glass** (Fantagraphics)
Toity-toid and Toid.

Kevin Huizenga, **Or Else #5** (Drawn and Quarterly)
You talking to me?

Tom Kaczynski, **Cartoon Dialectics Vol. 1** (Uncivilized Books)
I'm walking here; I'm walking here.

Winsor McCay, **Little Nemo in Slumberland, Many More Splendid Sundays** (Sunday Press Books)
Ain't no big thing.

Gary Panter, **Gary Panter** (PictureBox)
Are you fucking shitting me?

Honorable Staten Island Mention:

Lynda Barry, Jessica Abel and Matt Madden, eds. *Best American Comics 2008* (Houghton Mifflin)
Marguerita Abouet and Clément Oubrerie, *Aya of Yop City* (Drawn and Quarterly)
Ivan Brunetti, *An Anthology of Graphic Fiction, Cartoons and True Stories,* Vol. 2 (Yale University Press)
Paul Buhle, *Jews and American Comics* (New Press)
Joshua Cotter, *Skyscrapers of the Midwest* (Adhouse)
Sammy Harkham, *Kramers Ergot 7* (Buenaventura)
Dan Nadel and Ben Jones, *The Ganzfeld 7* (Picturebox)
John Porcellino, *Thoreau at Walden* (Hyperion)
Dash Shaw, *Bottomless Belly Button* (Fantagraphics)
Art Spiegelman, *Breakdowns* (Pantheon)

Daren White's Best

In no particular order:

Tamara Drewe by Posy Simmonds
Posy Simmonds again focuses thematically on the concerns of the English middle classes. Again she presents a thoroughly enjoyable yarn centering on a sexy female lead. Again a book that you'll be pleased to recommend to your non-comics-reading wife.

The Education of Hopey Glass by Jaime Hernandez
Reading this book almost feels like catching up with old friends that you haven't seen for a number of years. Without particularly meaning to, I'd stopped reading the

second incarnation of *Love and Rockets* over the last few years, and was almost taken aback by how good these stories are. In a medium where few characters age, it's refreshing to see it handled so well.

Berlin: City of Smoke Vol. 2 by Jason Lutes

Another old friend. *Berlin* is typical of the quality that every book should aspire to meet if the term graphic novel isn't to become synonymous with "young reader."

Acme Novelty Library #19 by Chris Ware

A few years ago, a Chicago friend sent a few clippings of Rusty Brown as it was then appearing in the local press. Having only seen the first few Rusty Brown pages in *Acme Novelty Library*, at the time, I suspected the weird science-fiction pages wouldn't form part of the eventual novel, much like the young Jimmy Corrigan strips weren't included in the collected edition. I was wrong. Not only do they fit, but are brilliantly integral to the story as a whole. It's hard to imagine any "best of year" lists not including whatever books Chris Ware releases. Astonishingly, the current release again saw comments branding Ware as some sort of misery-obsessed one trick pony. I can only shake my head and suggest they take another look. And pay attention this time. Absolute genius.

The Amazing Remarkable Monsieur Leotard by Eddie Campbell and Dan Best

The creators and characters of this book jump from one adventure to the next, barely pausing to take breath. They're having a fine old time, and so should you. My only minor criticism is that Campbell's gorgeous spreads have been overly reduced by First Second's prescriptive format. How about a full-sized version?

Kristy Valenti's Best

1. *Skim* written by Mariko Tamaki and drawn by Jillian Tamaki (Groundwood). A *bildungsroman* about a Japanese Canadian all-girls-high-school student, Kim (nicknamed Skim), set in 1994, it's told in first-person in the form of diary entries. Writer Mariko creates believable teenage characters, and as the characters' reactions to external events and peer pressure changes them, their relationships with one another ebb and flow.

This naturalism extends to Jillian's extraordinary art; her images tell us as much about a character (Kim's mother breaking spaghetti in half, a makeup-and-jewelry

From *The Education of Hopey Glass*. [©2008 Jaime Hernandez]

strewn table, Kim's Wiccan altar) as Mariko's words do. Just as Mariko's sparing period pop-culture references are always in service to characterization — we're shown many instances of Kim's mother's coldness, but she's weirdly humanized when we learn that only the television drama *Sisters* can jerk tears out of her — Jillian is able to evoke an era with a mere brush stroke delineating the curve of Kim's friend Lisa's bangs. (Jillian also passes my "can this artist draw authentic-looking girls" test, which has a lot to do with the way the artist draws knees.) Though I know I should treat terms like "realistic" and "naturalism" with suspicion, it's a credit to the creators that *Skim* should seem so "real," when it's such a skillfully constructed story. Very few comics are as accomplished in terms of both writing and art: This book is easily one of the best of the year.

2. *xxxHolic* Vol. 12 by CLAMP (Del Rey): Breathtakingly beautiful, both artwork and story. (Not recommended unless you've read the previous 11 volumes. Though *xxxHolic* crosses over with *Tsubasa: Reservoir Chronicle*, it's not necessary to have read that series.)

3. *The Night of Your Life* by Jesse Reklaw (Dark Horse): I was unfamiliar with *Slow Wave*, Reklaw's four-panel comic strip relating other people's dreams in even-toned first person, and frankly the hideous cover made me loath to read it. Once I did though, I had to stifle my guffaws in an otherwise silent, thin-walled apartment for fear that my next-door neighbor would think I was a loon. Reklaw isn't the most accomplished artist, but this actually works in his favor here, as his flat, generic-looking art is well-suited to the matter-of-fact feeling of dreams, no matter

what kind of weirdness might be going on in them. I would also say that the book is about two chapters too long, but, man, I don't think I've laughed that hard at anything else literally all year.

4. *Emma* **Vol. 7** by Kaoru Mori (DC/CMX): This manga, which is about bourgeois William and maid Emma's chaste and ill-advised romance — full of Victorian England period detail — thankfully stuck the landing. For someone who grew up on books like Frances Hodgson Burnett's *The Secret Garden* and *A Little Princess,* Eleanor H. Porter's *Pollyanna* and L.M. Montgomery's *Anne of Green Gables*, which are basically about how the female protagonists endure adversity, inspire those around them (or conversely, draw out the villains in their true colors) and upset the social order, this gracefully drawn series, on the whole, hit just the right note.

5. ***Buffy the Vampire Slayer Season Eight* Vol. 2: *No Future for You*** written by Brian K. Vaughan, penciled by Georges Jeanty and inked by Andy Owens (Dark Horse): Brian K. Vaughan's sure hand with the comics medium finally fulfilled *Season Eight*'s potential. In his tale about the painful process of redemption for rogue Slayer Faith, he managed to tell us where the character had been, ethically and emotionally, and where she's going, while hitting all the beats of an action-oriented supernatural story arc. Jeanty is also hitting his stride in regard to balancing character design versus actor likeness, and his action sequences both genuinely thrill and take full advantage of the sky-is-the-limit visuals afforded to the comic-book format. Well done.

6. *Explainers*: *The Complete* **Village Voice Strips (1956-66)** by Jules Feiffer (published by my employer, Fantagraphics): A coffee-table book in the truest sense of the term. I have a difficult time going through this book sequentially, but I love to flip through it and read flashes of Feiffer's insights, pinpointed neuroses and black humor. It's also fulfills another function of the coffee-table book: accessibility for readers not familiar with the genre or medium.

Honorable Mentions:
Britten & Brülightly by Hannah Berry (Jonathan Cape): This quirky little European-album-style mystery is the 25-year-old cartoonist's first book. Berry's pen-and-ink drawings, watercolored in somber grays, browns and purples, are assured, and her noir tale of big-nosed detective Britten and his pun-tastically named teabag partner

Brülightly (we never learn if Brülightly is "real" or not: my guess is no, but either way it's equally disturbing) doesn't lack for plot twists, double-crosses or femme fatales. While this promising work isn't at the best-of-the-year level, it's the one graphic novel this year that has me most excited about the cartoonist's next book.

The Quest for the Missing Girl by Jiro Taniguchi (Fanfare/Ponent Mon): A taut, minor thriller. The social commentary isn't all fresh, but Taniguchi's trademark detailed environments add flair to this book's exploration of the dangers posed by the natural world versus the city.

Fruits Basket by Natsuki Takaya (Tokyopop): You know how people say that if X doesn't move you, then you have a heart of stone? In this equation, X = *Fruits Basket*. The art, like the emotions of the characters, is all about nuance, no small feat for a series where the central premise resembles nothing so much as *Ranma ½* (a family cursed to turn into Zodiac animals when hugged by the opposite sex).

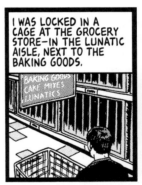
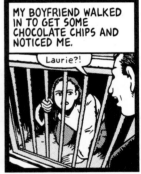
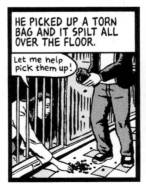
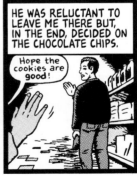

From "Lunatic Aisle" in Reklaw's *The Night of Your Life*.
[©2008 Jesse Reklaw]

Best of 2008 Master List

Acme Novelty Library **#18** Chris Ware (Acme) [Late 2007; also on last year's list]

Acme Novelty Library **#19** Chris Ware (Acme)

Against Pain Ron Regé (D&Q)

Age of Bronze **Vol. 3:** *Betrayal Part One* Eric Shanower (Image)

Alan's War Emmanuel Guibert (First Second)

Aldebaran **Vols. 1-2** Leo (Cinebook, Ltd.)

Aitienpaiva Amanda Vähämäki (Huuda Huuda)

All-Star Superman **#10-12** Grant Morrison & Frank Quitely (DC)

Amazing Remarkable Monsieur Leotard, The Eddie Campbell & Dan Best (First Second)

Anthology of Graphic Fiction, Cartoons, and True Stories **Vol. 2,** *An* Various; Ivan Brunetti, ed. (Yale University Press)

Arrival, The Shaun Tan (Arthur Levine) [late 2007 release: also on last year's list]

Batman **#676-681:** *Batman R.I.P.* storyline Grant Morrison & Tony Daniel (DC)

Beaton, Kate Web-comics katebeaton.com

Berlin **#15-16** Jason Lutes (D&Q)

Berlin **Book Two**: *City of Smoke* Jason Lutes (D&Q)

Berserk **Vols. 21-26** Kentaro Miura (Dark Horse)

Best American Comics 2008 Various; Lynda Barry, ed. (Houghton Mifflin)

Bottomless Belly Button Dash Shaw (Fantagraphics)

Boy's Club **#1-2** Matt Furie (Buenaventura)

Breakdowns Art Spiegelman (Pantheon)

Britten & Brülightly Hannah Berry (Jonathan Cape)

Buffy the Vampire Slayer Season Eight **Vol. 2:** *No Future for You* Brian K. Vaughan & Georges Jeanty et al. (Dark Horse)

"Call the Corners" Edie Fake

Call of the Wild: A Mutt's Treasury Patrick O'Donnell (Andrews McMeel)

Cat-Eyed Boy Kazuo Umezo (Viz)

Cartoon Dialectics **Vol. 1** Tom Kaczynski (Uncivilized Books)

Che Spain Rodriguez (Verso)

Closed Caption Comics **#7** Various (Self-published)

Coelacanthus **#15** Michael Connor (Self-published)

Comics Comics **#4** T. Hodler & Dan Nadel, eds. (PictureBox)

Complete Chester Gould's Dick Tracy **Vols. 4-5,** *The* (IDW)

Complete K Chronicles, The Keith Knight (Dark Horse)

Complete Little Orphan Annie **Vol. 1,** *The* Harold Gray (IDW)

Complete Peanuts 1967-1968, The Charles Schulz (Fantagraphics)

Complete Peanuts 1969-1970, The Charles Schulz (Fantagraphics)

Complete Terry and the Pirates **Vols. 2-5,** *The* Milton Caniff (IDW)

Crickets **#2** Sammy Harkham (D&Q)

Cryptic Wit **#2** by Gerald Jablonski (Self-published)

Daddy's Girl Debbie Drechsler (Fantagraphics)

DC Archives: Adam Strange **Vol. 3** Various; DC

DC Archives: Doom Patrol **Vol. 5** Various; DC

Deitch Gene, Kim, Seth & Simon Interview in *The Comics Journal* **#292** (Fantagraphics)

Deitch's Pictorama by Kim, Seth and Simon Deitch (Fantagraphics)

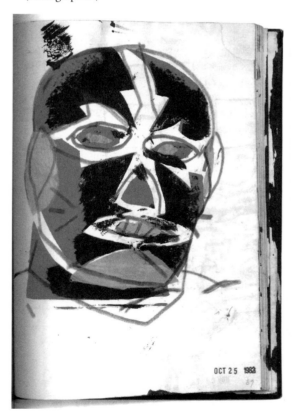

A sketchbook drawing collected in *Gary Panter* Vol. 2.
[©2008 Gary Panter]

From Clowes' "Sawdust" in *Kramers #7*. [©2008 Daniel Clowes]

DFC, The Various

Dix Fois/Kymmenen Kertaa Various (strips by Amanda Vähamäki, Jenni Rope & Pauliina Makela)

Donald Duck, The Barks/Rosa Collection Vol. 3 (Gemstone)

Education of Hopey Glass, The Jaime Hernandez (Fantagraphics)

Emma Vol. 7 Kaoru Mori (DC/CMX)

Essential Dykes to Watch Out For, The Alison Bechdel (Houghton Mifflin)

Explainers: The Complete Village Voice Strips (1956-1966) Jules Feiffer (Fantagraphics)

Final Crisis #1-7 Grant Morrison & J. G. Jones et al. (DC)

Freedom Comics Various; Coco Wang, ed. (Coco Wang)

Funny Humor Bendik Kaltenborn & Kristoffer Kjolberg

Fuzz and Pluck: Splitsville Ted Stearn (Fantagraphics)

Ganges Vol. 2 Kevin Huizenga (Fantagraphics)

Garfield Minus Garfield Jim Davis & Dan Walsh (Ballantine)

Gary Panter Gary Panter (PictureBox)

Gauld, Tom strip in *Kramers Ergot* #7 (Buenaventura)

Gentleman Jim Raymond Briggs (D&Q)

Goddess of War #1, *The* Lauren Weinstein (PictureBox)

Golden Age Comic Book Stories (website) portfolio of illustrations by Dugald Stewart Walker "for the The Boy Who Knew What the Bird Said"

Good-Bye Yoshihiro Tatsumi (D&Q)

Gus Chris Blain (First Second)

Hank Ketcham's Complete Dennis the Menace 1957-1958 Vol. 4 (Fantagraphics)

Harvey Comics Classics Vol. 4: *Baby Huey* (Dark Horse)

Herbie Archives Vol. 1 Shane O'Shea & Odgen Whitney (Dark Horse)

High Five Bendik Kaltenborn & Kristoffer Kjolberg

How To Love Actus Comics (Actus Independent Comics)

Hoytiden Rui Tenreiro (Jippi Forlag)

Injury Ted May, Jason Robards and Jeff Wilson (Buenaventura Press)

Inkweed Chris Wright (Sparkplug Comics)

International Journal of Comic Art Various; John A. Lent, ed.

J. Edgar Hoover Rick Geary (Hill and Wang)

Journey William Messner-Loebs (IDW)

Kaput & Zösky Lewis Trondheim & Eric Cartier (First Second)

King-Cat #69 John Porcellino (Self-published)

Kinship Structure of Ferns, The Dewayne Slightweight (Self-published)

Krazy & Ignatz: 1943-1944 George Herriman (Fantagraphics)

Kramers Ergot #7 Various; Sammy Harkham, ed. (Buenaventura)

Kuti Kuti Various (Huuda Huuda)

Lagoon, The Lilli Carré (Fantagraphics)

Last Musketeer, The Jason (Fantagraphics)

Laterborn #6 Jason Martin (Self-published)

Little Nemo In Slumberland: Many More Splendid Sundays Vol. 2 Winsor McCay (Sunday Press Books)

Little Nothings: The Curse of the Umbrella Lewis Trondheim (NBM/ComicsLit)

Love and Rockets: New Stories Los Bros. Hernandez (Fantagraphics)

Maakies with the Wrinkled Knees, The Tony Millionaire (Fantagraphics)

Middle of the Ocean Lydia Conklin (Self-published)

Mineshaft [#20-21] Various

Mome Various; Eric Reynolds and Gary Groth, eds. (Fantagraphics)

Monster Men Bureiko Lullaby Takashi Nemoto (PictureBox)

Moomin Vol. 3 Tove Jansson (D&Q)

More Old Jewish Comedians (A **Blab!** *Storybook)* Drew Friedman (Fantagraphics)

Nana #8 Ai Yazawa (Viz)

Night Business Benjamin Marra (Self-published)

Night of Your Life, The Jesse Reklaw (Dark Horse)

Or Else #5 Kevin Huizenga (Drawn & Quarterly)

Palookaville #19 Seth (D&Q)

Parasyte Vols. 3-5 Hitoshi Iwaaka (Del Rey)

People's History of American Empire, A Howard Zinn (Metropolitan Books)

Petey and Pussy, John Kerschbaum (Fantagraphics)

Popeye Vol. 3: *"Let's You and Him Fight!"* E. C. Segar (Fantagraphics)

Potential Ariel Schrag (Touchstone)

Portable Frank, The Jim Woodring (Fantagraphics)

Powr Mastrs CF (PictureBox) [November release: also on last year's list]

Red Colored Elegy Seiichi Hayashi (D&Q)

Rick Random: Space Detective Steve Holland, ed. (Prion)

Rumble Strip Woodrow Phoenix (Myriad Editions)

Sam & Max: Surfin' the Highway Steve Purcell (Telltale Inc)

Scorchy Smith and the Art of Noel Sickles (IDW)

Showcase Presents: The Brave and the Bold Bob Haney; Various (DC)

Skim Jillian and Mariko Tamaki (Groundwood)

Skyscrapers of the Midwest Josh Cotter (AdHouse)

Solanin Inio Asano (Viz)

Speak of the Devil Gilbert Hernandez (Dark Horse)

Spider-Man and the Fantastic Four: Silver Rage Jeff Parker & Mike Wieringo (Marvel)

Spirit World, The Conor Stechschulte (http://closed-captioncomics.blogspot.com)

Stew Brew #3 Kelly Froh & Max Clotfelter

Strange and Stranger: The World of Steve Ditko Blake Bell (Fantagraphics)

Tamara Drewe Posy Simmonds (Mariner/Houghton Mifflin)

Tales Designed to Thrizzle #4 Michael Kupperman (Fantagraphics)

Ten-Cent Plague: The Great Comic Book Scare and How it Changed America, The David Hajdu (Farrar, Straus & Giroux)

Thoreau at Walden John Porcellino (Hyperion)

Three Shadows Cyril Pedrosa (First Second)

Tokyo Zombie Hanakuma (Last Gasp)

Travel Yuichi Yokoyama (PictureBox)

Treno, Il (the Train) Chihoi-Hung Hung (Canicola)

"We Are the Fae and There Is No Death" *Meatcake* #17 Dame Darcy (Fantagraphics)

What It Is Lynda Barry (D&Q)

Where Demented Wented Rory Hayes; Dan Nadel & Glenn Bray, eds. (Fantagraphics)

Wizzywig Vol. 1 Ed Piskor (Self-published)

World War 3 Illustrated #38 Various [Late 2007]

xxxHolic Vol. 12 CLAMP (Del Rey)

Wormdye Eamon Espey (Secret Acres)

You Don't Get There from Here #9 Carrie McNinch

Zot!: The Complete Black and White Collection: 1987-1991 Scott McCloud (Harper Collins)

Honorable Mention:

Lynda Barry, Jessica Abel and Matt Madden, eds. *Best American Comics 2008* (Houghton Mifflin)

Marguerita Abouet and Clement Oubrerie *Aya of Yop City* (D&Q)

Paul Buhle *Jews and American Comics* (New Press)

Dan Nadel & Ben Jones, eds. *The Ganzfeld 7* (Picturebox)

Jiro Taniguchi *The Quest for the Missing Girl* (Fanfare/Ponent Mon)

Natsuki Takaya *Fruits Basket* (Tokyopop)

■

From "Can't Buy Me Love," first published in *Zot!* #21.
[©2008 Scott McCloud]

An Interview with David Hajdu

Conducted by R. Fiore

Looming in the background of any writing about mass entertainment is the question, "If you're dealing with art that's designed to be accessible to as many people as humanly possible, what do you need a critic for?" There could hardly be a better answer to that question than David Hajdu's *The Ten Cent Plague,* a history of the crusade to ban crime and horror comics that recreates the commercial context in which an art form developed. Here in what we must, in all honesty, still call the fan press, we've created a kind of folk scholarship built out of interviews and memories. In his book, Hajdu applies the best methods of scholarship and journalism to the subject, finding primary sources and matching anecdote to the factual record. For those of us to whom the story was part of the furniture of our inner lives, the book clears away a lifetime of fuzzy memories. The general reader was introduced to a fascinating stretch of cultural history they never dreamed existed, the Battle of Manassas in a cultural Civil War that would shape their lives. In his introduction, Hajdu writes, "The comic-book wars was one of the first and hardest fought conflicts between young people and their parents in America, and it seems clear, too, now, that it was worth the fight." What actually seems clear is that the defeat in this battle had little effect in the final outcome of the war. The thing that we often forget, which Hajdu reminds of us first and last, were the casualties in this battle, the dozens of people who were deprived of the one opportunity they had in their lives to be artists.

The interview was conducted in late November and early December of 2008 via e-mail, as will become apparent. Mr. Hajdu does not speak in charts. For my part, I spent almost the whole time learning more things I didn't know.

R. FIORE:

When you were working on the book did you or your editors have any idea of what kind of chord it was going to strike? Any sort of "we have a hit on our hands" feeling beforehand?

DAVID HAJDU:

Oh, no. I'm very lucky to be published by Farrar, Straus & Giroux, which is a scholarly and literary house focused on writing to the point of obsession. The place is not quite indifferent to the market; but it's hardly driven by the market. My editor is Paul Elie, and he's a serious writer, as well as an editor. He did a superb study of four 20th-century Catholics: Dorothy Day, Thomas Merton, Flannery O'Connor, Walker Percy. Paul and I worked closely for about seven years on the book that became *The Ten-Cent Plague*, and I can't remember us talking once about sales.

I know that some important works of literature and a lot of great comics were created with the market in mind: Robert Graves wrote *Good-Bye to All That* and Eisner did *The Spirit* with the intent to reach broad audiences. So I know that attention to the market is not necessarily corruptive. That said, I try not to think about the market when I'm doing the research and writing I do. For me, that kind of thinking gets in the way of the work.

You've probably answered my question, but I was actually thinking more about the critical acclaim than sales. (I wasn't even sure to what extent the acclaim had translated into sales.) This does raise a question: Does a scholarly and literary house focused on writing (and thank Christ there still is one) concern itself with critical reaction either?

I very much wanted the book to be taken seriously, just as many of the comics artists I interviewed — espe-

From the July 27, 1941 strip collected in *Will Eisner's The Spirit Archives* Vol. 3. [©2001 Will Eisner]

cially Eisner — wanted what they did to be thought of as grown-up work, and I'm very lucky that my book was taken seriously, even by a few critics who didn't like it or didn't agree with it.

What was the state of your knowledge of comics and comic books when you began the project? How much of a reader were you in youth, and did you continue to read any into adulthood?

I was a huge comics fan, and I still am. I grew up reading both newspaper comics and comic books — Silver Age stuff, almost exclusively DC, but also *Little Lulu*, which I loved, and sometimes the Archie books. I used to cut out the *Dick Tracy* dailies — this is in the era of the Moon Maid stories — and paste them onto typing paper to make my own comic books. I used shirt cardboard to make covers and white first-aid tape for the binding.

In ninth grade, I was accepted into Mr. Tomaino's Accelerated English class, and, being a nerd, I was very excited about this. The final project of the year was a term paper on a great writer, and each of the students had to present his or her idea in front of the class. I still remember standing up there and doing my proposal to write about Charles Schulz. I felt radical and experimental. An old friend of mine from that class, Tom McNulty, who's now a fine-art scholar, still teases about how goofily, defensively pretentious I was when I gave that presentation. The paper was awful, but I was on my way.

My love for comics led me to draw. By the time I was

a sophomore in high school, I was doing a pseudo-underground comic that was published in my school paper: *The Endless Odyssey of Skip Toomaloo*. In fact, the first things I had professionally published, while I was in high school, were cartoon illustrations for my local paper, the *Easton Express* (in Easton, Pa., across the river from my hometown of Phillipsburg, N.J.). The work was terribly derivative — one piece looked like bad Foster, another like bad Infantino.

Later, I went to NYU and settled in Manhattan. I met my wife one afternoon on the Lexington Avenue subway line. She sat down next to me, and she was reading Strindberg — *Miss Julie* — and I was reading a Batman comic.

This spring, I did a reading in New York, and during the Q&A, someone asked me a question about Spider-Man. I said, "To this day, I've never read a Spider-Man comic," and I could see that a few people in the crowd were appalled. Afterward, my son Jake came up to me and he said, "Dad, you really blew that Spider-Man question."

I said, "But I don't read *Spider-Man*."

Jake said, "Dad, who was Superman's double in the bottled city of Kandor?"

I said, "Van-Zee."

I could have added that Clark Kent's double was Vol-Don. I was a DC kid, and I just never developed a taste for Marvel comics, with the exception of Daredevil.

Gene Colan Daredevil or Frank Miller Daredevil?

I admire Colan, and I'm grateful to him for giving me a long interview for *The Ten-Cent Plague*. He talked to me candidly and at length, mainly to deepen my understanding of the world he populated.

With no slight to Gene's work, Miller's *Daredevil* speaks to me because of its grit and veracity. There's a lot of the Spirit in Miller's *Daredevil* — just look at Elektra, who's essentially a renamed Sand Saref. No Stilt-Man or the Owl, but hoods and madmen.

I read in the acknowledgments that the project began at the University of Chicago and carried on into other institutions. Can you tell me a little bit about the genesis of the project, how it started and how it grew?

It's hard to pin down the genesis of the book, because I had in mind since my college years to do something some day on the history of comics. What exactly that something would be, I didn't know until I was knee-deep into my preliminary interviews with early comics artists and writers. *The Ten-Cent Plague* is not a thesis book; I didn't start out with an idea to prove, in search of the evidence to support it. I started out with an ardent curiosity about the world of early comics, and, through the work I had done on postwar popular culture for my second book, *Positively 4ᵗʰ Street*, I had begun to understand that comics were, in certain ways, precursors to rock 'n' roll.

I had an appointment to the University of Chicago as Nonfiction Writer in Residence, and it was there that I began working diligently on the book. One of the responsibilities of my post was to give a big public lecture, and I was terrified, because of the university's reputation for scholarly rigor. I decided to give a talk about Will Eisner, drawing in part from a critical essay I had written about Eisner for *The New York Review of Books*. At the conclusion of the lecture, a professor from the English department approached me. He was writing a paper on serial form in popular literature, he explained, and he was studying the various strategies Superman used to trick Mr. Mxyzptlk to say his name backwards, so Metropolis would remain in a state of normalcy at the beginning and end of every story. When this professor pronounced "Mxyzptlk" flawless, effortlessly, I knew I was in serious company.

The thing that most surprised me in the book (if I'd known it I'd forgotten it) was that there had been a full-scale dry run complete with hearings on the crime comics before the horror comics. What did you discover that most surprised you?

Quite a bit. I was stunned to find that there was so much legislative and quasi-legislative action against comics — 50 acts on the municipal level by the end of 1948 and more than a hundred laws on the books by 1954. The first draft of my book had a lot more detail on that legislation. As a matter of fact, there were originally 6,000 words more — essentially, a full chapter's worth of text, which I decided to cut, mainly because it was repetitive. I figured out, in the writing, that a good account of one of the statehouse debates over comics could stand in for many of them.

I was also staggered to find that there were so many organized protests against comics for such a long period — public burnings from December 1945 to 1955. Ten years of kids led in public burnings of comics, not just a few incidents in the provinces.

You seem to have researched a lot of things that I've been content to merely surmise. One thing I surmised is that much of the hysteria of the anti-comics movement stemmed from frustration at learning these things couldn't just be banned. So from your research, (a) Did these hundred pieces of legislation do anything to significantly reduce the number of crime or horror comics published (other than encouraging the Code)? And, (b) if not, did the failure of these laws fan the flames of the movement?

The legislative action to control comics had two major phases, and both were consequential, the second far more so than the first.

Beginning in 1948, municipalities and states acted to restrict the sale of comics mainly on the grounds of public safety. That first wave of regulations and laws focused primarily on crime comics, on the grounds that the depiction of criminal acts in the panels might inspire their readers to act criminally. Before long, most publishers shifted the tone of their crime titles or discontinued them. Only two newsstand dealers were actually arrested for selling crime comics, as far as I know; but the legislation against crime comics, in concert with the atmosphere of panic over their role in changing juvenile mores, led publishers away from crime.

They turned to other genres, including horror and romance, proceeding blithely on the misconception that only crime comics could qualify as criminal. The second wave of regulations and bills aimed at comics targeted horror and romance — yes, romance, as hard as that may seem to believe today — as well as crime, on the grounds of defending public welfare and even public health. The debates in the statehouses centered on the alleged dam-

age horror and other genres had on youth minds, and the effect of this legislation was devastating to the comics industry. I go into this is some detail in my book, as you know.

Another thing that impresses me from your account is the role of local community groups in the anti-comics movement. I was wondering if, apropos of the "Bowling Alone" theory, you think the decline of censorship had anything to do with a decline of these community groups?

Yes, absolutely. Also, the groups declined in part because their work was done. They had successfully driven all the provocative comics off the newsstands.

So the community groups were more dedicated ad hoc organizations against comics rather than campaigns by established organizations like the local PTA?

I wouldn't measure one against the other in terms of dedication. They were all pretty zealous.

How important a figure was Fredric Wertham to the movement? Would it have been different without him?

When I started my research, I wondered if the hysteria over comics would have happened without Wertham, and I was surprised when I found that it *did* happen without him — that is to say, it began quite a while before he joined it. Wertham became important as a catalyst and as the public face of the campaign against comics. But he didn't start it; in fact, he didn't emerge as a prominent critic of comics until 1948, a full eight years after Sterling North, the children's author and book critic, wrote the newspaper column ("A National Disgrace") that was the manifesto of comics critics.

North sounded like Wertham before Wertham did. He called comics "badly drawn, badly written and badly printed — a stain on young eyes and young nervous systems," and he describe the "effect" of comics as "that of a violent stimulant." He charged comics publishers with being "guilty of cultural slaughter of the innocents," foreshadowing the title of Wertham's book by 14 years, while echoing the criticism of turn-of-the-century newspaper strips. That first piece of North's on comics (and it was only the first) was reprinted in 40 newspapers around the country, as well as in the journal of the National Parent Teachers Association.

A few years later, a Jesuit priest named Robert E. Southard took up the crusade against comics, making the first charge, in print in 1944, that comics were "largely

responsible for juvenile delinquency." Parochial schools distributed a list of "objectionable" comics that Southard made, and they used it to organize protests against comics and public burnings as early as 1945, three years before Wertham turned his attention to comics.

Wertham and the comics crusade — or, more accurately, the multiple crusades against comics — are not interchangeable. Still, he became important as one of the most visible and impassioned critics of comics, and his criticism carried special weight because he was a psychiatrist.

Could you pinpoint when Wertham came to eclipse the other figures in the movement, and become its personification?

By 1949, Wertham had become the most vocal critic of comics.

Do you suppose Wertham's motives were impure in any way? Was publicity purely a means to altruistic ends or did he in any degree seek it for its own sake?

Impurity is a conception more in Southard's area of expertise than in mine. (I thought of becoming a priest when I was young, but I gave up the notion at puberty. I think I spent too much time ogling Wonder Girl to go in for celibacy.) As for Wertham, he clearly had an appetite for attention, and he understood how to use the media. I don't think he was an evil man, though. He was a social idealist, and he did some valuable work, apart from what he did in the area of comics.

Another book about Wertham repeats at face value Wertham's charges of harassment by the comics industry, including having him and his employees followed by private detectives, and the thought that came to me as I was reading it was "If Hajdu were writing this he would have interviewed the detectives." In your own research did you ever actually try to confirm any charges of this nature?

There is a serious danger in taking at face value anything attributed to Wertham — or to North or to Southard or, for that matter, to Eisner or to Gaines or to any other human being. Wertham's claims to have been stalked by private dicks are impossible to check, of course. That is not to say they're true or untrue. An important rule of historical research is that the absence of evidence is not evidence of absence. There's just no way of knowing if Wertham was hunted by shadowy predators. All we know is that he claimed to be, and that fact is only moderately interesting.

From *Daredevil: Born Again*, written by Frank Miller and dawn by David Mazzucchelli. [©1987 Marvel Entertainment Group, Inc.]

Does it seem to you that in *The World of Fanzines,* Wertham was trying to make amends in some way?

That's certainly the standard reading of that text, and I'm inclined to agree.

One figure I found particularly interesting was Lauretta Bender[1], who was almost the Anti-Wertham. Your book doesn't go into great detail about her, but I was wondering if you did any research on her and what your impressions were.

I agree — she is fascinating! Her papers are in repository in the Special Collections division of the Brooklyn College Library, and I spent a few days studying them. If you were obsessive enough to have read the endnotes of my book, you might have noticed that I quoted a paper on the benefits of comic-book reading that she (and a colleague of hers, Reginald S. Lourie) gave to the American Orthopsychiatric Association in 1941. The paper

was mentioned only briefly in the press, misquoted and dismissed as "high-sounding." Bender is worthy of much more study.

Other than aggravating a propensity for antisocial behavior or the general coarsening effect, did any legitimate authority identify any specific psychological damage reading morbid or gruesome material such as the horror comics might have on a child?

There were several serious studies of comics reading and scholarly papers on the subject published in the late 1940s, and most of them came to the conclusion that comics did no particular harm to young minds. For instance, the November 1948 edition of the *Journal of Educational Research* included a study of 635 elementary-school kids in Farmingdale, N.Y., and it found no "significant differences between those children who read comic books, attended moving pictures, and listened to radio programs to the greatest extent and those who participated in these activities seldom or not at all."

In December 1949, after the early peak of hysteria over comics in 1948, the *Journal of Educational Sociology* devoted an entire issue to comics, and all the papers in the

1. Child psychologist for Bellevue Hospital in New York City from 1930 to 1956, she authored or co-authored several papers on children and comic books, was engaged as an editorial consultant by DC Comics, and testified before the Senate hearings on juvenile delinquency.

journal were tempered or positive about comics. This issue included a couple of fervent defenses of comics and critiques of Wertham's methods, including "The Comics and Delinquency: Cause or Scapegoat," by Frederic M. Thrasher of NYU. As Thrasher wrote, "In conclusion, it may be said that no acceptable evidence has been produced by Wertham or anyone else for the conclusion that the reading of comic magazines has or has not a significant relation to delinquent behavior."

Being a parent I assume you found yourself in the position of deciding what sort of things to forbid your child. If it's not too personal, what sort of lines did you draw, and at what point would you let a child have adult freedom of choice?

My wife and I have tried to have a household with high moral values and few laws. We don't so much draw lines as establish areas that we support. If that sounds like New Age double-talk, I'm not getting across our attitude. We have a 5-year-old, and we wouldn't surprise him with a toy Uzi for his birthday. But if he really wanted a water gun, we'd let him have one. His older brother plays GTA [Grand Theft Auto], and he's not stealing actual cars, so we don't stop him. Hong Kong action movies? Sure. Snuff films? No!

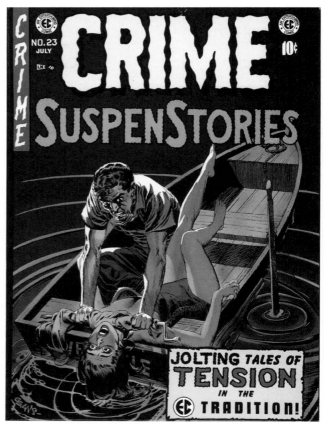

Cover art by George Evans. [©1983 William M. Gaines]

We had a discussion on the *Comics Journal* message board sparked by a review of *The Ten Cent Plague* that remarked on a "proliferation" of images of violence against women that came with the horror comics. My reaction to this was that (a) though women took their lumps the violence in horror comics (including *Crime SuspenStories*, which essentially became a horror comic without supernatural elements), the violence was directed predominantly against male characters (if only because they could take more punishment) and (b) given the wholesale slaughter male characters were subjected to, complaining about the violence against women seemed like a perverse kind of chivalry. (Leaving aside the fact that images of violence against women had proliferated far more on the covers of pulp-fiction magazines, where they were a staple.) However, my impressions were based almost entirely on EC comics. Was violence against women more prevalent in the other publishers' books?

You might be defining violence more narrowly than I would. Bondage and subjugation are acts of violence to me. Yes, guys got punched and shot up more than women; but females were bound and threatened with torture and sexual abuse more than males. Psychological violence is a real form of violence, and women were the primary victims of it in pre-Code comics.

Point well taken, but the other question I was meaning to ask here is: Was there stronger meat to be found in the non-EC horror comics?

Absolutely! I'm sure you've seen the vile things published by Stanley P. Morse. They made EC look like Dell.

I read recently in an interview with one of his co-workers that, during the EC era, Johnny Craig was having a really hard time with his wife, which has got to be one of the least surprising revelations of all time. Did you

come across that information in your research?

Yes, I heard about that from Jack Kamen and Al Feldstein. But ... I think there's a danger in reading too much into that. Kamen was happily married, and he was awfully good at drawing murderous, conniving husbands and wives.

The assumption is that in those days comic books were bought almost exclusively by children, an assumption you appear to concur with. At least some comic books were read by adults, who were not likely to advertise the fact. The question I want to ask is: Did anybody actually keep track of who was buying comic books? Is the anecdotal evidence that only children read comic books so overwhelming that there's just no reason to doubt it?

There were a few half-decent studies of comic-book readership in the Pre-Code era. For example, in September, 1947, the *Library Journal* published the results of a survey conducted by a group called the Market Research Company, and this is what it found about comic-book readership:

Age	Male	Female	Copies Read
6-11	95%	91%	12-13 per month
12-17	87%	81%	12-13 per month
18-30	41%	28%	7-8 per month
31 +	16%	12%	6 per month

To me, those figures are striking on a couple of levels. First, they show that virtually all kids read comics at the time — to be a kid was to be a comics reader. More surprising, perhaps, is the high number of adult readers — 41% of men between 18 and 30!

This is really interesting to me because one of the more substantive studies done during the crime-comics era was Thomas Hoult's paper "Comic Books and Juvenile Delinquency," in which the comics-reading habits of 235 minors arrested for juvenile delinquency were compared to those of 235 who had escaped detection. The results, as they were paraphrased when I read them, were that the delinquents had read 2,853 comics considered harmful and the non-delinquent group had read 1,786, and I couldn't figure out if this meant 2,853 each or 2,853 altogether. Triangulating from the *Library Journal* study this must have been a month's reading for each group, which meant the juvies read

12 harmful comics per month and the squares read 7.6. Which would seem to indicate that the threshold for depravity was eight crime comics per month.

Funny!

Another thing your book brought up that I for one had never fully considered was that the effect of the enforcement of the Comics Code had, above and beyond the specific strictures of the Code as written. The effect of any censorship regime is that it gives every artist a censor for a collaborator, but this was not so much being nibbled to death by ducks as being torn apart by harpies. Could you guess how much of the decline of sales of comics was because Code enforcement made them worse? Could you rank the factors in the decline (rise of TV, general stigma, enforced lousiness, etc.)?

I don't think anyone could rank those factors on hard evidence. They were acting simultaneously and feeding one another. ("Enforced lousiness!" That should have been the motto on the little Comics Code stamp.)

Suppose there had been a soft landing, that the horror comics controversy had petered out the way the crime comics controversy had, with no censorship regime put in place. What do you imagine the history of American comic books would have been like?

It couldn't have happened. If it could have, it would have. There were too many forces working in concert against comics at the time. Had the impossible happened, I suppose comics might have matured earlier. Manga would have an American name.

Do you see yourself ever returning to the subject of comics and comic books in a major way in the future?

Yes, yes — I've been doing critical pieces on comics (as well as occasional profiles) for years, and I plan on writing about comics as long as I'm writing. I'm putting together a collection of my essays for publication next year, and the main piece will be a long thing I've been writing on comics and film. (The title of the book will be *The Army of the Knights*.) I'm also working with a collaborator — the painter John Carey, who's an old friend of mine from college — on an actual *comic* at book length. I'd tell you what it's about, but we're having a little trouble figuring that out. ∎

Why 2008 Was A Very Good Year

by R.C. Harvey

Ol' Blue-Eyes may not have thought it was all that much of a year, but I thought it was terrific, partly, albeit not entirely, because Berke Breathed fled the funnies in November. But 2008 was also a good year for those of my ilk who chronicle the medium: A spate of books of historical ßportents surfaced this year.

The year's best contributions to our grasping the history of the medium were: a facsimile of the legendary Landon Course, a one-volume incarnation of Brian Walker's two monumental fact-jammed histories of newspaper comic strips in the 20th century, the Jackie Ormes biography, a compendious reprinting of all of Bill Mauldin's World War II cartoons, and an equally encyclopedic collection of Noel Sickles' watershed 1930s strip, *Scorchy Smith*.

Like John Garvin, I've heard all my adult life of the "Landon School" and its famed correspondence course in cartooning, in which, it seems, almost every cartoonist of a certain vintage had matriculated — from Carl Barks to Chic Young, with Milton Caniff, Jack Cole, Edwina Dumm, Floyd Gottfredson, V.T. Hamlin and Bill Holman, Edgar Martin and Bill Mauldin, and Gladys Parker and Allen Saunders scattered in between. With alumni like that, I thought, Charles N. Landon's cartooning course must've been music of the spheres, and I yearned to know what it was like, exactly.

Unlike me, Garvin was not content merely to yearn: He wanted to witness the entire course, and, when not teaching himself to paint funny fantasy animals in the manner of Carl Barks (which he now does with great skill, see johngarvin.com), he kept delving into obscure catalogs of auction-house offerings and scouring the Web until, at last, he found a complete copy of Landon's course as it was issued in 1922. And then he published it in facsimile, ***The Landon School of Illustrating and Cartooning*** (246 8.5x11-inch pages in paperback; $21.95 from Garvin's EnchantedImages.com). The book is not only an excellent antique peek into cartooning history: It's also a superlative instructional tome, one of the best of its kind even today.

Born Dec. 19, 1878, Landon the Legend grew up in Ohio and eventually went to work for *The Cleveland Press* from 1900 to 1912. In those years, a newspaper staff artist drew everything from borders around halftones to depictions of sensational courtroom dramas, as well as cartoons and caricatures and representations of local natural disasters: Like other staff artists of the day, Landon was often a pictorial reporter.

His last five years at the paper, he managed the art department. That's how he learned how to develop talent, Garvin tells us, an insight that gave him the idea of running a correspondence course in cartooning, which he launched in 1909.

Landon eventually became art director of the Newspaper Enterprise Association, one of the largest syndicates supplying comics and feature material to newspapers. And he continued operating his correspondence course, which now functioned to screen talent for syndication: If Landon saw a good cartoonist among his students, he would wait until the student graduated, then sign him up with NEA. And if the new recruit was successful, Landon's promotional material claimed the success was a direct result of taking the course. Which, strictly speaking, was almost true — even if the talent was inherent with the student rather than acquired through diligent course work.

Landon died May 17, 1937, and Garvin doesn't know if the Landon Course survived its founder's death. It did. Editorial Cartoonist Jim Ivey, now retired, remembers taking it in 1946. But for our present purposes, that doesn't matter. This facsimile is ample demonstration of what I've always wanted to know: What was the course like?

The Landon Course was, beyond dispute, very good. Very nuts-and-boltsy. Practical. Just exactly what anyone seeking to become a newspaper cartoonist needed to know. Each of the 29 lessons of the 1922 Course included several sheets (or "plates," as Landon called them) of illustrative material and numerous typewritten pages of discussion and instruction, dovetailing exactly with the accompanying pictures.

At the end of the text lesson, Landon gave the student an assignment. Here's part of the assignment from the "Action" lesson: "Use Fig. C of Group 1 on Plate 3 as a guide and draw a fat policeman in uniform pointing a pistol. Bear in mind in drawing this figure that his position is between a front and a side view."

After completing several drawings according to Landon's written specifications, the student sent them back to Landon. At the "Landon School," the drawings were corrected and/or commented upon by an artist Landon had hired — or, if the student had paid the extra stipend, by Landon himself.

Testimony from some of Landon's famous graduates, which Garvin quotes profusely, was universally enthusiastic about the course, how good it was, how professional, how valuable. But few actually completed the course. "I never finished it," Milton Caniff said, " — nobody ever did — because I got a job as an artist. Then, who needed the thing?"

Garvin's book is history on the hoof; Brian Walker's is a copious recitation of the facts and acts that, upon reflection, we call history.

Sensing that the history of newspaper comic strips since World War II had, by the end of the 20th century, been severely shortchanged, Walker researched and wrote *Comics Since 1945* (336 9x12-inch pages, in black-and-

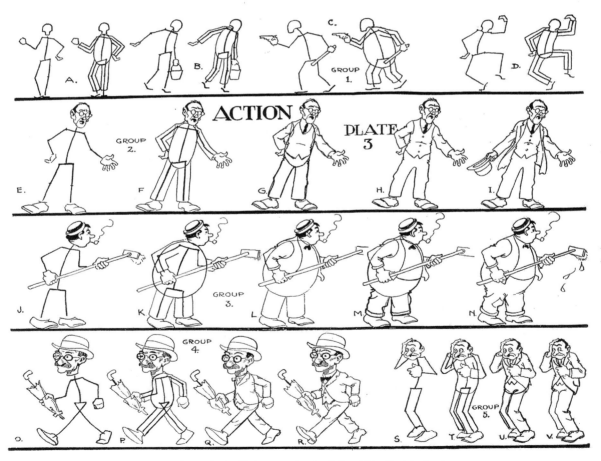

From *The Landon School of Illustrating and Cartooning* by Charles N. Landon. Facsimile published by John Garvin.

white and color; hardcover, $49.95), a book so well-received that its publisher, Abrams, prevailed upon Walker to revisit that portion of the history of comic strips that others had covered in previous books but not as well, not as thoroughly, not as fact-packed, not as profusely illustrated. And so Walker researched and wrote *Comics Before 1945* (336 9x12-inch pages, b/w and color; hardcover, $50), a suitable companion for its predecessor.

These twin tomes are the best histories of the medium around; I reviewed them separately when they first appeared in 2002 and 2004 (in #253 and #274 of the *Journal*). But the reason they are now, in 2008, back on a list of the Best of the Year is that Abrams has re-issued both books as a single volume, priced, affordably, at $19.99 — available only at Borders stores, though. Nowhere else. All of the content of each book is here, every detail (a few of which — very few, scarcely worth mentioning — the inadvertently erroneous ones, have been corrected). The combined volume bulks not much larger than either of the first two: just shows what using slightly lighter-weight paper will do. ***Comics: The Complete Collection*** is not only one of the best books on its subject ever, but this year, it's the Best Buy of 2008.

Nancy Goldstein's biography ***Jackie Ormes: The First African American Woman Cartoonist*** (264 8.5x11-inch pages, some in color; hardcover, U. of Mich. Press, $35) chronicles Ormes' life and presents a healthy sample of her work: a weekly comic strip in daily format, *Torchy Brown in "Dixie to Harlem,"* May 1, 1937 - April 30, 1938; *Candy,* a panel cartoon about a wise-cracking housemaid, March 24 - July 21, 1945; another panel cartoon, her longest running, *Patty-Jo and Ginger,* Sept. 1, 1945 - Sept. 22, 1956; and, concurrently, a Sunday comic strip in color, *Torchy Brown in Heartbeats,* Aug. 19, 1950 – Sept. 18, 1954, often accompanied by *Torchy's Togs,* in which Torchy appeared as a paper doll with an impressive wardrobe arrayed around her, demurely attired in her undies or a swimsuit — she was, in short, a pin-up, bearing a remarkable resemblance to her diminutive creator.

The biographical text takes only about 90 pages, most of the remainder of the volume being devoted to reprinting healthy samples of Ormes' panel cartoons and strips, many not seen since their initial publication in black newspapers — enough of each that, for the first time, we have a good idea of just how, for instance, Torchy Brown's 1950s incarnation was different than her initial appearance in the 1930s: The latter was a humorous continuity about a small-town girl venturing into the big city; the former, a serious adventure strip, in which Torchy is menaced more than once by would-be rapists.

It was in *Patty-Jo and Ginger* that the cartoonist often took a stand on many of the controversial political and cultural issues of the day, speaking openly and critically about racial bigotry, the arms build-up and current foreign policy, and in favor of voter awareness and feminist concerns.

The section reprinting *Patty-Jo and Ginger* is the longest in the book, 44 pages with two cartoons to a page, each extensively annotated by Goldstein, who explains the social context of the comedy. Having never beheld this feature before, I was intrigued by its visual rhetoric. Patty-Jo, a girl of about 8 or 9, gets all the lines, often speaking out against racism or some other societal hang-up, while her older sister, Ginger, a statuesque beauty, never talks at all: she is just there, standing or posturing in ways that display her admirable figure or her high-fashion frocks. Ginger, in other words, is a pin-up, Ormes' canny come-on that seduced readers, female (for the fashions) as well as male (for the sex appeal), so Patty-Jo could lay short, socially conscious sermons on them.

"Hey, Sis, Lookit! For saying NOTHING but NOTHING all last year, 'Cartoon Nuts, Inc.,' have voted you MISS YUMMY DUMMY of 1947!"

Patty-Jo and Ginger panel. [©1947 Jackie Ormes Features]

Despite its seeming brevity, this book is excellent, a revealing and thoroughly documented glimpse into African-American life of the times, the racist mores of the era, and the professional and personal life of a little-known but oft-celebrated figure in the history of American cartooning. Goldstein is scholarly without being pedantic, performing extensive research into the existing record of Ormes' oeuvre and interviewing the cartoonist's surviving relatives, who, upon learning of Goldstein's interest, shared family stories, newspaper clippings and photographs.

I haven't read all of IDW's big book, **Scorchy Smith and the Art of Noel Sickles** (394 giant 11x11-inch pages, some in color, with a sewn-in bookmark ribbon; hardcover, $49.99), but it's undeniably encyclopedic. On pages 144 to 381, it reprints Sickles' run (Dec. 4, 1933 – Nov. 21, 1936) on the Associated Press comic strip that he made famous by experimenting with drawing styles, one of which was the celebrated chiaroscuro technique adopted by his friend and studio-mate, Milton Caniff, for *Terry and the Pirates*.

Having this panoply of artistic endeavor before us all at once between the covers of a single tome would make the book treasure enough, but it is all prefaced with a long biographical essay by Bruce Canwell, copiously illustrated with Sickles' teenage artworks and then some of the comic sketches he made of Caniff during the years they shared a studio, followed by a generous and impressive selection from the hundreds of illustrations, in color as well as in black-and-white, that Sickles made for magazines and advertisements during a long career. Nowhere else can we find as much of Sickles' work outside of the *Scorchy Smith* comic strip.

This impressive and valuable work concludes on a poetic grace note. Sickles didn't like doing *Scorchy Smith* very much: He hungered for other artistic challenges. In the last strip he did, he may have signaled his feelings at leaving *Scorchy:* a character frees a pigeon from its cage, and the bird, unfettered at last, takes flight. So did Sickles.

The best book about war, *Up Front*, was written by cartoonist Bill Mauldin as padding for a collection of his cartoons about life in the trenches during World War II in Europe. What few of us realized upon first opening that volume is that Mauldin's oeuvre of Army-life cartoons is much larger than the contents of *Up Front* suggest. The book culls Mauldin's cartoons about hook-nosed Willie and pudding-faced Joe from *Stars and Stripes*, the Army newspaper, but Mauldin wasn't on the staff of *S&S* until February 1944. Mauldin enlisted in September 1940, long before the U.S. joined the hostilities in Europe, and he cartooned for his unit's newspaper, the *45th Division News,* for three years, most of it while the 45th was maneuvering its way around the U.S.

Qualifying on my list of the Best of the Year by reason of the cartooning history of its content, Fantagraphics' two-volume 716-page slipcased **Willie & Joe** (hardcover, $65) sets the record straight: Virtually all of Volume I's 325 8x11-inch pages are devoted to cartoons Mauldin produced before going overseas in July 1943. The eponymous Willie and Joe, as a familiar pair, don't show up until Volume II's Sept. 26, 1943 cartoon.

Mauldin initially entitled his cartoon *The Star Spangled Banter,* and it carried that name as long as it appeared in the *45th Division News* and in civilian newspapers like the *Oklahoma City Times* and *The Daily Oklahoman*, to which Mauldin occasionally contributed freelance; his cartoons acquired the title *Up Front* when they began appearing in *S&S* in late 1943.

The cartoon had no continuing characters for most of its run. Willie, hook-nose on vivid display, shows up in the very first cartoon, Oct. 25, 1940, and while he returns every so often thereafter, he's not a constant presence. At first, his name is Joe, and he's an Indian and talks pidgin and is often the butt of the joke or the comedic springboard.

To Mauldin, growing up in New Mexico, and to many of his comrades in arms, "Indian humor was irresistible," we learn in the introduction to the Volume I by its editor, Todd DePasinto, the author, not at all incidentally, of a fresh biography of the cartoonist, *Bill Mauldin: A Life Up Front* (372 6x9-inch pages; hardcover, Norton, $27.95).

The 45th Division, made up of National Guard units from New Mexico, Colorado, Oklahoma and Arizona, "had more Native American soldiers than any other division," plenty of fodder for ethnic comedy.

Joe had an Indian last name, Bearfoot, and was inspired, somewhat, by a tentmate of Mauldin's, a cultured and well-read, athletic Choctaw named Rayson Billey; Joe also looked a good deal like Mauldin's ne'er-do-well father.

Joe was being called Willie by the time the 45th was invading Sicily in the summer of 1943. The original Willie, who would take the name Joe, had a tiny moustache when he made his debut as "Willie" in the summer of 1941 in a 32-page souvenir booklet, *Star Spangled Banter*, for which Mauldin drew 16 new cartoons and 16 pages of illustrations in a single 48-hour period.

Other book ventures that are easily runners-up in the Best Historical Tomes of the Year competition in-

clude IDW's reprinting of Milton Caniff's *Terry and the Pirates*, now up to Volume 4 of a six-volume series; the second gorgeous volume of Winsor McCay's *Little Nemo in Slumberland,* published in the Sunday strip's giant "original" size from Pete Maresca's Sunday Press Books; the third volume of Drawn & Quarterly's reprinting of Frank King's *Gasoline Alley*, Volume 1 of which appeared too late last year to make this list but seems, now, worth mentioning as the strip passes into its 91st year, guided by Jim Scancarelli; and the first of Checker's proposed complete reprinting of Mort Walker's *Beetle Bailey*, which includes, for the first time ever, the first six months of the strip when Beetle was loafing through a college career.

Still in the book department, we also salute the publication of the long-promised *Kirby: King of Comics* (224 9x12-inch pages, hardback; Abrams, $40), a commemorative volume by Mark Evanier. More than any other figure in comic-book history except Superman, Kirby invigorated the medium in its infancy. And then, as the industry seemed about to expire 20 years later, he re-invigorated it.

Writing in that relaxed, headlong, familiar conversational manner of his, Evanier brings us in, sits us down at the nearest bierstube (more for the convenience of his guests than himself), and tells us the story of Jack Kirby, the man for whom, as a teenager, Evanier worked as a sort of office assistant, beginning in about 1970.

Being of a curious turn of mind, Evanier got Kirby to tell him about his career, his cohorts, his adventures with the great and the grating, with Joe Simon and Victor Fox. Such anecdotes and other fragments of comics history and Kirby lore as Evanier has collected through 30 years of active engagement in the profession, he strings them together here in more-or-less chronological order, his storytelling instincts giving every incident a beginning, a middle and an end, often a punch line.

The story rolls cheerily along — "and then and then and then" — passing familiar landmarks, giving them fresh nuances, and peeking into overlooked crannies, correcting errors or clarifying long-standing vagaries. Amply illustrated, it's the saga of a guy with a talent and a compulsion and how he became a legend. Jack Kirby's talent was drawing; his compulsion was to make enough money at it to feed himself and his family — first, his mother and father and brother; then his wife and children.

Finally, I gratefully applaud the conclusion of DC's Archival preservation of all of Will Eisner's *The Spirit*, achieved this year in the 26th volume.

The best historic events of the year include the International Museum of Cartoon Art (IMCA) finally finding a home for its collection of over 200,000 artworks and artifacts at the Cartoon Research Library at Ohio State University. The arrival of IMCA at CRL will make the OSU facility the largest collection of original cartoon art in the world — over 450,000 pieces, including drawings from all genres of cartoon art (comic strips, comic books, animation, editorial, advertising, sport, caricature, greeting cards, graphic novels and illustrations), display figures, toys and collectibles, and works on film and tape, CDs and DVDs. All that remains, now, is for the university to provide a suitable permanent exhibition facility.

Another historic occasion emerged from the shadowy legal depths of arcane copyright law last August when it was determined that the image of Mickey Mouse in his first movie, "Steamboat Willie," is in the public domain. Disney's Mouse, the very emblem of intellectual property, single-handedly responsible for Congress's successive extension of copyright protection to interminable lengths, has been discovered with ears of clay. The film's title card declaring the copyright blurted forth so many names that "an excess of ambiguity" was created, and when that happens, the copyright itself is void. Mickey Mouse, then, is in the public domain — that is, the Mickey Mouse image in "Steamboat Willie" is now free of its Disney cocoon.

The image has undergone several mutations since, and those are still safely in the grip of the corporate ogre, so for the foreseeable future, then, we can expect Mickey Mouse to be treated as if he were the exclusive property of the Disney Empire. Too bad. But a chink in the corporate armor may widen to accommodate a more realistic attitude about the seemingly interminable entitlement attached to some intellectual properties.

In somewhat the same vein, I'm happy to see that Jerry Siegel has apparently achieved posthumously what was denied him in life: control of his half of Superman, the half that doesn't belong to his drawing partner at the moment of conception, Joe Shuster. In Siegel's absence, the fate of the iconic superhero character will be controlled by Siegel's widow, Joanne, and his daughter, Laura Siegel Larson.

Last March, a district court judge in California ruled that Siegel's heirs are "no longer bound by the [1938] agreement by which Jerome Siegel and Joseph Shuster sold the rights to Superman for $130"; similarly, all subsequent agreements — dated May 1948 and December 1975 — are "terminated," effectively returning control of the character to Siegel's heirs.

At the heart of the findings, reported Jim Beard at *Toledo Free Press*, was the determination that Superman

was not created under the rubric of "work for hire" — that is, work undertaken as an employee of an organization or commissioned by an organization. Siegel and Shuster, the judge noted, brought to the comic book publisher a finished product in 1938, a product not produced at the behest of the company and therefore not "work for hire."

As a tribal ritual, we've bemoaned the injustice to Siegel and Shuster most of our fanboy lives; this, at last, seems on the cusp of rectifying that long-standing crime. The world would be an even better place if only the Sandy Ego Con would now admit how much it owes Shel Dorf and do something about it before he joins in bitter obscure penury the other two founders of comic-cons, Detroit's Robert Brosch and New York's Bernie Bubnis. "Who?" you say. My point exactly. Eventually, after much loud lobbying by the cartooning profession, Siegel and Shuster each got a pension out of DC in recognition of their having laid the cornerstone of the comic-book edifice. And what has Dorf received?

Moving with only the vestige of a segue into the realm of newspaper comic strips, we run rudely up against Berkeley Breathed and his third desertion of a nationally syndicated comic strip. At the time of *Opus'* launch as a Sunday-only strip, I was dubious about its possible success. There was a good deal of hue and cry about the return of *Bloom County's* creator. But it wasn't *Bloom County* that was returning. And judging from the short and frustrating history of *Outland*, Breathed's *Bloom County* successor of the 1990s, I wasn't optimistic that Breathed's brand of topical humor would work on a once-a-week basis: for that kind of comedy, you need a continuous, seven-days-a-week presence in the American psyche.

But this was Opus, the bird we loved, and so I rooted for the winsome flightless fowl — even though I think Breathed let his beak get much much too big. (Geez, he's no longer cute, Berke.) Breathed, however, had apparently once again reached his boredom threshold and decided to end the strip, going out wearing a mask of banal benevolence that could not, alas, disguise or assuage either his arrogance or his towering capacity to annoy.

Opus ended on Sunday, Nov. 2. But it didn't end in the funnies. To learn the end, you needed access to the Internet, the very institution that Breathed scorned when he brought Opus back, saying his pudgy penguin could be seen only in newspapers (scheming, with this ploy, to endear himself and his comic strip to newspaper editors everywhere, plagued, as they are, by the looming Web and the cripplingly high cost of newsprint). On the comics page that last Sunday, Steve Dallas, the world's most ostentatious male chauvinist, enters the County Animal Shelter where Opus has been lately imprisoned. Wearing only a towel, loosely clinging to his genital vicinity, Dallas contemplates the sleeping Opus, who has been reading something that he's hidden behind a copy of *To Kill a Mockingbird.*

"Opus" artist nose when it's time to go

WASHINGTON» Pulitzer Prize-winning cartoonist Berkeley Breathed is retiring, leaving a hole in Sunday comics pages after nearly 30 years because he wants to save his strip's main character, Opus the big-beaked penguin, from being dragged down in the current political climate. The last strip of "Opus" will run Nov. 2.

Breathed, 51, said in an e-mail that he believes the tone of America's public and political discourse is headed in a dark direction.

[©2008 Washington Post Writer's Group]

From *The Knight Life*. [©2008 Keith Knight]

Steve smiles a beatific smile when he sees what Opus has in his hands — er, flippers. Then comes the first step in the annoyance: to "see the final panel," we must repair to a computer and go to humanesociety.org/opus.

There, we learn that Opus has read himself to sleep as millions of children have before him, reading — or being read to out of — *Goodnight Moon*, the beloved bedtime story written by Margaret Wise Brown and illustrated by Clement Hurd. In the strip's "last panel," the book's nurturing mother rabbit sits in her rocker next to a bed where Opus lies asleep with a stuffed bunny next to him. The final words echo those in the book: "Goodnight Opus / And goodnight air / Goodnight noises everywhere." Sigh. Breathed could not even conclude the strip with originality: he had to poach the comforting language of a superior children's book.

Then, to compound the botheration of Breathed's ending, we are advised that we must now go to the cartoonist's website, BerkeleyBreathed.com, for his "final message." And so I dutifully did. Only to discover, as had an estimated 10-15 million other Opus addicts, that the website, which, according to Sherry Stern at latimes.com, normally gets 1,500-3,000 hits a day, had been thoroughly overwhelmed and could not be accessed. At all. For hours.

When, several days later, I managed to arrive at Breathed's final words, uncrashed, this is what I found: "Opus is napping. He sleeps in peace, dreaming of a world just ahead, brimming with kindness and grace and ubiquitous bow ties. Please don't mourn him. He lives in all my children's stories, if you look. I hope to meet you again there. Thank you, truly, for coming along with us on Opus' 28-year journey." A commercial for Breathed's children's books. Apart from that obvious meaning is the subliminal one: Breathed clearly hopes (and who, after all, can blame him?) that he will one day produce a book that will be as everlastingly popular with young readers (and their parents) as *Goodnight Moon*.

In the weeks before *Opus* ended, Breathed had claimed the last strip would preclude yet another revival of the waddling proboscis. He assured us that Opus could not come back from the destiny he'd arranged: "I'll be leaving

Opus in a way that it should be very clear that this time, there's no going back home." What? All Opus has to do is wake up — and he's back. What a fraud. Breathed, however — as we might expect — has another take on the so-called ending: "Opus," the cartoonist told the *L.A. Times*, "is in the comforting place that would make me smile when I think of him in the years to come. I can only hope that his fans will smile too. If Opus was cuddling with tropical girls wearing coconuts, I suppose I'd smile too, but tinged with regret that those things just never last after that early giddy stage."

Of course. But it seems that early giddy stage has devolved into the final entrepreneurial phase wherein the cartoonist seeks to sell the books of his alter ego, the children's-book author. Annoying. But then, wasn't he always? Why should we expect anything different as a finale? Plus a little wit. "A little song / A little dance / A little seltzer down your pants," and with that, the clown exits, giggling. And we are left to wonder if he's laughing at us.

Meanwhile (to deploy a subtle plug), along came *The Knight Life* by Keith Knight to rescue the funnies. Boston-born Knight may be the Renaissance man of alternative comics. He admits to having doodled comics for 40 of his 38 years (sic), including the requisite few in college at Salem State College where he earned a degree in graphic design and launched an early version of his signature creation, *The K Chronicles.*

The K Chronicles, which began appearing occasionally in the *Bay Guardian* in 1993 and then soon thereafter, regularly in the *San Francisco Weekly*, is unabashedly autobiographical. Keef (as we who love him call him) wandered the city, sojourning frequently in a favorite coffeehouse, sketchbook at the ready, one eye trained on his bicycle outside because he can't afford a lock for it — "Shows you how lucrative my line of work is," he said to Angela Hill at *The Crisis* in November 2004 — the other eye observing the passing scene. From what transpired near him, he manufactured his weekly strip.

Although usually focused on his own life, the strip's topics included politics, race and social issues affecting people of color like Knight. "It covers everything," he said recently, " — cops, homeless, kids, Vegas, supermodels, talk radio. All the weird stuff that happens to me, my friends and family."

Syndicates have courted Knight for years, but it wasn't until he won the Harvey Award in 2007 that he felt the time was right: "I figured it couldn't be a better time to go daily," he said during an online chat at Washington-Post.com. *The Knight Life* is another manifestation of *The K Chronicles* — Keef's life with his comments on the passing scene — but somewhat retooled for family newspaper consumption. The daily strip format is "like a challenge or a puzzle," he said: "How can I be funny and/ or relevant in such a small space? It's a fun, exciting challenge (so far), plus I have the Sunday strips to let loose a little." Keef and his wife are the principal characters. "She wasn't too happy when I first started putting her in," Knight said, "but she has come around."

Because Knight's strip comedy derives from his own life and his observations about the society around him — and because his view of the universe is eccentric — the jokes in *The Knight Life* are never predictable. And in his occasional recapitulation of "life's little victories," it's *joie de vivre* that brings a smile to our lips.

Fittingly, Knight's drawing style, what he calls his "trademark, poorly rendered, barely thought-out, last-minute cartooning style" — a sort of cartooning shorthand, as much sketchy suggestion as actual depiction — is as eccentric as his sense of the human comedy. His drawings are clear and uncluttered. Simple, yes, but they bubble with comedic energy: Whenever his

Trudeau's Nov. 5, 2008 *Doonesbury* strip.

characters talk, they are all mouth, usually unhinged, and eyeballs, a perfect evocation of the human visage for comedic purposes.

The Knight Life is undeniably the best new laugh- and thought-provoker on the comics page. Not since *Calvin and Hobbes* has there been so novel an entertainment in the funnies.

Leading the way among the Best Comic Strips of the Year is, as usual, Garry Trudeau's **Doonesbury**, a champion every year lately, and it seems to get better as time passes. This year's best individual daily release was Trudeau's post-Election Day Nov. 5 strip. Produced a week or so in advance of its publication date, the strip fearlessly pronounced Barack Obama the winner. In the strip, three soldiers in Iraq — a black guy, a white guy and an Iraqi guy — celebrate "the first African-American president in history."

But Trudeau's acumen as prognosticator was not as stunning as his adroit satire. The strip's punch line is the mark of his genius. After taking a stab at predicting the outcome of the election, Trudeau turned the knife to deliver one of his crowning satirical asides. He turns the historic achievement on its head to show that Obama's election does not mean the end of racism, all our celebration notwithstanding.

Traditional benighted racism in this country has always proclaimed that a person is black if he or she has as little as one drop of black blood in his or her lineage. So Barack Obama is, by tradition, black. The white soldier observes, quite rightly, that Obama is half-white. His observation would seem to deny and confound the tradition that determines that Obama is black. And so it does.

But when the Iraqi soldier responds, "You must be so proud," he nails the racism inherent in the white guy's comment. By noting Obama's white lineage, the white guy seems to the Iraqi to want the "white race" to be given some credit for Obama's accomplishment too. It's unassuming and sly, but the Iraqi's comment highlights the racism inherent in pronouncements of Obama's "historic" achievement. Nicely done.

Elsewhere, in Greg Evans' *Luann,* another earth-shaking event. Luann's nerdy older brother, Brad, finally worked up the nerve to ask the beauteous Toni, a fellow firefighter, to accompany him to the Firefighters' Ball, but en route to the affair, Toni wonders what they'll do at the dance: "I'm not much of a dancer," she says, " — are you?"

Brad says: "No. I guess we'll sit around, talk to other fire fighters about nozzles an' stuff."

A strategically silent panel follows as they think this over. In the last panel, Evans shows them buying tickets to drive go-karts at the local kart track. They have a great time. It's the conclusion of another of Evans' string of compassionate and thoroughly humane story arcs. And he prepared for this punch line carefully: While contemplating what to bring Toni when he picks her up, Brad decides to appeal to Toni's love of cars and brings her something appropriate. It reminds us that she loves cars — hence, go-karts.

Evans shows similarly penetrating discernment when, as Brad leaves Toni at her door, wondering whether to kiss her goodnight, Toni solves the problem: "You should kiss me," she says to Brad. And he does.

"Well," he exclaims afterwards, " — that was easy."

Says Toni: "You're saying I'm easy?"

Humor and humanity, all in one daily package. We can't ask for more. I'm in awe of Evans' unflagging ingenuity in constructing roadblocks on the highway to romance for Brad and then surmounting them with an enviable combination of care and comedy. I also think

McEldowney's Nov. 4, 2008 9 *Chickweed Lane* strip.

Toni is a stunning example of how even a simple rendering style can convey the hotness of a really hot babe.

But when it comes to telling the story of young romance with all its groping, yearning, heavy-breathing frustrated satisfactions, no one has done better — more sensitively, more authentically, more humorously — than Brooke McEldowney in his strip *9 Chickweed Lane*. And no one has been more daring in letting sex play a role in a comic strip akin to the role it plays in life. The strip concerned itself at first with the interaction among three generations of women in the same family — grandmother, mother and daughter. A year or so ago, the daughter, Edda, moved to New York to join a ballet company. When she couldn't find an apartment, she moved in, temporarily she thought, with her male dancing partner, Seth. A daring enough maneuver on its face but made even more so as we learn that Seth is gay.

Then Edda's high-school chum Amos comes to the city to play cello in an orchestra, and he and Edda strike up a relationship that is Young Romance with a capital R. As soon as they discover that their friendship is more than friendly, McEldowney depicts them necking hot and heavy on the couch for an entire, steamy week. At the critical moment, Amos proves gallant enough to evade the ultimate embrace of passion, postponing to another day the mutual abandonment of their virginities, but doing so with gentle humor and compassion as McEldowney invokes the character's usual posture as a caring if often blundering nerd.

Shortly thereafter, establishing his cred as a dauntless storyteller, McEldowney arranged a romance between a nun and a priest. Both eventually left their orders and they got married. No one — not even Trudeau — has pulled off anything quite as astonishingly risky. All done with great sensitivity for his characters and for his readers' sensibilities.

McEldowney displayed the same surpassing skill last October and November, when Edda and Amos succumbed to the inevitable. McEldowney handles this delicate matter with great humanity and comedic agility. He's an authentic storytelling master in the medium. Garry Trudeau has, on various matters, equaled McEldowney in skill, subtlety and flair, but no one has surpassed him. The visual device by which McEldowney depicts the deflowering of Edda and Amos is sheer genius — entwining hands. Breathtaking.

But not without comedy. The Edda-Amos encounter came about because Amos had the hiccoughs, and Edda knew an ancient cure — kissing, apparently, which then escalated to entwining hands.

McEldowney had been building to this conclusion for a month, during which Amos develops hiccoughs whenever thinking about a cello competition he's entered in. Just one of the narrative strands in McEldowney's carefully knit-together tapestry. Beautiful. Yet *Chickweed Lane* is in fewer than, oh, 70 papers.

More universally accessible is Tatsuya Ishida's online comic strip ***Sinfest***. It is not only the best comic strip on the Web but perhaps the best new comic strip around. It's been going since January 17, 2000, and the entire run is archived at sinfest.com so don't take my word for it.

Apart from the beautiful drawing (yes, beautiful — how else do you describe Ishida's flowing line and tidy compositions?), the comedy is persistent and hip, the punch lines wholly unexpected, time after time, a joyful surprise every time.

Ishida has tried, as I understand it, to get this gem syndicated but without luck. Once you've seen a few, you'll understand why: It borders on the blasphemous but uproariously so. Surely we deserve to be offended in so hilarious a fashion.

Ishida often posts a screed of one sort or another on his site; here's a recent one:

"Whenever I peel an orange, I save the stem end for last. There's something about pulling out the spine that is very satisfying. Texture-wise, visually, the little plucky squirty sensation, it's a fun little operation to cap the peeling process. That's sorta my modus operandi when it comes to food. I leave the best for last. When I have a chicken pot pie, for example, I eat all the carrots and peas first, and leave a stash of chicken for the big finish. When I have a sandwich I work my way around the crust to the middle. I have this shit down to a science. Sometimes, though, it's not so smooth. Things can get complicated. Like, when I'm eating a pancake breakfast with hash browns, bacon, and eggs, I can't decide what my favorite thing is. I panic a little in my heart because I don't know how it's gonna end. But that's what life is all about. Thrills, man. Thrills. I start out all confident that I'll end with a bite of bacon but then, the sweet syrupy pancakes start to win me over. Then the hash browns, that unassuming dark horse, makes a comeback. And then the eggs are like, 'Hey, we're the pure unblemished souls of chicken! Recognize!' At that point, all bets are off. It's anybody's game. I might go with bacon. I might not. Nothing's set in stone. Anything can happen. I know what you're thinking. You're thinking, 'Tat, You crazy fool! You HAVE to have the last bite planned out AT ALL TIMES!' But I like to live on the edge, Jack. I take *chances*. I flirt with danger. That's how I roll. — T."

From Tatsuya Ishida's Web-comic *Sinfest*. [©2008 Tatsuya Ishida]

Three collections of *Sinfest* strips have been published; they're all available through the site.

With comic books, it's becoming harder than ever to keep up. Not only is a vast flotilla of them issued every month, but most individual titles are so hooked into their continuities that if you miss an issue, you're lost: to enjoy any given issue, it seems, you must have climbed aboard the title in your infancy and kept notes about who's who and what's what for the entire run of the book — your whole life, in other words.

Needless to say, writers' carefully crafted allusions and plot nuances mean nothing to anyone buying the title for the first time at some point in the run other than the first issue. These readers will doubtless give up after one baffling encounter. And so the reading audience for each title dwindles steadily as various of us die off.

And it looks as if we're re-entering the 1950s when many comic books were based upon fictional entities that had succeeded outside the medium. What with the suc-cess at Marvel of the comic-book adaptation of Stephen King's *Dark Tower* series, Image is seeking to do some-thing in the same vein by producing funnybooks inspired by the fantasy paintings of Frank Frazetta. Reminds me of all those '50s and '60s funnybooks presenting the further manifestations of television shows: all those Westerns — *Gunsmoke*, *Wyatt Earp*, etc. — *I Love Lucy* and more.

But there arise among the dross a few soaring fledg-lings, and inaugural issues flood the newsstands. An admirable first issue must, above all else, contain such matter as will compel a reader to buy the second issue. At the same time, while provoking curiosity through myste-riousness, a good first issue must avoid being too mysteri-ous or cryptic. And, thirdly, it should introduce the title's principals, preferably in a way that makes us care about them. Fourth, a first issue should include a complete "episode" — that is, something should happen, a crisis of some kind, which is resolved by the end of the issue, without, at the same time, undermining the cliffhanger

that will compel us to buy the next issue.

Jeff Smith's new series, **RASL**, achieves all of these objectives in its first issue of 32 black-and-white pages. We meet the protagonist, whose name might be Rasl (or maybe not), who apparently makes a living stealing works of art, leaving the letters "RASL" painted on the wall where the painting once was hanging. He is not, by profession, admirable although we might admire his daring and ingenuity: "I have learned," he says to himself, poised on a window ledge, "that seven flights up, people have a false sense of security. I love it when I find the window unlocked."

Who, indeed, would lock the window of a room on the seventh floor? He swipes a painting, is discovered in the process, and, to escape, employs a kind of time-space navigation device that looks like a portable miniature twin-engine jet, transporting himself to another time and place by a process he calls "the drift." Thus far, we have the "complete episode" and the introduction of the title's principal. We may not like this guy much, but, as I say, we admire his daring.

The time-space travel is, seemingly, painful, and our protagonist enters a bar to imbibe enough to ease the agonies. While there, he realizes that he's in "the wrong place" — not the place he thought he'd wind up. With that realization comes menace: A lizard-faced guy in a black slouch hat and overcoat with the collar turned up comes into the bar, draws a handgun, and starts shooting at our "hero," who escapes momentarily then turns on his pursuer and overpowers him, discovering a tiny device embedded in the guy's wrist. "Sirens," says our hero, thereby identifying what is possibly a breed of menaces that he's run into before.

He then finds a deserted shack by the railroad tracks and goes in to "meditate," saying, "A few hours of meditation might be enough to get me home. ... You can fix this," he tells himself: "It's not too late." He meditates, and we see him next wandering in a torn T-shirt under a blazing sun in a desert, just as we first saw him when the book opened.

Is the desert the mental construct of his meditation? Or is he actually in a desert? How does "the drift" work, actually, and how did he learn about it? Will he get back "home"? Or before he can do that, will he be discovered by other Sirens or lizard-faced creatures out to kill him? There are enough questions to compel me to buy the next issue in the hopes of finding answers. There are, admittedly, a few too many mysteries here, a bit too much cryptic inexplicability. But the episode embedded in this issue is loaded with enough emotion (suspense, chiefly, but also some admiration and curiosity) and completed with enough storytelling skill to be a satisfying reading experience — that, after all, is the purpose of including a completed episode in a first issue, to give a reader a sense of satisfaction while not, at the same time, spilling all the beans in the title's concept.

But the admirable skill of the art thief is enough to make me want to know more about him and what will happen to him next. The satisfying episode and the personality of the protagonist constitute the emotional flywheel of the first issue, driving me to want to find answers to the questions that leave me dangling on the cliff.

Smith's storytelling skills are, as usual, superb. Visually, he keeps his focus on the main thrusts of the incidents he narrates, varying camera distance and angle for visual variety and dramatic effect. Several sequences are achieved entirely without words, displaying not only his pictorial storytelling skill but enhancing the mysteriousness: without words, a good bit of the action is somewhat inexplicable — in tone, at least — hence, mysterious and suspense inducing.

I have to wonder, though, at this black-and-white beginning. Is Smith planning the same sequence of production that his famed *Bone* followed? After the publication of a certain number of the black-and-white *Bone* issues, they were combined in a single trade paperback and offered for sale; and once all the entire series had been re-packaged and sold in this manner, the whole ensemble was reproduced again in color. At boneville.com, we learn that the first seven color *Bone* books have sold 2,481,500 copies — that's two-and-a-half million, *kemo sabe* — plus those earlier black-and-whites and single volume editions.

The first issue of *RASL* seems on its way to duplicating the *Bone* phenomenon: the initial press run was 24,000, and it sold out, and the book went back on the press for more. Makes me smile in anticipation.

In *Echo*, Terry Moore again proposes a female protagonist. Issue #1 opens with a picture of a character soaring straight up into the sky, attired in what reminds me of Dave Stevens' Rocketeer — a backpack rocket and a flight helmet. The character appears to be in trouble, being pursued by sidewinders, and says: "I'm wearing a nuke." Then comes a flashback to four minutes earlier, during which we discover that the would-be Rocketeer is a woman test pilot, testing a Beta Suit, a completely flexible "coating" of a mercury-like substance that covers her from head to toe.

The monitoring officials stationed on the ground have in mind other tests for which she was not briefed — in-

cluding bombarding her with missiles. She attempts to deflect the first missile as it approaches by throwing her helmet at it. It explodes. Taking her with it? Probably. We don't know for sure because the scene shifts to a desert where a young woman is photographing plant life.

The issue's episode is complete with the introduction of a special space suit and the destruction of its test pilot. The crisis — her being a doomed target — passes. It's sinister and therefore provocative; and the pilot's attempt to deflect the missile is heroic enough to inspire admiration — even if we suspect the pilot is no more after the explosion. The photographer in the desert sees the missile explosion overhead; she's then "sprinkled" with tiny globules that cling to her and to her vehicle as she drives off. We learn that the tiny globules are what is left of the Beta Suit: "The explosion turned the suit into silly putty; our one bomb is now many," says the head scientist on the ground.

This information is our final bit of intelligence about the Beta Suit. We now know it is virtually a weapon, and the knowledge completes the experience of the issue's episode and also provides enough information that the otherwise total mystery of the Beta Suit is somewhat reduced. Meanwhile, the photographer gets home, and we learn that she's in the midst of a divorce, penniless and down to her last hot dog. She finds a larger scrap of the "silly putty" in the back of her truck, and, as she fiddles with it, it clings to her and attracts and absorbs the tiny globules that have been stuck to her since the explosion.

All at once, she finds her shoulder and part of her chest "clothed" in the stuff, which has become larger as it absorbed the globules and is now fastened to her. "What have I done?" she murmurs, terrified. And the issue ends.

Moore's drawings, as always, are clean and crisp. The black-and-white pictures are almost entirely linear, with a little solid black for accent. And they are expertly achieved: the visual narrative is pristine in clarity, and despite several scene shifts, his characters are rendered instantly recognizable at every re-appearance. And Moore, like Smith, conducts a significant amount of his storytelling without verbiage, enhancing thereby the inherent suspense of a sequence.

As in *RASL*, the episode that is complete in this issue provides an emotionally engaging experience, satisfying enough in its resolution that we feel we're in the hands of an accomplished storyteller who knows where he's going. By the end of the book, we have been introduced to the Beta Suit and understand enough about it to know

a little more about the photographer's predicament than she does. Moreover, she's female, attractive and in trouble — sufficient, in our culture, to elicit our sympathy. Now — we want to know what will happen to her and the Beta Suit. So we are compelled, as much as a reader can be compelled, to buy the next issue.

Good as *RASL* and *Echo* are, the Best Comic Book of the Year, Continuing Title Division, is, for my money, available only in limited quantities, ***100 Bullets*** by Brian Azzarello as drawn by Eduardo Risso. And it has been ever since it started.

The stories were easier to understand in the early numbers, and once the notion of feuding gangland warlords was introduced, the books developed a continuity that's sometimes hard to keep track of. Nothing quite as obscure as Azzarello's *Loveless,* though. But it's Risso's artwork that brings me back for more even as we approach the 100th and final issue of the title.

Some of Risso's graphic gimmicks are now a little predictable, but his pages are still a storytelling treat of visual variety. On some pages, Risso tells pictorially a short story that's entirely separate from Azzarello's, adding a layer of atmospherics to the basic yarn. And his layout inventions, even if, by now, almost standard in the book,

are always intriguing. Best continuing title of the year on my score card.

And then there's Jim Robinson's ***Bomb Queen,*** which, when it first appeared in 2006, I scoffed at as just a blatant exercise in T&A aimed unabashedly at adolescent fanboys fascinated by T&A. The Bomb Queen's skintight fighting togs are clearly too small for her: they feature a bodice with a scoped-out neckline that reveals generous portions of her chest, a bare midriff that plunges to her crotch, where her thong underwear just barely rescues her pudenda from indecent exposure, whereupon her stockings begin.

And whenever the Bomb Queen turns her back to us, we get an unimpeded view of her derriere, its cheeks cupped provocatively by a non-existent garment. "Now, really," I said at the time, "No woman wears clothing like this unless she's intent on seducing whatever males wander within eyesight."

True enough. But there may be a subliminal narrative function the Bomb Queen's uniform is serving: She is billed as the series' villainess, but her ample embonpoint makes her the object of considerable male lustful admiration thereby undermining any vague moral disapproval that her alleged criminal activities might inspire. By the

- EVEN I HAVE MY *LIMITS!*

Bomb Queen is ©Jimmie Robinson.

fall of 2006, rampant nudity emerges when the Bomb Queen goes for a romp in the hay with a fella she thought was her friend; she wakes up alone in bed in the middle of a highway, and she's completely naked.

In the title's third story arc, her costume begins to deteriorate. This epidermis-hugging raiment, it seems, is not made of very durable material: the spandex is stretched to the shredding point by her bountiful bosom, and, stretched, it begins to rip itself to pieces. For the rest of the story arc, her nipples play peek-a-boo through the rents in her so-called bodice. This shameless display reminds me of the original Flare, who, years ago during her first appearances, had difficulty keeping her chest contained: her costume was so tight (or her neckline cut so low) that her upper anatomy would occasionally pop out, usually during a fight sequence when extravagant movement was likely test the confining capability of the costume — a nicely comic satire on superheroine costume design. The grace note on the satire was the sound effect of her bosom popping out: "Poit! Poit!" (They come in pairs.)

In the third Bomb Queen story, Robinson enhances the excitement of his villainess' decomposing outfit by depicting her during fight sequences from an array of absurd perspectives, producing anatomical contortions that expose her body parts to view from every conceivable angle until it is obvious that my original assessment of this title was right: this is T&A for the sake of T&A. But it's hilarious at the same time by reason of the very extremes to which Robinson has taken matters. Whether intentionally or not, the Bomb Queen's costume is hilariously satirical in the same way Flare's was.

Bomb Queen IV starts with the Bomb Queen wearing a freshly laundered costume that is no longer torn in revealing ways; but by the end of the story, it's in titillating tatters again. Oh, yes — the Bomb Queen has some sort of super-power, but I can't recall it. Confronted by her costume, who could?

The title with its scantily clad heroine is clearly the last word in ridiculing "beautiful, strong women" as lead characters in superheroicism. We all know "beautiful" and "strong" are euphemisms that aspire to intellectual justification for the T&A fixations of comic-book creators and their fans. Robinson's Bomb Queen has the integrity to confront hypocrisy and defeat it, hooters honking all the way.

That was my year. How was yours? ■

Consolidation Blues

by Matthias Wivel

I.

Here we are, roughly a decade after the tectonic shift in French-language comics began to make itself felt and decisively changed the European comics landscape. The new wave of *auteur* comics that emerged in the early '90s has shaped the look and content, if not always the ethos, of the contemporary French-language comic book. The "graphic novel" has been a publishing phenomenon in Western book markets for a number of years now, and — even if the term is not as widely invoked there — nowhere more pervasively than in the francophone parts of Europe.

These comics by no means drive the market — that would be manga and a few declining genre franchises in the classic album tradition — but they have come to characterize francophone comics culture to a considerable extent. Pretty much every comics publisher now has a line of graphic-novel-type books, and many of the large mainstream publishers are running comics imprints specializing in this type of "literary" comics.

Apart from the books of a few major figures, such as Marjane Satrapi, Joann Sfar and Lewis Trondheim, most of them do not sell in particularly large numbers, but they do well enough for them to be profitable, and well enough for a lot of cartoonists that are far from ready-for-print to see publication without much in the way of editorial guidance. In the hope of emulating the success of the above-mentioned paragons of the '90s generation, publishers seem to have resorted to throwing stale porridge against the wall in the hope that some of it will stick.

While the sheer number of books on offer, including the staggering amount of foreign material that sees translation into French, would impress just about any visiting

From *Little Nothings: The Curse of the Umbrella* by Lewis Trondheim. [©2006 Trondheim, English text ©2007 NBM]

What I had noticed in particular about him is that although he was a pretty athletic guy, he had to walk bent over, because his pack was heavy and he had a small chest.

Okay, California?

I liked the way he called me "California." Sometimes we'd talk for a while. We were drawn to each other, toward a friendship that never had a chance to develop.

I'll jump forward in time now, twice, to tell you what happened to him.

From Guibert's *Alan's War*. [©2008 Emmanuel Guibert & L'Association, English text ©2008 First Second]

comics aficionado, there is actually a depressing *sameness* to much of the product clogging the comics shelves of bookstores across francophone Europe. And the rate of production is so accelerated that the shelf life of the vast majority of individual books is crushingly brief.

Says French comics critic Xavier Guilbert of the website du9.org: "The big 'locomotives' [i.e. the aforementioned franchises] have seen their sales go down by 40% in average (that's Titeuf, Astérix, Le Chat, Lanfeust de Troy, etc.), while their print runs have remained stable. [This is] the recent evolution of the publishers' strategy: flood the market with your books, because it costs less to pay for returns and destroying a book than losing sales because of insufficient retail presence."

In this climate, the reluctance to experiment on the part of the large publishers is palpable. This may seem puzzling given that the market has been experiencing uninterrupted growth over the last 12 years or so. But as is customary during boom times, there has been for a while

a widespread fear that collapse is imminent, a feeling that is unlikely to change now that the economy has gone into recession and sales seem to be leveling out, if not dropping off.

Guilbert continues: "There's this sense of impending doom coming from all publishers, large and small, and they are all more or less waiting for the other shoe to drop. The big publishers had a business model based on yearly-or-so installments in well-established franchises. And this model is coming to an end, since those franchises are aging and see their readership slowly eroding. And yet, they have this decade-long tradition of 'same is good, same is safe.'"

What we are dealing with, then, is a period of consolidation. Many of the innovators of the '90s are now well established, and their work has recreated comics in its own image. This has instituted not only a practice of larger publishers cherry-picking some of the artists who previously drove the small press, but also a wave of publi-

cations that seek to replicate what made their works tick, which again has resulted in formularization.

Jean-Christophe Menu, co-founder of and now sole publisher at the seminal, artist-run small-press house, l'Association, noticed this development happening several years back and discussed it in his polemical 2005 essay "*Plates-Bandes.*" He not only openly criticized a number of players on the francophone comics scene, but also staked out a set of principles of avant-gardist inflection for the small press, which were further expanded upon and debated in the critical anthology he edited from 2006-2007, *l'Éprouvette* (for more, see my interview with him in *TCJ* #277). His response as publisher at l'Association has been to "radicalize" the profile of the house and publish a greater amount of experimental and emphatically noncommercial books. This is something he can afford to do, because he has a number of strong sellers on hand, notably the work of Marjane Satrapi, who has stayed with the small publisher despite her overwhelming success.

Today he says: "There's now a true overproduction of so-called 'independent comics,' be it from true alternative publishers or from fake ones ... Too many books, but above all, too many pointless books, published just to fill the shelves. Which is no help for the artists. The path we opened is now full of '*à la manière de*' ['in the manner of'] books and artists. I begin to be really bored with it myself. Just as any other amateur of comics, I can't keep up with everything that is published. ... I really don't know for how long this period of overproduction will last: Maybe the readership has increased enough to make it last, maybe not."

Of course, everything is relative and this is francophone Europe, after all. It is a bigger and potentially more fertile comics market than just about anywhere outside Japan, and things are certainly better than they were in the lean years of the early '90s, after the last wave of consolidation — the ignoble "adult-themed" genre books of the '80s and their ilk — had bled mainstream comics dry of new ideas. There is still quality work being published, but the truly outstanding comics seem few and far between, especially when one recalls the astonishing creativity and ambition of especially the small press scene in the late '90s and around the turn of the millennium.

A good way of illustrating the issue is to take a look at two remarkable books of 2008. One is Emmanuel Guibert's long-awaited, third and final volume of the biographical *La Guerre d'Alan* — the work I would emphatically nominate as the comic of the year, not just in France, but anywhere. The other is the last installment in one of the most popular series of this consolidation phase

of the New French-language comics, the fourth book of Manu Larcenet's *Le Combat ordinaire.* The former concludes one of the seminal works of the '90s new wave, the first two books of which were published by l'Association in 2000 and 2002. It has just seen stateside publication as the single-volume *Alan's War* from First Second. The latter ends what is surely the highest-profile series of its type, published at the center of the mainstream by Dargaud starting in 2003, with current American publication handled by NBM under the title *Ordinary Victories.*

II.

Emmanuel Guibert (b. 1964) is part of the generation that came into comics at the tail end of the crash of the '80s mainstream, and his photorealistically rendered debut *Brune* (1992), a story taking place during the rise of fascism in 1930s Germany, is very much in the slightly decadent vein of ornate historical drama that characterized 'adult' comics of the time. In 1996, however, he changed tack and began serializing *La Guerre d'Alan* in l'Association's anthology *Lapin.* He also started collaborating with peers such as Joann Sfar during the early recruitment drive by mainstream publishers of this new generation of artists. This resulted in works such as the historical romantic comedy *La Fille du Professeur* (1997, *The Professor's Daughter,* First Second) and the delightful children's SF series *Sardine de l'espace* (2000-2008, *Sardine in Space*, First Second).

From 2003-2006, Guibert produced the biographical *Le Photographe* in collaboration with Didier Lefèvre,

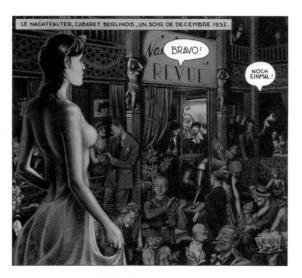

From Guibert's *Brune.* [©1992 SEFAM]

narrating the latter's experiences as a press photographer accompanying a team of Doctors Without Borders on a journey through war-torn Afghanistan in the early 1980s. This work, which apparently will also see American publication soon, is a magisterial effort that established Guibert not only as one of the medium's most distinguished documentarists, but as one of its most significant voices, period. Not only does it manage to seamlessly combine documentary photography with *ligne claire* cartooning, and actually make the former come alive in the story's most tightly sequential passages — something rarely seen in comics making use of photography — it is also a gripping story of human struggle and fellowship.

The fact that Guibert at the same time was working on *La Guerre d'Alan* demonstrates that the compassionate humanist tone that permeates both works is not just the luck of the documentary draw, but a quality of Guibert's sensibility as an artist that not only informs his choice of subject matter, but also animates it. Based on the life story of Guibert's friend, the American expatriate former GI Alan Ingram Cope, as told to the author, *La Guerre d'Alan* is a moving testament to the dignity and kinship felt between people who have the will power to choose it, even in tough times. It tells the story of Cope's experiences as a soldier during the invasion of France by American troops in the final year of World War II, as well as his life after the war, in the United States and France. Despite the grim setting of the war chapters, the book is remarkably low on drama, concentrating instead on the little moments in life. Cope's words are unadorned, precise and never banal, and they infuse the most mundane descriptions of daily routine with an acute beauty enhanced by Guibert's clean yet sensually suggestive use of aqueously inky line-work and lush wash. Cope's life was never particularly heroic, and he clearly had his imperfections, but *La Guerre d'Alan* nevertheless becomes a paean to a life worth living.

III.

Manu Larcenet (b. 1969) similarly made his debut in the '90s, but in an entirely different venue than Guibert, namely the humor magazine *Fluide Glacial*, for which he was a marquee name for years, until he quit in 2006. A prolific cartoonist, he produces albums in a variety of genres for several of the major publishers, with some of his earlier efforts drawn to scripts by such major figures of the New Wave as Trondheim and Sfar. Evidently these guys were an important inspiration to him, not least when, in the late '90s, he started creating more personal, largely autobiographical comics at Les Rêveurs des Rune,

a small publishing house that he had co-founded a few years earlier. While some of these books, particularly *Dallas Cowboy* (1997) and *Presque* (1999), had a certain stark intensity to them, they were ultimately rather lightweight affairs, combining distended ponderousness with cheeky wit in their pronunciations upon the complexities of life.

Nevertheless, it seems it was only a matter of time before Larcenet — earnestly ambitious and hardworking, a naturally eloquent draftsman, and a gifted storyteller — would take this vein of his work to a new level. This happened with *Le Combat ordinaire*. In many ways, this series is emblematic of the success of the new francophone comics movement in that it is an almost entirely naturalistic comic published by one of the most venerable mainstream publishers, Dargaud. The ground had been prepared by their progressive imprint, Poisson Pilote, which has been making good use of the best minds and hands of the new generation — Guibert, Trondheim and Sfar among them — to lend a sophisticated, contemporary feel to the classic Franco-Belgian genre series. But this was something different: an autobiographically derived, naturalist comics series *told straight* and published in the traditional format of the hardback, full-color album and consistently doing numbers around the very respectable 100,000.

Le Combat ordinaire tells the story of the 30-something Marco coming to terms with the fact that he is getting older and has to make important decisions in his life, such as accepting the fact that he has met a woman who wants commitment; achieving closure with his dying father, with whom he has a strained relationship; and deciding himself to accept fatherhood. Hard when your inclination is to either get drunk and fall down, or have all-night gaming sessions with your brother.

Larcenet is a consummate craftsman and manages his material with what seems like effortless grace. He has an ear for dialogue and understands paying off moments of tension with humorous and emotional catharsis. His big-nose characters are well animated, while his drawings are evocative and sufficiently detailed to bring the requisite sense of contemporary realism to the proceedings, and the coloring, alternately richly naturalistic and judiciously expressionistic, matches his intentions all the way.

The series has been a considerable success, counting among its awards the prize for Comic of the Year at Angoulême in 2004 and an Eisner nomination in 2006. It has become Dargaud's crown jewel in terms of cultural legitimacy — a tastefully executed 'art' comic fit for any coffee table worth its *café crème*. And that is the problem.

One time they played that game where the music stops suddenly and you have to stay frozen in position, you know? We did that really well, and one by one the other dancers were eliminated and disappeared around us.

From Guibert's *Alan's War*. [©2008 Emmanuel Guibert & L'Association, English text ©2008 First Second]

Just like its self-published predecessors, *Le Combat ordinaire*, for all its obvious qualities, is ultimately a rather shallow piece of work, which confuses romanticism for realism.

The fact that Marco is slimmer, trimmer and has more hair on his head than Larcenet (as we see him in the DVD documentary that accompanies the special edition of the third volume of the series) speaks volumes. Also, Marco is an *artist* — a formerly heroic, globetrotting photographer who struggles with creative paralysis until he finds his new path chronicling the ills of the working Joes at the condemned shipyard where his father was once employed. There is something slightly self-aggrandizing about this idealized autotherapy on the part of the author that never reaches much deeper than the comfortably middling. Worst of all, though, are the more naturalistically drawn, monochrome pages with which Larcenet intersperses the narrative to offer platitudinous musings on life, love and loss.

IV

At its heart, then, *Le Combat ordinaire* is a deeply bourgeois work, reducing to cliché the challenges of life and preaching conformity without fully engaging with the very real perils of the everyday struggle implied by its title. In this sense, it is emblematic of the banalization of the New Wave that characterizes so much of what is being published in the domain of graphic-novel-type comics today. It seems serendipitous that it comes to a close at the same time as *La Guerre d'Alan,* a work of that same New Wave and one that engages unflinchingly with the very same issues that elude thorough examination by Larcenet.

I feel kind of bad beating up on Larcenet, who is a gifted and ambitious cartoonist and cannot be accused of facile derivation, but for better or worse, he represents some of the more distinctive and troubling aspects of francophone comics today. And this problem goes further than commercial publishing itself — it was, after all, another large mainstream publisher, Dupuis, that put out Guibert's *Le Photographe*. It is rather a natural result of the colonization by the less adventurous that inevitably takes place after the expansion of a creative field.

One of the most important things the New Wave brought to francophone comics was naturalism, and this has become a new paradigm for the art form. The problem is that we are still waiting for a new generation of innovators to take the next step. The medium has experienced a parallel development in North America, and there is no doubt that picking up the ball after Ware, Gloeckner, Sacco, Clowes, Brown, Drechsler, Burns, Porcellino, et al. is a tall order at the best of times, but new talent is clearly emerging to meet the challenge of their forerunners.

In francophone Europe, on the other hand, the anxiety of influence still seems to weigh heavily on the younger creators. This is clearly a complex issue, but challenging the current order may actually be harder there than in the less structured and evidently less comics-friendly American book market, is precisely because the consolidation of a trend is felt that much more acutely when the market is so much stronger. Quality tends to get lost in the shuffle when it gets published at all.

What is most important, however, is that quality work is still out there. And I am confident that it will eventually prevail. The medium is still young and malleable enough, I hope, to prevent a rerun of what happened — and is still happening — to French film after the filmmakers of the New Wave rewrote all the rules in the '90s. In future columns, I will endeavor to explore these issues further, as well as treat in greater detail the multifaceted beast that is European comics culture in and beyond the francophone countries. So stay tuned ... ■

You'll Never Know, Book 1
by Carol Tyler

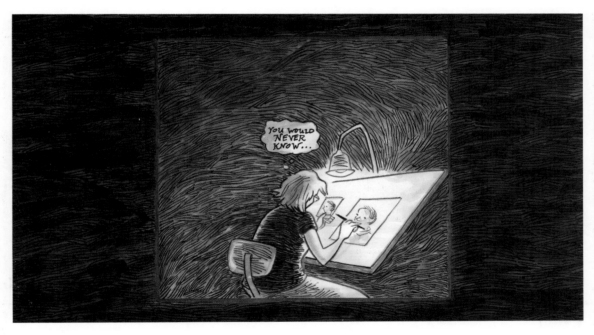

[©2009 C. Tyler]

The following preview is an excerpt from Carol Tyler's *You'll Never Know,* Book 1: *"A Good and Decent Man,"* the first installment of an annual trilogy concerning the cartoonist's father's experiences in Word War II and how that shaped their family life. Tyler made her debut in *Weirdo* in 1983 and was a prominent contributor to women's underground comix like *Tits 'n' Clits* and *Wimmen's Comix.* Her widely anthologized and twice-collected previous work (*The Job Thing, Late Bloomer*) often concerned the tribulations of being an artist, a wife and a mother. *You'll Never Know* Book 1 is the underground cartoonist's first full-length graphic novel. Equal parts biography, autobiography, journalism and history, Tyler's investigations into her veteran father's past are depicted in inks and a full palette of watercolors. The book will be available from Fantagraphics April 2009.

Our preview starts about 20 pages into the book. Tyler has begun to introduce her father via several anecdotes from her childhood in which she saw who had had been peeking through who he had become. In this excerpt, Tyler interviews her father while her mother watches on, and explains what was going on in her marriage to *Binky Brown* creator Justin Green to prompt her to take up this project.

— Kristy Valenti

Exciting as this was, I had a personal situation going on. Let me explain:

YOU GUYS. I GOTTA GET BACK—

PICK UP JULIA

I WAS GONNA ASK. HOW'S JUSTIN?

HEARD FROM HIM?

ONE NIGHT, A FEW MONTHS AGO. CALIFORNIA, U.S.A.

MAKE A TRAIN RESERVATION TO VISIT THE PARENTS THIS SUMMER.

OOHHH... ANNNH... I LOVE YOU TOO. I CAN'T WAIT TILL WE SIP FROM THE SAME CUP.

MY HUSBAND'S VOICE AND THAT FORMER BABYSITTER OF OURS.

!!

THUMP THUMP

BABE—WHAT'S THAT SOUND?

MAYBE CAROL'S GYM SHOES IN THE CLOTHES DRYER?

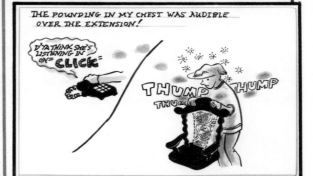
THE POUNDING IN MY CHEST WAS AUDIBLE OVER THE EXTENSION!

D'YA THINK SHE'S LISTENING IN ON— CLICK

THUMP THUMP THUMP

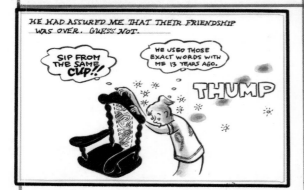
HE HAD ASSURED ME THAT THEIR FRIENDSHIP WAS OVER. GUESS NOT.

SIP FROM THE SAME CUP!!

HE USED THOSE EXACT WORDS WITH ME 13 YEARS AGO.

THUMP

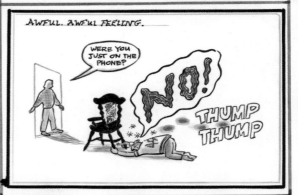
AWFUL. AWFUL FEELING.

WERE YOU JUST ON THE PHONE?

NO!

THUMP THUMP

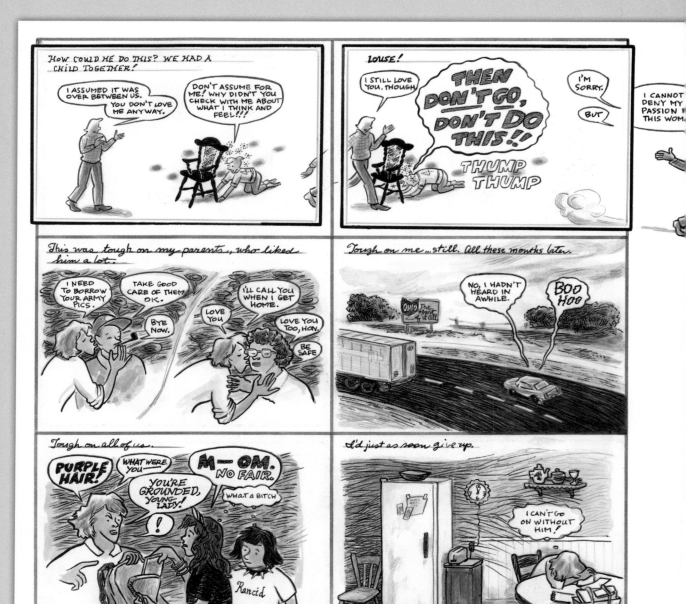

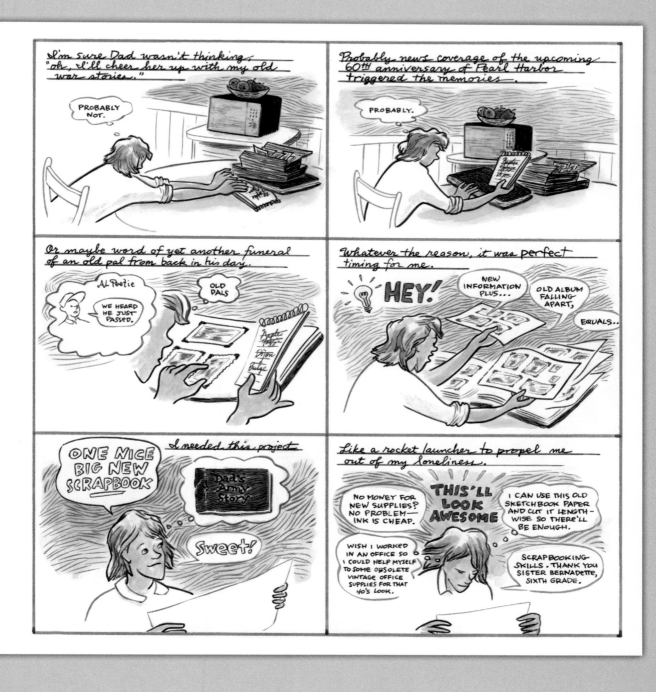

Bill Mauldin: A Life Up Front

Todd DePastino
WW Norton
329 pp., $27.95
Hardcover
ISBN: 9780393061833

Willie and Joe: The WWII Years

Bill Mauldin; Todd DePastino, ed.
Fantagraphics
650 pp., $65.00
B&W, Hardcover
ISBN: 9781560978381

Review by Tim Kreider

You know Bill Mauldin's cartoons, whether you know it or not. He was the creator of the cartoon characters Willie and Joe, those two tired-eyed dogfaces with the thousand-o' clock shadow who epitomized the everyman foot soldier of World War II, slogging through mud and bullshit with the same resignation, cracking wise in foxholes. You've probably seen his famous cartoon of a GI, eyes averted, about to put his crippled jeep out of its misery with his .45. He would be remembered as one of the great American editorial cartoonists even if he'd never drawn Willie and Joe, if for nothing else than for his iconic, endlessly imitated image of the Lincoln Memorial overcome with grief at Kennedy's assassination. Most importantly, he was one of the last cartoonists to become a hero to ordinary people, not just his colleagues.

Most of what I previously knew about Bill Mauldin comes from *Up Front,* his own account of life as an infantryman in World War II, which I'm going to go a paragraph out of my way here to recommend as one of the best non-comic books ever written by a cartoonist (alongside the hilarious and poignant *Hotel Bemelmans* by Ludwig Bemelmans, author of the *Madeline* books). The most admirable thing about Mauldin's authorial voice is a scrupulous fair-mindedness that's almost unheard-of among humorists and commentators (myself included) in today's vicious partisan world. He never dismissed anyone outright as a plain villain or a fool without giving him credit where it was due. It makes me nostalgic for an America I never knew, a country of greater decency, common sense and civility. But maybe Americans were never actually like that — maybe it was just Bill Mauldin.

Bill Mauldin was no ordinary man, and his life was raucous and implausible enough to make for good reading. He won Pulitzers, wrote best-selling memoirs, appeared in movies, and even ran for congress (and nearly won). I was very pleased to learn from Todd DePastino's new biography, *Mauldin: A Life Up Front*, that Mauldin wrote *Up Front* in a week while holed up in a Grenoble hotel room fucking an 18-year-old French girl. I also learned that he thought up the famous Lincoln cartoon the afternoon Kennedy was shot and drew it in less than an hour to get it in on time. The book is full of these sorts of anecdotes that you can't help but retell friends and spoil for potential readers. It also offers the incongruous connections that make even bad biographies such guilty fun: Mauldin's editor at Holt was William Sloane, my favorite gothic-horror novelist; actor René Auberjonois, who played the liquefiable Odo on *Star Trek: Deep Space Nine*, babysat for his kids. And real life allows for ironies and melodrama that would be too incredible for fiction, as when Mauldin, at a divisional reunion, meets the man on whom he based Willie, whom he'd believed dead for 36 years, or when his first wife comes back to care for him in his last days, five decades after he divorced her.

One of the less frivolous fascinations of reading biography is the chance to glimpse the shape of a whole human life in a way that we never do when we're in the middle of one (at least not until too late). Mauldin's peaked early and sharply, on the Horatio Alger model. His cartoons for *Stars and Stripes* endeared him to his fellow enlisted men (and a lot of officers) throughout the American army, earned him his own personal jeep and unlimited

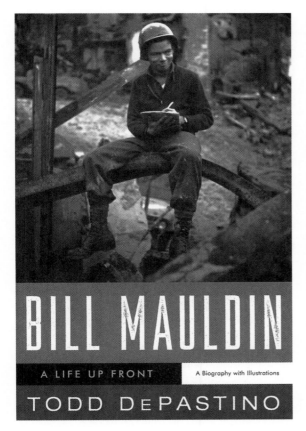

Jacket photograph by John Phillips/Getty Images:
jacket design by Chin-Yee Lai.

access to anyplace in the European theater (he was, for bureaucratic purposes, literally a one-man division), and got him an unprecedented closed-doors, no-rank, *mano-a-mano* talking-to from George S. Patton and defended by Ike. He was a national celebrity by the time he came home from the war, aged 24. In Hollywood, fellow wunderkind Orson Welles confided to him that "it all came too fast, too soon for us."

A lot of artists who attain greatness in wartime have learned, after their return to the peacetime world, that their only muses were Phobos and Deimos (I'm thinking here of cases like Michael Herr, whose *Dispatches* is one of the best documents of war ever written but who never really wrote another book again). But Mauldin's was not a one-act life. Although the war gave Mauldin the material that made him a star, it wasn't the source of his passion or talent. DePastino concentrates heavily on the war years, which I suppose only makes sense — I expect Chuck Yea-

ger's biography is probably heavy on the sound-barrier stuff — but it's still jarring when, after the book's taken 178 pages to cover the years 18 to 24, Mauldin's suddenly 30 only 28 pages later, and already 41 only 30 pages after that. (And I think this focus would irk Mauldin, who was mortified when the Chicago *Sun-Times*, in a publicity stunt, chauffeured him to his first day on the job in an Army jeep in 1962.) Like a lot of returning GIs, Mauldin did flounder a bit after his homecoming, at first clinging to Willie and Joe, drawing gags about their inglorious return to civilian life and grudging adjustment to domesticity, but he found a new *raison d'etre* and his own irascible voice again championing the same ideals his comrades had fought for, speaking out against the abuses of McCarthyism and Hoover's FBI and the injustice of segregation (he called the African-American "the enlisted man of society"). His civilian career was long and productive, with more high points than most artists ever get to have. It's instructive reading for this former political cartoonist trying to adjust to a post-Bush America.

The bio's subtitle is not just an allusion to Mauldin's Army days or his memoir; for the rest of his career Mauldin kept trying to find the front wherever it was, the place where men were putting themselves on the line for their ideals. "When I stay in an office," he said, "I start drawing elephants and donkeys." He went to Korea, and to Vietnam, and even Iraq; but he was also in Oxford, Miss., when riots erupted over James Meredith's admission to Ole Miss, and in Chicago when Mayor Daley's police went berserk with their bludgeons and gas. Even his recreation was on the edge: He flew a Piper Tri-Pacer, which "few who traveled with [him] considered … fun."

You suffer the same sort of disillusionments reading DePastino's biography that you do reading most artists' biographies: it turns out that Mauldin was an ordinary screwed-up person like the rest of us, and the stuff that he refined into something pure and noble in his art was often messy and unpresentable in his real life. DePastino uses the word "peppery" several times to describe Mauldin's temperament, which seems to be a folksy euphemism for having maybe been a little bit of a bastard. As Mauldin himself said, "You've got to be a misanthrope in this business, a real son of a bitch. I'm touchy. I've got raw nerve ends, and I'll jump. If I see a stuffed shirt, I want to punch it. If it's big, hit it. You can't go far wrong." But the reflexive pugnacity that made for unerring instincts as an artist and a gadfly was, needless to say, more problematic in his personal life, turning all his relationships adversarial. He had a quick temper; he was sometimes nasty to his wives; he went on ferocious drinking binges

to drown his demons. We don't hear that much about Mauldin as a husband and father in this book, and the omission seems telling. He had, in the course of his lifetime, three wives and eight children, most of whom, when quoted, speak of their father with what reads like a wary, rueful affection.

What exactly he was so mad at his whole life is what his son Andy called "the Rosebud question," and this book doesn't try to dig up any single, sled-like answer. His grandmother called him the angriest baby she'd ever seen; his childhood was what is called, in another quaint locution, "hardscrabble," meaning he grew up dirt poor with an alcoholic father; he was a runt and in a time and place that valued competence and brawn. DePastino's account of his early years fits a template that readers of David Michaelis' biography of Charles Schulz will recognize: He was a proud, insecure, scrappy kid, vain of his own smarts and talent and starved for the world's respect. You might call it the Cartoonist Personality Profile.

But these questions are maybe more interesting to biographers and armchair psychologists than lovers of art. How we wound up with the personalities we're stuck with matters less than what we choose to do with them. Mauldin owned up to having his "furies," but he felt fortunate to be able to work them out on paper instead of just being a barroom brawler. He refined the form of the editorial cartoon to a purity that's still a model for its practitioners. He disdained labels and stock symbols (the kinds of visual props and shortcuts still used every day by mainstream newspaper mediocrities as substitutes for talent) and instead drew slice-of-life tableaux that could crystallize a complex, abstract grievance into one resonant image. "To me," he enthused, "a captionless cartoon is like a home run to a batter." He deplored the "standardized and gutless strips" that dominated newspapers and always followed the advice of a general who'd told him that "when you start drawing pictures that don't get a few complaints, then you'd better quit, because you won't be doing anybody any good."

John Lardner, in reviewing one of Mauldin's memoirs, complained that "seeing both sides is a … fine, civilized passion, but you can see how it might get in the way of a crusader taking one side or the other of any question at all." But Mauldin's dogged fair-mindedness meant that he never got suckered in by ideological cant or turned a blind eye to the absurd excesses of his own side; he thought his communist friends were dangerously naïve in making apologies for Stalin's gulag state, and said that pacifists were "right ninety percent of the time — it is the other ten percent that worries me." He started out hawkish on Vietnam but warned that "the Viet Cong are more in tune with the aspirations of the Vietnamese people than we are." To some extent this may have been a matter of temperament rather than conviction, the impish perversity of a man who just liked to zig when everyone else was doing synchronized zagging. He was what you might call an ideologue — following an ideology of one. A friend tried to describe his political affiliation as "somewhere in the stew of Jeffersonian Conservative, Populist, Libertarian," and added, "and he'd kill me for getting that wrong, too."

The only times he abandoned his characteristic evenhandedness were when the evils he was attacking were, in his estimation, absolute: he depicted the defenders of Southern segregation as sneering morons and club-lugging Neanderthals — though let the record show that he also mocked the more polite and insidious racism of the North. He drew swastikas in denouncing the bullying chauvinism of the House Committee on Un-American Activities and the hooliganism of Mayor Daley's tinpot police state — this from a guy to whom Nazi imagery was not the mythic taboo it's become since, and who'd fairly earned the right to invoke it when he felt it was deserved. Anger from an angry man is just so much noise, but anger from a fundamentally fair and decent man commands attention.

What's truly extraordinary is that, in historical hindsight, he almost always ended up on the right side of the most important moral questions of his time. He saw the Soviet Union for the totalitarian nightmare it was but also resisted pandering jingoism or warmongering. ("Every time I start work on a drawing about Russia's misbehavior … I think of all the sons of bitches doing the same thing for reasons of their own and I often throw the drawing away.") He spoke out against McCarthyism and segregation when those positions were not the no-brainers they may seem in historical hindsight, but radical stands that provoked hate mail, canceled subscriptions, editorial disapproval and dropped papers. He stood up for economic justice, feminisim and even gay rights when most of his generational cohort was cracking jokes at the expense of the longhaired counterculture. (After growling at his sons' long hair and radical politics, he ended up growing a beard, smoking pot, and marrying a beautiful hippy chick 27 years younger than him.) And just as his wartime cartoons had gotten him in trouble with the brass, his views on domestic affairs earned him a file in Hoover's FBI and would eventually cause him to be classified a "security risk." He stopped getting invites to LBJ's ranch when he decided that Vietnam was based on sloganeering

instead of any real threat. As late as 1991, George Bush I got him barred from the Thanksgiving photo op with the troops in Iraq.

Of course. what posterity smugly judges to have been "right" can be pretty subjective, a matter of fickle ideological fashion. And anyway, we can enjoy the work of Swift or Mencken without agreeing with (or caring much about) any of their positions on the issues of their times. Maybe this sort of "rightness" is no more important than a science-fiction writer's lucky technical prescience. And yet it sometimes seems like there have only been two sides throughout all human history — the complacent, entrenched defenders of the *status quo*, and the cranks and dreamers and malcontents who've constantly led the charge for a better, fairer world. Even if he was "a real son of a bitch," I have to admire Mauldin's instincts in having always placed himself squarely on the side of the angels.

If it's the art, rather than the artist, that matters to you, you'll probably want to own Fantagraphics' collection of all Mauldin's Willie and Joe cartoons. It comes in two big volumes, bound in olive drab, the text printed in old-media typewriter font, as if it had been pounded out with two fingers on a Remington on the hood of a jeep. It's perhaps an obtrusively clever, self-referential design, but

Cover design by Jacob Covey.

it's also one I think Mauldin would've liked (he painted his civilian Willys-Overland Jeep olive drab because he felt it was the only acceptable color for a jeep). There's also something that feels authentically up-front about the fact that these cartoons have been salvaged from all sorts of sources and thus the quality of reproduction, especially in the early years, varies wildly. (You can imagine some of them being exhumed from moldering boxes of yellowed issues of the *45th Division News* bound with twine in somebody's grandpa's attic.) Appended also is a selection of drawings culled from the collection Mauldin donated to the Library of Congress, of which most of the published versions are nowhere to be found.

Vol. I is probably of more historical interest to the dedicated comics weenie, collecting very early, rarely seen cartoons from sources like *Arizona Highways* and the *45th Division News* (including an early version, identical in concept if not execution, of the GI euthanizing his jeep). One thing you learn from this juvenilia (if I can use that term of an artist whose most famous work was drawn when he was barely out of his teens) is that even Mauldin's earliest efforts were always funny. A gag for *Arizona Highways* startled me with my own loud laughter: It shows a guy in the front seat of a car that's just crossed a set of train tracks calling back, "Close one, wasn't it fellas?" unaware that the rear half of his vehicle has been cleanly ripped away.

You can also see how he quickly pared down his verbiage: When he first started drawing for the *45th Division News*, he crowded his panels with as many word balloons as 18th-century political cartoons, often including two or three different iterations of the punch line: "Dad blasted ossifers! They come tearin' by on them puddle-jumpers, an' then raise whoopee on accounta the mud on our uniforms." Partly he was honing his ear here, trying to capture the salt and drawl and cadence of Army dialect. But by 1944 he had distilled the same gag — infantry splashed with mud by an officer in a jeep — into one line: the oblivious receding driver calling back to the muck-splattered dogfaces, "Damn fine road, men!" (I've learned that one excellent way to cultivate an appreciation for the craft of Mauldin's captions is to attempt to paraphrase them from memory and then find, through double-checking, how much more concise and euphonious his originals are. Also bear in mind that he had to accurately replicate the speech of soldiers *without using profanity*, effectively a feat of translation as creative as rendering Euripides or Li Po into colloquial American.)

It's in Volume II, all the cartoons drawn in Europe, that Mauldin has found his trademark voice and style.

"Close one, wasn't it, fellows?"

From *Arizona Highways* (June, 1940), collected in *Willie and Joe:
The WWII Years* Vol. 1. [©2008 The Estate of Bill Maudlin]

You can see his drawings change in a very short time from an illustrative style with finer lines and fastidious detail, often employing a collage of images and anecdotes, to the stark, black-and-white panels you can read as instantly as a stenciled warning. DePastino's biography explains how this evolution was an adapation to the ridiculous technical privations under which Mauldin worked: He often used ink that was cut with wine or used motor oil; he often drew on the hood of a jeep or a piece of rubble; once he had to engrave a cartoon using black-market acid and zinc ripped from a coffin lining. Also, people were shooting at him. So he ditched his fine pen for a brush and drew in thick bold strokes that would show up clearly when reproduced on cheap newsprint and read in less-than-ideal lighting conditions. (After the war he found that his frontline style was too aggressively eye-grabbing for the editorial page, and returned to a finer line and gentler shades of gray.)

And God*damn*, what brushstrokes. If you blew his details up to the point of abstraction they'd look like Chinese calligraphy or Franz Kline paintings. No one's ever drawn rain and mud and ruts and puddles as well as Mauldin: raw, sloppy, perfect scrawls, form following content like the visual analog of onomatopoeia. And Mauldin is to wrinkles what Bonnard was to bathwater, what Turner was to waves — his loose, sagging uniforms are filled out in thick, black, interlacing loops and ribbons of shadow, drawn with the intimate familiarity and attention that's a kind of love. Mauldin would have been mortified to get details of outfitting and equipment wrong — it was a matter not only of professionalism but his integrity as a soldier. (A note to an editor tentatively permits for the substitution of the generic term "rifle" in a caption for clarity's sake, but makes a plea for the more specific,

truer-to-life "B.A.R.") His depictions of mud and rubble and gear remind me of the Zen master's instruction for painting bamboo: study bamboo for 50 years, then paint. As Joe, knee-deep in a trench he's digging, puts it: "I'm gone be a perfesser on types o' European soil."

The best single-panel cartoons all imply a whole narrative universe beyond their borders, but Mauldin's concisely evoke a very specific and real world of which most of us are, thankfully, ignorant. The famous panel captioned, "Joe, yestiddy ya saved me life an' I swore I'd pay ya back. Here's me last pair o' dry socks," is obviously the punch line to a whole life of relentless, sodden wretchedness in which socks could truly be the most precious of commodities. (It's also a gruff/tender symbol of the only currency that means anything in combat, friendship.) That these cartoons were drawn for other soldiers, not a general civilian audience, makes them the truest representation of the servicemen's subjective experience (just as the best way to get to know any group is not to ask them to explain themselves to you but to invisibly eavesdrop on them talking amongst themselves). This insider's specificity also occasionally renders the jokes unintelligible to us civilians, but helpful endnotes in the Fantagraphics collection usually provide definitions and context where necessary. But even if some of the topical in-jokes are lost, the most important things come through; I don't need to know exactly what an "88" was, since thanks to Mauldin I can instantly apprehend the dread and loathing that soldiers felt for the weapon, in the same way I can understand how a pair of socks might well seem adequate reward for a man's life.

The worst things about war, of course, were things that could not be spoken of, much less depicted — and not just because of Army censorship, but because of the grave decorum distinctive of that less confessional generation. The closest Mauldin comes to depicting the shitless terror of combat are in cartoons with captions like: [Willie and Joe desperately hugging the dirt] "I can't git no lower, Willie — me buttons is in th' way," "I lose fifty bucks. I got here safe," and "I'm beginnin' to feel like a fugitive from the law of averages." The empty shells of buildings and heaps of rubble had to fill in for corpses, crippling and disfigurement; as Mauldin put it, "The bodies are just offstage." He felt there was something dishonest about having kept his beloved dogfaces implausibly alive, like cartoon children staying young decade after decade, when the men they'd been based on had long since been

Opposite: From the Aug. 16, 1944 *Stars and Strips* (Mediterranean),
collected in Vol. 2. [©2008 The Estate of Bill Maudlin]

"Try to say sumpin' funny, Joe."

[©1963 Bill Mauldin]

killed and his own rifle company had seen a 1000-percent turnover rate. He'd actually intended to draw a cartoon, to be run on the last day of the war, showing their gear flung around a smoking crater, but his editor told him he'd never run it. "I should have killed them," he said after the war.

But the men his cartoons were based on and drawn for never talked much about death themselves, so Willie and Joe tend to displace all their frustration and outrage at their situation onto relatively petty complaints, cracking wise about the filth and indignities of the front, griping about the petty injustice and omnipresent bullshit of the Army. The pervasive language of bureaucratic euphemism ("I need a couple a guys what don't owe me no money for a little routine patrol,") and propaganda ("Must be a tough objective. Th' ol' man says we're gonna have the honor of liberatin' it") they seem to take ruefully as a matter of course, as ubiquitous and unavoidable as the mud they have to slog through and the stagnant water they have to sleep in. They regard the gung-ho naïveté of new recruits and the tough-guy act of rear-echelon "garritroopers" ("That can't be no combat man — he's lookin' fer a fight") with a dull weariness that's more eloquent than contempt.

Mauldin was more stridently intolerant of what was called "chickenshit" — the picayune regulations that served only to exclude and harass, and generally enforced the de facto class division between officers and enlisted men, a division to which Mauldin, proud white trash from way back, was particularly sensitive. (The most famous example, as poetic in its way as a Searle or Leunig cartoon: Two officers admiring an Alpine vista, one of them inquiring, "Is there one for the enlisted men?") It should be recalled that this was a civilian army, composed of men who hadn't exactly volunteered for this shit and weren't used to living regimented lives or being ordered around — hence the recurring gag about hoping to run into this or that ranking idiot or martinet back in civilian life, a revenge fantasy finally consummated in the last cartoon in the book: Willie and Joe addressing a hotel bellhop who's hauling their luggage, "Major Wilson! Back in uniform, I see!"

Mauldin was no sentimentalist, and he had no patience for the hagiographic hooey about the "Greatest Generation" that attended the 50th anniversary of the war. His Willie and Joe were no saints; they were slovenly and insolent and got drunk (and doubtless laid, although, like death, the sex is implied offstage) every chance they could, their main mission objectives were to stay warm and dry and not get killed, and the only thing they were really fighting for was each other. As Mauldin said of the soldiers he'd fought with, "they were human beings, they had their weaknesses and their flaws and their good sides and bad sides." Some of the most touching and memorable stories in DePastino's biography illustrate the real respect, even reverence, paid to this skinny little cartoonist by his fellow soldiers. A couple of GIs who were about to bully Mauldin out of his jeep and appropriate it for themselves backed off when one of them noticed its custom license plate, telling his partner, "We don't want to take this guy's jeep." When Mauldin was hospitalized with Alzheimer's at the end of his life, he received a flood of letters and tributes and visits from well-wishers — even a pair of socks. These stories are so moving to me, not, I think, as fables about the brotherhood of combat, but as testaments to the power of art — even cartoons — to give voice and solace and sanity to ordinary men in the worst of times. For decades Charles Schulz referenced Willie and Joe in his annual Veteran's Day strip. When Mauldin asked Schulz about his yearly tribute when they finally met in 1989, DePastino relates: "Schulz responded simply that he had been an infantryman in France." ∎

500 Essential Graphic Novels:
The Ultimate Guide

Gene Kannenberg, et al.
Collins Design
528 pp., $24.95
Color, Softcover
ISBN: 9780061474514

Review by Bill Randall

Randall writes, "It views manga and Eurocomics through the lens that put *Epileptic* on the same shelf as *Gunsmith Cats*." This image is from Kenichi Sonoda's *Gunsmith Cats* Vol. VIII: *Mister V*. [©2001 Kenichi Sonoda, flipped artwork ©2001 Studio Proteus and Dark Horse]

Osamu Tezuka's *Karma*, one of the finest comics I've read, can't even break the top 10 in its genre. This I learned from Gene Kannenberg's *500 Essential Graphic Novels*, a catholic tome that seeks to define both a medium and a marketing term. I also learned that *Karma*, set in 8th-century Japan with not a robot in sight, is science fiction. I should protest this claim, and many others. In books like this, the arguing is part of the pleasure.

The author can handle it. Kannenberg is one of the few true scholars of comics. He received his Ph.D. from the University of Connecticut's English department, his dissertation focused on Winsor McCay, Art Spiegelman and Chris Ware. Now he directs ComicsResearch.org, an annotated bibliography of scholarly works on comics, while continuing his work as an independent scholar. While this *Guide* is his first book, he participated in a similar project in 1999 for this journal's best 100 comics of the last century. Then he penned essays on *Calvin & Hobbes*, *Maus* and *Zippy*. Now, with a team of more than 20 writers, he adds many more.

Fortunately for readers, the *Guide* hasn't been peer-reviewed to death. It invites, bursting with colorful images and conversational reviews. It includes genres like adventure, humor and war. Superheroes have their place in Kannenberg's canon, as do some comics I've never even seen. So it rewards browsing. The book is at heart a list of the best comics. Commissioned by the Ilex Press, a British specialist in art and design books, it recalls *The Art*

Book from Phaidon.

However, it goes into more depth than Phaidon's coffee-table books. Kannenberg opens with a brief history of the medium. He tentatively defines "graphic novel" as a work with "serious intent," unlike the casual entertainments of before. Artists now try "to create work of lasting value," a trend beginning with Will Eisner, running through the class of '86 to the present. After the history lesson, the book divides its 500 entries into 10 genres, each with its own top 10 and an introduction. Anyone who has read this journal for more than a few months will find these essays elementary, but they are aimed at new readers.

As to the 500 entries, any reader will find surprises — one of the two main pleasures of lists. I, for one, did not realize Marc-Antoine Mathieu had been translated into English, or that Sarnath Banerjee's *Corridor* even existed. Nick Abadzis' odd-looking children's book, *The Amazing Mr. Pleebus*, contrasts with the historical fiction of *Laika*. Both are included, and cross-referenced: the book links entries by the same artist, as well as those that are similar. The *Guide* offers a detailed map for occasional strolls through comics history. While just a start, neophytes can come away rather well-versed.

The other main pleasure of lists — the carping — has been cornered by the Internet, so I will be brief. The *Guide's* most obvious weakness as a critical work is its

From the graphic novel *Dead Memory*, written and drawn by Marc-Antoine Mathieu. [©2003 Guy Delcourt Productions and Marc-Antoine Mathieu]

target: It aims for book buyers more than readers, so it includes only in-print, readily available books. It favors the first volume of reprints, even when later volumes offer a better introduction. The first volume of DC's *Plastic Man* archives shows a pedestrian artist; later ones, or the Spiegelman-Kidd book on Jack Cole, show a brilliant one. Kannenberg notes that out-of-print works have been either omitted or put in the "Further Reading" lists under each entry. But he doesn't show the new reader where to look for such books. Libraries are mentioned, but not the special collections, or even the websites that reprint old classics.

Furthermore, the *Guide* struggles to reconcile comics' various histories with the bookstore. Though the two have converged just recently, the *Guide* shoehorns comics into bookstore marketing categories. General Fiction has so many quality comics that *Palomar* and *Jimmy Corrigan* appear tucked away at the section's end. Non-Fiction showcases one of comics' most developed forms, the memoir, but bulges with both historical fiction like *The Salon* and didactic works by Scott McCloud and Larry Gonick. Horror, never a Direct Market mainstay, gets padded with Hollywood dross. *Clive Barker's Hellraiser* gets deemed "confusingly written and illustrated," and even "dull." 499 Essentials, then.

Finally, the rankings in these genres can seem daft. Each genre's section starts with 10 "must-reads," presumably the best of the best. In "Adventure," I was surprised to find *Owly* more worthwhile than *Tintin in Tibet*. Kannenberg often confounds received wisdom in this way. But with no real discussion of the ranking criteria to expand my thinking, such rankings confuse. If "the importance of [*Tintin in Tibet*] cannot be disputed" for its realism, emotional heft and precise art, shouldn't it be valued more than a book whose main virtue "is its special ability to deal with weighty themes … in simple and engaging stories"? And if this is an apples-and-oranges comparison, why lump them together?

So I'm left disappointed. A new reader gets a guidebook with a sketchy map; an old one has little to chew on. Of course, I'm not the target audience. I still hoped to see more of Kannenberg's thoughts on the page, one of the joys of reading criticism. Unfortunately, the *Guide's* reviews are just too short. It shares more with Jason Thompson's epic *Manga: The Complete Guide* than *TCJ's* best 100 comics. With 500 works, why not go for a thousand?

Even with the 500, there are omissions. The *Guide's* vision of comics favors the comic-book store of the last few years, not the medium as a whole. It views manga and Eurocomics through the lens that put *Epileptic* on the same

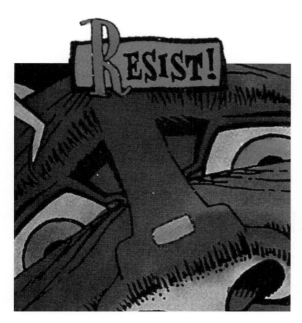

From "The Girl in the Peephole," written by Del Stone Jr. and drawn by Mark Hempel, in *Clive Barker's Hellraiser Collected Best* Vol. 1. [©2002 Checker Publishing Group/Clive Barker]

shelf as *Gunsmith Cats*. It omits important small American publishers like PictureBox and AdHouse, yet includes several books by Titan, a British publisher specializing in reprints. Most glaringly, nothing by Eddie Campbell appears. Not *Alec*; not *Bacchus*; not even *From Hell*.

Kannenberg tried to put him in; Campbell refused. As he wrote in his blog, on August 13, 2008:

> For the record, they did ask my permission to include images from my very first book and I said NO. Why they should choose that and ignore all that followed tended to raise my ire but I would have told them anyway, and I did, that anyone who thinks there are more than a few dozen so-called 'graphic novels' worth reading is an idiot.

It's a forceful claim, but Campbell had already spoken his piece on such comics in *How to be an Artist*. That book ends with his list of those few dozen graphic novels worth reading. Since then, he has crusaded against the term, almost quixotically.

He has a point. "Graphic novel" has always been a poor term, but now it has apparently stuck. So we're having second thoughts. But few other terms are much better: "picture novella," "sequential art" or even Art Spiegelman's old stab "comix," for the "co-mixing" of word and image.

All just mean comics, another poor term, like "novel." With the former not always funny and latter not new since *Oroonoko*, neither fits. But they're compact, with enough currency that people have a chance of knowing what they mean. I suspect (and hope) that in the long run, "comics" will be the term that sticks. If "graphic novel" must hang out for a while to reassure new readers it's OK to take comics seriously, fair enough. Let's just keep marketers from controlling the discussion for too long.

The problem for the *Guide* under review is that, while "graphic novel" keeps *Maus* out of the humor section, it cannot contain the breadth of the form. A graphic novel is a book. Many comics aren't. Kannenberg includes a few, strips like *Terry and the Pirates,* which ebb and flow over weeks and years. Reading them daily is companionship, while collecting them into books is transcription a best. At worst it betrays their shape and rhythm. As much as I enjoy certain runs in the strip collections on my shelf — *Alley Oop, Li'l Abner,* even *Pogo* — many of them I've never read cover-to-cover for this reason. The ones that work well as books find new audiences, while others that don't fade from view. Kannenberg admits in his general introduction that the handful of included strips fit poorly in the "graphic novel" model. So do the short strips collected from Golden Age and EC comic books. So do all the trade paperbacks plucking superhero comics out of continuity. Were one to cull the final list rigorously in favor of graphic novels as defined, it would look closer to Campbell's, if not quite as short.

The view from further away, I suspect, would reveal that "graphic novels" — the products of interesting times when a mass of artists have taken up the single-volume comic for self-expression and bookstores actually sell the things — are in the late middle, or late beginning, of their moment in the sun. As strips dominated the medium before the wars, comic books after, now it's books with whole narratives. And that is the format that has taken hold at roughly the same time in the three largest comics cultures.

Judging the *Guide* based on how well it accounts for these tensions at this point in history, it fails outright. As a work of criticism, too, it is spread too thin for serious consideration. But as a book to browse, as a gift for a new reader, it works just fine. Even long-term readers will find works, or whole genres, to reconsider. Kannenberg's list of comics is clearly generous, even if it lacks the sharp edge that makes a list cut your fingers so that you always think of it when you pull a book from the shelf. ∎

Garfield:
30 Years of Laughs and Lasagna

Jim Davis
Ballantine Books
287 pp., $35.00
Color, Hardcover
ISBN: 9780345503794

Garfield Minus Garfield

Jim Davis & Dan Walsh
Ballantine Books
128 pp., $12.00
Color, Softcover
ISBN: 9780345513878

Review by Noah Berlatsky

Garfield should be better than it is. Jim Davis is not and has never tried to be a great artist, but he is a talented cartoonist. Flip through *Garfield:30 Years of Laughs and Lasagna* and you will see slapstick humor executed with hyperbolic panache. (Odie's tongue stuck to an ice-cold street lamp and then stretched across an entire Sunday spread is a stand-out.) You'll read some solid schtick: "Irma, is this tea or coffee?" "What does it taste like?" "It tastes like turpentine." "Oh, that's our coffee. Our tea tastes like transmission fluid." Badabump! You'll even find the occasional moment of surreal brilliance. (On an island vacation, Jon's palm-frond skirt is devoured by an infestation of leaf weasels.) The visuals are inventive and flexible; Davis is able not only to draw, but to render

From "the third decade" of *Garfield* (1998 – 2008): collected in Jim Davis' *Garfield: 30 Years of Laughs and Lasagna*. [©2008 PAWS Inc.]

From *Garfield Minus Garfield* by Jim Davis and Dan Walsh. [©2008 PAWS Inc.]

instantly recognizable, everything from a Baroque arch-way over a mouse hole to a Mongolian mime fish — the last of which is pretty much exactly what it sounds like it should be. In other words, all the elements are present for consistent, day-in, day-out, high-quality laffs.

Alas, it's that very consistency that ultimately drags the comic down. Not that *Garfield* never delivers; I chuckled more than once while reading through this book. But three decades is a long, long time. To remain entertaining over that span, there needs to be change as well as continuity. Charles Schulz managed to go on, and on, and on by continually introducing new characters — Lucy, Linus, Woodstock, Peppermint Patty, Sally, Rerun, Spike — and revising old ones like Snoopy. Berkeley Breathed and Garry Trudeau had continuity; their characters existed in a loose but ongoing storyline, which helped to place even repeated gags in different contexts.

Garfield, though, was from the beginning more in the vein of crotchety warhorses like *Beetle Bailey*. There's a fat, sarcastic cat. There's Jon, his hapless owner. Shortly thereafter there's Odie the stupid dog, and a few other ancillary characters — Irma the waitress, Nermal the cute cat, Pookie the teddy bear. And then that's it. For 10, 20, 30 years. Reading through this collection, the repetition across the decades is first amazing and then numbing. There's one wow-coffee-makes-you-bonkers! gag … and then there's another … and, yep, it still-makes-you-bonkers! It's telling that when Jon finally, finally, after 25 years, gets a girlfriend, it's Liz the veterinarian, the sardonic woman he's been pursuing almost that entire time. Another writer might have … I don't know, made up a different girlfriend who hadn't already shown herself entirely uninterested? Not Davis, though. Why draw somebody new when you've got a perfectly good character design just sitting there?

Davis shows the same level of creative attention in choosing his 30 favorite *Garfield* cartoons for the end of this volume. He predictably picks the strip's debut … and after that one, he seems to make his selections entirely at random. They're all just decent gags, like any other decent gag. Of course, what else could they be? The strip has no milestones, no events. Not only is nothing happening now, but nothing has ever happened, or will ever happen. It exists in an eternal amnesiac present.

This is what makes www.garfieldminusgarfield.net such a brilliant coup. In the last few years, some Internet users and bloggers started to digitally remove Garfield from the *Garfield* strip, leaving only poor Jon Arbuckle talking to himself. In 2008, Dan Walsh, an Irish musician and businessman, took the idea to the next level, systematically altering strips and posting a new one every day.

The result is that *Garfield*'s greatest weakness — its monotony — suddenly becomes a strength. Hammy sitcom vaudeville turns into Beckett — which makes it both more poignant and a hell of a lot funnier. Jon and Garfield threatening each other with sock puppets is fairly amusing; Jon brandishing a puppet at nothing and then sinking into utter lethargy is absurdist genius. Even the art is startlingly improved. When you take out the main character, the strip suddenly starts to use negative space as if it had taken an intensive design class. A three-panel sequence will often have two squares of nothing; just a primary color and a single line defining a table top. When he does show up, Jon is pushed to one side of the panel or the other, dramatically isolating him. Visually, it's daring and funny, and perfectly captures the emptiness of Jon's sad and lonely existence.

Walsh's site became an Internet sensation, and then began garnering mainstream attention as well. Soon enough Davis discovered it. To his eternal credit he didn't issue a cease-and-desist order; instead, he co-opted it. The result is *Garfield Minus Garfield* — a book featur-

Jim Davis himself removes Garfield from *Garfield*. [©2008 PAWS Inc.]

ing Walsh's de-felined efforts next to the original Davis strips that spawned them. Davis even tries his hand himself, personally eliminating the cat from several of his own comics. In fact, once he started erasing, Davis enjoyed it so much he employed it on the book's cover as well, cheerfully blotting out Walsh's byline. *Garfield Minus Garfield* claims that it is "by Jim Davis"; Walsh is credited only with the introduction, and as the creator of www.garfieldminusgarfield.net.

In some sense, Davis is right to claim full credit. What's most fascinating about this volume is that it shows the extent to which Walsh's transformed strips are true to Davis' vision. Indeed, the majority of altered strips feature Davis' jokes, essentially as he wrote them. It is Davis' Jon who has spent 30 years without being able to find a girlfriend; it's Davis' Jon who stays home alone on Friday nights playing with Scotch tape or staring vacantly at the wall. It's Davis' Jon who says, "What is the purpose of life?" and then hits himself in the face with his own ice-cream cone. Walsh isn't engaged in détournement; instead, he's creating brilliantly inspired fan-fic. As Walsh himself notes in his introduction:

"... Jon has always been talking to himself. Garfield never *really* answers because his replies are always just thoughts ... Jon has always been telling us these things; it's just that with Garfield there you've been distracted from the truth: Jon needs some help!"

So Davis is an underappreciated genius then? Well, no ... not exactly. Walsh is right that Jon is talking to his cat ... but then Garfield's not a real cat. He's a cartoon character. Though his words are always in thought bubbles, he and Jon clearly are able to communicate much more effectively than I can talk to my two Siamese. When Jon and Garfield are together, they're a routine — with Jon as the eternal straight-man for Garfield's deadpan zingers.

When Walsh takes Garfield away, though, you lose

that stand-up frame, and have to start thinking of Jon as an actual person. In many cases, what this gives you is simply the slapstick without the final snarky putdown. "I had a pretty good day today. (Beat.) Once I got my leg out of the bear trap," works pretty much the same whether or not you have Garfield around to add "Jon never disappoints me." The Davis-created *Garfield Minus Garfield* strips in the second part of the book are almost all of this sort; the joke is the same in both original and revised strips.

Walsh takes this route too sometimes. But the best of his efforts are the ones in which Garfield was more intrinsic to the original gag, so that, when he is removed, Jon is left overreacting to nothing but his own troubled psyche. Thus, Jon takes a sip of soup ... looks horrified ... and then collapses, weeping. Jon lies on the floor ... and lies on the floor ... and lies on the floor. Jon says, "Do you have any unfulfilled dreams?" and then sits there silently for two panels. In at least one instance, when Jon seems a bit too witty, Walsh gratuitously removes a punch line.

The point is that the genius here *is* Davis' — and it also isn't. Borges has a short essay in which he argues that Edward Fitzgerald's translation of Omar Khayyam's *Rubaiyat* was greater than anything either could have done alone. "[F]rom the lucky conjunction of a Persian astronomer who ventures into poetry and an English eccentric who explores Spanish and Oriental texts ... emerges an extraordinary poet who resembles neither of them." Something like that seems to have happened here as well. Davis is an aesthetically dicey mainstream cartoonist; Walsh is a wannabe rock-and-roller who never hit it big. Together, though, they are, as Borges said, an extraordinary poet. Erase Garfield and you are left with a Davis who is just the same, only funnier. ∎

Mary Perkins On Stage Vols. 1-2

Leonard Starr
Classic Comics Press
B&W, Softcover
Vol. 1: 150 pp., $19.95 ISBN: 978-1424310234
Vol. 2: 212 pp., $21.95 ISBN: 978-1424326624

Review by Bill Sherman

When we're first introduced to the title heroine of Leonard Starr's 22-year comic strip, *Mary Perkins On Stage* (original title: *On Stage*), our would-be actress is preparing to leave for the Great White Way. With long, curly hair and a hat that shouts Small Town Ingénue, she concludes her big Sunday debut, standing in the midst of a bustling Pennsylvania Station, looking overwhelmed by her big move. It won't take long for our heroine to lose the homespun look, but, at heart, the former Strawberry Queen retains her small-town earnestness — no mean feat in this biz we call show.

The first two volumes in Classic Comics Press's reprints of *Mary Perkins On Stage* follow our girl from her Feb. 10, 1957 premiere through April 19, 1959. A lot goes on in those two-plus years: in Volume One, she's hooked by a smooth and mustachioed theatrical agent named Gordon D'Avilla, who makes his living bilking naïve would-be starlets; is pulled into obsessive producer Kirk Arno's desire to cast her in the role of a long-dead lover; gets a job as a cigarette girl at a nightclub called the Pink Cherub, where she attracts the attention of an alcoholic composer, and plays Liza Doolittle with the dashing photojournalist Pete Fetcher. In the second volume, Mary's career as an actress begins in earnest.

Though writer-artist Starr himself states in an interview reprinted in Vol. 2, that he "didn't decide to do a show business strip out of some tremendous love for show biz," the cartoonist's evocation of the '50s era theatrical milieu is so strong and lovingly detailed that his strip still reads like an insider's glimpse. Starr credits the "tremendous public relations offices" of many New York theaters for giving him that inside view, but the cartoonist's friendship with actors like a young Larry Hagman (used as the visual inspiration for self-destructive method actor Jed Potter in Vol. 2) must have also helped when it came to crafting storylines and adding the telling details. When

Mary gets enmeshed in a movie contract under a Napoleonic Hollywood producer, for instance, we're shown the workings of a demeaning studio system no theatrical PR department would have deigned to describe.

If Starr's avowed storytelling preference was for more exotic, action-oriented fare, he had a clear knack for rendering more internal states: jealousy, acquisitiveness and blind ambition — all the things that make the actor's life so entertaining to observe from afar. The facility that made *Mary Perkins On Stage* one of the greatest (and arguably most mature) of the American soap strips was his sly ability to suggest adult duplicity and the rationalizations that frequently accompany it. "With your gift of gab, you'll convince yourself you're Sir Galahad," snaky agent D'Avilla's knowing secretary tells him, and the remark crackles with screwball comedy wit.

Jed Potter is played by Larry Hagman. From *Leonard Starr's Mary Perkins on Stage Vol. 2: January 12, 1958 to April 19, 1959.*
[©2007 Tribune Media Services]

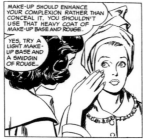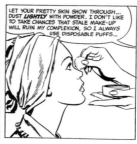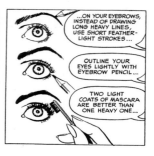

From Volume 2. [©2007 Tribune Media Services]

At times in the early entries, you can see Starr still struggling to find the apt visual depiction, though. In one episode from Vol. 1, for example, an unscrupulous hat-check girl is shown greedily poring over her savings account book — an act only slightly less subtle than Scrooge McDuck's dives in his money bin. The bulk of Mary's beaus, fellow thespians and cast members are more believably delineated: You can practically hear the brassy tones of Mary's confidante and blues singer Flora Deeds, for instance. Working with his engagingly neurotic theater folk, the artist captures his characters' histrionic proclivities with visual relish — as when the old vaudevillian Jo Jo Cole throws a cane-wielding tantrum over Mary's adept rehearsal performance.

Though its prime focus was on romance (the on-again/off-again relationship between Mary and her photog beau Pete Fletcher predominating) and show biz intrigue, Starr wasn't averse to messing around with other story types. Each of the first two reprint volumes contain a gothic exercise, for instance — the first being the Arno plot's mesh of *Laura* and *Rebecca*, the second tweaking *Phantom of the Opera* by intertwining it with the 1957 Lon Chaney bio flick *Man of a Thousand Faces*. (Starr resists the temptation to actually show us his story's disfigured phantom, however.) A sequence in Vol. 2 that we at first assume will be a reworking of *All About Eve* (with our heroine in the Bette Davis role) instead winds up in a cops-and-robbers shoot-out.

The artist includes a neat visual joke in that last when he introduces robber's moll "Magnolia Peachtree Dade," as a garish doll-like parody of the young Holmesfield gal we saw in the strip's opener. Mary spiffs her up, of course — our girl's a quick study — in one of Starr's typically efficacious montage sequences, but it doesn't stop the ungrateful wench from attempting to kill Mary and handsome young NYC plainclothesman Luke Sanders. Later that year, our heroine gets wooed by the vaguely unsavory Johnny Q, a figure with undefined mob ties and the kind of rep nobody wants to discuss openly. Mary's involvement with Johnny brings nice-guy Pete Fletcher back into the picture. Nudged by an unethical gossip columnist named Googan, who has set up a public conflict between the two men, our sturdy photographer once more comes close to getting hitched to our heroine, before the usual missed connections and misunderstandings send him behind the Iron Curtain.

It's during their first doomed romance that Mary proves herself to be very much a woman of her times. Given an engagement ring, her Holmesfield upbringing reasserts itself: She immediately begins to go domestic, fretting over Pete's bachelor spending habits, chastising him over an empty refrigerator and too many nights eating out. Though she clearly wants to be mother/wife to Pete, her desire to continue working as an actress remains strong. "I think we'll have so much more in common if I continue my career," she tells the diva-esque actress Gaye Brittle (who herself shares history with Pete), and you can just hear the strip's pre-feminist '50s readership going, "You naïve little thing, you."

Mary may have her gullible and girly moments — usually when the plot demands it — but, on the job, she's no milquetoast. Given the "treatment" by a group of noisy stagehands in her first big Broadway rehearsal, she still manages to take command of the stage; naïve she may be, but, on stage, she can hold her own. Confronted off stage by a string of men (crazed Peter Arno, manipulative movie producer Samson Alexander, sleazy talk-show personality Homer Hanks) scheming to control her life, Mary strives to hold onto her one true self. Starr was not above doing a panel of our heroine weeping inconsolably over lost love — the heartbreak of the young and beautiful is what the readership came to see, after all — but in the end the prime focus in the strip remains on a talented young woman's struggles to make her own name. When filmmaker Alexander renames her Chandra Lure, for instance, to star in a series of crappy Hollywood epics, we know this faux identity won't last.

Leonard Starr's Chandra Lure On Film? Just doesn't have the right ring to it. ∎

Aya of Yop City
Marguerite Abouet & Clément Oubrerie
Drawn & Quarterly
128 pp., $19.95
Color, Hardcover
ISBN: 9781897299418

Last year's *Aya* showed a defiantly feel-good Africa. Instead of a Côte d'Ivoire ripped open by corruption and civil war, it showed a rambunctious village life during the flush prewar years. This year's *Aya of Yop City* does the same, though the economy's slowed a touch. Abouet and Oubrerie show a girl's changing world. Her friend's a mother now and her father's being downsized. The developing world has every right to the mundane, after all.

The new book picks up where the old left off, with the question of the baby's father. This question is echoed in the teenagers' steps to become like their parents, who aren't much more mature. The themes are universal, at least for the middle class. The characters are well drawn,

From Abouet and Oubrerie's *Aya of Yop City*.
[©2008 Gallimard Jeunesse]

often simple. They worry about school — Aya dreams of university — and money. The new middle class still shops in open-air markets, a far cry from the towering skyscraper for rich Ivoiriens.

Abouet's story and dialogue both belie the richness of her world. Though not autobiography, it is an act of memory, of fixing in art somewhere long gone. So Yop City feels like a place to visit and her characters like friends to make. Their sturdiness as cartoon characters — each clearly defined and mostly unchanging — makes them comforting, like old friends. Abouet manages this with a minimum of fuss. Their presence matters more than what they say or do.

Oubrerie contains this presence in his spare, energetic line. It makes the characters live and move. His carefully emptied drawings fit the sun-drenched tropics, too hot for all but the essentials. He draws it like he lived there, which of course he didn't. He has traveled to Côte d'Ivoire, but not until the place Abouet describes was long gone. So he draws on something in her words, and an alchemy occurs between them. It somehow evokes humid air, bleached concrete and the chatter of half the village beneath the palaver tree.

— Bill Randall

Joker
Brian Azzarello (script), Lee Bermejo (pencils,
 covers, and some inks), Mike Gray (inks) and
 Patricia Mulvihill (colors)
DC Comics
136 pp., $19.99
Color, Hardcover
ISBN: 9781401215811

"We heard you were released. No one can figure out *how* . . . "

"Well," the Joker replies, "I'm not *crazy* anymore."

And maybe he's not. Maybe he's merely vicious, ruthless, sadistic and thoroughly bad.

Brian Azzarello has written a classic mob story. A crime boss returns from prison and, finding that his territory has been divided among his rivals, sets out to regain control. It's just that in this version of the story, the mobster looks like a psychotic clown and his turf is Gotham City.

The scariest thing about the Joker has always been his intense unpredictability. Azzarello has shown us that a calculating Machiavellian crime lord is just as terrifying as the spontaneous, almost Dadaist, serial killer.

From *Joker*, written by Brian Azzarello and drawn by Lee Bermejo.
[©2008 DC Comics]

Lee Bermejo, Mike Gray and Patricia Mulvihill's art, with its realistically detailed ugliness, is perfectly suited to both the character and the story. It is gruesome, but not grotesque. It shows the horror of the violence, the corruption of the criminals, the darkness of the city. Every frame, every image — along with the witty Tarantino-like dialogue — drips with cruelty. When the Batman finally shows, it's anti-climactic.

— Kristian Williams

Neil Gaiman: Prince of Stories
Hank Wagner, Christopher Golden
 & Stephen R. Bissette
St. Martin's Press
546 pp., $29.95
B&W, Hardcover
ISBN: 9780312387655

Neil Gaiman now has his own *Tiger Beat* and it's a book, a hardcover with as many pages as a heavyweight novel. Filling the pages are old quotes from Gaiman interviews and the man's blog; brief new interviews with Dave McKean, Charles Vess and other Gaiman artists; a long new interview with the man himself (54 pages); some nice odds and ends, such as the magazine report the young Gaiman wrote about his first convention; and a whole lot of recapping devoted to Gaiman's many, many works. Take out the recapping and you wouldn't have a book. As far as I know, teachers haven't started assigning papers on Gaiman, so the logic here seems to be that people who love him will love experiencing his stuff in any

form it takes, even as wannabe Cliffs Notes. But when the paper assignments do start coming in, *Prince* won't be very useful. The treatment is skimpy, and themes are not so much tackled as tentatively patted on the elbow. A favorite bit: "'Alvie' is, of course, an anagram for 'Alive.' From a writer of Gaiman's caliber, this cannot be coincidence." And for some reason the authors don't give each book a straightforward synopsis. Instead a given piece's recapping is scattered among capsule descriptions of the work's characters.

At least, the writing is smooth, and you do learn a few things here and there. Neil Gaiman hates the Iraq war, loves Stephen Sondheim. Good man! He was planning a new Sandman miniseries a few years back, but DC wanted to stick to his old royalty rate (four percent) and the project didn't happen. In fact, Gaiman gives a bit of detail on how and why he wanted his deal structured; as so often with him, his argument is sensible and canny, a fine example of enlightened self-interest. Admittedly, the poetic boy with the busy *kop* has a sense of humor so winsome it plants a painful itch beneath my fingernails; admittedly, that sense of humor infects every page of *Prince* until the book seems like a massively expanded version of the sort of author's bio where you hear about the writer's cats. But Gaiman also has a very clear sense of himself and of how the world works, and of how he and the world can interact so as to bring Neil Gaiman a maximum of fulfillment with a minimum of hard feeling for anybody around. It's been a while since he wrote anything brilliant, but he has a brilliant career and it didn't happen by accident. *Prince* will at least give you an idea as to why that's so.

— Tom Crippen

Jack Kirby's OMAC: One Man Army Corps
Jack Kirby
DC Comics
200 pp., $24.99
Hardcover, Color
ISBN: 9781401217907

If Jack Kirby's *Kamandi* envisioned an apocalyptic future where civilization lay in ruins and mankind was reduced to a Cro-Magnon-like state, subservient to mutated animals, his *OMAC: One Man Army Corps* series took the complete opposite tack.

Here mankind is not a slave to lion- or tiger-men but to technology itself. Civilization has become weak, not through any outside forces, but via its scientific advances.

In this future world, people have become complacent, because so many of their needs are taken care of, making them perfect targets for the rich and powerful.

At least that's the inference gained in the first issue, as nebbish ne'er-do-well Buddy Blank (gotta love that name) is transformed by the intelligent robot satellite known as Brother Eye into the blue-mohawked, muscular superhero known as OMAC.

The change is brought about by the (literally) faceless Global Peace Agency, who, fearful of using large armies that might incite chaos, see OMAC as a one-man UN force, containing conflict and halting evildoers, so OMAC across the globe.

In Mark Evanier's introduction to this new hardcover volume, which collects all eight issues of the series, he states that OMAC'S origins lay in an idea Kirby had to do a futuristic version of Captain America, where a new star-spangled hero was called upon to keep the peace.

That's not a terribly surprising revelation, as more than any of Kirby's other work for DC in the '70s, OMAC feels rooted in traditional superhero genre. While Kirby throws a number of fantastic and mind-boggling ideas at the reader — pull-apart sex dolls that can be turned into suicide bombs, "destruct rooms," where people are encouraged to wreck everything in sight — a lot of the comic is spent with the main character in pursuit of evil scientists and despots attempting to take over the world. There's a bit of modern resonance in some of the stories, particularly the one involving the aforementioned despot who bears a slight resemblance to a former Iraqi dictator, but overall there's disappointingly little in the bulk of OMAC's run that Kirby and those who followed in his

From "Medi Mind" in *Jack Kirby's OMAC: One Man Army Corps*, written/penciled by Jack Kirby and inked by D. Bruce Barry. [©2008 DC Comics]

footsteps hadn't done before.

Still, if OMAC doesn't have the epic vision of his Fourth World saga or the high-pitched insanity of books like *Kamandi* and *The Demon*, it's still a visual treat for the eyes. Kirby adopts a basic six panel grid throughout the series, with the exception of the sumptuous two-page spreads that introduce every issue. It's in these panels that the traditional late-period Kirby is in full effect, and any fan of his work will find plenty of wonderful compositions to swoon over.

As with DC's recent Fourth World collection, OMAC bears the same attention to detail and nice production values. Some will no doubt quibble about the seemingly low-grade paper stock, but I find it fits the pulpy material perfectly. I also enjoyed the sampling of uninked pages that intersect the various chapters and would love to have seen more "behind the scenes" material like that in future Kirby collections (hint, hint).

OMAC ended on an intriguing note, with a powerless Buddy Blank and seemingly destroyed Brother Eye having to face off against another global madman. Though the plot is rote, there are hints that Kirby was going to explore Blank's character — and his relationship to his alter ego — a little more in depth. It's a shame then that the series, like so much of Kirby's later work, never was completed. It looks like it was just starting to pick up some steam.

— Chris Mautner

The DC Vault: A Museum-in-a-Book Featuring Rare Collectibles from the DC Universe
Martin Pasko
Running Press
192 pp., $49.95
Color, Hardcover
ISBN: 9780762432578

Last year *The Marvel Vault* came out and it was great. Now we have *The DC Vault* and it's great too. It may even be more great, since DC has always been a prosperous, well-organized company and therefore has more stuff filed away for retrieval. To recap *Vault* basics: The book takes the form of a ring binder that holds 96 shiny, plasticine leaves with 10 clear plastic sheets interspersed among them. The leaves are printed with a decent history of the company in question and with a few hundred nicely chosen and beautifully reproduced illustrations. The plastic sheets have pockets, in which are tucked painstaking facsimiles of objects and documents — memorabilia. In the

Bat mask (1943) created for Philadelphia Record: collected in *The DC Vault*. [©2008 DC Comics]

case of *The DC Vault,* the 25 or so items include an ash-can edition of the never-published *Double Action Comics,* a cardboard decoder gadget issued in 1943 to members of the Junior Justice Society of America, a Neal Adams drawing for an unbuilt Rocket to Krypton amusement park ride, a Brain Bolland pencil of Wonder Woman, and various *Crisis on Infinite Earth* memos, including the one where Jenette Khan signed off on Supergirl's death. Illustrations include unexpectedly charming cartoons done by Bob Kane for fans in the early 1940s, a Dick Sprang lithograph of the Bat Cave that's so detailed it bends the mind, a *Strange Adventures* cover that features invading alien snowmen with stovepipe hats and laser-beam eyes, color snapshots of Jerry Siegel, Joe Shuster and DC bigwigs at the World's Fair, and cover sketches and layouts by Steve Bissette, Joe Kubert and Joe Orlando, among others.

The package is very nicely put together by a book design firm called Becker&Mayer. If you're a superhero fanboy, the people involved in *The DC Vault* have done everything possible to get your $50. You might as well give it to them.

— Tom Crippen

Metamorpho Year One

Dan Jurgens, Mike Norton, Jesse Delperdang
DC Comics
142 pp., $14.99
Color, Softcover
ISBN: 9781401218034

One of the first comics I read was *The Brave and the Bold* #154, featuring Batman and Metamorpho. Metamorpho had hardly any face time, as it turned out, but his brief appearance made a decided impression. Bob Haney's plot had the element man wearing jodhpurs and consorting with Turkish drug dealers while spouting supposedly hip but actually dada-esque lines like, "Wowee! Kaman kiddo wasn't kidding!" Meanwhile, Jim Aparo drew that malleable body from all sorts of bizarre angles: an almost unreadable shot upward through telescoped metal legs; a vertiginous shot from above with Metamorpho's mouth gaping open as a baddy shoots a flamethrower down his gullet. Both artist and writer were clearly having a blast, and their enthusiasm for the character was infectious. I wanted to read more about him.

I never did, though. Oh, I read a fair number of comics featuring Metamorpho, but none of them had anything like the charge of that first meeting. Still, even with my expectations suitably lowered, *Metamorpho: Year One* is quite, quite bad. Jurgens and Norton switch off on the drawing chores, but neither of them takes any advantage of Metamorpho's visual potential. Everything looks CGI, with limbs turning into smooth blades or smooth drills — it's like Metamorpho's a bottom-basement Terminator. Nobody here can even draw mildly successful cheesecake. Sapphire Stagg, the Metamorpho mythos' gratuitous sex bomb, has the requisite blond hair, big bazoongas and lack of attire, but through the miracle of stiff poses, shaky anatomy, incompetent stylization and godawful computer coloring, she still ends up looking as sensual as a hunk of plastic.

Dan Jurgens' story is, if anything, even worse than the art. Rex Mason (the guy who turns into Metamorpho) has all the personality and gumption of a wilted houseplant. The evil Simon Stagg tries to kill him? He gets so mad that he ... whines a little. The beautiful Sapphire Stagg doesn't want him any more, because he's all, like, ugly now? He gets so mad that he ... whines a little. And when the Justice League tricks him into thinking he's fighting a deadly supervillain and then brags about how clever they were, Metamorpho ... tells them how superheroic they are. Oh, yeah, and then he whines a little. Peter Parker had angst; Metamorpho has querulousness.

Still, I'm not in any position to whine myself, I suppose. To read a comic based on your affection for a character you first encountered 30 years ago is pretty much begging for disappointment. I guess I momentarily forgot that the whole point of superhero comics these days is to sully the childhood memories of paunchy, middle-aged fanboys. At that mission, at least, *Metamorpho Year One* succeeds admirably.

— Noah Berlatsky

Deitch's Pictorama
Kim Deitch, Seth Kallen Deitch
 and Simon Deitch
Fantagraphics Books
200 pp., $18.99
B&W, Softcover
ISBN: 9781560979524

The five stories in this collection aren't comics; they're prose pieces that occasionally try to combine the two media. In his introduction, Kim writes that his ambition for the book was "to contribute toward a hybrid medium for graphic novels, better merging the written fiction and comics mediums." Kim's "The Cop on the Beat," which deftly mixes prose exposition with cartooned scenes and asides, is the only piece that succeeds in this regard. "The Sunshine Girl," adapted by Kim from interviews with story protagonist Eleanor Whaley, handles the blending of media far more awkwardly. And "Unlikely Hours," a prose story by Seth that Kim attempts to shoehorn into the format, would have been better served if it had been left alone. The interplay between prose and pictures often seems gimmicky, and worse, it frequently disrupts the

From Kim's "The Cop on the Beat, the Man in the Moon, and Me" piece in *Deitch's Pictorama*. [©2008 Kim Deitch]

flow of the story. "The Golem," written by Seth with art by Simon, is an illustrated story in the traditional sense. Seth's "Children of Aruf" is all but exclusively prose; the only illustration is Kim's frontispiece.

The story quality is mixed. "The Cop on the Beat" is the best of them. It's a [quasi]-autobiographical piece about an unrequited romance of Kim's that shifts gears into a discussion of the musicians Kim loves from the 1920s and '30s. It ends with an amusing epiphany that ties the story together. "Children of Aruf," which imagines a world in which dogs can talk, is the most enjoyable of Seth's contributions. "The Sunshine Girl" and "Unlikely Hours" are ostensibly autobiographical pieces ("as told to" with the former) that veer into wild fantasy, and they both have the same problem: The stories don't effectively prepare the reader for the outlandish climaxes, and they come across as ridiculous. "The Golem" recounts the Hebrew legend (in a Holy Land setting instead of Prague); its only distinction is in using shifting points of view to tell the story.

The book has several distracting editorial flaws. Kim's stories are both hand-lettered, and given the sloppiness, typesetting would have been preferable. There are numerous problems with baseline adherence, word spacing and size consistency. The lettering also occasionally butts up against the pictures. And as is common with prose titles from Fantagraphics, the book wasn't properly copy-edited or proofread. I counted at least six errors in Kim's introduction alone. These may seem like minor matters, but they help make the book a needlessly bumpy ride.

— Robert Stanley Martin

Meatcake #17
Dame Darcy
Fantagraphics
24 pp., $3.95
B&W, Softcover
ISBN: 9781560977957

Even when she's not especially inspired, Dame Darcy creates superior goth comics: cheerfully mean-spirited, idiosyncratically stylish and oozing with surreal ichor. Thus, in this issue's "Rockstar Romance," we get to see rock star Trixxie put paid to her stinking boyfriend Tex — the gross-out high point being a half-page panel in which Tex appears as a bulbous, weeping worm strangling itself with its own belt. "Spider-Silk Tropics" features Darcy regulars Effluvia (a mermaid) and Stega-Pez (a girl who speaks by spewing bloody, inscribed tablets from

From "Rockstar Romance" in Dame Darcy's *Meatcake* #17.
[©2008 Dame Darcy]

her throat) as they use their amorous wiles to bamboozle a spider-loving Duke. In both stories, Darcy indulges her goth tropes and her feminism: Men are tormented, sisterhood is affirmed, and light-hearted squick is relished by all. And, as always, Darcy's eccentric drawing is a joy, with perspective, proportion and visual logic all flattened out to fit into geometrically obscure but oddly elegant patterns.

I do have an effervescent attraction for these narratives. But I pledge my true and more hopeless passion to Darcy's less tongue-in-cheek efforts. "We Are the Fae and There is No Death" forswears quirky hipster humor and jokey man-bashing alike. Instead, it simply tells a fairy tale: Oriana and her younger sister Hyacinth live in a castle ruled by their harsh father, a king whom we never see. Hyacinth wants to leave the castle and marry the forest ruler ... but Oriana doesn't believe there is any such person, and tries to stop her. As is the case in fairy tales, the plot takes numerous twists and turns, but has an eerie inevitability, pregnant with pain, love, death and magic. The sisters escape from the tyrant king, who is both abusive father and, perhaps, life itself. But where do they end up?

Oriana answers in a remarkable poetic denouement, where she speaks for the first time directly to the reader — as if she has become unmoored from the story. Against a design of stars and flowers, she's drawn with her hair down and in a transparent shift. "Am I alive or am I dead?" she asks. "It doesn't matter in this place. Time does not run in a linear line as pronounced by man, but

instead runs in an eternal spiral like the rings of a tree. My sister is in eternal holy union with a God." A full-page illustration shows two skeletons embracing; in the lower right of the panel, stylized but lovingly patterned flowers contrast with the white bones. In the last panel, we see Hyacinth bathing in an idyllic pool, while Oriana sits beside it, head on her knees, butterfly wings sprouting from her back. Her expression is difficult to read; her face may be slightly smiling, or wistful, or perhaps just blank. "Now we are the fae," the caption says, "and there is no death."

This isn't the retro-smirk of Jhonen Vasquez, or even, for that matter, of Edward Gorey. Instead, Darcy's conclusion is reminiscent of the chillingly beautiful take on immortality at the end of *Peter Pan* ... or of Lovecraft's "Shadow Over Innsmouth." "We Are the Fae ...", is in other words, not goth, but true gothic, in which queer doublings suggest a relationship between the human and the uncanny — or in which, indeed, the relationships *are* the uncanny. In Darcy's other stories in this book, sisterly love triumphs and evil men are destroyed. Here, in contrast, all love — between sisters, between parents and children, between men and women — seems to run together like dark water, where the self sinks and dissolves until all that's left is a smiling, empty mask. All three of these stories end, more or less, with a "happily ever after," but only in this one does it sound so resolutely inhuman.

— Noah Berlatsky

SCUD The Disposable Assassin: The Whole Shebang
Rob Schrab
Image Comics
$29.99
B&W, Softcover
ISBN: 9781582406855

SCUD is a pulpy cyberpunk romp. The main character, SCUD, is a robot assassin who comes out of a vending machine: Put a coin in, tell him who the target is, set his contempt level to determine how much extreme prejudice he employs, and let him rip. SCUD's supposed to self-destruct after completing his assignment, but a loophole allows him to prolong his life and his career of mayhem. Over the course of 24 issues, he fights a monster with a plug on its head, a squid on its face and mouths on its knees; a werewolf who switches arms with him and then turns into a black hole; a bull with chainsaws for horns;

and the severed head of Jayne Mansfield. Allies, on the other hand, include British astronauts who all have backgrounds on the Shakespearean stage; a cute child made out of drywall, zippers and interdimensional portals; and a sexy bounty-hunter with a kink for robot sex named, of all things, Sussudio.

Action, gore and outlandish character designs abound. Rod Schrab's visual imagination is both voracious and unstoppable. His pages are a mess of panels spilling into and over one another, sound effects, motion lines and outlandish details. His work reminds me of a cartoonier Pushead, or of some of Keith Giffen's loonier moments as an artist. Inevitably, in all the chaos, the narrative becomes at times incomprehensible — but so what? You're not here to watch the hero foil evil and get the girl. You're here to watch the three-way fight between an imitation shogun warrior, zombie dinosaurs and the mob.

Unfortunately, as the series goes along, Schrab and his co-writer Don Harmon start to move away from violent nuttiness for its own sake and begin to try to Say Something Meaningful. Bad move.

Many creators do, of course, imbue their punky future dystopias with bite — *Tank Girl* comes to mind, as, to some extent, does Adam Warren's *Dirty Pair*. Alas, *SCUD*'s bad attitude is as prefabricated as its hero. Schrab

From *Souvlaki Circus*.

[©2008 Michelangelo Setola and Amanda Vähämäki]

makes fun of God and angels and casually has Ben Franklin murder a nun. But it's all in the name of jovial fratboy crassness, not out of actual misanthropy or bile. I wasn't surprised to see in the author blurb at the back that Schrab had done time as a stand-up comic.

When he tries to give the narrative a point, therefore, Schrab goes, not for satire, but for melodrama. The end of the story devolves into tragic backstories, doomed heroes whining and a saccharine and unmotivated quest for true love. The series officially jumps the shark when it is suggested that Sussudio has a robot kink not for the goofy reasons originally propounded (something to do with a malprogrammed robot maid), but instead because her parents didn't pay enough attention to her. The initial joke was rather funny; the attempt to make us take it seriously, however, starts to border on tasteless. Vending machines are great for a callow rush of sugar. But when they try to sell real food — say, an egg-salad sandwich — the results are invariably repulsive.

— Noah Berlatsky

Souvlaki Circus
Amanda Vähämäki and Michaelangelo Setola
Buenaventura Press
80 pp., $13.95
B&W, Hardcover
ISBN: 9780980003918

Humans are nature made self-aware, and nature doesn't care. But in Michelangelo Setola and Amanda Vähämäki's vision, it actually seems pissed. A dog bites a man's hand. On the next page, the man cuts open the dog's belly to find a human baby. Everyone's skewered as food for the other.

The drawings throughout *Souvlaki Circus* often evoke the dread of someone lost in the woods. But they also have a dark humor, as when a bird rests on the crotch of a sex doll, pointing its long bill at the crotch of a worried boy. These drawings, one to a page, play off one another. For instance, a drunk weeps at his horse's grave; next to it, he drives his horse to death pulling his tractor. Horse sweat mirrors his tears. In another pair, the swirl of a man's hair rhymes with the swirl of twigs in a bird's nest. Both are invaded by insects.

Likewise, the artists play off one another. Vähämäki, one of the brightest lights from the Canicola group of Finnish and Italian artists, merges styles brilliantly with Setola. Both work in spare pencil with sparse tones, so who did what is not always clear. The drawings, even with

a few stray lines and erasures, never seem anything but whole. The setting, though, seems Vähämäki's — Finland is Europe's most forested country, and the shanties in this book are perched uneasily next to thick stands of pine.

As to the story, it unfolds free of the dull mechanics of plot, with neither time frame nor conclusion. A bear catches fire; a man's head is covered with bees; later, his bee-covered head catches fire, too. Sometimes, the animals and humans commiserate, as when a bird weeps with a man at a diner. And a woman and a wolverine find some common group by the corpse of a reindeer. The richness of this story lies in the recurrence of certain tropes throughout the book. Nothing's explained — it's all instinctual.

These drawings and their story began as a gallery exhibit in Hamburg. They translate into a fine book thanks to another of those beautiful packages I can only imagine Alvin Buenaventura creating. Its small cloth cover suggests a lost diary, found years later so that the things it contains remain mysterious.

— Bill Randall

Katja Tukiainen Works
Katja Tukiainen; text by Timo Valjakka
Daada Books (www.daadabooks.com)
112 pp., 28 Euros
Color, Hardcover
ISBN: 9789529920174

Pink. Pink-faced baby deer, pink mountains, pencil-drawn children in winter coats floating on pink ground. Some other colors have their place, especially a pastel shade of green in her arresting landscapes. But mostly pink. Even in "Baga salt pans," a 2005 painting taken on a trip to Goa on India's west coast, the salt's not white but pink, reflecting the thick pink sky.

So Katja Tukiainen creates a warm world. Her subjects, usually domestic scenes of children, evoke a sense of both innocence and comfort. While known as a cartoonist — she appeared in *Comix 2000* and elsewhere, and her husband Matti Hagelberg's known for his angular, detailed comics — the *Works* here on display are paintings, oil on panel and canvas, large and small.

Unlike many painters who work in cartoon and childhood imagery, Tukiainen doesn't do dread. *Works* opens with her quote: "I want the joy of painting to show." And it does. She paints children discovering the world around them, or wrapped in contemplation. One leads a worm by a leash and looks at the viewer with wonder and de-

light. Despite their content, these images avoid cloying in the same way children tend to confound our idealizations. Her subjects are just being themselves; it's not for our benefit.

Her spare canvasses and big-eyed characters recall Yoshitomo Nara. His images of children and dogs have been a minor sensation in hip boutiques from Tokyo to Paris. Takashi Murakami lumps him in with his Superflat movement, but his subjects, genre paintings of cosmopolitan pop, owe as much to Kaz and Sonic Youth. Besides, he's a painter, not a cartoonist. And Tukiainen goes further than Nara in trusting flat fields of abstract color.

In this, she owes more to Nara's peer Hiroshi Sugito. Her stroke and color palette recall his; she borrows his curtains to transform the canvas into something between a stage and a window. In particular, her 2005 painting "One and a half birds on the window sill of Hiroshi Sugito" makes the connection explicit, though her maternal birds cheerily discard Sugito's controlled lines.

In the book's text, critic Timo Valjakka notes the connection, writing that seeing Nara and Sugito's works while in art school in Venice gave Tukiainen "the courage to do what she felt right." As a "conscious act of provocation, a brazen 'girlish' or 'childish' protest at the masculinity and heroicity" of the art world, she shares much with Nara's punk children. Clutching knives, they gaze out with defiant, wounded eyes. Faced with them, any number of art critics have thrown up their hands.

Their best explicator, the Japanese critic Midori Matsui, calls them "Micropop." Though she covers many of Murakami's Superflat artists, like Nara and Aya Takano (*TCJ* #289), she's less interested in Japanese pop than Gilles Deleuze's idea of minor literature. In her essay "What Is Micropop?" she explains it as:

> a stance taken by people who have been relegated to a 'minor' position vis-à-vis the major culture that surrounds them, in the same manner as immigrants and children do. Those people — forced to function within the major culture without having sufficient tools to do so — make do with what they have.

So they make personal worlds, small archipelagoes of meaning where the fragments of a cartoon matter more than the Church or the State. Tukiainen creates a fine image for Micropop in her 1999 series of panels, "A crochet hook," in which a woman crochets herself a cocoon.

But attached to the last string of yarn is a baby. While showing a "'minor' position," it's also a link to the real

"A boy walks a caterpillar" (2005), collected in *Katja Tukiainen Works*. [©2008 Katja Tukiainen]

world. Tukiainen, despite her name splashed in Japanese across her website, breaks with Micropop's tendency to *otaku* solipsism. She draws from life and photos. Her paintings of toys, like the teddy bear in her 2005 work "The birds," have the heft and texture of the real thing. Even her 2006 series *Thousand Dollar's Buck* [sic] renders the American West more postcard than *Blueberry*. It's the remnant of a trip planned but never taken, hardly a retreat into the comforts of a pop cocoon. Her recreation of the trip as a Western just shows her sense of humor.

In fact, Tukiainen's forays into the world — to India, to be precise — have influenced her work as much as anything in pop culture. She's best known for her travel comics to the subcontinent in the anthology *L'Association en Inde* and her own book *Postia Intiasta*. She's been there at least 10 times since her first visit in 1999, often for longer stays. She finds it "visually very rewarding. It is aggressive, hectic and sensually replete. It is simultaneously difficult and easy, chaotic and utterly peaceful." And it appears in her work not just in the occasional bindi on

the forehead of a winter-suited child. Her brushstrokes and use of color share much with Indian vernacular art. In Barry Dawson's book *Street Art India*, he chronicles the kind of murals, advertisements and comic books that Tukiainen has no doubt taken in during her travels. A series of paintings from 2002 includes ready-mades, sheets of comic-book instruction for Indian children. Even more, she expresses a spiritual repose, found either on the ground or in the Western imagination, in her contented, centered paintings of children.

Curiously enough, I find this most clearly in her landscapes. In particular, her 2005 canvas "Reykjavik" lays down sea and mountains in thick strokes punctuated by daubs of white for clouds and snowcaps. The city, on a placid field of light green, has a few buildings drawn on in pencil here and there. They're almost like toys you could hold in your hand. Even without a trace of pink, it speaks of this artist's defiant joy and peace in her work.

— Bill Randall

■

Finn Arts
A Gallery of Finnish Comics New to the U.S.

For such a small country, Finland can boast of a very rich comics scene. Careful readers of *Eurocomics for Beginners* will have heard Bart Beaty give compliments to Finnish comics artists on several occasions. Unfortunately, most are difficult to track down. However anthologies such as *Glömp* and *Kuti* have found their way to a select number of overseas comics retailers. This gallery in the *Comics Journal* is a small taste of what is brooding in exotic Finland and, we hope, serves as a good incentive to explore these unknown artists.

Amanda Vähämäki's work could be described as realistic dreams. Reading her work renders the same feeling as waking up and not knowing whether what you just dreamt was real or fantasy — that moment where you can't shake off the drowsiness and all the surreal events in your dreams still seem logical. Amanda Vähämäki studied art in Italy where she was one of the founders of *Canicola* magazine. Upon returning to Finland, she became one of the members of the Kuti Kuti studio which publishes a free comic tabloid. She was featured in the most recent *Drawn & Quarterly Showcase* and Buenaventura Press has just published *Souvlaki Circus* by her and Michelangelo Setola.

Jenni Rope has refined her comics into a masterful blend of fragile art with poetic text. Jenni also runs the Napa store and publishing house, and her work can be found in select art boutiques throughout the world.

Although firmly rooted in superhero themes, **Marko Turunen**'s comics deal mostly with mundane, day-to-day events. His yearlong dishwashing diary stands as a good example: Turunen meticulously records every spoon, plate, fork that he has washed in a one-year period. The main characters in the book are given superhero names such as The Green Eagle, Popsicle Girl, Thermis, Black Panther, although they can't possess any super-powers. Marko's comic gains extra depth through his dry deadpan humor and language.

Petteri Tikkanen is probably best known by the international guests of the Helsinki Comic Festival as that masked wrestler who was shouting, singing and generally harassing people onstage during the legendary comics battles. This peculiar character goes by the name of Black Peider and has won second prize at the International Air Guitar Championship. Black Peider is also a very skilled comics artist whose debut novel was published by Marko Turunen's imprint Daada books. Although the themes are sexually tinged, the overall tone is one of innocence and friendly humor. Black Peider's drawing style is loose and spontaneous, yet carefully executed. Tikkanen also draws stories under his own name and he is the author of the Kanerva stories, an all-age series that nevertheless handles quite heavy, heart-rending subjects. These books are more refined and polished, obviously aimed at a greater audience.

Tommi Musturi edits the yearly anthology *Glömp*, which has been called the cousin of *Kramers Ergot*. It features a healthy array of the most noteworthy Finnish and foreign artists. All texts are in Finnish but English subtitles are provided at the bottom of each page. Musturi has lately been concentrating on two projects: the silent stories of Samuel and the *Book of Hope* series. The latter is a study of Finnish country life and a contemplation of opportunities lost; the former is a more narrative experiment that places a silent character (Samuel) in different colorful backgrounds, from which he tries to break away. Samuel's escape methods are always ingenious and surprising and often involve playful metatextual solutions.

— Jelle Hugaerts

Jelle Hugaerts is a Belgian immigrant in Finland who runs the Pitkämies comics shop in Helsinki and has 92 friends on Facebook.

Thanks to Marko Turunen for providing the Journal with the material displayed in the following gallery.

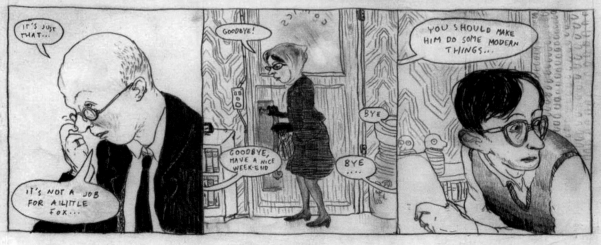

Amanda Vähämäki

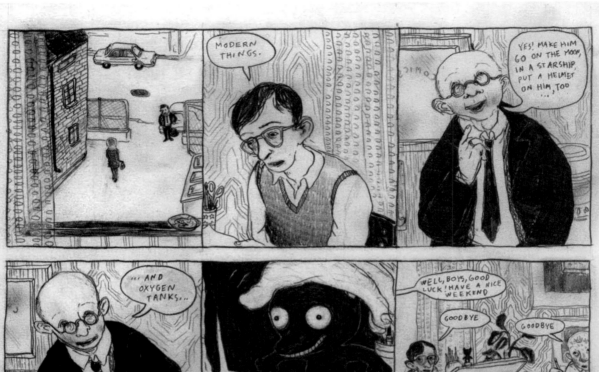
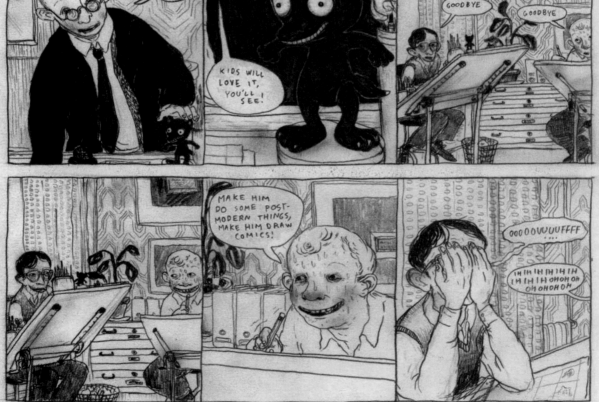

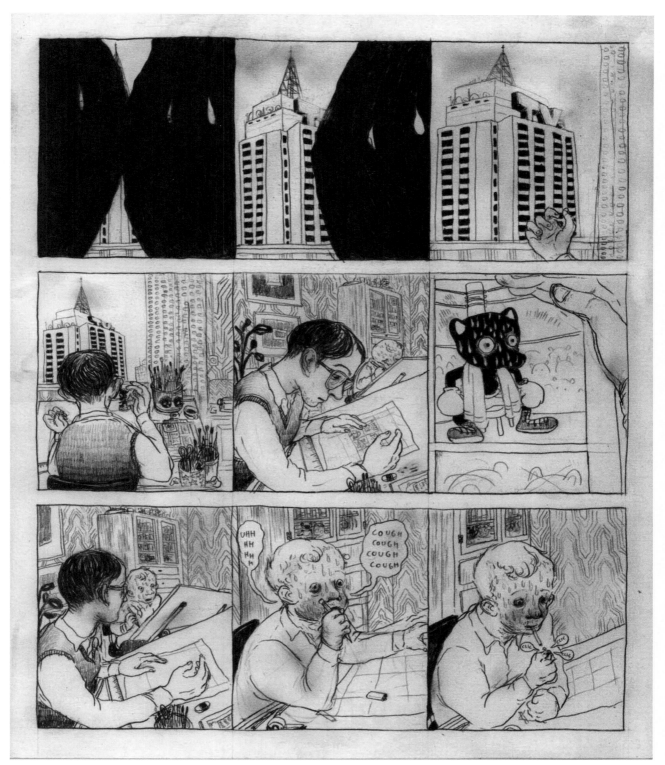

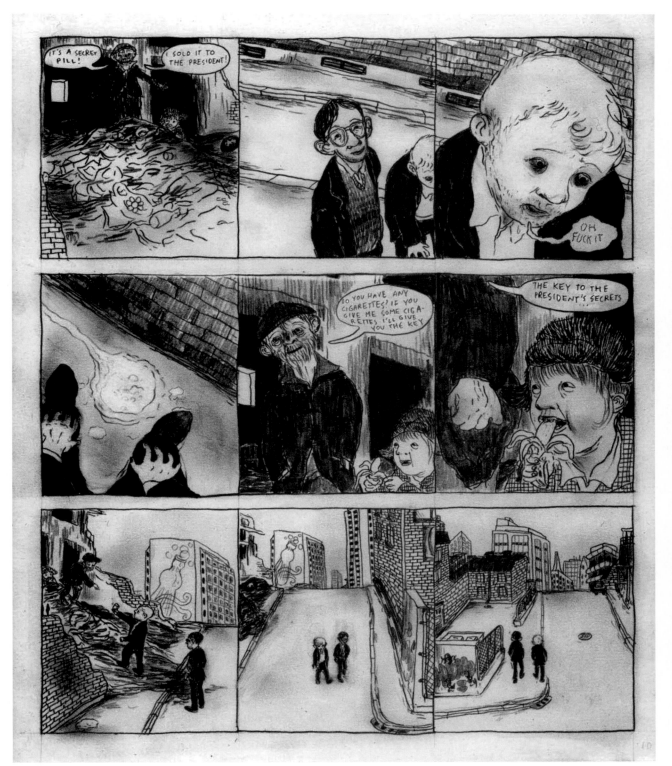

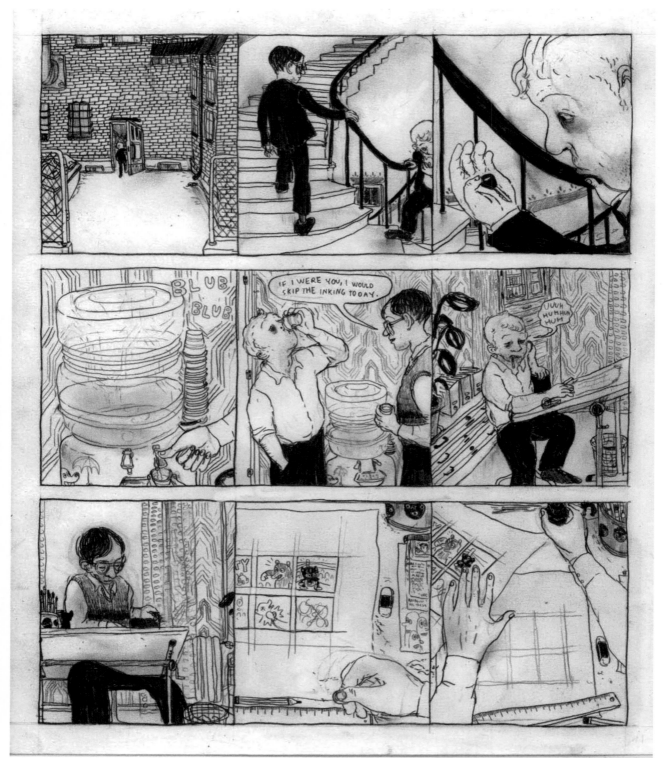

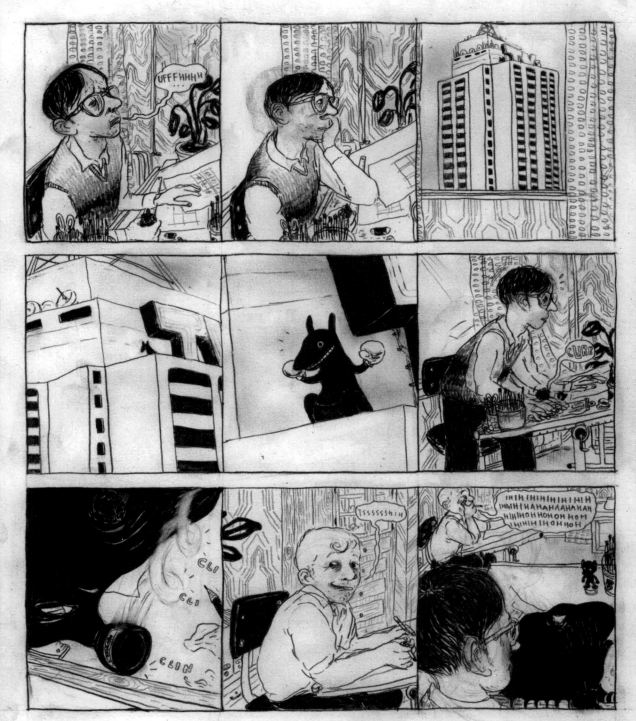

Marko Turunen

Jenni Rope

Petteri Tikkanen

Tommi Musturi

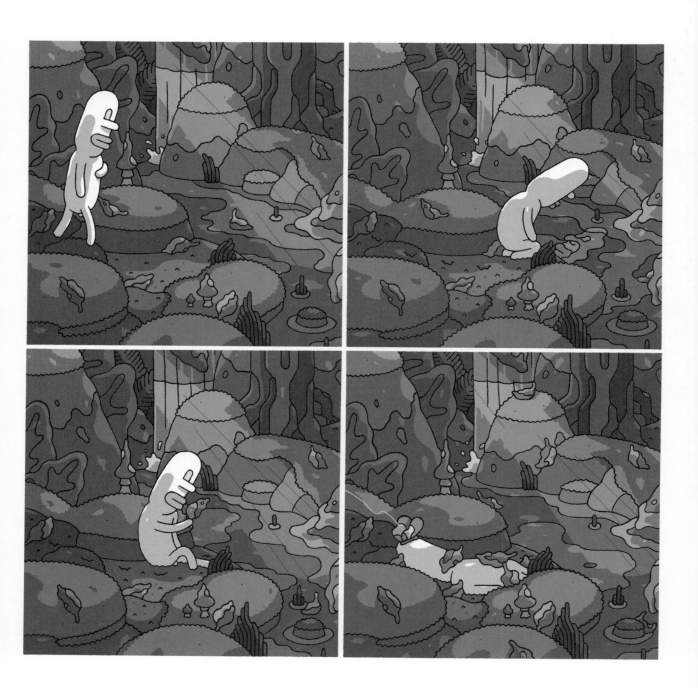

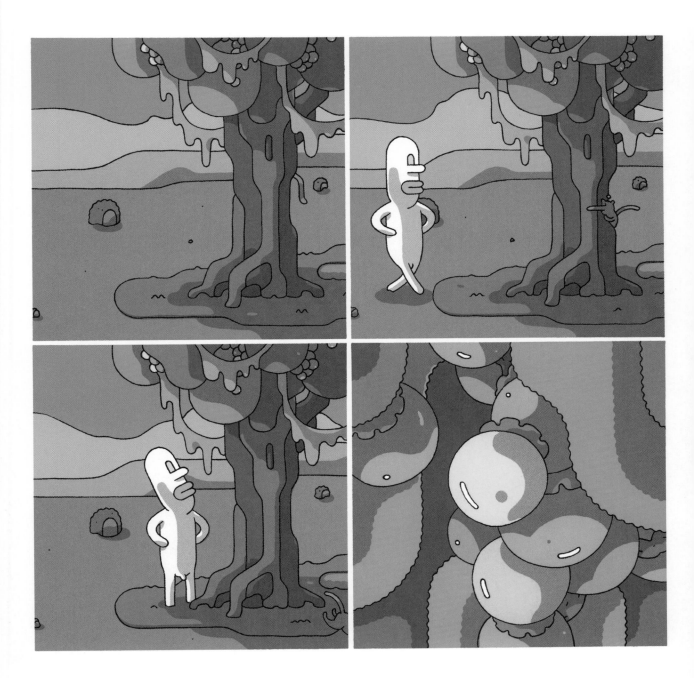

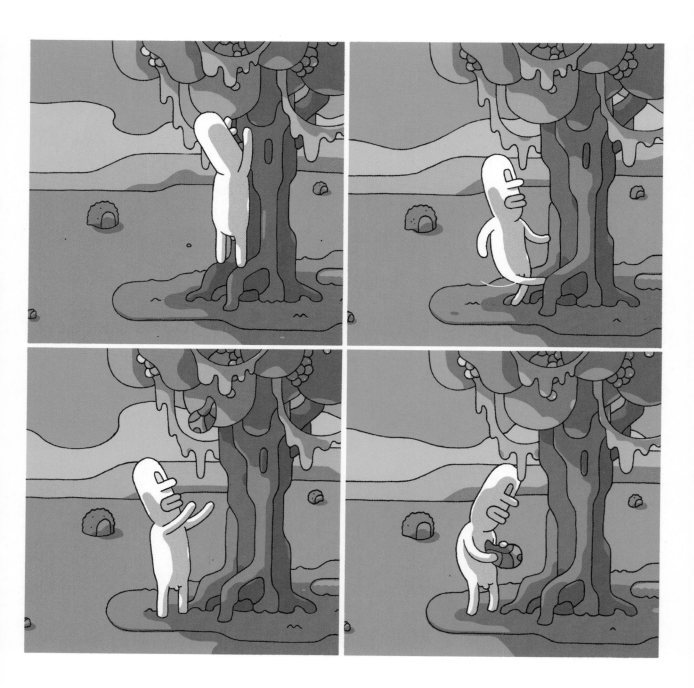

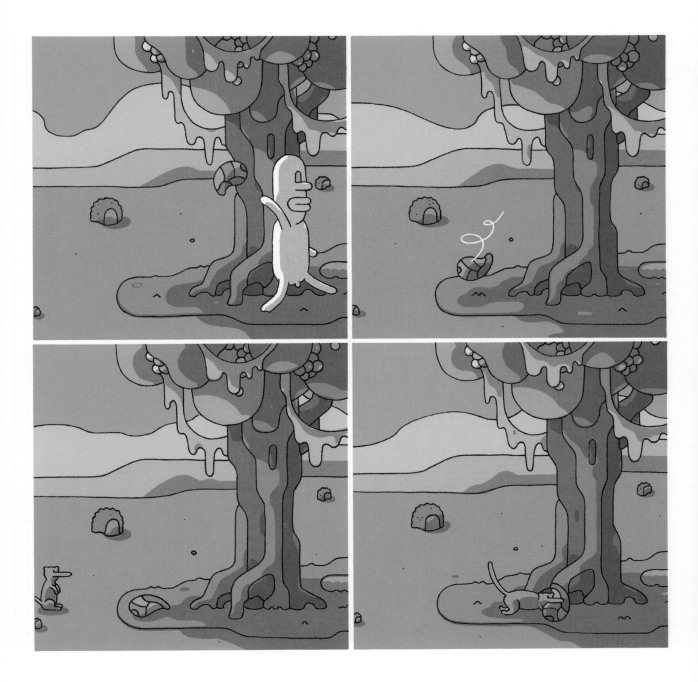

Jenni Rope

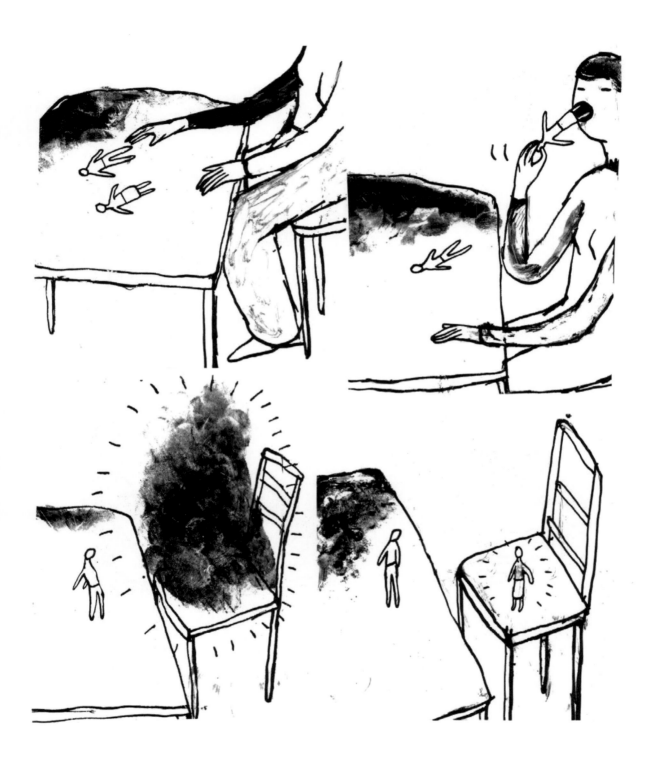

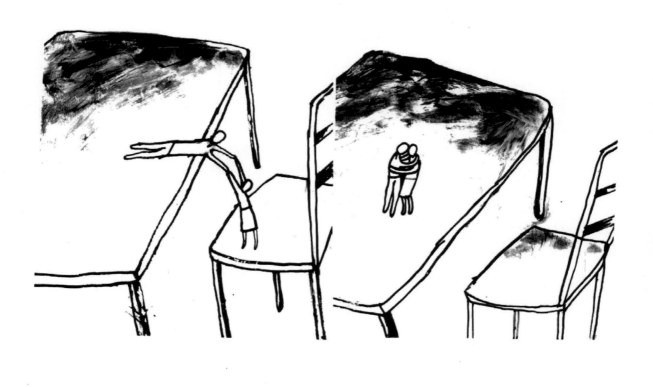

JENNI ROPE
2000

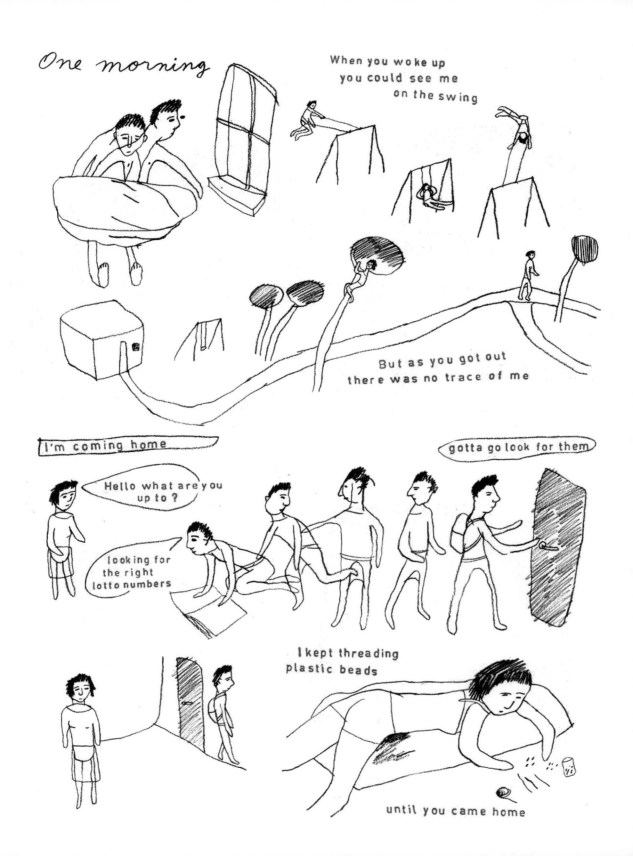

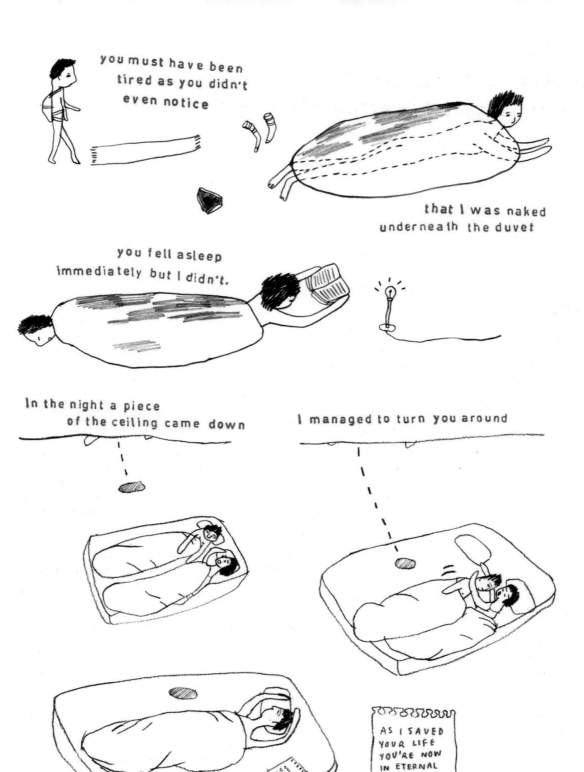

James Stephens' Wayward Masterpiece

by Donald Phelps

"**P**edestrian" — usually a term of denigration — summarizes the vitality and the shadowy, shimmering ambience of James Stephens' masterpiece: *The Demi-Gods*. The novel's backbone is the trek across rural Ireland of elderly Patsy McCann, his daughter Mary, their donkey, an old flame of Patsy named Eileen Ni Cooley and three angels — Caeltia, Finaun and Art — who have joined the party for purposes of observation.

These angels are no scatterers of miracles and wonders. Their manifest purpose is to observe the world's goings-on, and to taste the strangeness of the little party's earthy actuality. Stephens is not involved with any cabaret magician's trinkety wonders. His fusion of reality and fantasy is a chiaroscuro: a mating dance of shadings that ultimately enriches reality. And, unlike so many professional fantasists, Stephens' manifest aim is not the suspension of disbelief: rather, the enlargement and the enrichment of belief. The three angels might be viewed as the artist/observer's surrogates, and those of the reader. No need to "posit" a fantastical premise: Scrape reality's hide! Art, during a sojourn in a dilapidated house, conducts a sociable interview with a spider:

"What did you have for dinner," asks Art.

"Nothing, sir, but a little, thin wisp of a young fly," says the spider. And points out to the angel a champion of the arachnid set: "The lad with stout, hairy legs …. caught a blue bottle yesterday … but that spider is always lucky, barring the time he caught the wasp."

The poetic energumen of Stephens is what fuses — rather, renders identical in a new stylistic identity — Stephens' "fantasy" and his realism. As with him, so with Ibsen, I.L. Peretz, Kenneth Patchen. His poetic eloquence is at once luxuriant, billowing and steadfastly economical; borne along by his love — legacy of a vastly oral culture — for conveying information. His characterization (not a "sketch," a portrait, weighty with philosophy) of Patsy Mac Cann, an elderly opportunist with outlaw ambitions — mingles poetry with oratory.)

Always, the gravid harshness and robust loveliness of Irish landscape lend contours to the picaresque musculature. The passions exchanged by Patsy and his once love, Eileen, are as abrasive as anything in Sean O'Casey's *The Plough and the Stars*, or *The Silver Tassie*.

The swells, the freshets of human identity and its mutations is always imminent. An itinerant concertina player called Billy the Music cheerfully acknowledges his past identity, as Old Carolan, a wealthy cattleman and slave-driver ("They were a poor lot … but they were able to work … and I saw that they did it.") Though happy in his new life, he is unapologetic about the old: "Don't be thinking … that men are courageous and fiery animals, for they're not … they're as timid as sheep and twice as timid." *The Demi-Gods* offers a rambunctious and enriching tour of not one, but multiple Irish landscapes: natural, spiritual, social, legendary. It delivers an epic supplement to the sunlit phantasmagoria — triumph of Nature, both earthy and idyllic — that *The Crock of Gold* proffered. The former epic was ruled by the figure of Great Pan, protective of the Philosopher, whose academic viewpoint the god enriches and delivers from intellectual Puritanism. The pagan gods and fairies conduct the favored mortals through their world.

But *The Demi-Gods* underwrites the earlier work with a reaffirmation of realities, among which, the trio of demi-dieties wander and observe, embroiling themselves now and then in the turbulences, minor or major, of human love. ■

World, Soul, Psychetypes, Psychoecology — A New Logic of the Psyche
1. Organized Life and Psychic Life
by Kenneth Smith

"We cannot destroy this world for we have not constructed it as something independent; what we have done is to stray into it; indeed this world is our going astray, but as such it is itself something indestructible, or rather, something that can be destroyed only by means of being carried to its logical conclusion, and not by renunciation; and this means, of course, that carrying it to its logical conclusion can only be a series of acts of destruction, but within the framework of this world."
— *Kafka,* Blue Octavo Notebooks IV

All of us bleed at secret sacrificial altars; all of us burn and roast in honor of old idols.
— *Nietzsche,* Thus Spake Zarathustra III

Is metaphysics or cosmology too abstruse a topic for moderns to wrap their minds around? Here, fit for the modern "world" in particular, is a *modally violent* characterization of the topic of "the world" or the encompassing Allness of things, a thesis that (like Kafka's) collapses modern anomie into ancient norms or principles, the objective order into the subjective, consciousness into conscience, reality into judgmentality:

> *The modern world is the* congealed or crystallized, uncomprehended vices *of humans at large, the viscous and ungraspable* pathos-made-coherent-and-systematic *of countless multitudes who pathetically* — in and through and by means of and for the sake of their governing and incompetent pathoi *and idiotism* — conspire in unison

every minute in the empowerment of such a "system" against their own *selves.*

Self-incomprehension, ineptitude therefore at moral evaluation, has become a profound if not defining *structuring force* — a force of blind nature — in the tacit shaping and formatting of the modern "noosphere." As the nadir or antipode of the civilizational-cultural ethos of "know thyself," our supposed *demokrateia* is the polar antagonist to the mode of rationality and self-mastery that orchestrated ancient *aristokrateia*: We no longer inhabit a humanly nutritious and spiritually or normatively evocative *culture* but rather have a passive/pathetic dependency on a wholly artifactual and *spiritually inert* techno-matrix, as the term "noosphere" implies. Kafka would certainly have appreciated the ironies: The *cleverness* of humans

has collaborated in modernity to *cater to and intensify the stupidity* of humans, so that human obtuseness may ingeniously consolidate itself to make its barbarically dense and cretinous point of view *normalized and insuperable, precluding all other* points of view. For everything — *even* obtuseness and brutishness — *evolves* and grows *more sophisticated and complex* over time, without thereby becoming *any wiser, saner* or *more self-clarified.*

Within the modern ideological obsession with "reality" or "thingliness" (materialism, scientism, capitalism, consumerism, sensualism, etc.), everything — even one's own self, even the viscous and elusive eruptions of need, purpose, insight, within one's self — is preconceived as some kind of "thing" on a par and interactive with other things; and the enclosing totality of things, the "world," is also imagined necessarily to be a thing. (What else could it conceivably be, when one possesses only this stupefyingly materialist vocabulary?) All immaterial issues — "culture," "values," "psyches," "ideas" — are, modernly considered, worthless and meaningless, some kind of trash for our infamous incoherent and unseeing "pragmatism" to deal with. Exactly how untrue this *modal falsification* is, moderns cannot grasp at all. Kafka has tried, above, to spell out with rabbinical subtlety why the world has *unthingly power over us* and why that power is more *divine* or *daimonic, i.e. more authoritarian or obsessive,* than "real." The power of the modern "world" over moderns is such that — *in league with it* — they *need to imagine* the exact contrary of the truth, i.e. the untruth that they *ordain and control and define* it, that it is their real or objective *reciprocal* and supposedly *responds to* them (as the market to their needs, or the government to their mandate); but not a single modern per se is capable of specifying any "wants" that are not merely the *extrinsic* and *conventionalist* wants of mass markets or mass ideology. As humans millennia ago were porous and pathetic before the order of nature, so they now are — necessarily in ways they cannot perceive or comprehend — before their own artificial or techno-order.

Kafka, so truly an intermediate between ancient Judaic tradition and anomic modernity that he belonged in a resolving sense to neither one, grasped what it most concretely meant for moderns to "relate" to their enclosing world-order by *inadvertence, i.e. pathetically,* by means of vices, needs, passivity, gullibility, self-obscurity, inadvertence, and self-incomprehension, all the "soft spots" in their otherwise-hardened "realistic" personalities: modern "consciousness" is ideologically obliged to focus upon its supposed *powers in abstracto* over against the domain

of "reality," upon its idealized/ideologized self-conception as detached or pure "ego" and as arbitrary or irrational "will." It has neither concepts, vocabulary, values nor culture to enable it to diagnose or perceive its many forms of passivity or *being-acted-upon.* But the relation of modern "consciousness" to its world-order is defined not by its modes of self-action but by the unexpressed *liabilities* of psyche as a whole, by its most abysmal and formless naiveté or darkling *immediacy.* The power of this world over us, as of every historical form or phase of "world" (and of "us"), is inscribed not in our self-presumed omnipotent "knowing" or consciousness but in our subliminality, our taken-for-granted and radically unthoughtabout "soul" (to deploy an archaism lapsed out of the epoch of apotheosized Ego and its systematic reign of "luminous" egologism).

What does it actually, practically, most significantly and humanly mean for our society to have *evolved into something "scientized," "technologized"* — an *artificialized matrix?* And what does this indeed mean "subjectively"? What has this process most profoundly *done to us* in our forms and resources of "subjectivity" or "soulishness"? Most incredible of all the *self-revelations-to-itself-in-spite-of-itself* of modern scientific "Enlightenment" has been the demonstrable profundity with which — already formatted and thus limited in their abilities and intelligence by abstractive "educational" systems, by abstractive fiscal controls and markets to define for them what their expected needs and "values" will be, and by abstractive media that focus their concerns, attentions and rhetoric as required — masses of humans are capable of being *mass-organized, mass-oriented and mass-gulled,* as American political culture so richly illustrates. Humanity in its subpolitical mass-subjectivity has become just another divertible natural resource, a blind *olkssturm* or mobilizable river of energies like those that drive hydroelectric plants or wind farms.

In socio-economic jargon, the subliminal behavioral control of human beings via their "beliefs," "values" and "consciences" has been *"rationalized,"* made systematic and regularizable according to known and replicable techniques. Circumventing the feeble or nominal powers of "consciousness" or "reason" of most humans to this end is patently child's play. Oscar Wilde's canny post-Nietzschean recognition of the role of deception and untruth among the "bourgeois decencies" is, in our time, no longer a personal or "biographical" matter but a societal, mass-scale premise: "The truth about the life of a man is not what he does, but the legend which he creates around

himself." That is the lesson not just of the Nazi, Fascist and Communist eras but of the turbo-capitalist era as well: Like Reagan and Bush the elder, Bush the younger and McCain exemplify the magnitude and depth of power implicit in the *utter lack of resistance* of true believers *en masse* against media-contrived, *fabricated/pseudologized personae*, utter *creatures of rhetoric* with pseudo-careers, pseudo-creeds/concerns concocted out of programmatic strategies. That is the way power-elites reap the wholesale benefits of mass-decay in cultural intelligence, in value-intelligence and discriminating insight into both character and culture (and into culture's modern surrogate, the dysculture of ideology as a parasitic virus upon abstractivist mentality). The same "value-neutralization" that advances the scientist ideological program is, as well, *epidemic anomie and nihilism* from another strategic or diagnostic standpoint, the *atrophy* of morally animating principles and ultimate norms of self-coherence, self-criticism and self-mastery ("values") in a "post-credal" form of society (a collectivity of personality types generically inept to frame or recognize or criticize their own "beliefs" for themselves).

Far indeed from refuting the presumptions of ancient societies about ingrained or natural proclivities toward slavishness, modernity has proved instead that the human species *en masse* is *far more profoundly passive*, *docile* and *uncritical*, far more emotionally and irrationally dirigible than even the most pessimistic misanthropist of antiquity would have imagined — and certainly far more than culturally and psychologically superficialized moderns can conceive as true of themselves. When William Randolph Hearst's reporter, Frederick Remington, wired back from Manila that there was no war going on there, Hearst replied: "You provide the story, I'll provide the war." The Spanish-American War demonstrated Hearst was no flippant braggart. Whipping up modern irrationalisms, chauvinisms and jingoisms into a war-fury is, every time, *so facile* a task that the modern state is constantly tempted to over-use or abuse it, thus rupturing the skin of obtuseness that contains moderns' delusionality.

Modernity, as Hannah Arendt realized in *The Origins of Totalitarianism* and as others have gleaned from the remarkable developments of the 20th century, has produced an extensive *experiment in the implementation* of the *cult of experimentalism:* our society at large is "scientific" only in the sense of being mindlessly devoted to blind faith in "progress," which is to say in morally, valuationally and culturally untempered *mutation, adaptation and techno-control.* Without being at all rationally competent to understand its implications, we believe as facilely as little children in the thesis that "all things are possible," that "nothing is unthinkable," "forbidden" or "impermissible" for those with power, wealth and control over "mass-technology" (actually: the *technology of* massification or coordination). Over against such presumptive omnipotence the vast majority of moderns have no initiative, audacity or passion to depart from the institutionalized path of least resistance: they evolve thus into the reciprocal *pathos* or the trusting/obedient/mindless victims of that system of power, the putty worked by power's digits. They do not actively or consciously *exist* but only *subsist* in a climate-controlled attitude of impotence and infinitely permeable blind faith, a *formatted, undiscriminating, emotionalizing omni-acceptance* ("right-thinking positive-mindedness," a.k.a. "piety" or "patriotism" etc.).

"Freedom," "will," "consciousness," "independence," and "rationality" overwhelmingly exist today only as nodules of self-flattery within a normalized, gelatinous social organism of *false consciousness* that *cannot begin to fathom* how utterly it belies all such ideals and euphemisms. Modernity is by design a world order purged of virtually all moral, cultural, spiritual, and philosophical intelligence that would enable its denizens or patients to perceive that the mode of "living" ordained by its dominant scheme of order is a *defenseless and subcritical complicity*, within a complex of mechanized systems of receptive slave culture or "massified" subsistence. This *pathos of orthodoxy or slavish servility* may be recognized in a given nation or religion by outsiders, but never in a people by its own self. The whole purpose of such a *pathos* or dysculture is to strip them of all competence to see anything for themselves. (Hegel: "The people is that part of the state that does not know what it wants.")

Modernity is thus a tacit feudalism, a system of crypto-hierachic *vassalage* that dares not speak its true name, whether as "paternalism," "padronism," "plutocratism" or "capitalism." Its slaves are far more readily managed *under a cloud cover of delusions* that they exist in a "democratic" system, even though this order exploits and disposes of them ruthlessly and is mass-implacable to their needs, interests and rights. Their concerns and self-interest, their quality of existence and intelligence, are no longer an independent and transcendent "principle" with an intuitive truth of its own but only a function of how the orchestrated modern machine-order demands they should serve it. The only reason the seeming forms of democratic order and law are still tolerated is that, in truth, the *actual powers* of these forms are checked and self-castrated

everywhere under the mind-toxins of a controlled climate of false consciousness, a culture of correlative sloth and predation. Never before have so many abstracted, amoral or nihilized personalities (*banausoi*) been professionalized to take command over and to prosper from controlled mass experiments (understood as "marketing" and "PR," "media" and "political campaigns" and the "propagation of ideologies and rhetoric"). Never before have such mass-scale societies been conditioned to live under wholly artificial or *designed/dictated* conditions and such utterly depthless or *pathetically contemporaneous and self-cloistered* "cultures." Our systems of education, culture and political rule lie in such ruins that, as one national education commission starkly observed, if some foreign power had done this to us, we would regard it as grounds for war; and yet we have "done" all this *to ourselves*. Among us, all that is *willfully controllable* is subject to being commandeered for the interests of the utmost constellations or complexes of power, for petrochemical and financial cartels, around which our mass-political parties orbit as satellites; indeed, practically and conceptually, "power" wouldn't truly be or remain "power" if it *couldn't* harness such matters to its own purposes.

— As Nietzsche recognized, we live still among the ghosts of ancient and anciently significant forms and forces, little as we can perceive or comprehend that this is in truth what they are. And we obey still those innermost ancient *daimones* that were the way darkling human natures once gave shape unwittingly to their own obscure imperatives — little room as we now have in the pantheon of modern "ego-cults" for such vague, naïve and mythical topics as "human natures." Like all naifs and all self-enclosed idiots, we prefer by far our own petty and plastic myths, never grasping that our current miasma is where those modern idolatries and organized infatuations have borne us, and that our "self-fulfillment" is at the same time a self-extrapolated, intimately self-tailored straitjacket. In the prison of modern life each one of us is policeman, prosecutor, judge, prisoner and guard to himself; but the law over them all is that no human can tolerate recognizing that he is ultimately *responsible for his own* idiotic warpage and self-doom. ■

May, 2009 – June, 2009

From *Static Shock!: Rebirth of the Cool* #3, written by Dwayne McDuffie and drawn by John Paul Leon. [©2001 Milestone Media, Inc.]

ALTERNATIVE

Seth's *New York Times* strip **George Sprott (1894-1975)** is collected by Drawn & Quarterly in May ($24.95, 96 pp.). It's about the life and times of a TV host. **T-Minus: The Race to the Moon** is writer Jim Ottaviani's latest comics-and-science project. Published by Aladdin, it's drawn by Zander and Kevin Cannon and aimed at kids (May, $12.99, 128 pp.). **The Eternal Smile** from First Second contains three fantasy stories by co-creators Gene Luen Yang and Derek Kirk Kim (May, $16.95, 176 pp.). Also from First Second in May comes a collaboration between artist Emmanuel Guibert and photojournalist Didier Lefèvre. Entitled **The Photographer**, it recounts a reporter's experiences in Afghanistan in 1986, following the Soviet invasion ($29.95, 288 pp.). From Fantagraphics comes **Abstract Comics: The Anthology**, edited by Andrei Molotiu, in which cartoonists such as Gary Panter and Patrick McDonnell contribute their non-representational comics. This collection also includes virgin efforts by Ivan Brunetti, James Kochalka, Waren Craghead and many more (June, $39.99, 208 pp.). In June, Fantagraphics gathers Jason's short comics along with his *New York Times* Western chess serial **Low Moon** ($24.99, 216 pp.).

CLASSIC STRIPS/BOOKS

Joe Simon, who co-created Captain America with Jack Kirby, picked his favorite collaborations with Kirby from all genres (superhero, Western, romance, etc.) for Titan's May release: **The Best of Simon and Kirby** ($39.95, 320 pp.). Also in May from Fantagraphics is editor Craig Yoe's **Great Anti-War Cartoons** ($19.99, 112 pp.), which features comics by Francisco Goya, Art Young, Robert Crumb, Honoré Daumier and many more. Seth continues to design the covers of classic comic collections with his work for **Nancy Vol. 1**, put out by Drawn & Quarterly in late May. This 128-pp., $9.95 book samples the *Nancy* comic books by John Stanley (the character was created by Ernie Bushmiller). **You Shall Die by Your Own Evil Creation!** is editor Paul Karasik's sequel to his Eisner-winning collection: *I Shall Destroy All the Civilized Planets!: The Comics of Fletcher Hanks*. This volume has

From *Final Crisis* #1 (July 2008), written by Grant Morrison and drawn by J. G. Jones. [©2008 DC Comics]

Set in Civil War-era New Mexico, it introduces the films' characters to the page, with pencils from Wellington Dias and inks by Richard Isanove (Dynamite Entertainment, $19.99, 168 pp.). Having been the star of his own WB kids' cartoon, Static Shock comes home to comics in *Static: Rebirth of the Cool*, a direct spin-off from his small-screen adventures. Dwayne McDuffie returns to write (with Robert L. Washington III) his minority superhero, with art from John Paul Leon (DC Comics, $19.99, 192 pp.). Also in May, DC collects Jim Starlin's *Rann/Thanagar Holy War* **Vol. 1**. The post-*Infinite Crisis* animosity between the two alien races continues: in addition to blaming each other for the destruction of their homeworlds, they now face religious schism. This book features an ensemble cast from DC's sci-fi roster, including Adam Strange, Hawkman and the Omega Man. Penciler Ron Lim and inker Rob Hunter return to draw the cosmic territory that garnered them acclaim during the '90s (DC Comics, $19.99, 168 pp.). June sees the collection of Grant Morrison's high-concept superhero saga, *Final Crisis*, which pays homage to Jack Kirby's *Fourth World* tales, as well as offering a sequel to his own *Seven Soldiers of Victory* maxiseries. In the wake of the death of Orion of the New Gods, the Green Lantern unites with some new Japanese heroes to stop the destruction of the Earth. This volume contains the core seven-part series with the satellite stories to follow in future collections. J.G. Jones pencils and Carlos Pacheco inks this storyline (DC Comics, $24.99, 240 pp.).

ABOUT COMICS

Underground Classics: The Transformation of Comics into Comix by Denis Kitchen and James Danky showcases the work of, among others, Gilbert Shelton, Kim Deitch and S. Clay Wilson. It includes original artwork and a selection of new essays (Abrams ComicArts, $29.95, 144pp.). On the other end of the spectrum, we have mainstream maven *Stan Lee's Complete How To Draw Comics* (ably assisted by a whole host of mighty Marvel's pencilers, inkers and colorists). This hulking hardback sets Lee's insider advice in a step-by-step format to take aspiring creators from initial sketches to a finished product. Each stage of the process is illuminated by some of Lee's former collaborators, including work by the late John Buscema (Dynamite Entertainment, $29.99, 200 pp.). Paul Lopes charts the cultural shift of comics from reviled trash to hip fiction in *Demanding Respect: The Evolution of the American Comic Book* in both a hardcover and paperback edition in May (Temple University Press, $69.50/$24.95, 256 pp.). ∎

twice as many stories as the last and the two combined are the sum total of Hanks' comics output.

INTERNATIONAL

Edo Cats: Tails Of Old Tokyo is a cat's-eye view of Japan's past by historian and *manga-ka* Ryuto Kanzaki (Japanime Co. Ltd., $9.99, 96 pp.). Seth designs another May Drawn & Quarterly title: *The Collected Doug Wright: Volume One: Canada's Master Cartoonist*. *For Better or For Worse*'s Lynn Johnston introduces the first of two lavishly illustrated volumes portraying the cartoonist as a young man, leading up to his acclaimed strip *Nipper* ($39.95, 240 pp.).

MAINSTREAMY

Christos Gage tells the continuing tales of Sergio Leone's Western antihero in *Man With No Name: Volume One*.

Have you recently discovered a new favorite cartoonist and want to read an in-depth interview with him or her? Are you doing research for a book or a paper, or do you just want to catch up with the comic industry's magazine of record? Below is a sampling of *TCJ* back issues available from our warehouse for your perusal. For the full backlist of in-print issues, please visit www.tcj.com.

40: JIM SHOOTER interviewed, Spiegelman's BREAKDOWNS reviewed. ($3.50)

48: A 140-page partial-color Special, featuring interviews with JOHN BUSCEMA, SAMUEL R. DELANY, KENNETH SMITH AND LEN WEIN! ($6)

72: NEAL ADAMS interview. ($3.50)

74: CHRIS CLAREMONT speaks; plus RAW with SPIEGELMAN and MOULY. ($3.50)

89: WILL EISNER interview; EISNER interviews CHRIS CLAREMONT, FRANK MILLER & WENDY PINI! ($3.50)

124: JULES FEIFFER interviewed; BERKE BREATHED defends his Pulitzer. ($5)

127: BILL WATTERSON interviewed! Limited Quantity! ($10)

131: RALPH STEADMAN interviewed! ($5)

142: ARNOLD ROTH and CAROL TYLER. ($5)

152: GARY GROTH interviews TODD McFARLANE! ($6)

154: DANIEL CLOWES interviewed; HUNT EMERSON sketchbook. ($6)

156: GAHAN WILSON! ($6)

157: BILL GRIFFITH; special KURTZMAN tribute. ($6)

158: ED SOREL; R. CRUMB discusses life and politics. ($6)

162: Autobiographical cartoonists galore! PEKAR, EICHHORN, NOOMIN, BROWN, MATT, SETH! ($6)

169: NEIL GAIMAN and SOL HARRISON ($6)

172: JOE KUBERT interview. ($5)

180: ART SPIEGELMAN; R. CRUMB. ($7)

187: GILBERT SHELTON; GIL KANE. ($6)

206: PETER BAGGE and MILLIGAN, SPAIN II, TED RALL interviewed, JACK KATZ profiled. ($7)

209: FRANK MILLER, SAM HENDERSON! ($6)

213: CAROL LAY interview, Kitchen Sink autopsy! ($6)

215: JOHN SEVERIN pt. 1, TONY MILLIONAIRE! ($6)

216: KURT BUSIEK, MEGAN KELSO, SEVERIN II. ($8)

225: MAD issue. JAFFEE, DAVIS and FELDSTEIN! ($6)

227: CARL BARKS tribute, C.C. Beck's *Fat Head* pt. 2 ($6)

231: GENE COLAN, MICHAEL CHABON, ALAN MOORE interviewed! ($6)

241: JOHN PORCELLINO, JOHN NEY RIEBER! ($6)

242: GIL KANE chats with NOEL SICKLES! ($6)

244: JILL THOMPSON, MIKE KUPPERMAN! ($6)

247: Our 9/11 issue: RALL, RUBEN BOLLING interviews. ($7)

248: STEVE RUDE ! ANDI WATSON interviewed! ($7)

250: 272-page blowout! HERGÉ, PANTER, CLOWES and RAYMOND BRIGGS interviewed! CARL BARKS and JOHN STANLEY chat! NEIL GAIMAN vs. TODD McFARLANE trial transcripts! Brilliant manga short story NEJI-SHIKI translated! Essays on 2002-In-Review, EC, racial caricature, post-9/11 political cartooning, Team Comics, etc. and a rare essay by the late CHARLES SCHULZ on comic strips! ($14)

251: JAMES STURM! Underground comix panel! ($7)

252: JOHN ROMITA SR., RON REGÉ interviewed. ($7)

253: ERIC DROOKER, JOHN CULLEN MURPHY, JASON! ($7)

254: WILL ELDER, Kazuo Umezu interviews! ($7)

256: KEIJI NAKAZAWA; FORT THUNDER! ($7)

257: A suite of four never-before-published interviews with the late, great comix artist RICK GRIFFIN! Hardworkin' writer JOE CASEY interviewed! ($7)

258: A comprehensive look at the work of STEVE DITKO, and a conversation with GILBERT HERNANDEZ and CRAIG THOMPSON! ($7)

259: 2003 Year in Review: Comics and Artists of the Year! Youthquake! A new generation emerges! ($7)

260: DUPUY and BERBERIAN! JEAN-CLAUDE MÈZIÉRES! They're foreign! ($7)

261: PHOEBE GLOECKNER! JAY HOSLER! ($7)

262: NEWFORMAT! ALEX TOTH profiled, plus an interview with STEVE BRODNER! ($10)

263: ED BRUBAKER interviewed! CEREBUS examined! George Carlson's JINGLE JANGLE TALES in color! ($10)

264: IVAN BRUNETTI interviewed, Underground Publishers, Harold Gray's LITTLE JOE in color! ($10)

265: Essays on WILLIAM STEIG, ERIC SHANOWER interviewed, Harry Anderson's Crime Comics! ($7)

268: CRAIG THOMPSON! BOB BURDEN! TINTIN AT SEA! WALT KELLY'S "OUR GANG" in color! ($10)

269: SHOUJO MANGA ISSUE! MOTO HAGIO interviewed and her short story "HANSHIN" in english! ($10)

270: JESSICA ABEL! MARK BODÉ and LALO ALCARAZ! NELL BRINKLEY comics in color! ($10)

271: JERRY ROBINSON interviewed! RENÉE FRENCH! Pre-Popeye THIMBLE THEATRE! ($10)

273: EDDIE CAMPBELL interviewed! JUNKO MIZUNO interviewed! ART YOUNG goes to HELL! ($10)

274: MIKE PLOOG interviewed! SOPHIE CRUMB! Early HARVEY KURTZMAN comics in COLOR! ($10)

275: 2005 YEAR IN REVIEW! DAVID B. interviewed! BOODY ROGERS comics in COLOR! ($10)

276: TERRY MOORE interviewed! BOB HANEY pt. 1! Early B. KRIGSTEIN comics in COLOR! ($10)

277: 30 YEARS OF THE COMICS JOURNAL! THE STATE OF THE INDUSTRY! IT RHYMES WITH LUST! ($13)

278: BILL WILLINGHAM interviewed! BOB HANEY pt. 2! JAXON tribute! ($10)

279: JOOST SWARTE interviewed! JOHNNY RYAN! LILY RENÉE comics! ($10)

280: FRANK THORNE interviewed! CARLA SPEED McNEIL! CRIME DOES NOT PAY comics! ($10)

281: THE BEST COMICS OF 2006! YOSHIHIRO TATSUMI and MELINDA GEBBIE interviewed! ($10)

282: ALISON BECHDEL! FRED GUARDINEER! Andru & Esposito's GET LOST comics! ($10)

283: LEWIS TRONDHEIM! DAVID SANDLIN! THE 39 STEPS comic adaptation! ($10)

284: ROGER LANGRIDGE! GENE YANG! Frederick Burr Opper's HAPPY HOOLIGAN in color! ($10)

285: DARWYN COOKE! ERNIE COLÓN! KEITH KNIGHT! John Buscema WANTED comics! ($10)

286: POSY SIMMONDS! GAIL SIMONE! Otto Soglow's THE AMBASSADOR in color! ($10)

287: JEFFREY BROWN! GREG RUCKA! Non-Krazy Kat comics of GEORGE HERRIMAN! ($12)

288: NEW FORMAT! THE BEST COMICS OF 2007! Tarpé Mills MISS FURY in color! ($12)

289: ROBERT KIRKMAN! SHAUN TAN! A gallery of MINUTE MOVIES strips! ($12)

290: SCHULZ AND PEANUTS ROUNDTABLE! MATT MADDEN! A gallery of '50s horror comics by BOB POWELL! ($12)

291: TIM SALE! JOSH SIMMONS! A gallery of DAN GORDON comics! ($12)

292: THE DEITCH ISSUE: GENE, KIM, SIMON and SETH all interviewed by Gary Groth! ($12)

293: S. CLAY WILSON! ALEX ROBINSON! ($12)

294: Norwegian star JASON! MARK TATULLI! ($12)

295: BRIAN K. VAUGHAN! GIPI! JOHN KERSCHBAUM! ($12)

Libraries and Specials:

TCJ SPECIAL I: WINTER 2002: JOE SACCO interviewed! ($24)

TCJ LIBRARY VOL. I: JACK KIRBY: All of The King's Journal interviews! ($23)

TCJ SPECIAL II: SUMMER 2002: JIM WOODRING interviewed! ($27)

TCJ SPECIAL III: WINTER 2003: BILL STOUT interviewed! ($27)

TCJ LIBRARY VOL. II: Frank Miller: All of FM's Journal interviews and more! ($23)

TCJ LIBRARY VOL. III: R. CRUMB: All of Crumbs Journal interviews! ($23)

TCJ SPECIAL IV: WINTER 2004: Profiles of and interviews with four generations of cartoonists — AL HIRSCHFELD, JULES FEIFFER, ART SPIEGELMAN and CHRIS WARE! ($23)

TCJ LIBRARY VOL. IV: DRAWING THE LINE: Lavishly illustrated interviews with JULES FEIFFER, DAVID LEVINE, EDWARD SOREL and RALPH STEADMAN! ($23)

TCJ SPECIAL V: WINTER 2005: Almost half of this volume is devoted to MANGA! Also features Vaughn Bodé, Milt Gross, and a comics section! ($25)

TCJ LIBRARY VOL. V: CLASSIC COMICS ILLUSTRATORS: A full-color celebration of the work of FRANK FRAZETTA, RUSS HEATH, BURNE HOGARTH, RUSS MANNING, and MARK SCHULTZ! ($23)

TCJ LIBRARY VOL. VI: THE WRITERS: Interviews with ALAN MOORE, CHRIS CLAREMONT, STEVE GERBER and more! ($20)

TCJ LIBRARY VOL. VII: KURTZMAN: Interviews with HARVEY KURTZMAN! ($23)

The Independent Press Award Winner for Arts & Literature coverage just keeps getting better. Subscribe now to get these issues:

THE COMICS JOURNAL #297

A career-spanning interview with Mort Walker, the creator of the long-running comic strips *Beetle Bailey* and *Hi & Lois*. Graphic designer, editor and cartoonist Jordan Crane discusses his groundbreaking comics anthology NON, his internationally acclaimed graphic novel, *The Clouds Above* and his new series *Uptight*. Plus an essay and comics gallery focusing on the work of the famous 17th-century caricaturist Thomas K. Rowlandson.

THE COMICS JOURNAL #298

The multiple-Eisner-Award-winning Brazilian twins Gabriel Bá and Fabio Moon tell us about working together on graphic novels such as *De-Tales* and *Ursula*, as well as collaborating with My Chemical Romance's Gerard Way on *Umbrella Academy*, Joss Whedon on *Sugarshock* and Matt Fraction on *Casanova*. *Perry Bible Fellowship* creator Nicholas Gurewitch gives us the scoop on his BBC television pilot based on the strip and why he semi-retired thecomic after its phenomenal success on the Web and in college-newspapers, alt-weeklies and collections.

"Still the best and most insightful magazine of comics criticism that exists."
— **Alan Moore**

"You ignore it at your peril."
— **Neil Gaiman**

"The good is always in conflict with the better. *The Comics Journal* attempts to explain the difference."
— **Gil Kane**

"All in all, *The Comics Journal* is a stand-out inspiration to me."
— **Kim Deitch**

Read *The Comics Journal* the way the professionals do:

by SUBSCRIPTION.